NATIVE VISIONS

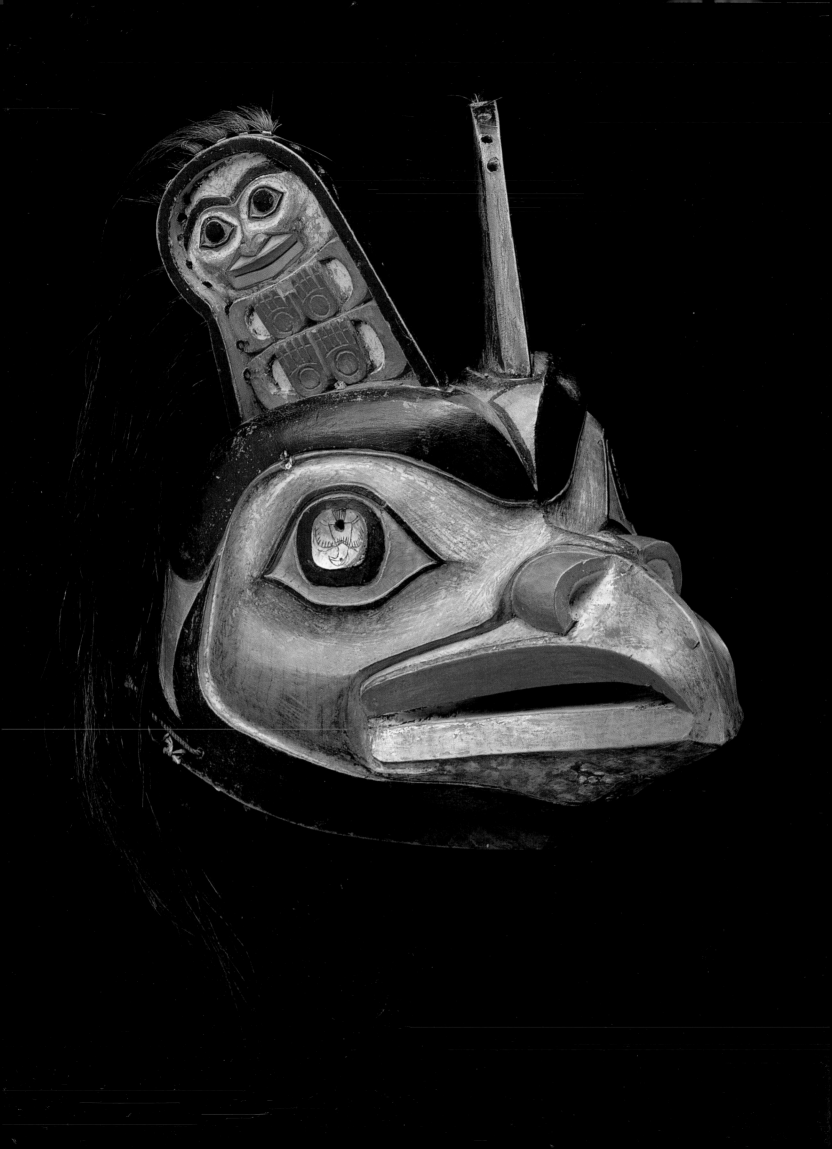

NATIVE VISIONS

Evolution in Northwest Coast Art
from the Eighteenth through
the Twentieth Century

STEVEN C. BROWN

Photographs by Paul Macapia

The Seattle Art Museum *in association with the*
University of Washington Press *Seattle & London*

A generous contribution towards the exhibition catalogue was made by The Eugene V. and
Clare E. Thaw Charitable Trust. A leadership grant for the exhibition and the catalogue has been
provided by The Henry Luce Foundation. The Seattle Art Museum would like to thank the follow-
ing organizations and individuals for their support of this project: The Andrew W. Mellon Foun-
dation; The Seattle Arts Commission; SAFECO; SAMS (Seattle Art Museum Supporters);
The Mary and Dean Thornton Endowment Fund for the Seattle Art Museum.

Library of Congress Cataloging in Publication Data

Brown, Steven C.
 Native visions : evolution in northwest coast art from the
eighteenth through the twentieth century / Steven C. Brown ;
photographs by Paul Macapia.
 p. cm.
 Based on an exhibition organized by the Seattle Art Museum.
 Includes bibliographical references and index.
 ISBN 0–295–97657–8 (cloth : alk. paper).—ISBN 0–295–97658–6
(pbk. : alk. paper)
 1. Indians of North America—Northwest Coast of North America
—Exhibitions. 2. Indian art—Northwest Coast of North America
—Exhibitions. I. Seattle Art Museum. II. Title.
E78.N78B76 1998
704.03'970795—dc21 97–30413
 CIP

Cloth ISBN 0–295–97657–8
Paper ISBN 0–295–97658–6

The paper used in this publication meets the minimum requirements of American National
Standard for Information Sciences—Permanence of Paper for Printed Library Materials,
ANSI A39.48–1984. ∞

This book has been published in conjunction with the exhibition
Native Visions: Northwest Coast Art, 18th Century to the Present
organized by the Seattle Art Museum

Itinerary of the Exhibition (at the time of publication)

Seattle Art Museum, Seattle, Washington
February 19—May 10, 1998

New York State Historical Association, Cooperstown, New York
June 15—September 13, 1998

Anchorage Museum of History and Art, Anchorage, Alaska
October 18, 1998—January 10, 1999

Eiteljorg Museum, Indianapolis, Indiana
June 12—September 6, 1999

Key to Abbreviations

AMNH American Museum of Natural History, New York City
ASM Alaska State Museum, Juneau
CMC Canadian Museum of Civilization, Hull, Quebec
FM Field Museum, Chicago
MCRC Makah Cultural and Research Center, Neah Bay, Washington
MdeA Museo de América, Madrid, Spain
SAM Seattle Art Museum, Seattle

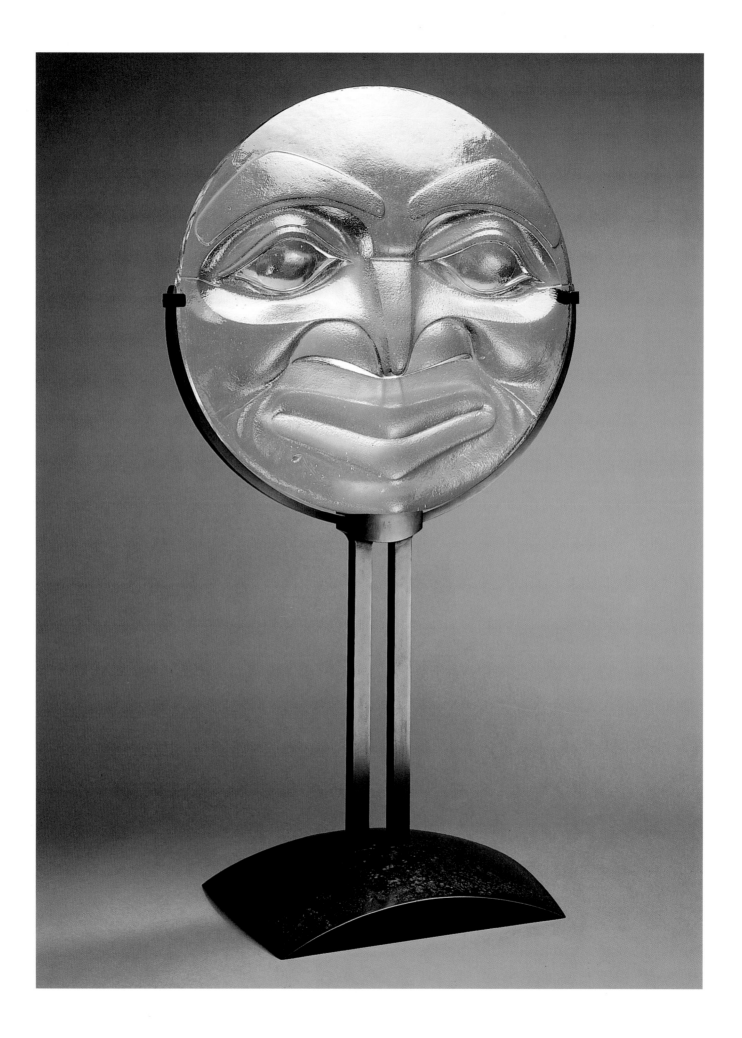

Contents

FOREWORD ix

ACKNOWLEDGMENTS xi

LOOKING BACKWARD: AN INTRODUCTION 3

1. Ancient Roots:
 Prehistoric Perspectives on Northwest Coast Art 7

2. Curious Visions:
 Northern Northwest Coast Art in the Historic Period 13

3. Sleeping Treasures:
 Northwest Coast Art of the Late Prehistoric Period 21

4. Changing Times:
 Art of the Early Classic Era, 1820–1865 47

5. Expanding Traditions:
 Art of the Late Classic Period, 1865–1920 99

6. Bridging Generations:
 Northwest Coast Art in the Middle 20th Century, 1920–1965 139

7. The Spirit of the Masters:
 Northwest Coast Art in the Contemporary Period, Since 1965 161

NOTES 193

SOURCES 201

INDEX 211

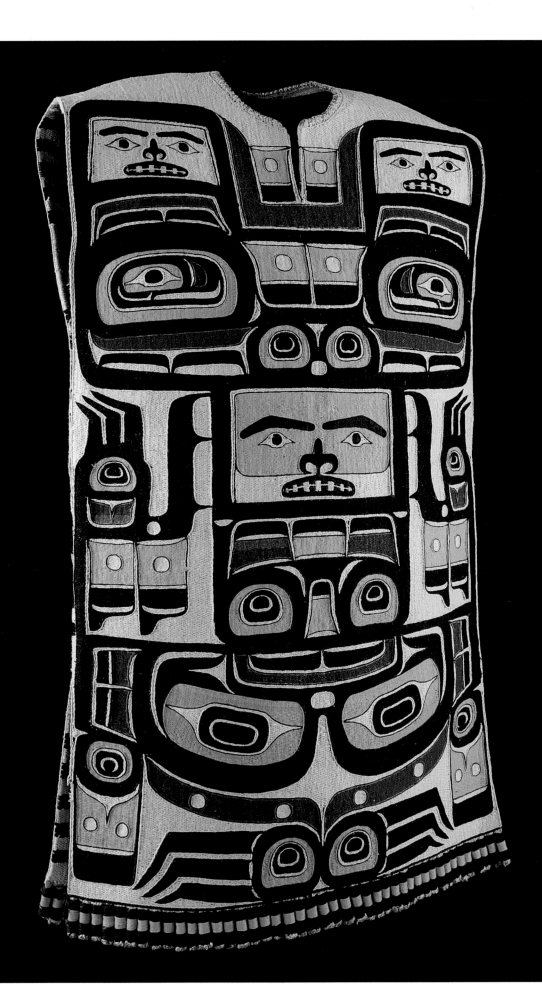

Foreword

Mimi Gardner Gates
The Illsley Ball Nordstrom Director
Seattle Art Museum

The Seattle Art Museum is proud to present *Native Visions: Evolution in Northwest Coast Art, from the 18th through the 20th Century*, an exhibition and publication that we feel will make a valuable impact on the study of the Native American art tradition from this region. The gradual development of the unique Northwest Coast two-dimensional design system is described here by Steven C. Brown, associate curator for Native American art, in a manner that is accessible to scholars and a wide range of Northwest Coast art enthusiasts. Composed of pieces generously loaned by Seattle area private collectors, complemented by a number of pieces from the museum's renowned John H. Hauberg collection, this exhibit and publication clearly illustrate the changing design concepts and conventions described in the narrative text.

The museum is especially grateful for the extraordinary generosity shown by the lenders, whose enthusiasm and participation were essential to the project. The collector's planning committee deserves our thanks and appreciation for initiating this project and seeing it through to realization.

This publication marks the first collaborative project between the University of Washington Press and the Seattle Art Museum. The staff of the University of Washington Press, notably director Pat Soden, managing editor Julidta Tarver, editor Gretchen Van Meter, and designer Bob Hutchins, worked smoothly with curator Steve Brown and helped invaluably in producing a handsomely designed book and a lucid, rewarding text. The superb photography, which enhances appreciation of the objects, is the work of the Seattle Art Museum's talented photographer, Paul Macapia.

Many members of the Seattle Art Museum staff worked diligently on this project. Gail Joice, senior deputy director and registrar, and Riva Davis, assistant registrar, provided oversight. Michael McCafferty and Chris Manojlovic designed the elegant installation; Jack Mackey, Gordon Lambert, and B. J. Farrar skillfully made the exhibit mounts and preparations; art handlers Dennis Meyer and Paul Martinez oversaw the movement of objects; and exhibitions coordinator Zora Foy managed the logistics, including the traveling tour of the show. Without these experienced and skilled professionals, major exhibitions would not be possible.

Steven C. Brown, curator of the exhibition and author of this book, deserves singular praise. A respected scholar and artist, he has dedicated himself to this project for several years in order to share with us his deep knowledge, special insights, and sincere passion and respect for these objects and the artists who made them. We appreciate his efforts and his profound contribution to the field of art history.

Generous and enthusiastic support for this project has come from numerous sources. We are most grateful to the Henry Luce Foundation for their funding of all aspects of this effort. In addition, the Eugene V. and Clare E. Thaw Charitable Trust helped to underwrite the publication, ensuring its high quality. The Andrew W. Mellon Publication Endowment Fund helped to complete this production.

The Seattle Art Museum is committed to the advancement of knowledge and critical thinking about arts and culture. It is our hope that this project's new approach to Northwest Coast Native American art will visually and intellectually enrich old friends of these traditions and newcomers alike.

Acknowledgments

THE IDEA TO ASSEMBLE THE VARIOUS SEATTLE AREA PRIVATE COLLECTIONS THAT have become the *Native Visions* exhibition first came from among the collectors' group itself, individuals whose collections were featured in the *Box of Daylight* exhibit held at the Seattle Art Museum in 1983. To these individuals goes a great deal of thanks for their patience and dedication, and for the many fine meals that spiced our meetings. The original effort was spearheaded by John Putnam, Eugene and Martha Nester, Jim Hussey, and James and Marion Bergstrom, although the latter couple, at the end of a rather protracted scheduling process, no longer had a collection to exhibit (it had been sent to auction at Christie's). This planning committee was joined by Allan Lobb, a most knowledgeable and enthusiastic collector and author in several fields, Lloyd Averill and Daphne Morris, who contributed ideas regarding the contemporary segment of the exhibition, and by Gail Joice, deputy director of the Seattle Art Museum, a much-appreciated colleague whose interest and enthusiasm for the art of many cultures are always apparent. The important support contributed by all the lenders to this exhibition has made this endeavor possible. Their patience and generosity are greatly appreciated.

Watercolor artist Evelyn Vanderhoop, a member of the Haida nation, was invited to participate in the exhibit planning, particularly the contemporary section, in recognition of her successful work in the Native community both as an artist and education administrator. Evelyn had (somewhat reluctantly) agreed to compose an essay for this publication which was to address the meaning and importance of the art traditions in the lives of contemporary artists. Her contribution and patient input has been nonetheless appreciated, even though a number of obstacles came between the idea of the essay and its completion.

The inspiration, guidance, and preliminary contributions of Bill Holm have been pivotal to my understanding of this tradition, as well as to the undertaking and completion of this particular project. His words of encouragement and advice over thirty years are sincerely appreciated. Bill's and his wife Marty's eternal willingness to read and review my ideas in this manuscript and to express support in a host of unforeseen additional situations, have assisted immeasurably in this effort, and to them

both I am ever grateful.

Thanks are due as well to other colleagues who helped through inspiration, example, or in the sharing of important information. Appreciation goes to Steve Henrikson, Alan Hoover, Peter Macnair, Aldona Jonaitis, Robin Wright, Allen Wardwell, and Trevor Fairbrother for their kind assistance. A special word of thanks also goes to Eugene and Clare Thaw, enthusiastic collectors and warm, supportive people who have shared their hospitality with me and given assistance with this volume that helped to get the project off the ground.

Many thanks go to individuals of the several Seattle Art Museum departments that assisted so efficiently in developing and mounting this exhibition and publication, in Grants, Registrars, Preps and Mountmakers, and Development. All the efforts of the staff have been generous and have contributed greatly to the success of this project.

Sincere thanks and acknowledgment also go to the many Native people who have shared their warmth and hospitality, their art, and their personal insights and stories with me over the years. Without the friendship and acceptance of many of these individuals, I would never have gained the courage or the experience to overcome the many personal and professional situations that one encounters in this field of undertaking, and I recognize and appreciate their wisdom and kindness. Special thanks go to the Makah people of Neah Bay, Washington; the David families of Tofino and Port Alberni, British Columbia; Esther Shea and her family of Ketchikan; Marge Byrd and the Bradley family of Wrangell; and the Dalton family of Hoonah, Alaska.

To experience the inside of another culture gives one a perspective and sense of participation that is invaluable and indelible. It colors all subsequent experience in the world. In my case, it has reinforced the notion that this art tradition is, in an important manner, inseparable from the culture in which it was spawned, and from the families who have proudly maintained their respect and allegiance to it through the ebb and flow of varied waves of opposition and discouragement. More recent times have been kinder, but have not been without competition from a variety of sources, from the non-culture of television and technology to the profits deriving from over-romanticization and imitation.

It is in part for these reasons that the selection of materials for the contemporary section of this project was limited to the work of Native artists. This is a decision that has not been without criticism from certain quarters, but one which many realize is made out of deep respect for the source of this tradition: the collective spirit of the ancient ones who forged this art style from the visual and spiritual elements of their world. The history of Native and non-Native relations is the context from which we endeavor to create a more positive future: one in which all peoples can live and work in a mutually appreciative atmosphere and share in the joy of meaningful creation. It is toward this hope that the work contained in this volume is dedicated.

NATIVE VISIONS

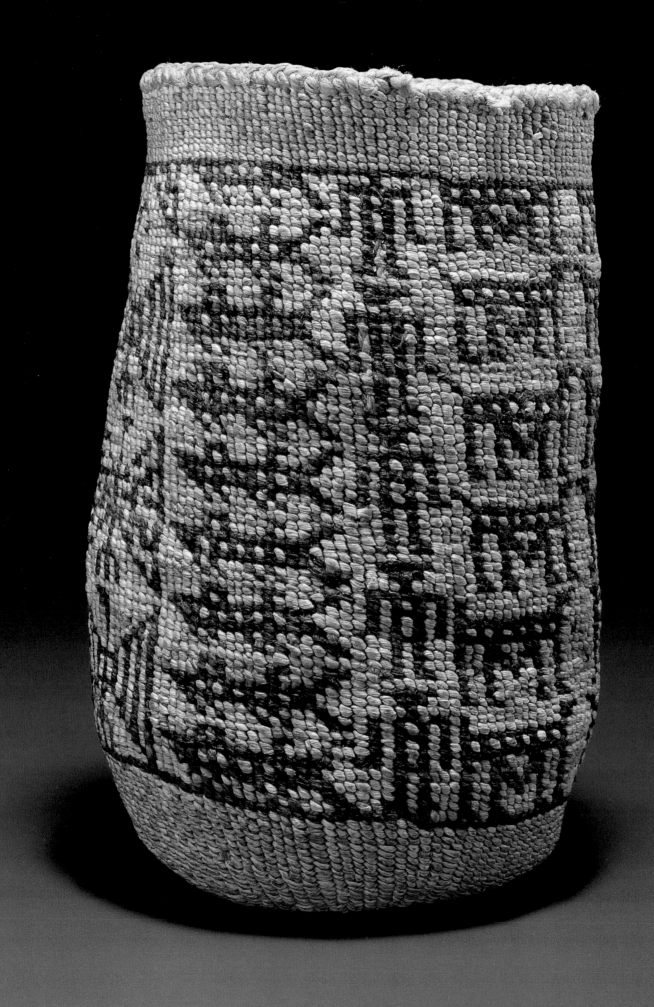

Looking Backward

An Introduction

> *When we look at a particular work of Northwest Coast art*
> *and see the shape of it, we are only looking at its afterlife.*
> *Its real life is the movement by which it got to be that shape.*
>
> —*Bill Reid, Haida (1971)*

THE CURATORIAL CONCEPT FOR THIS EXHIBITION CAME ABOUT INDIR-
ectly as the result of ongoing conversations with Allen Wardwell, the well-known
scholar of tribal art, regarding the inconsistent dating of Northwest Coast objects in
the art historical literature, a subject of great interest to both of us. This culminated
in my involvement in one of a series of presentations given before Wardwell's gradu-
ate-level class in Northwest Coast art history at Princeton University in April of 1995,
and a paper entitled "Dating on the Northwest Coast: Breaking the 18th-Century Bar-
rier," presented at the Symposium on Native American Art in July of 1995 at the Feni-
more House Museum of the New York State Historical Association in Cooperstown.

It had become apparent in the literature of art history that, in spite of new archae-
ological evidence of the antiquity of the Northwest Coast cultures and art forms,
there existed a general reluctance to attribute dates of origin to historically collected
objects that preceded the late eighteenth century. Certainly it would seem unlikely
that all the materials gathered from the Northwest Coast in the last two hundred
years had been created only within that same period. Surely numerous objects were
already in use, perhaps for decades or more, at the time of the first Euro-American
contacts in the closing decades of the eighteenth century. There must have been
nearly as many artifacts present in 1700 as in 1800. How could we learn to recognize
these creations?

A precious small number of such objects, collected by the early explorers and now
housed in many different museums, illustrates the status of Northwest Coast arts in
this period. The archaeological record of ancient work is deepening our concepts of
this tradition. In between these points of time is a vast undocumented period of great
interest and mystery which has largely been ignored by art historians in this field,

mostly for lack of information. The question has been how to separate out those objects of early manufacture from the many others of later date which share the space on the world's museum shelves. Many objects that appear to be very early were acquired by the world's natural history museums during the late-nineteenth-century period of aggressive artifact collecting (see Cole 1985). In addition to the information provided by important dated pieces in well-documented early collections, part of the answer to the problems of attribution of undated objects lies in understanding the progressive development of the Northwest Coast two-dimensional art tradition. Armed with some visual experience, one is able to recognize certain common traits that distinguish, among all the existing artifacts from this area, those which were most likely made in the oldest time periods.

The stylistic comparison of Northwest Coast First Peoples arts has been best expressed and analyzed in the work of University of Washington scholar Bill Holm, whose writings, both published and unpublished, will be drawn upon throughout this presentation. Other scholars, writers, and Native artists have also contributed significantly to the understanding of the Northwest Coast art tradition over a long period of time, and several of these sources have been called forward as well. The knowledge and experience of the individual collectors involved in the exhibition have also been invaluable, lending important points of view and bits of information that have helped to shape this effort.

An Overview

The Northwest Coast Native art style, first introduced to Euro-Americans in the late eighteenth century, is without doubt the product of many generations of conceptual evolution and refinement. The apparent levels of complexity and sophistication in the two-dimensional design style, first successfully interpreted in Bill Holm's important 1965 study, *Northwest Coast Indian Art: An Analysis of Form,* indicate the depth of its development.[1] The elaborate system of forms and conventions described by Holm was certainly not invented overnight, nor even in a single century. As further evidence, we have the historic record of the artifacts themselves, both archaeological and ethnographic. These, when carefully examined, display a great deal of progressive change through time, suggesting that Northwest Coast art has always been a dynamic tradition, responsive to the innovations and ideas of successive generations of practicing artists. As such, various stages in this evolutionary process become visible in the characteristics of individual artworks, which can reveal important information about the tradition in any given time period.

Remarkable developments took place in the northern two-dimensional style during the tumultuous two centuries since the first Euro-American contact with First Peoples of the Northwest Coast. From the onset of the historic period, tens of thousands of Native artifacts were gathered up by early explorers and innumerable field collectors and distributed through the museums and private collections of the world. Unfortunately, only a small minority of these were systematically assembled and documented as to each object's geographic location and the year in which it was collected.[2]

By sorting out the oldest documented objects from those known to have been made in the nineteenth century and later, we can identify a stylistic progression that can assist in attributing undocumented artifacts to comparative timeframes. Northwest Coast art can then be seen as a tradition-in-process that has been and is still expanding and evolving. Native artists of today are willing to experiment with and stretch the apparent limits of the tradition as they have inherited it from their predecessors. Evidently their predecessors had played their part in evolving the tradition, as they knew it, in much the same manner. The metamorphosis of this tradition, a process inherent from the time of its origins, appears to have accelerated significantly since the beginning of the Euro-American historic period. Today, contact between individual Northwest Coast artists is increasing via the modern media and the contemporary art market. Notable advances in artistic mastery and new directions in the tradition have come about in the last twenty years, owing largely to the inspiration of a handful of gifted individuals.

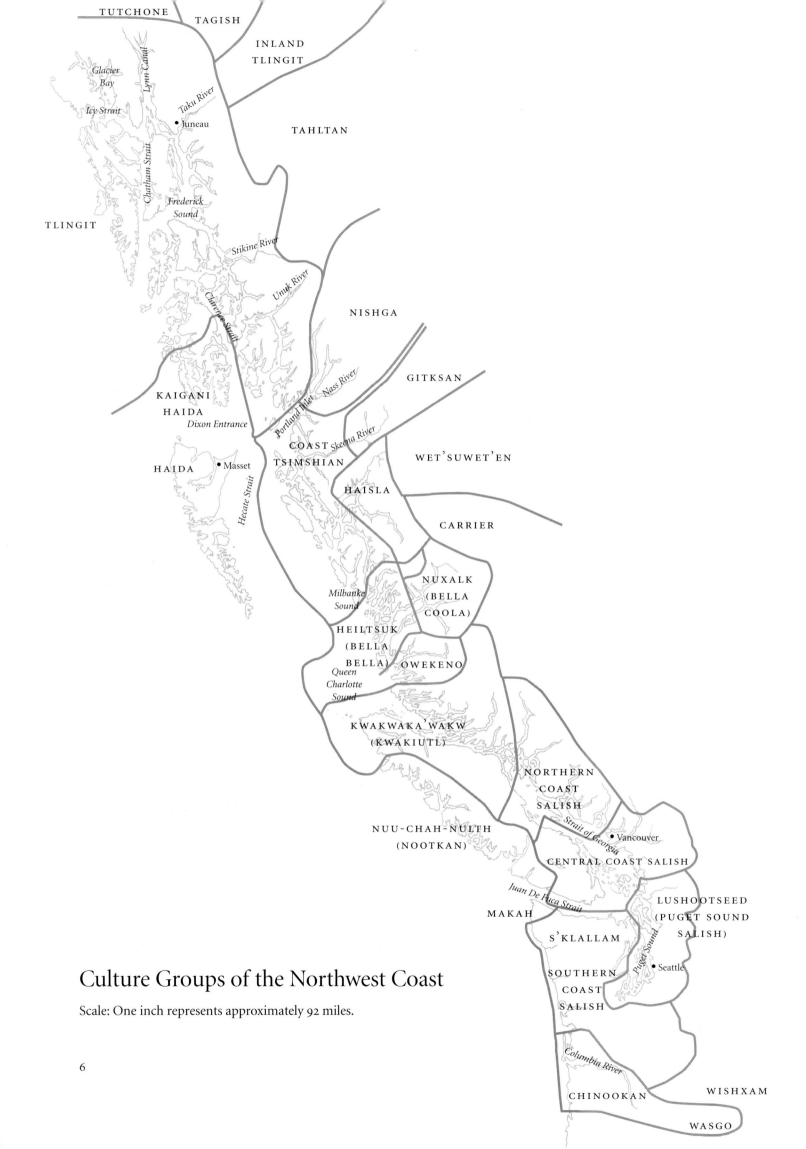

TUTCHONE

TAGISH

INLAND
TLINGIT

*Glacier
Bay*

Lynn Canal

Icy Strait

Taku River

TAHLTAN

• Juneau

Chatham Strait

*Frederick
Sound*

TLINGIT

Stikine River

Unuk River

NISHGA

Clarence Strait

Nass River

GITKSAN

KAIGANI
HAIDA

Dixon Entrance

Portland Inlet

COAST

Skeena River

WET'SUWET'EN

HAIDA

• Masset

TSIMSHIAN

Hecate Strait

HAISLA

CARRIER

NUXALK
(BELLA
COOLA)

*Milbanke
Sound*

HEILTSUK
(BELLA
BELLA)

*Queen
Charlotte
Sound*

OWEKENO

KWAKWAKA'WAKW
(KWAKIUTL)

NORTHERN
COAST
SALISH

Strait of Georgia

• Vancouver

NUU-CHAH-NULTH
(NOOTKAN)

CENTRAL COAST SALISH

Juan De Fuca Strait

LUSHOOTSEED
(PUGET SOUND
SALISH)

MAKAH

S'KLALLAM

Puget Sound

• Seattle

SOUTHERN
COAST
SALISH

Culture Groups of the Northwest Coast

Scale: One inch represents approximately 92 miles.

6

Columbia River

CHINOOKAN

WISHXAM

WASGO

CHAPTER 1

Ancient Roots

Prehistoric Perspectives
on Northwest Coast Art

ARCHAEOLOGICAL DISCOVERIES IN THE LAST TWENTY-FIVE YEARS HAVE revealed some tantalizing glimpses into Northwest Coast art traditions of 1,000–6,000 years ago.[1] Basketry fragments that are structurally identical to baskets made in the nineteenth century have been found in southeast Alaska, in Tlingit territory. These fragments are dated as early as 5,500 years ago, demonstrating material culture continuity over an extremely long period.[2] At this point, no decorated objects in durable or perishable materials have been found within the Tlingit culture area. Some very significant artifacts have come to light, however, from the soils of northern British Columbia, excavated from ancient sites in the Prince Rupert harbor area, well within the northern design region.[3] One of the most striking of these is a small comb made of bone, decorated bifacially with incised line work [fig. 1.1]. The piece is dated stratigraphically at about A.D. 800–1000 (MacDonald 1983a:108). Though the flowing, interconnected design forms depicted on this object are distinctly related to historic northern Northwest Coast design styles, they are, as noted by MacDonald, "much more characteristic of Straits Salish design in the historic period" regarding the utilization of incised elements.

The differences in design techniques between this comb and historic northern objects can be described using design terms from Bill Holm's widely accepted nomenclature. There are no hollowed tertiary areas, even where one would expect to see this treatment, such as between negative T-shapes and their surrounding U-form incisings, or around the eyelid forms within the one incised ovoid shape. This eye, in addition, is not formed like its typical historic-period northern counterpart. The iris of the eye is merely an implied positive shape, formed by two opposing negative shapes, and does not stand alone as an independent circular form. This is a common eye treatment in the Central Coast Salish design style, and is very different in detail from the historic-period northern standard, though its visual relationship to the later northern style is clearly apparent.

It appears that in this comb we have a glimpse of the embryonic beginnings of the historic northern two-dimensional style, one stage of an evolutionary concept that could be termed *proto–Northwest Coast art.* Present herein is the core structure

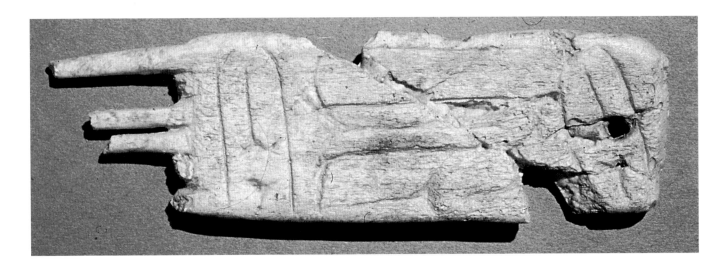

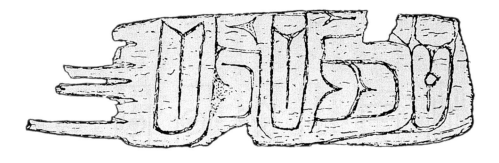

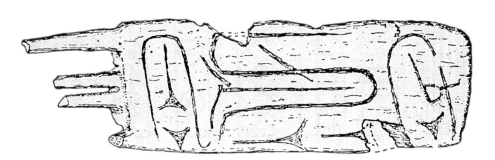

1.1 a, b. **Incised comb**
Tsimshian, *c. A.D. 800–1000.*
Bone. 3.5″ L. CMC GbTo 34–1805

*This revealing artifact, excavated
near Prince Rupert in northern
British Columbia, is dated between
1,000–2,000 years old. The structure
of the overall design, though similar
to historic period northern styles, sug-
gests that certain specific features of
the style conventions typical of the
historic period had not yet developed
at this early date. Photo and drawing
courtesy of Canadian Museum of
Civilization.*

of northern coast two-dimensional design: the interplay of incised (negative) and
surface-level (positive) design elements that create a continuous, flowing pattern.
The incised elements of this comb, however, are limited to simple lines that separate
positive forms, and the characteristic T- or Y-shaped incisings that have come to be
known as *trigons.*[4] Absent are the hollowed and beveled negative areas that lend
sculptural depth and definition to the historic-period northern styles, as well as a
host of other characteristics described by Holm (1965). And yet this simple comb
holds, in its design structures, many of the conceptual seeds that eventually grew
into the design forms of the "classic" northern Northwest Coast styles in the mid-
nineteenth century.

Another very early archaeological artifact with significant bearing on ancient
northern design was also excavated near Prince Rupert, from a wet location known
as the Lachane site. There, bent-corner boxes, carved bowls, paddles, and basketry
were preserved from deterioration in anaerobic, waterlogged deposits dated between

520 B.C. and A.D. 320 (MacDonald 1983a:117). The *only* elaborate, decorated artifact recovered from these approximately 2,000-year-old deposits is a carved redcedar fragment made with tenons for attachment to some unknown object, possibly as a handle [fig. 1.2]. As with the comb, the simple incisings on this surface display more in common with Central Coast Salish art than with two-dimensional art of the historic period from the northern coastal region in which the object was found. This design also lacks the specialized negative relief areas known as tertiary elements, as well as positive U-forms developed around the negative trigons in their characteristic shapes. Though the contiguous nature of the positive surface vaguely suggests the formline concept, the surface forms in general do not adhere to design practices that had become conventionalized by the historic period. These two examples (and a small number of related artifacts) bear only a limited amount of information, of course, but their appearance, and the lack of any two-dimensional embellishment on the many other Lachane site materials, certainly suggests that the northern style was in its conceptual infancy 1,000–2,000 years ago.

Similar evidence comes from the central British Columbia coast at the Kwatna archaeological site, in the form of two bone artifacts with incised trigon elements (Carlson 1983a:124–25; fig. 7:3a, b). These artifacts have been dated from approximately 700–1800 years B.P. Here, the use of the trigons connects these objects to proto–Northwest Coast design concepts, but the decorated field is not addressed as it most likely would have been in the later historic era. This geographic region

1.2. Object handle (?)
Tsimshian, *c.* A.D. 50.
Redcedar. 6″ L.
CMC GbTo 33–C423

A rare decorated artifact from very early northern British Columbia, c. 2,000 years old. The simple oval, trigon, and curvilinear incisings suggest that the northern Northwest Coast two-dimensional formline style, as known from the historic period, was not fully developed at the time this object was created. Photo courtesy of Canadian Museum of Civilization.

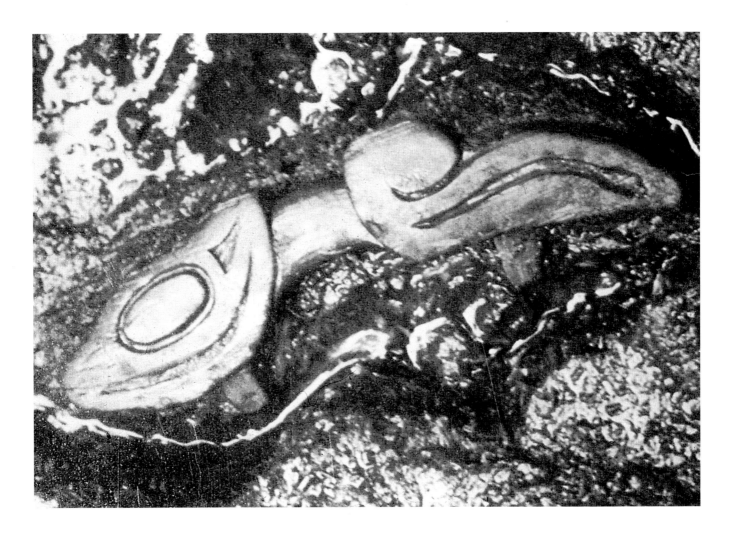

fell within the Heiltsuk/Nuxalk (Bella Coola) culture area in the historic period. Though theirs is a Salishan-language culture, many Nuxalk artists practiced the northern design style in the nineteenth century, as did most Heiltsuk artists. The two-dimensional design of these ancient bone pieces strongly suggests, as do the Lachane site objects, that the northern formline system was then but an embryonic concept.

With so small a sample of very early two-dimensional design from either the northern or southern Northwest Coast, precise conclusions regarding origins and development are evasive. The archaeological record seems to tell us, however, that northern two-dimensional *formline* art (as we know it from the historic period) was not fully developed at a point about 1,000 years ago, and that prior to that date, two-dimensionally decorated objects bore a distinct stylistic resemblance to Central Coast Salish art styles. The term proto–Northwest Coast art, when applied to these very early stages of the northern coastal design styles, describes what can be seen as a kind of parent tradition, perhaps the core art form from which both the northern and southern historic styles evolved over time. Within this embryonic phase of northern art traditions can be found some, but by no means all, of the important principles and elements that contribute to the formation of classic northern formline designs. It appears, though, that at this stage of development, a number of unique conventions which distinguish the historic-period northern styles had not yet materialized.

Antiquity in the Southern Design Tradition

Looking at the archaeological record of the southern coastal region, we find the artifact with the current title of "oldest known Northwest Coast carved wooden object." This small carving was recovered from the Hoko River wet site in Washington state

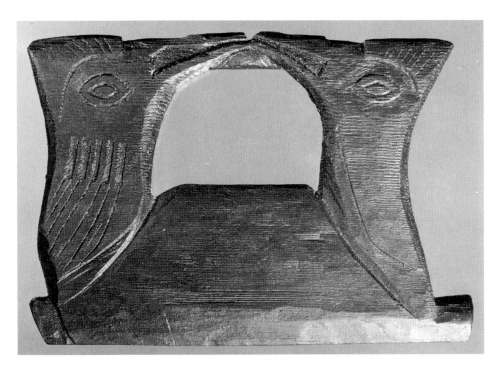

1.3. Tool handle

Makah, *C. 750 B.C. Redcedar. 6.5" L. Recovered at Hoko River, WA, c. 1983. MCRC*

The mouth of the Hoko River (located a few miles east of Neah Bay, Washington) was apparently the site of a fishing and food preserving camp of great antiquity. This object, which may have been the handle of a fish-cutting blade of ground slate or shell, exhibits a bird silhouette with minimally incised wing feather separations. Many of the earliest existing creature images from both the northern and southern regions of the Northwest Coast are rendered in such an elemental depiction. Elaborate two-dimensional space decoration seems to have developed more recently. Photo by Ruth Kirk.

in 1983, and was attributed by carbon-14 dating to approximately 770 B.C., nearly 3,000 years ago [fig. 1.3].[5] This artifact, along with a handful of other decorated pieces from southern British Columbia sites in bone and antler, helps to illustrate that the southern or Coast Salish two-dimensional style has been more or less continuous over a very long period of time.[6] The archaeological record in general informs us that curvilinear (as opposed to geometric) designs, which include such elements as incised circles, crescents, and trigons, began to appear on southern coastal artifacts about 3,000–4,000 years ago (Carlson 1983b:203).

Precisely where and when the use of these signature proto–Northwest Coast design elements originated is impossible to ascertain. They may have been developed and employed first on the Northwest Coast, in either the northern or southern region. The use of such design elements may have come about as the result of dreams or visions, and may perhaps represent the interpretation of natural features or energies into a visual code (Brown 1995:279–80). By the same token, their use may have originated elsewhere and spread to the Northwest Coast by physical transport, or by what the English scientist/philosopher Rupert Sheldrake refers to as "morphic resonance," the simultaneous appearance of ideas in distant places.

It is interesting to note the presence and similar artistic employment of the same design elements in other cultures from distant parts of the Pacific Rim, particularly New Guinea and the Massim culture district.[7] (Some Native Northwest Coast oral histories speak of long-distance Pacific travel by canoe during generations long past.) Information concerning the antiquity of the circle-and-trigon two-dimensional tradition in the Pacific islands could be very revealing, given the consistency of ocean currents and the possibility that any number of southwest Pacific artifacts may have drifted to the Northwest Coast shores in previous centuries.[8] A ceremonial staff held by a Stikine Tlingit chief (Toya.áat of Wrangell, c. 1810–80), was acknowledged by his clan tradition to have come from distant Pacific lands via the prevailing ocean currents (Emmons 1991:331. Quoted from Young 1927:223).[9] Structural iron, steel tools, and the occasional surviving seamen have been deposited for centuries on North American shores by drifting Japanese cargo vessels. Documentation of this phenomenon began nearly 400 years ago with the discovery of the wreck of a Japanese ship and a survivor named Magomè near Acapulco, Mexico, in 1617.[10] Glass and now synthetic fishing floats from Asia have continued to wash up on the Northwest Coast since the beginning of their use.

A number of authors have written of the possible connections between Northwest Coast art and various Asian/Pacific traditions.[11] In addition, some writers have postulated ways in which the visual elements and principles of the Northwest Coast tradition reflect the tenets and values of the cultures and social systems that artistically employ them (Brown 1995:276). Bill Reid has stated this concept succinctly: "The rules were there, and they were part of a pattern that went far beyond the conventions of art, were more than a part of the life of the people, were the very essence of their lives" (1967). Though the true origin of the distinctive elements that characterize the broad Northwest Coast design tradition may not be discernible, a somewhat clearer picture of the evolutionary paths taken by the artists employing these elements in varying parts of the coast can now be drawn together.

Curious Visions

Northern Northwest Coast Art
in the Historic Period

*2.1 a, b. **Charm or pendant**
Haida, c. 1750. Ivory, cordage.
1.75″ H × 2.5″ L. MdeA 13.042*

*The wing design, defined by fine
incised lines, shows that prior to the
late 18th century, the northern two-
dimensional tradition had developed
the attributes that make it unique
among the world's Native design
styles. At this stage, the formline style
of two-dimensional art can be seen to
have evolved out of the proto–North-
west Coast style in a distinctly
different direction from that of the
southern Northwest Coast traditions.
Presuming that most of the wear evi-
dent on this object predated its collec-
tion by Perez, the charm may have
already been of considerable age in
1774. Drawing by Bill Holm. Photo
and drawing courtesy of Museo de
América, Madrid.*

THE LEAP FROM THE TIME OF THE PREVIOUSLY ILLUSTRATED
archaeological artifacts to that of the earliest documented objects of the historic
period is a large one, spanning 700 years and more. Through some evolutionary
process within this broad chasm of time, the most significant definition and refine-
ment of the essential principles and forms of the northern Northwest Coast style
appears to have taken place. The first northern Northwest Coast artifacts that were
collected by Euro-Americans display a style in which the formline system has clearly
matured far beyond the stages illustrated by the archaeological pieces in figures 1.1
and 1.2. Two of the earliest documented objects from the northern region were
received in the area of Dixon Entrance, the body of water separating Haida Gwaii
(the Queen Charlotte Islands) from the Alexander Archipelago of southeast Alaska.

In 1774, Commander Juan Perez of the *Santiago* acquired an ivory charm in the
form of a small seabird, the wings of which are embellished with fully developed
northern-style formline designs [fig. 2.1]. It has been established that "This little
masterpiece . . . has the earliest known collection date for an existing object exhibit-
ing the . . . formline system of design . . . of the northern Northwest Coast" (Holm
1989:105–6). Here the fine incised lines and other carved, negative design elements
define positive formlines of very characteristic shape and movement, which have
been manipulated into the design of a profile face structure. The eye element and its
surrounding hollowed area are in their "classic" northern form, enclosed by a wide,
positive formline in a typical ovoid-shaped movement. Further northern-style con-
ventions can be seen in the appearance of a distinct "cheek" design area within the
formline structure, and the pairing of positive-design U-shapes to represent the lay-
ering of wing feathers.

The formlines are generally angular, and negative relief elements are small and
slim. The area measure of the positive (surface level) formlines far outweighs that of
the minimal, narrow incisings and negative (carved-out) areas, a characteristic that
is seen in the oldest northern (and also southern) designs with some consistency.
This dominant relationship of positive design areas over negative elements can be
seen to change through time as the conceptual influence of the negative elements

(circles, crescents, and trigons) fades, and the conceptual edge of their structural opposite, the positive formlines, gains precedence.

The importance and influence of the Northwest Coast painting tradition appears to have been instrumental in this development. Bill Holm has written:

> The transformation of such a straightforward two-dimensional style [as proto–Northwest Coast art] into the sophisticated northern formline system must have required the catalyst of painting. I see the techniques and versatility of a painting style, perhaps initially derived from the incised negative/raised positive concept, in its own turn refining relief carving as it began to conform to the painted formline. (Holm 1983a:33)

Certain structural conventions, such as the secondary or opposite-color concept, would obviously not have evolved as they did in the absence of painting. And, as in most cases, once this concept was in use, its adoption and refinement through time by an ever-increasing field of artists caused the initial idea to expand in an evolutionary manner.

Another significant artifact illustrating this early historic period of design development was collected in 1787 by Captain George Dixon, from the Haida of the Queen Charlotte Islands (adjacent to the strait or Entrance that bears his name) [fig. 2.2]. Now in the British Museum [N.W.C. 25], the object is an elegant and finely carved oil dish that blends the form of the vessel with the representation of a human/bird transformation (see also Holm 1965:4). The human hips, legs, and feet are compactly

2.2. Grease dish

Haida, *c. 1700. Alder (?). 10″ L. Collected by Capt. George Dixon, 1787. Museum of Mankind (London) NWC-25*

The transformational human figure carved on the dish includes the depiction of wings along its sides as well as a beaklike nose. The massive quality of the formline design is a common characteristic of the oldest northern Northwest Coast two-dimensional art. Photo courtesy of British Museum.

tucked up against the rear of the dish. The arms, hands and fingers span the lower edge of the dish sides, and the head faces forward on the front end of the vessel. The nose of the human face is carved to represent an abbreviated beak form, and a broad-formline design pattern, evidently depicting a feathered wing, flows back below the rim of the dish from behind the head to the tips of the human fingers. This image most likely represents the transformation of bird and human characterized by Raven-at-the-Head-of-the-Nass, often depicted with a short, recurved beak (see Brown 1991:78; Brown, ed., 1995:30, cat. 1, for a Tlingit example of this representation). Judging by the polished black surface of this dish, the result of oil saturation, oxidation, and handling, this vessel was already old when acquired by Dixon in 1787. By comparison with contemporary wooden oil dishes, it takes decades of use for the surface to reach that level of dark patina, indicating that this object could easily have been fifty or more years old when it was collected.

The formline elements of the wing and feather designs on both these objects display characteristics that can help to establish the evolutionary status of northern two-dimensional styles in the early historic period. These include wide positive formlines, very minimal carved-out areas (such as the negative elements referred to as *tertiary spaces* in the Holm analysis), angular corners, and the general lack of developed *secondary* design elements. In Holm's terminology, secondary areas are the positive spaces enclosed within the main *primary* formlines. They are painted in the opposite color to that of the primary formlines (black primary/red secondary, and vice versa). The cheek design in the drawing of the Perez bird indicates the use of secondary color (in gray shading). One could presume that the presence of the secondary concept here (however minimal) implies the presence of secondary designs in painted objects of the same general time period. The conception of this opposite-color tradition represents one of the most significant departures from the more elemental concepts of proto–Northwest Coast and those of historic Central Coast Salish art styles.

The following list of characteristics is taken from Bill Holm's handwritten notes, made in 1976 while studying the early Tlingit objects in the collection of the Museum of Anthropology and Ethnography in St. Petersburg (then Leningrad). Holm noted some commonalities among two-dimensional designs on early Tlingit objects collected during the period of Russian occupation in southeast Alaska, between 1804 and 1867. These collections (not consistently or precisely documented as to when or by whom they were acquired) include objects that were most likely made in the eighteenth or very early nineteenth century.

- Less non-concentricity [of inner ovoids than in later 19th-century designs][1]
- More massive junctures [implying smaller negative relief elements]
- Unusual structure of elaborated inner ovoids [such as: no mouth, no cheek design, an elaborate nose, lower jaw formline bending back to forehead]
- Ovoid-type [negative] relief in inner ovoids [is common]
- Tertiary [fineline] U surrounds tertiary U-shapes.
- Solid secondary U-shapes [not formline U-type shape, i.e., the simplest form]
- Angularity [of forms is common]
- Tertiary [fineline] ovoids [negative/hollowed out]

- Red tertiary lines [finelines done in red, often seen in place of red secondary elements]
- Circle relief in tertiary U-shapes
- Long, tapered eyelids
- Use of spiral forms
- Use of black, lobed teeth
- Square U-shapes [are common]
- Tertiary "split" U-shapes somewhat uncommon
- Use of double tertiary U-shapes [not as common in later designs, with the obvious exception of Chilkat weavings][2]

In a paper presented at a 1988 Madrid conference that focused on the early Spanish collections, Bill Holm presented a description of the early historic-period styles visible in those eighteenth-century objects:

> This early northern style is characterized by massive formlines with minimal tapering. There are often right-angled U-forms in conjunction with rounded ovoids. Relieving slits and background areas are generally narrow. Ovoids range from almost round to extremely long, this length often emphasized by their massive formline borders. Eyelids are typically very long, often reaching the ends of the socket, and almost evenly tapered from the iris or inner ovoid to their ends. Very often the upper edge of the inner ovoid merges with the eyelid. Compositions from this early period are usually much simpler than those of the mid-19th century, especially in the secondary complexes. For example, almost all cheek designs are of the simplest form, without the elaborations seen in later work. (Holm 1989:107)

These characteristics correspond with the styles of many extant northern two-dimensional designs and can assist not only in revealing the artistic conventions in common use around the turn of the nineteenth century, but also in attributing the creation of undocumented pieces to this early period. Some objects that reflect these styles were collected very early, while others have been acquired from Native sources well into the twentieth century. The historical record has often attributed dates to artifacts based on the time that they were collected, in lieu of information regarding the time such pieces were created. Stylistic dating is, of course, based on relatively new scholarship. With increasing awareness of stylistic differences, a changing picture of Northwest Coast prehistory may emerge.

What is, for the purposes of this analysis, the largest and most significant group of eighteenth-century northern objects was collected by members of a Spanish expedition led by Captain Alejandro Malaspina, who landed in the Yakutat Bay region of the Alaskan Coast (then known as Port Mulgrave), the northwestern extent of Tlingit territories.[3] Malaspina's collection, now housed in the Museo de América in Madrid, includes some spectacular artworks that display very refined, early-style, two-dimensional design as well as some remarkable sculpture. One of the most striking pieces is a war helmet, the configuration, sculptural execution, and two-dimensional decoration of which rank among the most elegant and refined of any

2.3 a, b, c, d, e. **War Helmet**
Tlingit, *c. 1750. Spruce, copper, oper-*
cula, paint. 28.5 cm H. Collection
attributed to Malaspina, 1791.
MdeA 13–909

The composition of the painted
design incorporates a fair amount
of unpainted space outside the main
formlines, though the tertiary areas
and negative relief crescents are typi-
cally small and narrow. Drawings by
Bill Holm. Photo and drawings cour-
tesy of Museo de América, Madrid.

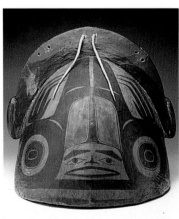

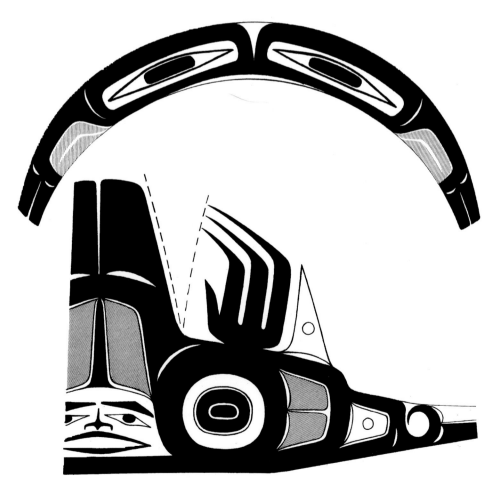

such object or historical period [fig. 2.3]. The helmet's inspired humanoid face sculpture and two-dimensional designs reflect the hand of one of the most assuredly masterful Tlingit artists whose work survives, though his identity is not now known.[4]

The Malaspina collection also includes some of the earliest documented spruce root hats extant, one of which features a painted image of particularly fine design and execution [fig. 2.4]. The painted image on this hat exhibits a number of early characteristics in its configuration and design style. First, the painted area is limited to the upper crown of the hat, the section executed in fine two-strand twining. The lower, unpainted brim of the hat is textured with self-patterned weaving in a two-strand, skip-stitch design of short, spiral lines in three lanes of opposing directions. Perhaps due to the artist's preference for a smoother surface on which to paint, the majority of eighteenth-century northern spruce root hats (collected by Etolin, Perez, and others) are decorated in this configuration.[5] Second, the formline structure of the painting itself is very compact, with wide positive formlines and relatively small negative-design and unpainted ground areas, much like the relief-carved designs in figures 3.3, 3.4, and 3.5. Here, though, the artist has incorporated several red-painted secondary designs (another class of positive design elements) within the black primary formlines. The red secondary areas are limited to single design elements, a characteristic of many early expressions of the opposite-color design tradition, as noted above in Holm's descriptions.

If we could total up the measure in square units of the red and black positive areas on this hat and relate that to the square unit measure of the negative spaces (within

2.4 a, b. **Woven painted hat** **Tlingit**, *c. 1780. Spruce root, paint. 5.5″ H × 15″ Dm. Collection attributed to Malaspina, 1791. MdeA 13–572*

The use of positive red secondary design elements represents an important development in the evolution of the northern design style from its earlier proto–Northwest Coast form. Their existence here (and in fig. 2.1) indicates that the concept seriously pre-dates the initial contact period of the late 18th century. Drawing by Bill Holm. Photo and drawing courtesy of Museo de América, Madrid.

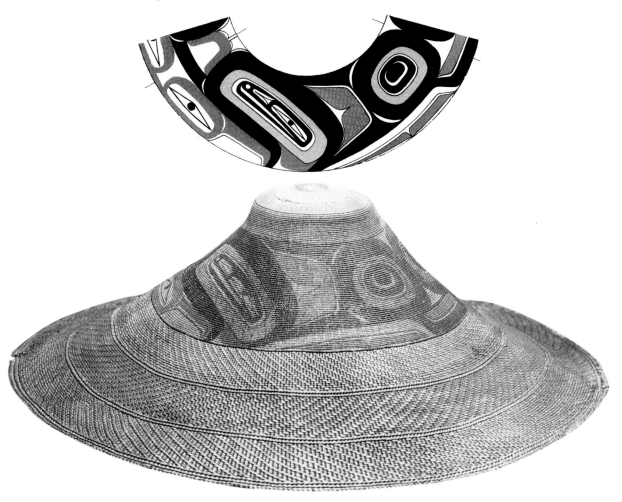

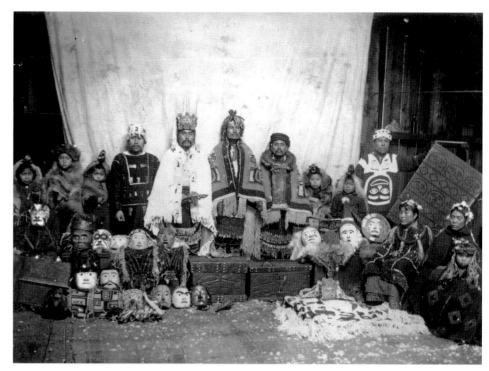

*2.5. **Dressed in full regalia**, a group of Tsimshian ritualists pose with a display of heirloom treasures. The four chiefs are (left to right): Andrew Nass, John Nass, James Skean, and Philip Nass. In the foreground are two carved chests with opercula-inlaid lids. Both chests show characteristics of the very early historic period: small size and a compact design in which the negative (carved-out) areas are minimal in comparison with the positive forms. Photograph taken at Gitlaxdamiks, Nass River, British Columbia, c. 1903, possibly by C. H. Orme. Courtesy of RBCM PN4330.*

*2.6. **Globular rattle**
Tshimshian, c. 1750–1800.
Birch, bone, hair, paint. 11″ H.
Collection of George Terasaki*

The remarkable human face sculpted on the head of this well-worn and polished ritualist's rattle is carved in a classic Tsimshian style, with prominent cheekbones, thin drawn-back lips, and a short, broad nose. Most unusual and effective is the subtle hollowing of the iris of the eyes, which enables the spirit of the rattle to turn its gaze as the head is rotated. Photo courtesy of George Terasaki.

the painted area of the hat), we would find an eighty to ninety percent coverage of positive design units. Looking at *all* documented eighteenth-century objects with two-dimensional designs, an eighty-percent coverage would be about average, with some higher (like this hat, and figures 3.3, 3.4, and 3.5), and some distinctly lower. We might be able to assume, by its condition, that this hat was relatively new when acquired by Malaspina, maybe only a decade in age at the time.

By one hundred years later, in the 1880s, the dominant relationship of positive-to-negative design elements had reversed substantially in most of the northern design tradition, and almost completely in some regions. The most extreme examples of this reversal come from the northern British Columbia mainland and adjacent islands, home of the Tsimshian-speaking First Nations, Haisla, and Haihais peoples. The very thin formline style, however, was not always present in this region. The design tradition in northern British Columbia appears to have evolved into its mid-to-late-nineteenth-century thin-formline (large negative area) configuration from one that was much its opposite. Very old objects from this area also exhibit broad positive and relatively narrow negative areas, as seen in the objects illustrated previously, and suggest a similar kind of development.[6] In addition, some objects depicted in historic photographs from this region display the minimal negative-area style. Two such pieces, which appear to have been quite old at the time, can be seen in figure 2.5. An especially striking Tsimshian-style globular rattle with a sculptured face also illustrates this point [fig. 2.6]. The formline design on the back of this rattle is carved with very minimal negative areas and broad positive forms in the same general style as the documented eighteenth-century objects collected from Haida and Tlingit peoples. The broad primary and secondary formlines are very much in keeping with the dominant-positive, early historic–period style as seen in the previous objects.

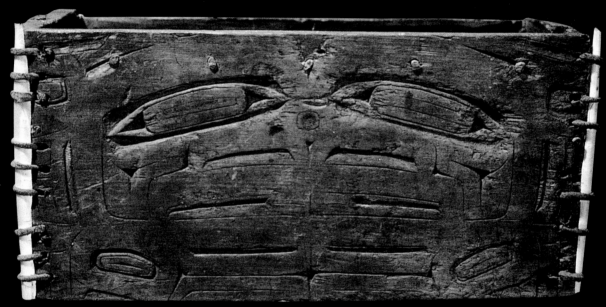

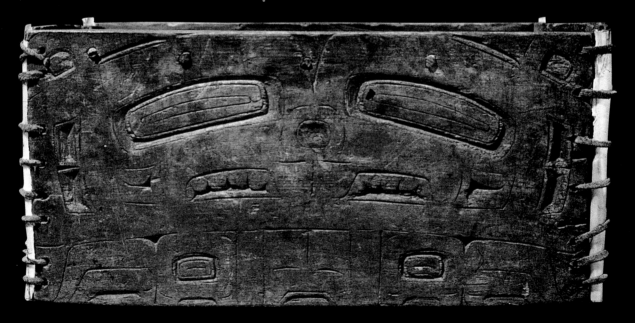

CHAPTER 3

Sleeping Treasures:

Northwest Coast Art of the Late Prehistoric Period

WITH THE PREVIOUS EXAMPLES AND MANY OTHER EARLY DATED OBJECTS to use as yardsticks of time, some interesting comparison pieces arise from among the surviving body of Northwest Coast artifacts. Some of these appear to be much older than the documented eighteenth-century objects. One such object, a small bent-corner chest, collected by G. T. Emmons in the Juneau area of southeast Alaska, displays relief-carved formline designs on the front, and back, and on parts of each side. The side-panel designs each border a higher-relief sculptural depiction of a beaver or bear [fig. 3.1]. In these formline patterns, the spatial dominance of positive forms immensely outweighs the surface area made up of negative design elements. The carved-out areas are so minimal, and the eyelid shapes, tertiary elements, and sculptural forms are so archaic in appearance, they suggest that this chest was created at some point within the unknown span of time between 200 and 1,000 years ago. (The physical condition of the object also implies great age, but this by itself is a less telling indicator of specific antiquity, because wooden objects can "age" to such a degree fairly quickly under certain conditions in the coastal environment.) Most of the design conventions of the early northern historic style are visible in this container's formline compositions, but the style of work overall appears much earlier on the theoretical time scale between the bone comb (fig. 1.1) and the documented eighteenth-century pieces.

Despite its apparent antiquity, the front and back design faces of this chest nonetheless conform exactly to the highly conventionalized primary design arrangements seen in the vast majority of historic period chests and square boxes (Holm 1997). The primary design structure depicts a broad, frontal face in the upper center of the field, with smaller ovoids in both the upper corners and the lower design field that flank the "body" area beneath the dominant formline face. This same essential configuration can be seen on perhaps ninety percent of all existing Northwest Coast chest designs, though each of these is unique in the design of specific details (especially secondary elements) and the style characteristics of the individual artists. Existing examples from varying time periods indicate that the establishment of a conventionalized chest-design form came very early in the two-dimensional north-

ern design tradition, and that seldom did these designs contain specific structural references to the common range of clan crests.

It is not known where or by whom the chest and box design archetype was originated, but the record is clear that northern coast artists through at least the middle nineteenth century followed a rather limited arrangement of primary formline patterns far more often than not. Illustrating many Haida, Heiltsuk, and Tsimshian examples, George MacDonald identifies the design as representing "Konankada, the Chief of the Undersea World," whose image protected the contents of the chest during a chief's life and his remains after death (MacDonald 1996:118,127). The Tlingit name for this revered and powerful being is *Gonakadeit,* from whom all wealth is said to be provided.[1] These beings are often depicted as combining whale and mammal characteristics (on Chilkat-style robes, for example), showing a large head, front clawed feet, and whale-like tail, a conception that corresponds at least generally with the typical chest and box images. Artists of the Haida, Tlingit, Tsimshian, and other northern groups consistently employed these design conventions, altering the standard arrangement to depict other particular creatures only very rarely (see fig. 3.3, chest panels). Perhaps the generic quality of the images (the Gonakadeit is said to be the *Shagoon* of all the Tlingit clans: Jacobs, pers. comm., 1988) enabled the containers to be widely traded without compromising the propriety of any new owner's crest image.

Comparison with some of the documented examples, in terms of design system development, enables an attribution of relative lifespan to be made. If the Perez ivory bird (fig. 2.1) and the Dixon bowl (fig. 2.2) were, in fact, already of some age when collected, and if they therefore represent the design style of the early eighteenth century (conservatively), then this chest could easily be many decades older than they, made sometime in the seventeenth century or perhaps even earlier. The face on the Dixon bowl is sculpturally far more developed than are the archaic high-relief faces of the chest, suggestive of many years of refinement with better quality tools (individual artist's skill notwithstanding). Many factors could precipitate the preservation of such an object as this chest over a long range of time, the most obvious being careful custodianship by its Native owners. There are Native artifacts in ceremonial use in southeast Alaska today which appear (both stylistically and by oral history) to be 150–200 years and more in age. Similarly, antique objects in use in the mid-to-late nineteenth century would now be 250–350 years old, though only a very few may have managed to survive the interim period. If this chest was collected from a grave, as its condition suggests, its placement in a cave or other protected enclosure (like a grave house) could also have contributed to its preservation.

We can never know how many highly decorated artifacts from the pre-1700 period once existed, or what strokes of fate may have allowed certain of these to survive until today, but the unusually archaic appearance of a few extant pieces makes them plausible candidates for attribution to this time period. One of these is a large bent-corner box featured in this exhibition [fig. 3.2]. The box itself is in very good condition, and fastening of the joined corner and bottom piece is done with sewn root or withe (as opposed to pegged fastening), a characteristic of the earliest documented examples. The primary formline designs on the front and back of this container also follow the general organizational pattern of historic-period boxes and chests

*3.2 a, b, c. **Bent-corner box***
Tlingit, *early pre-contact (c. 1700).*
Redcedar, paint.
34″ H × 23″ W × 23″ D.
Collection of Mr. and Mrs. Gene Zema

This bent-corner box is extremely archaic in style. The design structure displays many unusual characteristics, including the appearance of the relief-carved faces at the center of the design area, which suggest that the box may have been made long before the earliest documented historic period artifacts. The fourth corner seam and the bottom fastening are both sewn, a characteristic of most early containers.

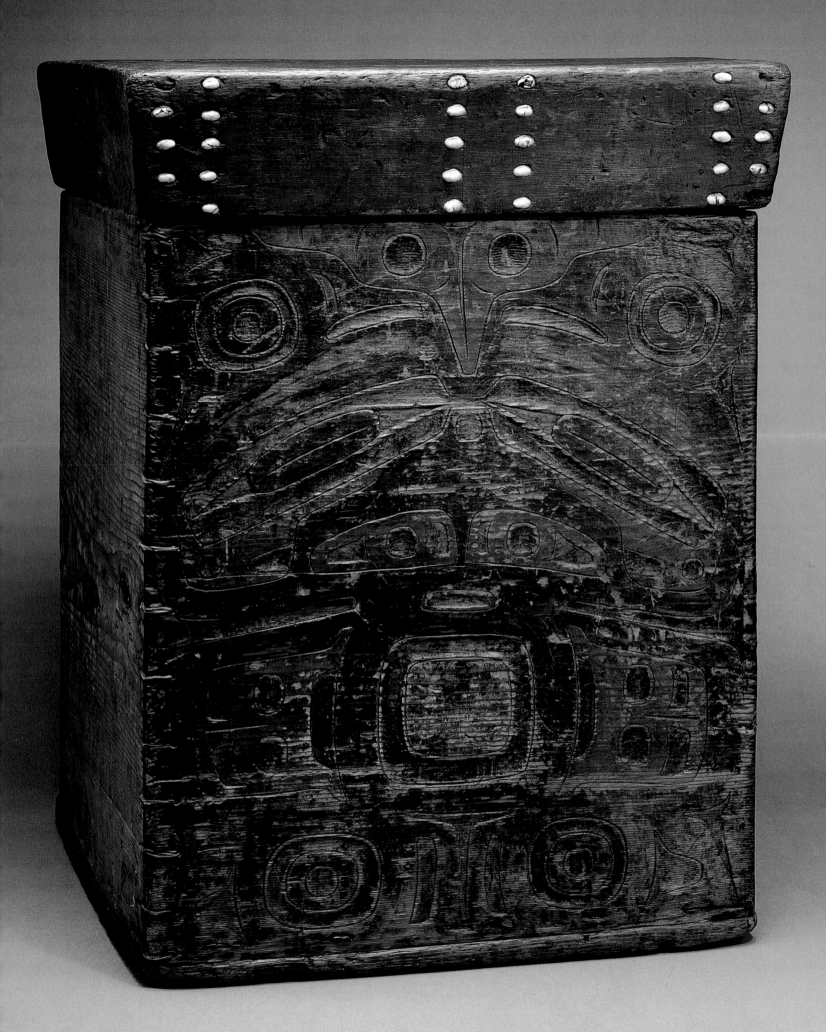

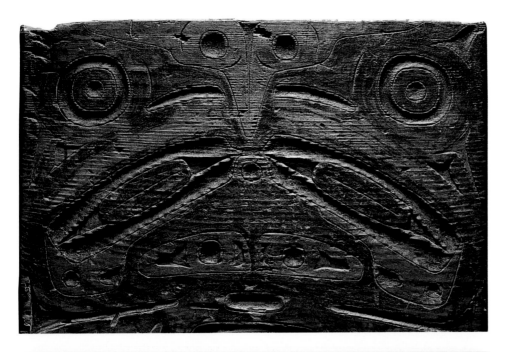

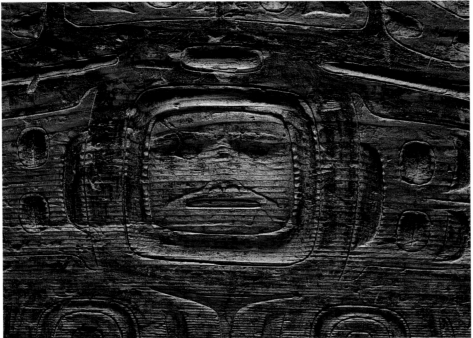

as noted in the previous illustration, with typically imaginative variations in detail.

Many aspects of the designs on this box suggest great antiquity. Some of these aspects derive from this particular artist's unique style, while others imply creation at a time when some characteristics of the ancient proto–Northwest Coast art remained, and others common in the historic period had not yet become universally conventionalized. The upper field corners of the front and back box surfaces display profile formline face designs that incorporate large circles as the eye forms. The lower outside corners of the formlines surrounding these circles are defined by two fairly large trigons. The placement of these trigons actually distorts somewhat the eyebrow formlines of the main frontal face design below them, rather than acting to maintain the typical flow and dimensions of the positive forms as is seen in virtu-

ally all historic examples that reflect the northern design tradition. Large trigons in the lower box corners similarly distort the end-curves of the formline U-shapes just inboard of them. Again, the most significant difference between proto–Northwest Coast art and the fully developed northern tradition is the conventionalization of the inner and outer dimensions of the positive forms.

This period of transition and evolution is not conceivable as a clear and arbitrary borderline between styles. It is instead a broad period of exploration and development, when new ideas and concepts were being added to the core elements of the proto–Northwest Coast system by individual artist-practitioners, and conventionalized through their adoption and continued use by other artists. The same process of stylistic evolution can be observed in action between any two historic periods, such as the hundred years between the beginning of Euro-American contact and the late nineteenth century, or between the late nineteenth century and contemporary times.

Certain other Northwest Coast two-dimensional art concepts display a developmental expression in the designs on this box. The position of the inner ovoids is very concentric within the surrounding formlines, and the negative ovoid-shaped relief is present. The ovoids themselves differ from those in the great majority of historic examples in two ways. First, all are either circles or true ovals, symmetrical quadrilaterally, rather than being flatter along the bottom than across the top curve, as in the conventional historic ovoid concept. This, by itself, could be seen as a particular artist's stylistic feature, though it is accompanied in this context by other evolutionary indications.

Second, and more significantly, the hollowed negative area surrounding each circle or oval appears to lack the distinct feature referred to by Holm as a *tertiary line,* the positive, painted fineline that encircles nearly 100 percent of inner ovoids in the historic tradition. Proto–Northwest coast style, as seen in figures 1.1 and 1.2, also does not include this tertiary line feature, and neither does Central Coast Salish art. It can be suggested that the concept of the painted tertiary fineline may have grown out of a specific technique of hollowing the negative area around inner ovoids. When done as it was in this example, the hollowing is a curved valley between the V-cut at the edge of the inner ovoid and the V-cut at the inner edge of the surrounding formline. The sides of the V-cuts remain as fine ridges at the outer borders of the hollowed valley, resulting in a kind of fine echo of the inner ovoid or circle shape parallel to its outer edge.

This fineline echo does not commonly appear in proto–Northwest Coast or Central Coast Salish art, because in these styles the negative cut that defines a circle or oval is usually a simple V- or U-shaped incising, done without the finer V-cut definitions that became a feature of the later pre-historic carving style. Hypothetically, that little carved visual echo seems to have been conventionalized into a distinct feature that is present, even when the design is not carved, as a painted fineline paralleling the edge of inner ovoids and certain U-shapes. This painted tertiary fineline remains on the surface as a positive form when a design is relief-carved. The absence of these lines is always very conspicuous, especially around floating inner ovoids. The fineline echo of the positive shapes give a sense of depth and delicacy to a design which it would not otherwise possess, and finelines have become an integral part of the classic Northwest Coast tradition. This box shows no *painted* fine-

lines, though the resulting ridge of the hollowing technique conveys their appearance or visual message. The concept is illustrated here as it may have appeared during the developmental process, probably pre-dating this particular box. The previous container, possibly of earlier date, exhibits well-defined tertiary finelines, so the question of when the concept was developed remains unanswered. The tertiary or fineline concept stands out as one of the essential characteristics and conventions unique to the development of the northern Northwest Coast design style.

Though not limited to just single elements, as seen in the Malaspina hat (fig. 2.4), the secondary areas on this box are nonetheless simple in form and are composed of arrangements limited to two or three U-shapes in straightforward, parallel combinations. The red cheek designs in the main face structures display only minimal negative elements to relieve their broad positive forms. The positive red secondary forms surrounding the U-shaped and circular elements in these cheek areas are barely conceivable as formlines under the usual design conventions. By the middle nineteenth century, formline elaboration of such a cheek area had become the common standard, frequently including black inner ovoids. In these and all the secondary areas, positive formlines surround negative circles that lack inner ovoids, as if the concept of black inner ovoids had not yet been applied to secondary designs.

Other characteristics from Holm's list also apply, in addition to those previously mentioned, such as the fact that tertiary "splits" (painted fineline trigons) are not present. The sculptural faces carved in the center body area of the front and back designs of this box are very archaic in appearance. Shallow and simple in sculptural form, they show much more kinship to the carving style of very old archaeological pieces than to historic period work. All these characteristics combine to suggest that this box is one of the earliest Northwest Coast bent-corner containers extant.

Related characteristics are exhibited by a select group of objects in the Native Visions exhibit collection, suggesting that these are the earliest pieces in this assem-

3.3 a, b. **Four chest panels**
Tlingit or Tsimshian, *c. 1780.*
Redcedar, paint. (2) 9″ H × 25″ L;
(2) 9″ H × 15″ L. Collection of
Eugene and Martha Nester

Though previously separated in two different 20th-century collections, these four panels together once formed the sides of a telescoping chest, from which the lid, bottom, and inner box have been lost. The small size, compact design field, and minimal negative areas indicate an early date of creation, most likely from middle to late 18th century.

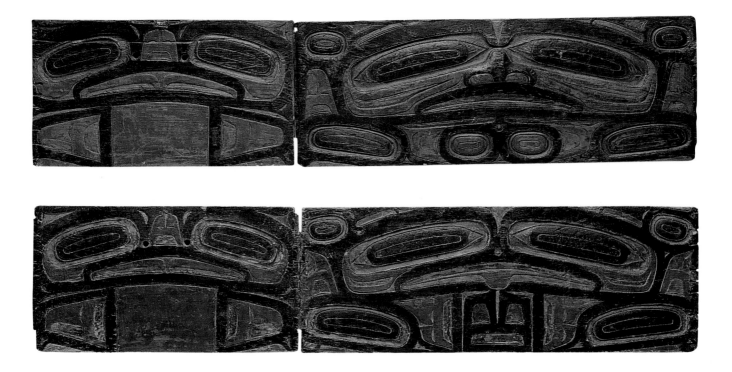

bly of artifacts (figs. 3.3, 3.4, 3.5). Applied to a variety of objects with different shapes and representations, the two-dimensional design properties of these pieces share the early historic period style of image conception and design element vocabulary. The objects in this collection which appear to be the oldest may in fact date from the middle eighteenth century or possibly before. There is no documentary information that accompanies these pieces, however, other than what is recorded in their appearance. By curatorially grouping these objects together by relative age, the similarities of their design characteristics become more apparent.

The early chest (fig. 3.3) is a case in point. Though many older positive-dominant designs such as this have been almost exclusively identified as Tlingit, the historic record suggests that chests of this time period and style may also have been made by Tsimshian or Haida artists (see fig. 2.5). Certain examples very similar to these were collected from Tsimshian sources in the late nineteenth century (Field Museum 79733, 87989; Smithsonian 73819; CMC VIIA 127). Two of the artifacts that share a distinct stylistic relationship are the seal/head canoe dish (fig. 3.4) and the sheep horn ladle (fig. 3.5). Depicting some of the same iconography, certain two-dimensional details of each are also handled with the same attributes of design.

Kihle is the Haida name for a small, personal dish that was carried to feasts and potlatches for the consumption of grease as an accompaniment to dried fish and roots (MacDonald 1996:43). The majority of northern Northwest Coast carved dishes conceptually blend an animal image with one of several traditionalized bowl forms. In figure 3.4, the bowl form is clearly an adaptation of the archaic head canoe shape. The head and tail of the seal are composed in a manner that replicates the thin, finlike characteristics of the indigenous canoe style of the northern coast as well as the graphic form of a swimming seal. Beneath the head and tail, these extensions are hollowed out in order to lighten the overall sculpture and prevent checking in the wood, a technique common to the seal dish tradition.

3.4. Kihle, (Seal/head canoe dish) **Tlingit or Haida,** *c. 1750. Alder. 6.5″ L × 3.5″ W. Collection of Eugene and Martha Nester*

The heavyweight, angular formline style of this dish is comparable to the earliest group of extant northern carvings. Many aspects of this dish imply that it is similar in age to the group of documented 18th-century historic objects, such as the bowl collected by Dixon in 1787 (fig. 2.2).

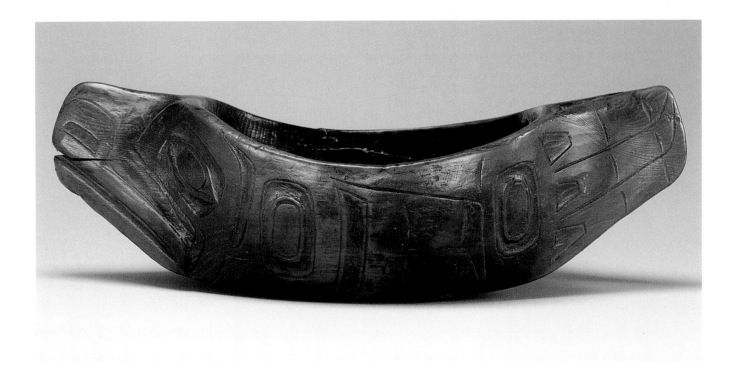

The seal image of the bowl is depicted with minimal design elements that represent the head, pectoral flippers, and hind flippers. There is very little negative space in the design, as each body segment is made up of massive formlines. All U-shapes are quite angular, especially the three sets of parallel, stacked U-forms that define the finger-like structure of the hind flippers. Very slim negative relief slits or crescents separate these broad positive forms that flow back over the rising end-form of the dish.

The sheep horn ladle (fig. 3.5) depicts two separate animal images. Very fine and shallowly engraved massive formlines on the outside of the ladle portray a sea lion. Its head is at the tip of the ladle and its body and tail flippers extend toward the handle. A wide, undecorated area spans the edges of the ladle on either side of the sea

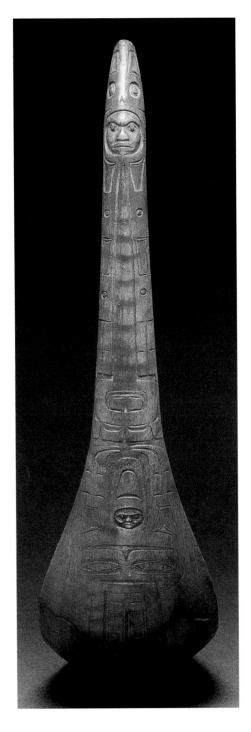

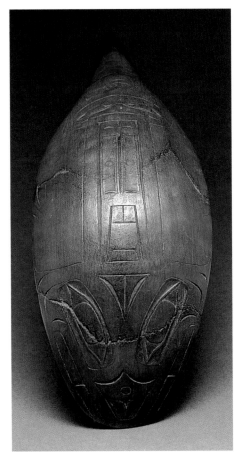

3.5 a, b. **Horn ladle**
Tlingit, *c. 1750. Mountain sheep horn.*
13.5″ L × 3.5″ W. Collection of
Bill and Marty Holm

This very delicate and darkly patinated ladle is clearly an early example, and its craftsmanship is extremely fine and precise. The sculptural style of the blowhole face suggests that it was carved by a Tlingit artist.

The use of heavy positive forms, extreme angularity in design shapes, very minimal tertiary areas, and very slim negative crescents all suggest that this object pre-dates the late-18th-century documented materials. Everything about the look and presence of this ladle conveys great age and commands respect for the mastery of its maker.

lion's body, contradicting the common but incorrect notion that Northwest Coast artists prefer to completely fill a given space.[2] The flowing stack of U-shapes within the parallel body formlines is a very rectilinear composition that also employs narrow relief slits. The hind flippers are formed of angular U-shapes and massive formlines in a manner similar to the seal/head canoe dish. The animal's short tail is shown with a tiny spirit face within an ovoid base.

The upper end of the ladle's handle is carved as the three-dimensional head of a whale. A human face is carved in the whale's blowhole. The whale's pectoral fins, body, and tail stream down the handle and terminate at the tip of the sea lion's hind flippers. The archaic style of these images is best exemplified by the extreme angularity of many of the forms, such as the whale's pectoral fins, composed entirely of square-ended U-shapes.

The transformation of the spiraled, gnarly, battered horns of mountain sheep into graceful and elegant spoons, ladles, and bowls is one of the most remarkable achievements of the Northwest Coast art tradition. Certain craftsmen seem to have specialized in their creation, as implied by numerous groups of stylistically similar bowls and ladles. A small number of extant examples, like this one, suggest that the masterful techniques of producing these wonderful objects were developed and refined by at least the early pre-historic period.

The paddle-like spoons made especially for the consumption of bittersweet soapberry foam[3] appear to be unique to the most northern Northwest Coast cultures. Frequently made as matching sets, they were once kept in special boxes or woven containers made for the purpose.[4] Some soapberry spoons are delicate and plain while others are painted or relief-carved with designs.

The massive formlines and marked angularity of certain elements in the set of four soapberry spoons in this collection (fig. 3.6) relate them to the early period and its design style, as does an additional element in these elegant spoons: the use

*3.6 a, b, c, d. **Soapberry spoons** **Tlingit**, c. 1800. Alder or maple. 18″ L. Collection of Eugene and Martha Nester*

The four spoons in this group were gathered from various sources and seem to have been made by two distinct artists, each of whom may have originally created an entire set. Certain soapberry spoons in this style were collected from the Stikine Tlingit (Burke Museum 10.35–10.40), suggesting that the ones illustrated here also originated in that area.

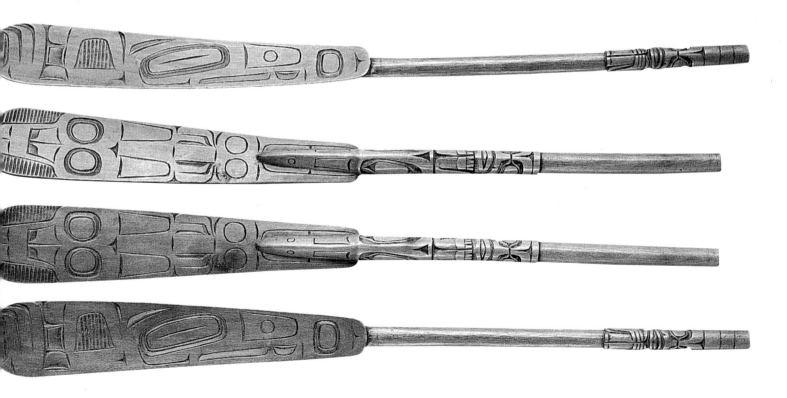

of fine parallel grooving. Knife- and adze-texturing is used as a final surface in a lot of Northwest Coast work, though the particular kind of fine grooving seen here often appears in pieces of archaic style. Some boxes and bent-corner dishes employ this grooving in the absence of any other surface decoration, suggesting that it is perhaps an ancient surface-finishing technique. In examples like these spoons, we may be seeing this technique in a vestigial form.

Like the previous examples, the construction and two-dimensional characteristics of the two small bent-corner dishes (figs. 3.7, 3.8) connect them to the earliest historic period. The flat design work on these containers, so shallowly relief-carved, is made up of very broad and massive forms. In the beaver dish (3.7), the eulachon or seal oil has saturated through the cells of the wood and oxidized on the surface to a rich black color. The design style suggests that this bowl may have been made in the middle eighteenth century. The surface decoration centers on a bilaterally symmetrical axis, and depicts a semi-sculptural face on each end with flexed legs and feet represented on each side panel. Each side panel is nearly symmetrical front to back, though the claws of the front feet turn down, while the claws of the hind feet turn upward. In figure 3.8, the construction of the bowl also conforms to early conventions, indicated by its compact size, the small degree of curve in the top edges, the use of sewn, rather than pegged, fastenings, and the excavated interior and raised outer edges of the added bottom. This style of hollowed bottom fitting appears to be related to the bottoms of oval bentwood containers made by Yu'pik and Inupiaq craftsmen of western Alaska (Fitzhugh and Crowell, 1988:212, fig. 274 top). The handling of unusual features such as the tiny hands on the side panel designs also connect this work to other early period objects extant. The style of the face sculpture relates the beaver dish (3.7) to others that were collected in southeast Alaska in the early nineteenth century. These faces also illustrate the interrelationship of sculpture and two-dimensional traditions on the Northwest Coast. Conceptually, the flat design conventions are overlaid on the sculpture in a kind of symbiotic fashion, where the development of one appears tied to the other. "In fact, the two art expressions are so interrelated that it is at times hard to say where one ends and the other

3.7 a, b. 'Kaakanéi (bent-corner bowl) Tlingit, c. 1750. Spruce (?), redcedar. 4.5" H × 6" W × 6" L. Collection of Eugene and Martha Nester

This small bowl exhibits the blackened, waxy surface typical of very old grease dishes. The two end faces are quite different, and in fact appear to represent the head and tail (or facialized hip joint) of a beaver. The actual cross-hatched tail of the beaver extends like a tongue from the mouth of the rear face (b). Both faces, and especially the rear one, illustrate the sculptural-flat-design concept so prevalent in early northern work, and can be readily compared to the head structure on the early Tlingit frontlet (fig. 3.9).

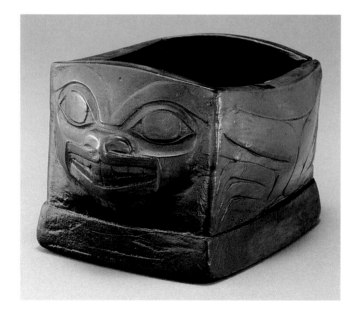
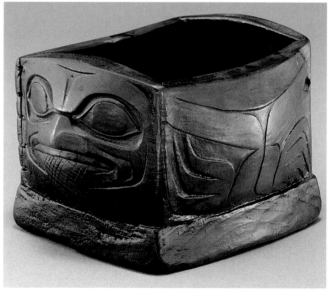

3.8. 'Kaakanéi (bent-corner bowl)
Tlingit, *c. 1780–1810. Spruce,*
redcedar. 7" H × 8" W × 10" L.
Collection of Jack and Jane Curtright

More complex in design than figure
3.7, this bowl nonetheless displays the
extremely broad positive formlines
and minimal negative areas that sug-
gest an early creation date. Other
design aspects support this early attri-
bution, such as the concentricity and
simple reliefs of inner ovoids, the
square corners of many U-forms, and
the very minimal employment of sec-
ondary elements in the design.

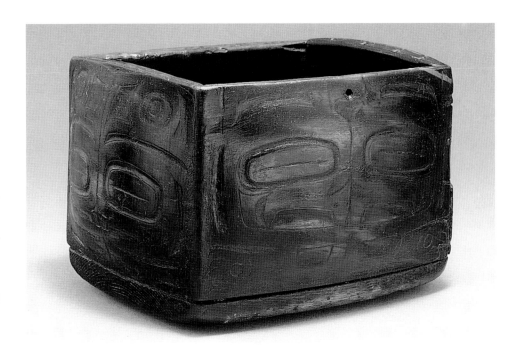

begins" (Holm 1965:14–18; 1983a:33). This principle is evident in many examples of sculpture but is especially clear in this dish, the seal/canoe bowl (fig. 3.4), the early Tlingit frontlet (fig. 3.9), the elaborate raven headpiece (fig. 3.10), and most raven rattles (fig. 3.13).

Many of the earliest documented objects are relatively small and sculpturally compact, as is the Tlingit frontlet (3.9). This may reflect a sculptural approach developed during the pre-historic era, under the influence of smaller and more limited tool types. The rims of many early-style frontlets are not inlaid with abalone shell, but rather are carved smooth (some are tool-textured) and painted with the old northern blue-green, as is seen here.[5] The sculpture and inlay styles of this frontlet make possible its attribution to a well-known group of early Tlingit masterworks.[6] In the context of these artifacts and the lifetime of their attributed maker, this frontlet can be assigned a late eighteenth- or very early nineteenth-century date of origin.

In the raven headpiece (3.10), without the presence of diagnostic two-dimensional designs to attribute an age to this piece, one must look at more subtle details, several of which stand out. The whole image is very compact, a trait of many early sculptures, and the relief-carving is relatively shallow and subtle, even in the depiction of humanoid figures in the tall ears. The most apparent two-dimensional design indications are the eyebrow bands and the trigons at their outer ends, and these suggest broad formline characteristics. Perhaps more indicative of age is the connection of this carving to other known work. Stylistically, this piece can be attributed to Kadjisdu.áxch' II, the carver of the Whale House and Chief Shakes house posts, whose carving career can be deduced from evidence to have been between about 1770 and 1810 (Brown 1987:156–74).

More fine examples of early-style flat design, though perhaps not so old as the previous objects, are seen in the eagle battle helmet (fig. 3.11), the Tlingit dance staff (fig. 3.12), the double killer-whale dish (fig. 3.14), bowl of the two-piece horn spoon (fig. 3.15), the tobacco pipe (fig. 3.16), and the raven headband (fig. 3.17). These, while

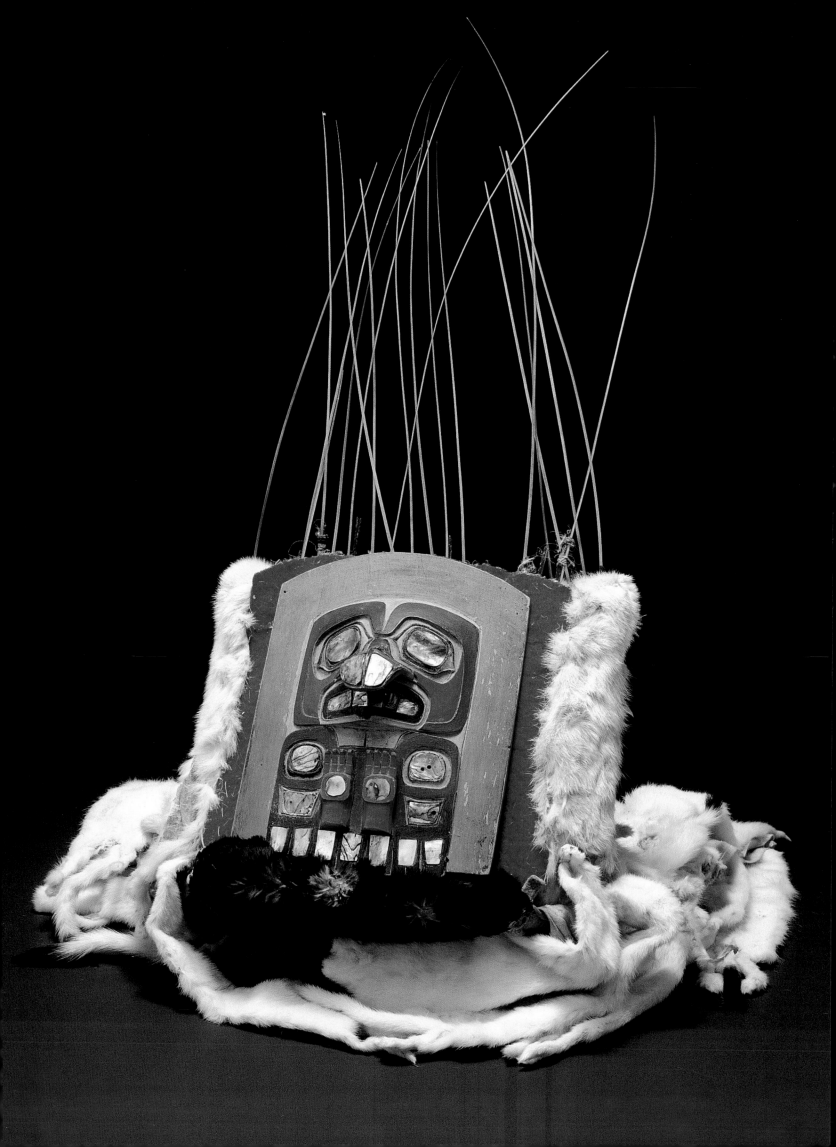

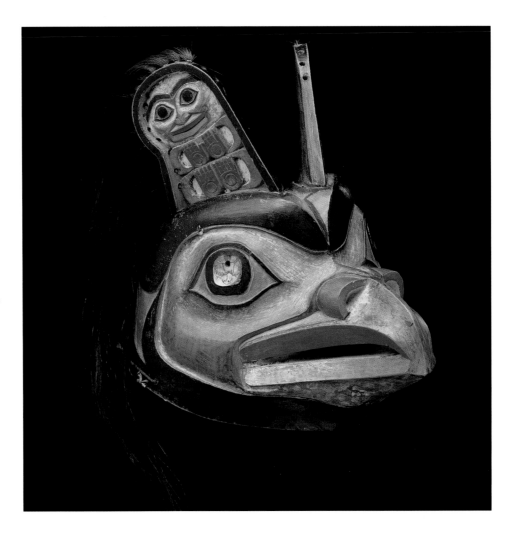

3.9. Shaki.aat' (headdress and front-let) Tlingit, *c. 1780–1800. Frontlet: alder, paint, abalone.*
7.5" H × 6.5" W × 2" D.
Headdress: sea lion whiskers, ermine skins, mallard skin, baleen, leather, cloth. 44" H.
Collection of Bill and Marty Holm

A number of features embodied in this superlative headdress and frontlet reflect the characteristics of very early examples, and certain aspects of the sculpture and inlay styles may connect the frontlet to a particular Tlingit artist's work. In the context of this object's style and the lifetime of its attributed maker, this frontlet can be assigned a late 18th- or very early 19th-century date of origin.

3.10. Naas Shagi Yeil S'aaxw (Raven-at-the-Head-of-the-Nass hat) Tlingit, *c. 1780–1810. Maple, abalone, paint, hair, baleen.*
8.5" H × 7" W × 12" D. SAM 91.1.125

This masterpiece of clan emblem headgear illustrates the deep interconnection of the Northwest Coast sculpture and two-dimensional design traditions. Attribution of this object to the early historic timeframe is based more on its relationship to datable examples of a known artist's work than on the characteristics of its design features. Stylistically this piece can be attributed to Kadjisdu.axch' II, the carver of the Whale House and Chief Shakes house posts, whose carving career can be deduced from evidence to have been between c. 1770–1810 (Brown 1987:156–74).

not appearing to be as distinctly archaic in style as the previous pieces, still show indications that they were made in the late eighteenth or very early nineteenth century. In some of these objects, the formlines are less massive overall, and consequently a greater number of design elements are able to occupy the same amount of given space. Negative reliefs and tertiary areas are still small in comparison with the overall dominance of positive design elements in each of the examples.

The Tlingit dance staff (fig. 3.12) is of interest in that the length of the staff has been carved into separate concave cylinders, alternately painted red and black. One of three visually related staffs depicts the same type of cylindrical forms connected to the back of a raven's head, and is identified by its Native owners as *Yeił Toodéixi*, or Raven's backbone (Bradley 1984). There is a clan house tradition among the Kogwontaan of Hoonah, Alaska, and an existing building known as *Tóos' Deixi Hít*, or Shark's Backbone House (Hanlon 1988).[7] It is possible that the shark-backbone concept of this staff is related to that tradition. The dense two-dimensional design on the shark's tail displays the minimal negative areas, very basic secondary elements, and general angularity of late-eighteenth-century-style design work from the Tlingit.

The raven rattle (fig. 3.13) is another case in point. Each aspect of the object's appearance suggests that its maker was working within the design conventions of the early nineteenth century, including the wide-open eyelid forms, the broad formline weight, the minimal size of negative elements, and the basic nature of the secondary

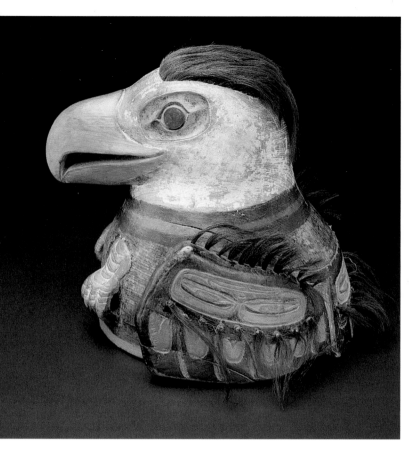

3.11. Ch'áak' Shadaa (eagle helmet) **Tlingit,** *c. 1790.*
Spruce, paint, hair, brass. 11″ H × 11″ W × 12″ D. SAM 91.1.72

Native oral history places this helmet at the 1802 battle of Old Sitka,
when the Kiks.ádi Tlingit drove the Russian America Company fur
traders and settlers away from their traditional homeland (Brown
1995:36). In 1804 the Russians under Alexander Baranov, assisted by
dozens of conscripted Aleut sea otter hunters, recaptured their foothold
on what was to become known as Baranof Island. Even in the absence
of its rich documentation, this helmet can be recognized as a product
of the 18th-century style. The flat design features on the abbreviated
wings and the tail of the eagle clearly exhibit the minimal negative
areas and resultant dense formline compositions of the prevailing
early styles.

3.12. **Speaker's or dance leader's staff** **Tlingit,** *c. 1800.*
Spruce, paint, abalone. 53″ L × 4″ W × 1.5″ D.
Collection of Bill and Marty Holm

This staff is one of a small group of iconographically related pieces,
though its appearance and design style suggest that it is the oldest
among the three known similar staffs. The image seen here is the thin,
heterocercal tail of a shark, covered with early-style flat design and
inlaid profusely with iridescent abalone shell.

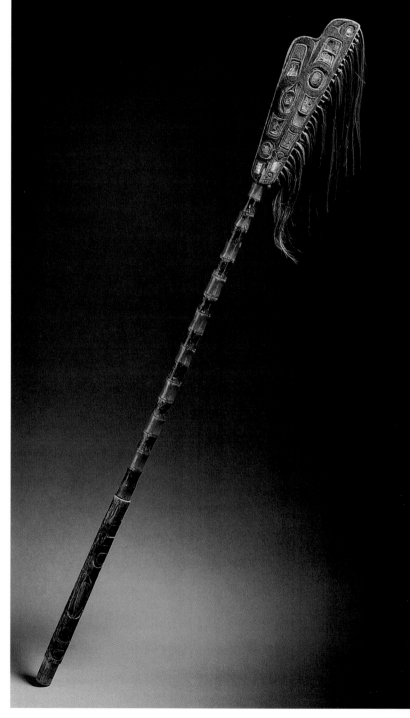

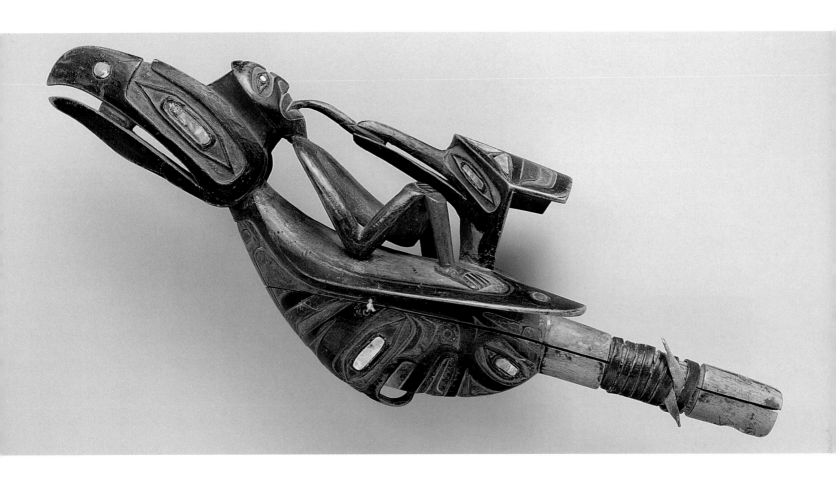

3.13. Sheishoox (raven rattle)

Tlingit or Haida, *c. 1800–1820.*

Maple, paint, abalone. 4″ H × 13.25″ L

× 5″ W. Private collection

This early historic period expression of
the raven rattle displays the complete
raven/human/tail configuration of the
fully developed rattle form. The bird's
beak is proportionally shorter and
slightly more recurved than in many
examples, though it still most likely
represents the prominent raven image.
The inclusion of abalone shell is very
uncommon in these rattles, and the
inlay work here is superb.

forms. The sculptural style of the human's face could have been produced by either a Haida or Tlingit carver, as the archaic two-dimensional style was common to both groups at the turn of the nineteenth century.

In the masterful double killer-whale dish shown in figure 3.14, the flat designs depict the blowhole, body, pectoral, and dorsal fins of the whale images, and are vastly different on the two opposite sides of the dish, though each side-composition is itself symmetrical from end to end. The design elements are very rounded, and flow smoothly through the changing movements of the patterns. Certain aspects of these designs, such as the use of negative circle reliefs in formlines and secondary elements, and the balance of design shapes and sizes in a rectilinear arrangement, suggest that the maker of this dish also may have been a designer of pattern boards for Chilkat-style weavings.

The carving on the outside of the two-piece horn spoon (fig. 3.15) shows many characteristics of the early design styles: broad primary formlines, finelines around tertiary areas, and minimal secondary elements. The facelike design image was conceived for the spoon with great care and a fine sense of balance. The sculptural handle of the spoon could be a later addition, copper-riveted to the shank of what may have originally been a one-piece spoon. The abalone shell inlay in the eyes of the lower figure appears to be of the Native Northwest Coast species, a type very rarely seen, especially in early work.

Native tobacco pipes often contain a shamanic style of imagery, which is related to their function at the smoking feasts connected to high-ranking funerals (Emmons 1991:341; Brown 1995:72). In the example here (fig. 3.16), the massive quality of the

bird as it arches over its human spirit counterpart lends the sculpture a monumental appearance. As is often the case, it is the two-dimensional component of an object such as this which gives the most clues to the time of its origin. Here the main formlines that make up the wings of the eagle are very massive, and the negative elements are minimal and thin, suggesting that it is at least an early-nineteenth-century carving. The polish and wear apparent on the surface underscore this idea.

In the example of the raven headband (fig. 3.17), we see that the very minimal negative areas in the relief-carved surface associate this piece with the style of the early historic period. The leather band may be a later Native replacement and is possibly a modification from the object's original use and appeararance.

Looking again at the chest panels (fig. 3.3), the effect of even slightly thinning the positive formlines becomes apparent. Balance, in many aspects, is a principle

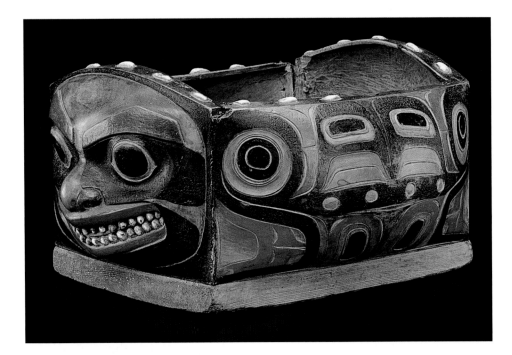

*3.14 a, b. **Kaakanéi (bent-corner dish)** Tlingit, c. 1800–1830. Maple, redcedar, paint, opercula, fiber.*
6″ H × 14″ W × 11″ D.
SAM 91.1.56

Masterfully executed, this fairly large dish illustrates a wonderful blending of pure sculpture with skillfully developed two-dimensional designs. The image evidently portrays a double-headed killer whale, with humanized faces beautifully carved at each end of the dish. The deep bulges, thin cross-sections, and complex corner-lap forms indicate that the maker of this container was a master craftsman as well as a visionary artist.

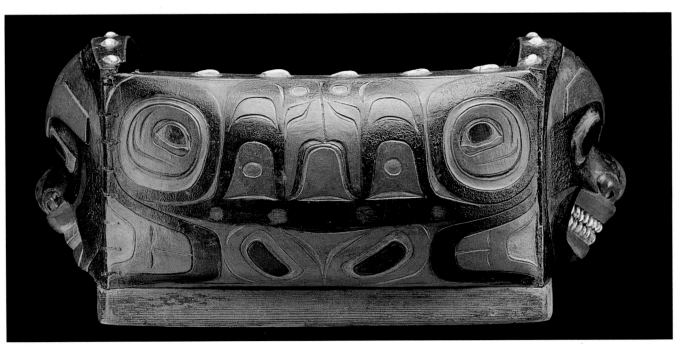

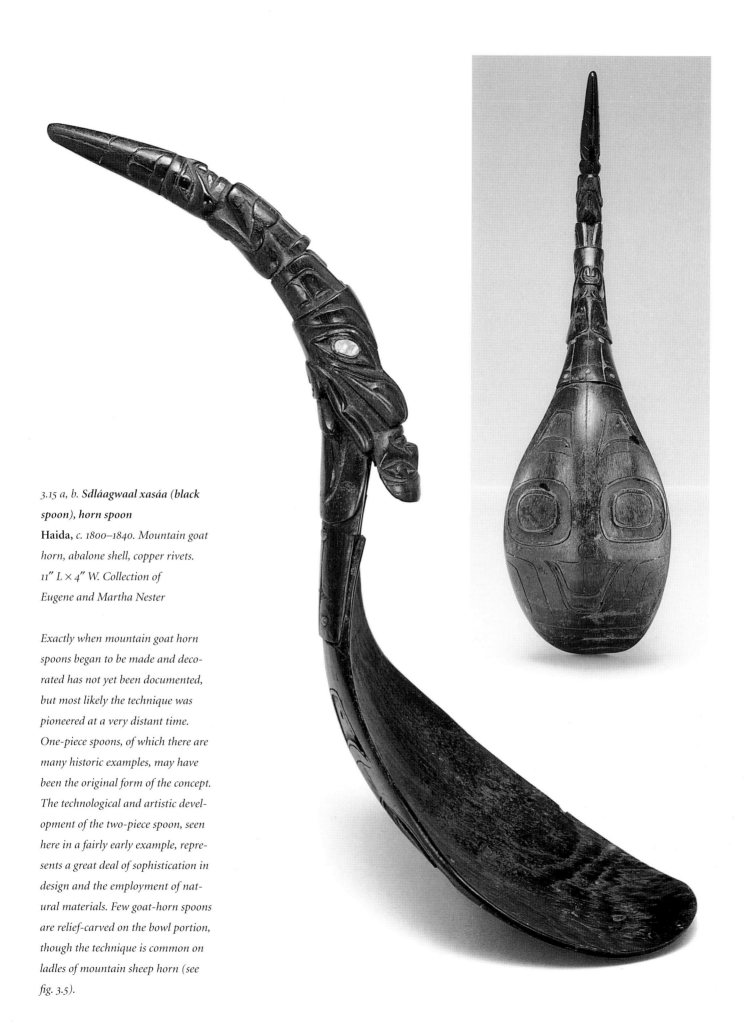

*3.15 a, b. **Sdláagwaal xasáa (black spoon), horn spoon***

Haida, *c. 1800–1840. Mountain goat horn, abalone shell, copper rivets. 11″ L × 4″ W. Collection of Eugene and Martha Nester*

Exactly when mountain goat horn spoons began to be made and decorated has not yet been documented, but most likely the technique was pioneered at a very distant time. One-piece spoons, of which there are many historic examples, may have been the original form of the concept. The technological and artistic development of the two-piece spoon, seen here in a fairly early example, represents a great deal of sophistication in design and the employment of natural materials. Few goat-horn spoons are relief-carved on the bowl portion, though the technique is common on ladles of mountain sheep horn (see fig. 3.5).

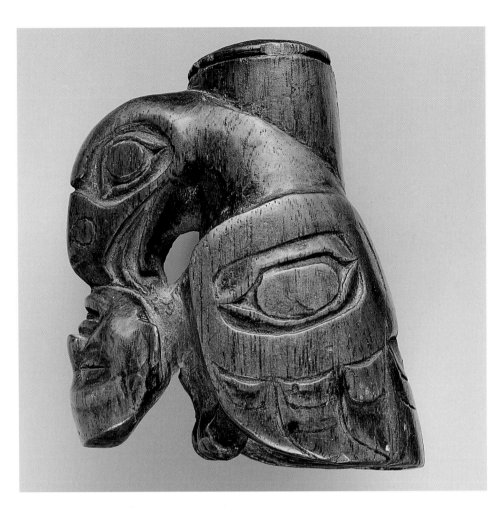

3.16. S'eik daakeit (smoke container),
tobacco pipe
Tlingit, *c. 1800–1840. Walnut, iron.*
3.5″ H × 3.5″ W × 2″ D. Collection
of Eugene and Martha Nester

The incorporation of trade musket materials into tobacco pipes may have been done to transfer to the pipe the power over life and death embodied in firearms (MacDonald 1996:94). Both Tlingit and Haida cultures employed tobacco smoked in pipes to assist the raising of prayers to spirits in the sky world. This compact little image is one of the most dramatic representations to be adapted to a tobacco pipe configuration.

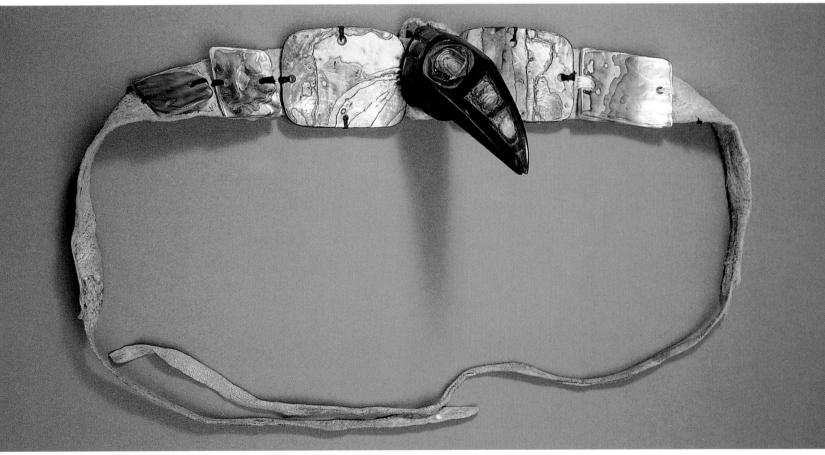

constantly at work in Northwest Coast art, so as one side of the design equation decreases, the other increases in order to maintain a visual equilibrium. The concepts of balance and reciprocity are also embedded in the moiety system of social organization (Dauenhauer 1990:13; 1995:24), and can be related to their role in visual art (Brown 1995:276). As formlines become thinner, the distribution of negative space proliferates, placed here and there as if to keep the overall fabric of the design evenly woven. Where solid secondary shapes once adequately fulfilled their role within the broad-primary style, the new scale of design complexity calls for them to be opened up by the incorporation of subtle negative spaces.

These chest panels follow the same essential primary design format as the very early chest (fig. 3.1), but most secondary red areas in the panels contain small complexes of elements instead of single or doubled solid forms. On the front and back panels, the cheek designs, the lateral areas outside of the central head, and the spaces flanking the body field, all share the same degree of balance between positive and negative space which is evident in the overall images. Positive space still dominates, but instead of an eighty:twenty proportion, the relationship can be seen as more like sixty:forty. The change in this comparison alone is interesting to monitor as the development of the art proceeds through the nineteenth century.

The artist has skillfully blended two different creature representations into the conventionalized chest design structure (Holm 1997), almost without altering its most common traits. The front panel (a) portrays the attributes of a whale: rounded snout (shown as a three-dimensional extrusion), tail flukes (centered below the head), and pectoral fins in the lateral fields outside the head. The rear of the chest (c) depicts bird attributes in a similar fashion: tail joint and feathers are centered below the head, wing feathers flank the tail, and additional featherlike shapes are depicted in the lateral fields. The artist is apparently representing one of the most powerful creature juxtapositions of the Northwest Coast tradition, the thunderbird and whale, while still conforming in essence to the chest-design structural tradition.

The side panels of this chest both show a very interesting anomaly, particularly in light of the tendency to maintain positive/negative balance discussed above. In the lower central body area of each side panel is a large rectangular field painted solid red, in a place where one would expect the type of formline complex seen on the front and rear panels. Not unlike the undecorated spaces on the early horn ladle (fig. 3.5) in general concept, these smooth, solid fields provide a kind of quiet counterpoint to the active flow of the rest of the design surface, and can be seen in a handful of other chest and box designs from this same general period.[8]

Another unusual design twist can be found in the outstanding design work on the double whale dish (fig. 3.14). Two instances of what can be called secondary color shift are notable: On one side, the large, elaborated inner ovoids directly behind the sculptured eyesockets are painted red, rather than the more conventional black. On the opposite side, the formline ligatures connecting the two secondary red formline ovoids between the pectoral U-shapes are black instead of red, as they are on the other side of the dish, and most commonly are in other cases. In each of these examples, and in general, such a color shift appears to satisfy the artist's desire to balance the overall distribution of red elements within the black primary designs. The same shift-of-color feature is also present in the wing designs on the eagle battle helmet

3.17. Raven headband/ornament
Tlingit, *c. 1820. Mountain goat horn, abalone, leather. 12″ L × 2″ W × 2″ D. Collection of John Putnam*

This small carving and attached leather band were apparently made as a headpiece, designed to display the raven crest image on the forehead of the wearer. The raven's head is carved from the tapering tip of a mountain goat horn, and has been skillfully inlaid with the highly prized shell of the California abalone (Haliotis fulgens). Several pieces of the shell have been restored.

(3.11) and the two lower ovoids on the chest panel front. This kind of departure from convention also suggests the spirit of an artist who enjoys "pushing the envelope," who is skilled enough in conception and imagination to initiate ideas or to incorporate innovations new to his own experience. The color shifts of these objects, subtle though they may seem, represent the kind of imagination that set the stage conceptually for some of the very revolutionary ideas that found expression in the later nineteenth century.

The Southern Region in the Early Historic Period

By far the earliest (and best documented) southern coastal object in this collection is the stone club collected by Captain James Cook at Friendly Cove, Vancouver Island, in 1778 (fig. 3.18). George MacDonald (1983a:111) states: "By historic times the stone work of the North Coast had achieved a high degree of refinement on a par with that of classic civilization in Central and South America." Certainly this club from the southern coast deserves to be counted among the masterpieces considered in such an assessment. Drawings made of this remarkable stone weapon in 1783 by an artist named Sarah Stone, while it was in the Leverian Museum collection, London,

3.18. Ḵaʼheitʼạm (killing object),
stone club
Nuu-chah-nulth, Mowachaht, *pre-1778. Basalt, hair. 14″ L × 6″ W × 2″ D. SAM 91.1.21*

The sculptural representations of a bird and a wolf on this club relate very directly to the types of wooden masks and headgear that were acquired in the Nuu-chah-nulth region in the historic period. That the subtle yet powerful sculptural forms known from such wood carvings are here rendered in a dense, brittle stone elevates one's visual appreciation of this object, however violent its original purpose.

confirm its acquisition on Cook's third voyage (Holm 1983b:97). The club is one of two documented Cook pieces in the United States. (Force and Force 1968:149). Exactly how old the club was in 1778 is indeterminable; its age might span from decades to centuries earlier. Very refined stone clubs have been recovered archaeologically on the northern coast which are dated between 1500 and 2000 years B.P., with an earlier date of 2500 years B.P. postulated as the beginning of the large stonework tradition (MacDonald 1983a:101–2, 114–5). Wooden objects acquired at this time provide a limited but intriguing view of the pre-historic Nuu-chah-nulth art traditions (King 1979:44–46, figs. 34, 37, 38; Kaeppler 1978b:251–65). A fine and important weapon such as this most likely had a special Nuu-chah-nulth name and an oral history that were well known and respected in its time.

The head of the wolf at the tip of the club displays the same use of design elements of the proto–Northwest Coast style as would be seen in wood or bone carvings. The crescent just behind the mouth opening, the trigons on either side of the eye oval, the rhythmic row of crescents at the base of the blade point, and the concentric circles surrounding the eye of the bird are all similar in application to the way these elements were employed on a great variety of southern and proto–Northwest Coast objects from a broad span of time. Some of these features can be seen on later historic-period artifacts in this collection.

In addition to weapons of stone, the Nuu-chah-nulth and Makah peoples created a particular style of battle club made from the jawbone of a whale. The earliest known weapons of this type were excavated in the middle 1970s from the Ozette village deposits, an archaeological site dated between 300–500 years B.P. (Daugherty and Friedman 1983:193, fig. 10:11). This site also yielded unfinished examples, recovered as they appear in various steps of the creation process.[9] In general iconography

3.19. Bone club

Nuu-chah-nulth or Makah, *early 18th century. Whale jaw bone. 23″ L × 3″ W × 1″ D.*

Collection of Allan and Gloria Lobb

One of the archetypal conventionalized forms of the Nuu-chah-nulth art tradition is the whalebone club, of which this is a classic example. Perhaps the earliest known clubs of this type were excavated at the Ozette archaeological site near Neah Bay, Washington, in the middle 1970s. This club exhibits the polish of long wear, the color tone of great age, and the workmanship of skilled hands steeped in an ancient tradition.

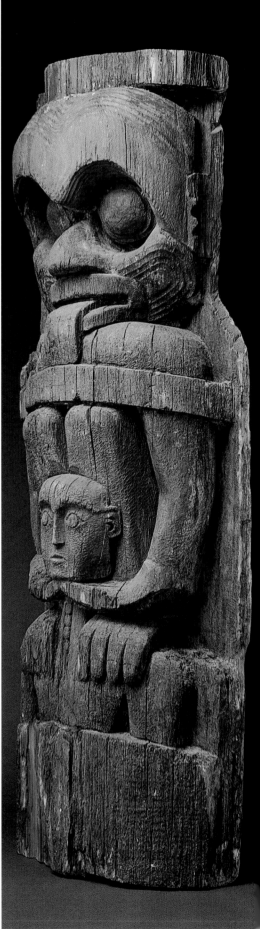

This grand and elegantly gruesome house post carving was acquired in the 1890s by Captain D. F. Tozier. The sculpture of the massive upper face in this composition is very deeply set, and features some fantastic texture lines within its captivating representation. The head of the human figure below, which the monsterlike image is apparently in the act of decapitating, displays an early and archaic-looking carved form that differs from prevailing styles found in that area in the late nineteenth century. From the expression on the man's face, he seems oblivious to his predicament, adding a note of Zenlike passivity to the total image.

and form, the centuries-old Ozette clubs do not differ from the club illustrated here or most other ethnographic examples (fig. 3.19). The club forms share the long, tapered blade, the blunt shape of the tip, the oval grip, the sculptured images (often double, or stacked, as seen here) at the grip pommel, and usually some type of incised designs down the length of the blade surface. Noticeable differences amount to those of style, owing to the individuality of the artists who produced the many existing examples of these evidently important weapons.

The eighteenth-century explorers conducted little interpersonal contact outside of major trading centers such as Nootka Sound, Sitka, and, later, Fort Victoria. The Kwakw<u>a</u>ka'wakw territories were somewhat more remote from the direct sea-otter trade and collecting activities until the third quarter of the nineteenth century, when it seems that every ethnologist in the Northwest Coast field came to work among them. Kwakw<u>a</u>ka'wakw artifacts from the early or pre-contact periods are extremely rare, though the house post in this collection (fig. 3.20) certainly exhibits characteristics that suggest it dates from these times. The general lack of two-dimensional embellishments and the finely detailed use of tool textures associate this piece with some of the earliest examples from this region. The scale of the adze marks on the surface, especially on the man's face, suggests that relatively small tools were used in carving this piece, an aspect that adds to the sense of great age exhibited in the sculpture.

Examples of highly decorated southern coastal or Salishan objects, especially early pieces, are very much more rare than are northern ones in the overall historic record. The reasons for this may be embedded in the cultures themselves, and in motivations

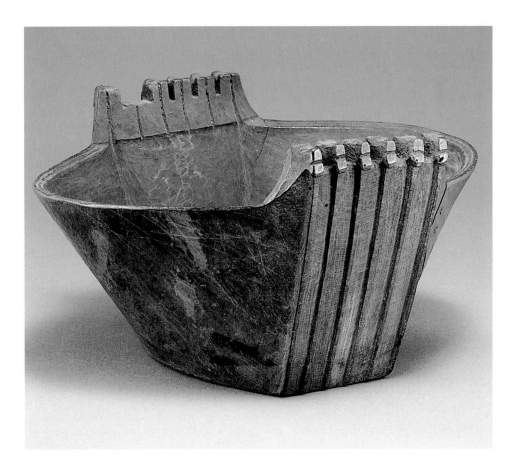

3.21. Wooden bowl with animal head finials
Makah, Chinookan, Coast Salish,
c. 1800–1850. Alder.
6″ H × 11″ L × 11″ W.
Collection of Jack and Jane Curtright

This deep wooden bowl from the southern region is an object of conventionalized archetypal form. A number of existing bowls are essentially identical in form and representation to this one, each varying only in minor details of proportion and finish.

for artistic production which differ widely from those among the middle and north-ern coastal peoples. Wayne Suttles's enlightening essay on Central Coast Salish art explores differences in Salishan motivation to decorate art objects, as compared with decorative practices in the northern regions, and discusses as well the cultural and religious restraints practiced by those who display such objects. He also notes how Coast Salish social structure does not possess the same concentrations of authority (and associated wealth) as are present among northern peoples, which motivate the display of ancestral inherited crests and emblems (Suttles 1983/1987:1–36).[10]

Two wooden dishes among the southern artifacts in this collection represent fur-ther examples of a highly conventionalized object form that appears to have been re-created over a great span of time (figs. 3.21, 3.22). This type of vessel appears in a variety of places in the Washington/British Columbia border region. Canadian artist Paul Kane painted the image of a dish he saw in a Straits Salish house near Fort Vic-toria in 1846 (MacLaren, in press). An example that is essentially identical to the ones illustrated here was found in the Ozette village remains, a site that has revealed

3.22. **Wooden bowl with animal head finials**

Makah, Chinookan, Coast Salish,
c. 1800–1850. Alder.
7″ H × 10″ L × 11″ W.
Collection of Allan and Gloria Lobb.

The oldest example yet found of this type of bowl was excavated at the Ozette archaeological site on the Washington coast, where the south-ernmost village of the Makah people was located in historic times. This ex-ample is essentially identical in form to the earliest documented versions.

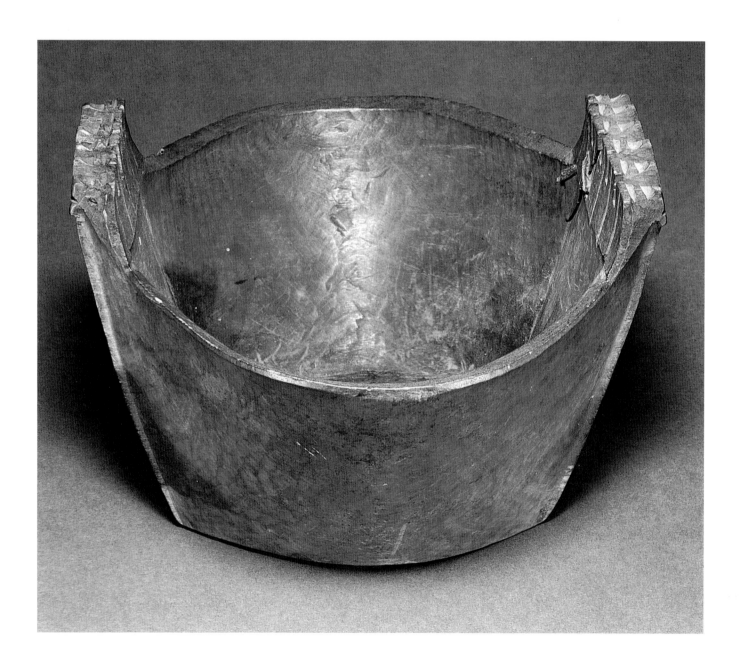

thousands of artifacts of wood and other perishable materials preserved beneath a huge mudflow that inundated several houses in that village between 300 and 500 years ago.[11] The Ozette dish has almost exactly the same shape, and the same rows of animal-like heads and raised ridges as are carved in these examples. Robin Wright has suggested that the resemblance of these rows of heads to the (less detailed) sculpture of canoe bows may indicate that a fleet of canoes is being represented (1991:97, fig. 52). Many of the artifacts from Ozette indicate an influence of Salishan-style traditions, such as roller-bar loom weaving and coiled basketry types, which indicate common trade or intermarriage. The fact that the form of these dishes appears not to have changed over several centuries says much about the artistic conservatism of the southern tradition.

#1

Greetings Person Reading this book!
Have a fantastic day because you are awesome :D
Sincerely,
A random Stranger

Changing Times

Art of the Early Classic Era 1820–1865

The rigid conservatism of an old tribal system enduring through centuries, giving pattern but no explanation, must have nagged constantly at the restless humanity of such a dynamic people. In their art, they seem to have been seeking always a solution to this oldest problem.

—Bill Reid, Haida (1967)

The Expansion of Northern Northwest Coast Art in the Nineteenth Century

NORTHERN NORTHWEST COAST ART HAS CONTINUALLY EVOLVED, generation by generation, though it is apparent that change accelerated more rapidly in the century following Euro-American contact than in the several centuries preceding it. The possible reasons for this are many and varied, reflecting the outgrowth of influences from both within and without.

Traditional Native societies are conservative in nature, with internal changes coming slowly due to a variety of limiting factors. Not just anyone could become an artist in the old society, for example. One had to inherit the privilege through family lines. And one's training in the art traditions was not free and intellectual but was instead guided by direct, demonstrated instruction in "the way it's done" (Davidson 1993).[1] Radical social changes due to outside influences in the nineteenth century were also in part responsible for the acceleration of design evolution. Euro-American contact, steadily increasing as the nineteenth century progressed, introduced new materials, new ideas, new values, new religions, and new diseases, each of which affected the continuity of culture in significant ways. Population increases, made possible by the expansion of trade, wealth, and improved access to food resources, were offset by losses from introduced diseases. Numerous epidemics reached their apex with a major smallpox outbreak at Victoria in 1862. This plague, which soon spread to nearly

every village, claimed between 20 and 90 percent of the Native population in different areas. The individuals lost must have included many artists and this would certainly have created a severe impact on the production of material culture after that time. The introduction of large-scale missionization in the 1870s, the subsequent erosion of Native social traditions, and the emergence of new markets and motivations for art production all must have exerted influence on the evolution of the Northwest Coast art tradition. In addition, the diminished authority of the more conservative traditional elders may in turn have expanded the sense of artistic freedom experienced by upcoming generations of artists, allowing them to press more firmly against the perceived limits of the design system as it existed in their times.

However one defines the impetus for significant change, the historical record makes it clear that the traditions of northern Northwest Coast art evolved dramatically in the first half of the nineteenth century. Based entirely on the concepts of color, space, and formline structure evident in the two-dimensional art created in and before the eighteenth century, the new directions taken by Native artists in the decades of the ensuing period (especially between about 1820 and 1870) transformed the pre-contact Northwest Coast tradition into the complex and elaborate system interpreted by Bill Holm in his landmark 1965 publication. Initiated by decades of interest in and familiarity with the subject, Holm's study was statistically based on nearly four hundred two-dimensionally decorated objects for its interpretation of the classic Northwest Coast style. More than thirty years later, the *Analysis of Form* remains the only written work that has clearly defined those mainstream nineteenth-century design conventions upon which all Northwest Coast artists have since improvised.

Elaboration As an Evolutionary Measure

> So it had to be within the strictures that individuality developed, and as each artist grew, he discovered new ways of making a personal statement, and developed a distinctive style that set him apart from all others. (Bill Reid, Haida, 1967)

An influential natural law appears to be at work in the progress of northern Northwest Coast art through time, summed up in these words of Bill Reid: "All is containment and control, and yet always there seems to be an effort to escape" (1967). The seemingly strict conventions of the tradition have apparently always challenged the creative artists to improvise, to make each new design different from all those done before. In addition to those personal traits of artists seen in the characteristics of their particular design forms (whether rounded, angular, rectilinear, or curvilinear), the internal structures of formline designs were also improvised upon by the leading masters of the form. Once the structural conventions of the formline tradition were in place, one of the most apparent avenues of personalization open to individual artists lay in the elaboration of secondary forms.

Primary formline structures, to a large degree, are frequently conventionalized by tradition. Chests, boxes, carved bowls, raven rattles, and other artifacts illustrate this in the structural consistency of their primary formline patterns. This is indirectly

illustrated in Holm (1967: no page numbers), using similar face-design structures from a raven rattle, a chest front, and a house frontal painting. As the scale of a given design increases, it is the inner ovoids, the secondary, and the tertiary areas within the design (rather than the essential primary formline structure) that become elaborated. In addition, these aspects can be progressively developed regardless of overall design scale or size, though that is the immediate subject of Holm's illustration. As an artist focuses on a given design field (such as an eye or cheek design), progressively more detailed developments can be imagined and applied to that area.

This is certainly not the only way that artists have expressed their originality, but it is one of the most clearly visible realizations and has been very noticeable in the tradition through time. The most creative artists also improvised within the primary design patterns, though many types of objects (of which chest and box designs are the most obvious examples) maintained a structural tradition that prescribed certain design conventions or formats. Still, the imagination of the most inventive artists could not be forever contained. By the time of the middle nineteenth century, some significant differences can be noted in the overall picture of northern Northwest Coast art that illustrate the elaborative principle.

The conventionalized types of chest designs display the concept of secondary design elaboration very clearly. The chest panel illustrated in figure 4.18 displays nearly the same primary design structure as that seen in the much older chest in figure 3.1, but every secondary design area enclosed by a black primary formline is elaborated far beyond the corresponding ones of the older piece. (In figure 3.1 the paint has weathered off, but those areas that would be red or black are nonetheless discernible through awareness of the traditional system.) This includes the eyes and all other inner ovoids, the cheek designs, the mouth area, the lower body area, the hand area outside the body, and so on. The simple red units or stacked U-shapes (the secondary areas) of the container in figure 3.2 are replaced by red (and black) secondary complexes combining painted ovoids, U-shapes, and hollowed-out tertiary and ground areas on the panel in figure 4.18. The positive-to-negative spatial relationship in this example is approaching fifty:fifty, showing only slightly more positive (black and red) surface area than negative (relief-carved away).

When asking which motivation drives this development—thinning the formlines relative to the negative space or elaborating the secondary area—the answer is one of salmon-versus-egg. Many factors come into play: tool development; larger more ambitious productions (bigger boxes, chests, housefronts, etc., created in response to patrons made wealthy through increasing trade) that called for more coverage from the same design structures; and a shift in conceptualizing the designs from the negative aspect to that of the positive, the formlines themselves. Within the shift from proto-Northwest Coast art to the early, archaic northern style, the *conceptualizing* units are in both cases the negative ones, those that are carved out: the inner and outer edges of formlines are defined *initially* by the placement of the negative (or carved-out) tertiary and ground areas. When conceptualization shifts to the positive aspect, the artist is laying down positive, painted formlines that surround conceptualized negative and tertiary areas. It's like the difference between highlighting the subject of a black-and-white drawing either by blackening in the background with a white subject, or by blackening in the subject with a white background. In

true practice, the traditional Northwest Coast artist is constantly doing both, shifting back and forth across this conceptual edge. Though by focusing one's conception on the positive aspect, the freedom and the ability to elaborate in this field seems to be facilitated by the formlines themselves.

In the range of artifacts from the early nineteenth century, greater variations of individual expression can be seen to proliferate as improvisation and inspiration multiply and the spatial freedom of thinner formlines creates more room for elaborated compositions. The tendency to elaboration existed among each of the three main northern coastal nations—the Tlingit, Haida, and Tsimshian—though it was the Tsimshian-speaking nations and their southerly neighbors, the Haisla and Heiltsuk, who carried the formline-thinness principle to its greatest extremes, as in the style of the Heiltsuk chest in figure 5.4. The oldest extant examples of work by each of these groups show that heavier-weight formlines were employed at one time by artists of all northern Northwest Coast language groups. The transition from the simple negative elements of proto–Northwest Coast art to the complex structures of the mature formline system almost *required* the incremental, evolutionary step of a positive-heavy design structure in which the true formline concepts could be refined. The thinning of positive lines and the resultant opening-up of the design fields also saw expression among artists of all language families. The degree to which individual artists embraced these concepts differed greatly, however, just as it does today—some artists are more conservative; others are more willing to stretch the tradition. Each succeeding generation is inspired not only by the older established work, but also by the newest and most experimental work being done at any one moment. Each artist who left behind masterful new ideas or variations of the design principles forged new visual tools for manifesting the expressions of their successors.

Variations in personal design style and, by extension, regional or tribal styles, have always been driven by the inspiration of individual artists, a process that is evident within the living Northwest Coast tradition today. Regional masters, touched by dreams, visions, and the seemingly unquenchable desire to make visible their own mark on the tradition, have expanded design concepts, incorporated unexpected color changes and hierarchies, and pushed the limits of conventional design structure and proportion, and they have inspired new generations of artists to do the same. Passed from one hand to the next within a village, a region, or a language family, individually inspired new ideas have become a part of the tradition within their area of influence. These innovations in turn have given rise to an ever-expanding variety of styles that can assist historians today, with acknowledged limitations, in placing a given object both geographically and chronologically.

One's ability to observe and quantify these changes is naturally limited by the irregular manner in which Northwest Coast objects were assembled in the nineteenth century. An unfortunately incomplete record exists, both in geographical and chronological terms, so that we can get but scattered glimpses of the result of an immense field of artistic development. Similar limitations exist within the exhibit collection that is the subject of this study. Though we do not see each conceptual step along the evolutionary path as clearly defined as we might like, a sense of the nature and general directions of this movement can be acknowledged and illustrated.

The rather arbitrary date of 1820 has been selected here as the initial year of the

classic period study-era for a number of reasons. Because the European calendar, per se, meant not much to the people of the Northwest Coast, the beginning of the nineteenth century (the year 1800) by itself had no real significance. Regarding the continuum of this art tradition, it would seem futile to try to strictly differentiate between late eighteeth-century and very early nineteenth-century design styles. It seems apparent that Northwest Coast art made in the first years of the nineteenth century would be most heavily influenced by eighteenth-century design concepts, and that design development would become more varied as new ideas became increasingly incorporated.

As the nineteenth century progressed (especially on the northern coast), more and more differentiation in style seems to have become common, increasing the visual means or criteria by which distinctions can now be made between objects for the purpose of dating. Documented objects from the 1840–1860 period indicate that a high level of design-concept evolution had taken place by that time, suggesting that the first decades of the nineteenth century were a time of expanding florescence and experimentation.

The changing nature of intercultural social relationships in this period no doubt accelerated in a manner parallel to that of the design tradition, increasingly interrupting the continuity of the old Native world. The 1820 date has been regarded as the approximate beginning of the quickly burgeoning trade in argillite carving by Haida artists, though some recent scholarship would re-date certain of the earliest artifacts, attributing their creation to a somewhat later time (Macnair and Hoover 1984:203). The argillite trade provided early sailors and fur traders with souvenirs of their journey and some fantastic examples of the art tradition, executed in a medium that had seldom been explored previously.[2] As the starting point of a significant new trade in Native artworks, this year seems a reasonable date to employ. It also effectively shifts the criteria of distinction for dating to the difference between the *very early* nineteenth century and its second quarter. Consequently, and owing as well to the particular cross-section of materials presented here, the cut-off date of roughly 1820 for the early historic period seems a reasonable one for the purpose of these observations.

The Southern Traditions in the Early Nineteenth Century

In contrast to the evolutionary changes apparent in the northern design tradition, the visual art traditions of the southern Northwest Coast seem to have been altered little by the influx of Euro-American cultures, except of course in terms of the severely diminished numbers of objects that were created. The Chinookan nations of the lower Columbia River were once resident masters of this huge and influential waterway to the continental interior, but they suffered greatly under the earliest incursions of non-Natives to the area.[3] The Lewis and Clark expedition noted in 1805 the presence of smallpox-scarred Native individuals at the Dalles and Cascades. The disease was introduced through contact with Euro-American sailors from the Pacific as early as 1775 (Boyd 1990:137, 138). The previously itinerant maritime fur-trading business became entrenched inland with the establishment of Fort Astoria

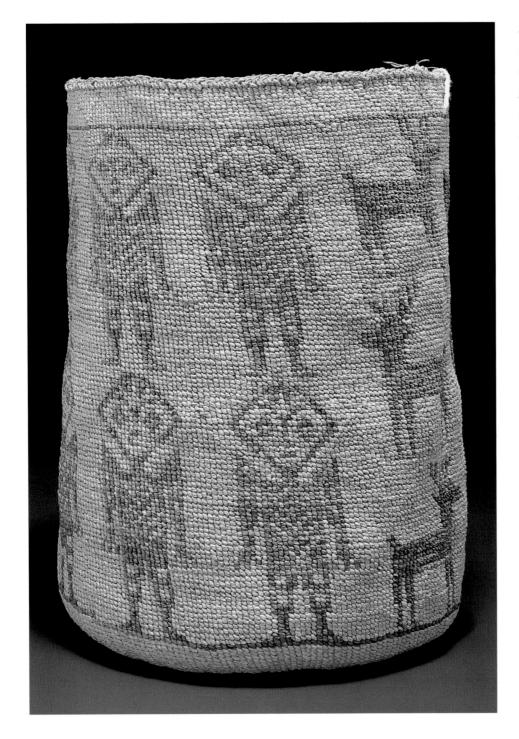

4.1 a, b. Aqw'alkt (root-gathering bag) with images of humans, elk, condors, sturgeon (see fig. 4.1b on p. 46). **Wishxam-Wasgo,** *c. 1840. Indian hemp, corn husk, leather. 10.75″ H × (a) 6″ W × (b) 4.2″ W. Collection of Allan and Gloria Lobb*

Indigenous food roots like the bitterroot, caus, and camas were dug with special tools, called "kapin" in Sahaptian(Schlick 1994), then collected and stored in specially made, full-turn twined, soft baskets or bags. These cylindrical root-gathering and storage baskets are often called "Sally bags."

in 1811 and Fort Vancouver in 1825. In 1830, a tragic epidemic (identified as "fever and ague," or malaria, ibid.:139) raged through the area, annihilating several language groups. Total losses in the area between 1830 and 1841 have been calculated as high as 92 percent (ibid.:139), the survivors being absorbed into the remaining viable cultures of the area.

As populations declined, and as trade goods replaced certain types of objects formerly created for traditional uses, a few surviving artifacts must have served the diminished numbers of First Peoples who maintained indigenous ceremonialism. Burial customs in this region called for the placement of earthly goods in the sepulchral canoes of noble deceased, which may have been the fate of many artifacts. Little

4.2. Aqw'alkt (root-gathering bag)
with images of humans, condors, stur-
geon, dogs (or cows?).
Wishxam-Wasgo, *c. 1860. Indian*
hemp, corn husk, dye. 8″ H × 4.5″ W.
Collection of Allan and Gloria Lobb

The highly geometric designs and
compositions seen in the basketry
of the Kiksht (or upper Chinookan)
language family show very little styl-
istic change through the historic
period (see also p. 2).

alteration in the geometrically based design work from this area appears to have taken place over time, though the initial periods of trade and expanded wealth among the leaders of the region probably prompted an increase in the numbers of decorated artifacts created, and possibly a concurrent elaboration of decorated surfaces. A woven hemp bag acquired by members of the Lewis and Clark expedition in the lower Columbia River area in 1805–6 (Schlick 1994:96) displays very much the same kinds of geometric figures and patterns as those "Sally bags" made and collected in the late nineteenth century,[4] and wood and sheep-horn vessels from early collections exhibit the same kinds of geometric chip-carving patterns as those seen on archaeological objects from the region. These traits appear in pieces illustrated here from

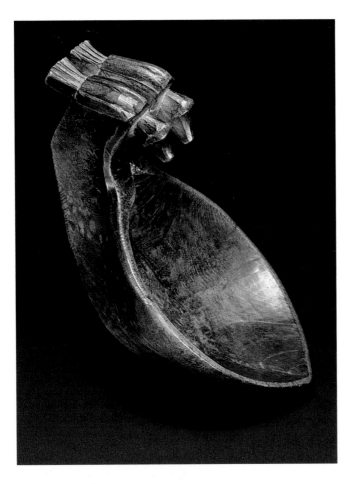

4.3. Wooden spoon with two birds. Chinookan, Kiksht, *c. 1850.*
Spruce (?). 6.5″ L × 3″ W × 3″ D. Collection of Allan and Gloria Lobb

The sculptural style of the Columbia River reflects many of the geo-
metric forms present in the two-dimensional design work of weaving
and basketry. This can be seen in the rounded-diamond shape of the
bowl of this ladle and the styling of its two small bird images. Many
Chinookan carved figures display a wonderfully abbreviated represen-
tation of animal images, often very geometric in composition and
without small details such as eyes or individual feathers.

4.4. Wooden spoon. Chinookan, Kiksht, *c. 1850. Hardwood (maple ?).*
7″ L × 4″ W × 2″ D. Collection of Lee and Lois Miner

The small quadruped figure on this spoon is typical of Chinookan
carving style in the 19th century. In wood, such figures remain very
compact in order to take best advantage of the innate strengths and
weaknesses of the grain structure. The shape of wooden spoons appears
to be closely related to their sheep horn counterparts, even imitating
the opened-out look of the horn ladles where the bowl and handle
intersect.

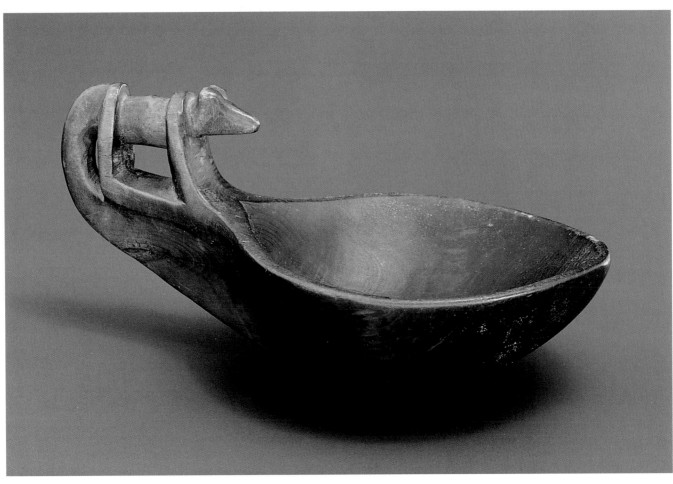

the lower Columbia River (figs. 4.1–4.6)[5] and are stylistically very much related to the Quinault bowl from the Pacific Coast north of the Columbia River (fig. 4.7). Food dishes from all over the Northwest Coast are carved with low, sweeping sides and raised ends, differing from one First Nation to another in the details of curves, proportions, and decorative finish. The chip-carved rim detail seen here can also be seen on vessels from the Chinookan area to the Gulf of Georgia. The flat-topped, raised end-forms of the dish are similarly represented over the same geographic region. The end finials illustrated in figure 4.7 are shorter than those seen on Columbia River horn bowls, abbreviated perhaps in part due to the lesser strength of this section in wood as opposed to horn.

Figure 4.5, a sheep horn ladle, can be dated prior to about 1860. By that time, it would seem that many traditional pursuits would have been interrupted through settlement of the region. Mastery of the tough horn material involves certain preparatory procedures. The bowl sections are thinned, limbered by boiling, and flexed out to a dimension wider than the original horn, while the handles maintain the natural curvature of the horn's spiral shape. The thin cross-sections and piercing of the animal images on the handles are possible in part because of the toughness and resiliency of the material. These tough fibers of the horn also follow the curving shape, which helps to allow for greater sculptural delicacy than is possible for the same configuration in the straight grain-structure of wood.

The population of the Halkomelem, Straits, and Puget Sound Salish regions in the mid-nineteenth century is said to have been the most densely distributed of any

4.5. Sheep horn ladle
Chinookan, Kiksht, *c. 1850. Bighorn sheep horn. 14″ L × 5″ W. Collection of Eugene and Martha Nester*

Though perhaps not as delicately formed as some of their northern Northwest Coast counterparts, the Columbia River horn ladles represent nonetheless their own kind of mastery of the tough horn material.

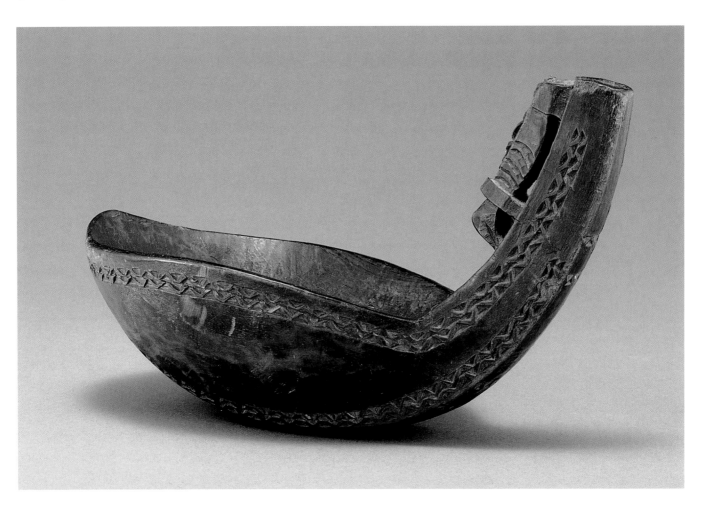

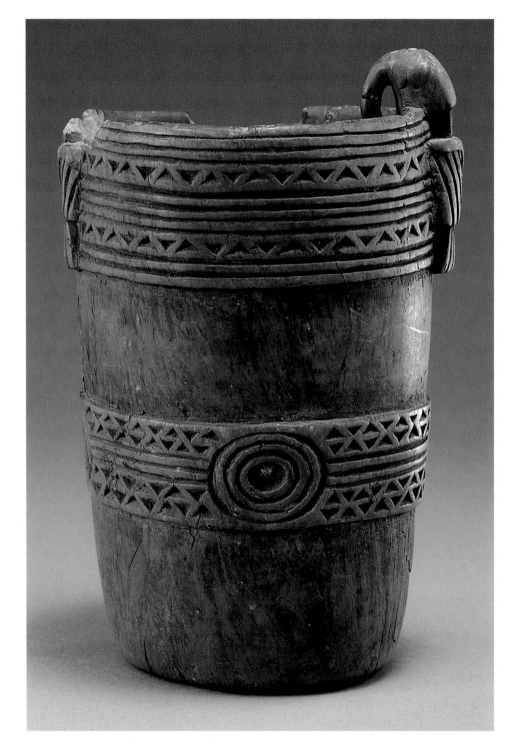

4.6. *Wooden vessel*
Chinookan, *c. 1830. Maple (?).*
9" H × 3" W. Collection of
Jack and Jane Curtright

Simplified bird images similar to
those on the wooden ladle (fig. 4.3)
once adorned the edges of this
remarkable vessel. Carving a tall,
cylindrical cup shape like this from
a section of wood is no mean feat,
regardless of the tools a sculptor has.
Most of the surface is on the end grain
of the wood, thereby creating some
difficulty in finishing and a weaker
cross-section that accounts for the
missing parts of this piece. Many
Columbia River vessels have this tall,
round form—from small cups like
this one to large wooden mortars used
to pound dried fish and meats into
meal for preservation. The character-
istic geometric designs here are carved
with great skill.

on the Northwest Coast (Suttles 1983:69; 1987:102), and was perhaps one of the most densely distributed indigenous populations in North America. Certainly this protected coastal micro-environment includes what was once the most bounteous and readily inhabitable country of all the Northwest Coast area, able to support a much heavier concentration of peoples than any other region of similar geographic size.[6]

Owing in part to its natural hospitality, this area was also the first to be intensively settled by Euro-Americans, who had already begun occupation in earnest by the 1850s. Fort Victoria, the center of Hudson's Bay Company trade in the region, was established in 1843 and soon flourished into a major city and colonial capital. Gold discovered on the Fraser River in 1854 drew thousands of fortune-seekers into the

4.7. Wooden bowl

Quinault, Coast Salish, *c. 1840.*

Alder or yew (?). 7″ L × 5″ W × 3″ D.

Collection of Jack and Jane Curtright

Small wooden feast or grease dishes similar to this one have been collected among the Quinault of the southwestern Washington coast, whose main village in historic times has been at the mouth of the river bearing their name. Examples now housed in the Smithsonian Museum of Natural History vary, from nearly identical to this one, to foreshortened with the same basic sculptural form (Hajda 1990:510, fig. 7, USNM 127857). The "compressed" lines of this dish, without much variation in curvature, are typical of dish types from the greater Coast Salish region.

region. The settlement that quickly grew into the city of Seattle was founded on traditionally Salish lands in 1854. The year 1855 saw the drafting of resettlement treaties under territorial Governor Isaac Stevens, and the subsequent establishment of restrictive reservations, to which the First Peoples were induced to relocate. The numerous displacements of Salish peoples from their traditional lands in this time period, coupled with the influx of trade articles that replaced some types of Native manufacture, certainly must have adversely affected the production of artifacts by Salish craftspeople. Within Coast Salish traditions, the internal motivations for creating the types of objects called "art" by outsiders have always differed from those of northern peoples. In consequence, even artifacts dating from less disrupted decades of the early nineteenth century are rare from this region (see Suttles 1983/1987).

In the evolution of the proto–Northwest Coast design style among the Central Coast Salish, however, there appears not to have been significant change in the essence of the two-dimensional styles of this area between the archaeological and ethnographic periods, or over at least the last 300–500 years. The naturally sketchy archaeological record provides some artifactual evidence that goes far beyond that time as well. Even in terms of design evolution, the internal motivations toward art production must be examined in order to understand the variance between the southern and northern culture regions.

Coast Salish culture and art were not clan-based, and the northern impetus toward the ostentatious display of the emblems of clan history has had no counterpart in the southern region. Ritual objects and those associated with ritual object production (such as weaving tools) were embellished with symbolic images, the importance and literal meaning of which were fairly well guarded by their owners

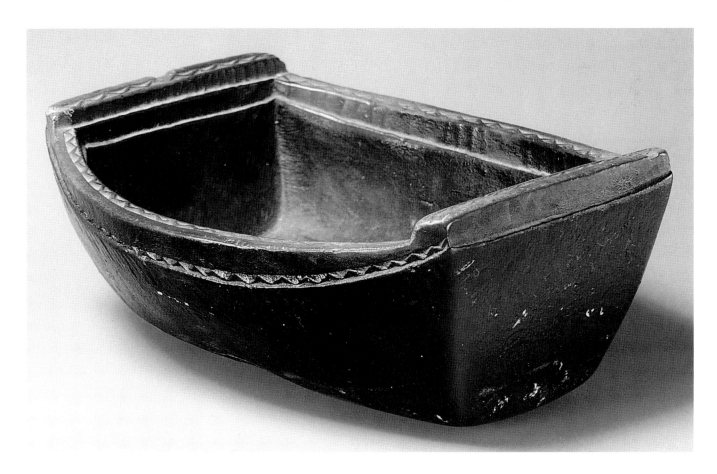

in order to protect the efficacy of their spiritual powers. The central religious activity in the area was and is the guardian spirit quest and its attendant ritual ceremonies. These rites are participated in on a more-or-less individual basis, and the personal meanings of images that decorate a dancer's regalia are one's own private property, not to be revealed to others. Those relatively few examples of the fine masterpieces of Coast Salish style that remain extant reveal the inherent beauty of the art forms employed in the area, which have only recently begun to be seriously explored by contemporary Coast Salish artists (see Feder 1983). The essence of the Central Coast Salish style is illustrated masterfully within this collection by the carving on both sides of a Halkomelem ritualist's rattle (fig. 4.8).

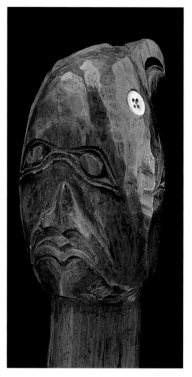

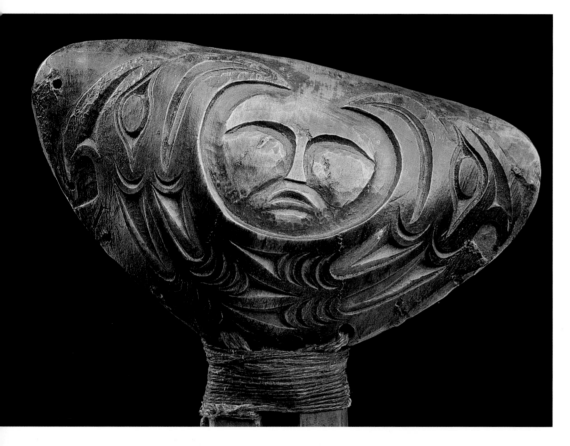

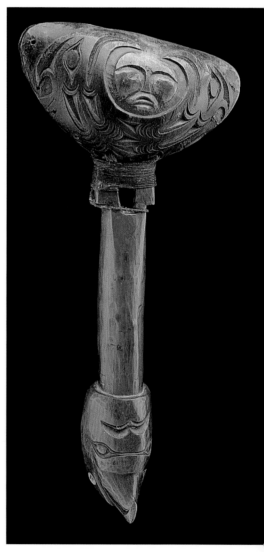

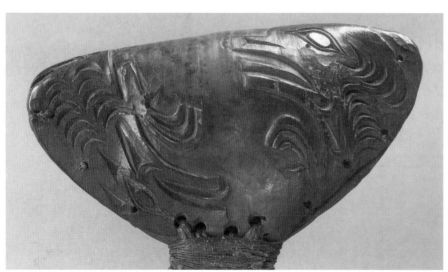

*4.8 a, b, c, d. **Sxelm_axwts_as***
(sheep horn rattle)
Central Coast Salish, Halkomelem,
c. 1860. Mountain sheep horn, yew,
shell buttons, fiber.
14″ H × 6.5″ W × 2″ D. SAM 83.236

The relief-carving of the front and rear faces of this rattle show a wonderful visual and conceptual sophistication in the use of traditional Central Coast Salish–style design.

Employing only the simplest elements drawn from the proto–Northwest Coast design cabinet, a beautifully descriptive pattern with great visual control of flow and movement has been created on this surface.

Branching from perhaps the same proto-Northwest Coast design origins as the Coast Salish traditions, artworks of the Wakashan language nations reflect their own evolutionary developments on the core art styles. The southern Wakashan linguistic family includes the speakers of the Nuu-chah-nulth and Kwakwaka'wakw languages. These First Nations have been known in the past as *Nootka* and *Kwakiutl*, both of which are technically misnomers.[7] Objects from the early historic period in this region display a number of interesting connections to very ancient styles.

Prior to the influence of the proto–Northwest Coast circle and trigon elements on southern coastal art, the representation of creature images was likely to have been in silhouette, judging from such surviving examples as certain Ozette images, paintings on canoe models with archaic feeling, and the types of designs depicted on redcedar bark mats (figs. 4.10a, b). These exhibit simple but very powerful forms, not unlike the character of certain designs from the region that are several centuries old, such as those from whalers' hats acquired by early explorers. The whale image of these mats is a straight silhouette, unbroken within its outline except by the intrusion of the mouth slit, which is readily comparable with the more geometricized whale shapes often depicted on the knob-topped whalers' hats of this area (Wright 1991:84, fig. 38). The images depicted in figure 4.10 are created with dyed redcedar bark strips

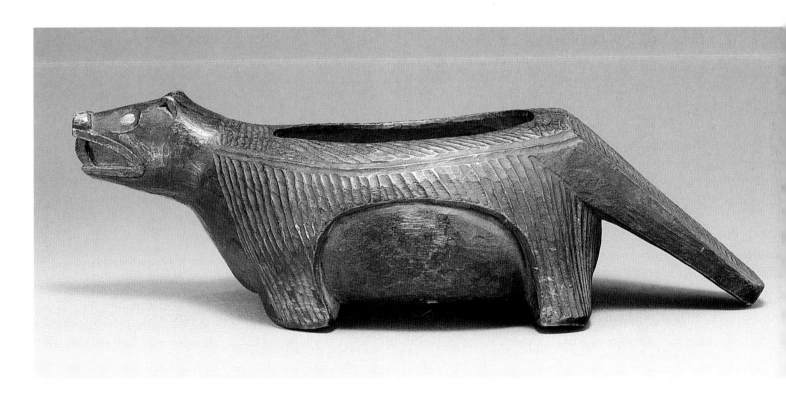

*4.9. **Beaver bowl***

Makah, *c. 1840–1860. Alder. 14″ L × 7″ W × 4″ D. Collection of Jack and Jane Curtright*

This lively beaver vessel illustrates the predominant southern Northwest Coast approach to representative bowl sculpture. The conceptual emphasis is on the creature represented, the body of which is hollowed out to form the bowl cavity. The fine knife-grooving visible on the surface of this dish is an ancient pan-coastal finishing technique, probably established in the era of beaver-tooth carving tools, which has been applied to all manner of wooden surfaces.

4.10 a, b. *Cedar bark mats*
Nuu-chah-nulth, *c. 1850.*
Redcedar bark. (a) 33.5″ H × 31″ W;
(b) 20″ H × 31″ W. Collection of
Eugene and Martha Nester

*The earliest creature images on the
whole Northwest Coast were most
likely of this character, a style referred
to by one historian as "a simple
rendering of life forms" (Carlson
1983:204). Given the basic outline or
silhouette of a creature, the addition
of an eye or other elaborative details
can be readily accomplished with the
inclusion of negative elements such as
circles, crescents, and trigons in the
design area. These archaic silhouettes
are comparable to some of the images
depicted on screens and other objects
from the Ozette village site.*

overlaid on the undyed redcedar plaiting elements. A group of paintings in a certain southeast Alaska beachfront cave depict very similarly styled imagery, and include the picture of a Nuu-chah-nulth or Makah-style canoe and a whale's tail (Autry 1987), perhaps indicating that the painters were a canoe-wrecked crew of southern whalers blown northward by winds and currents. This stylized simplicity is also

Some of the most elegantly simple sculptures of the Northwest Coast are the plain bird rattles of the Nuu-chah-nulth and Makah peoples. Many of these are based on a globular form (Holm 1987:82, fig. 27), while this one is much less bulbous and includes an abbreviated pair of wings and the shape of tail feathers on the bird's back. In this case, the creature's head appears more mammal-like than avian, with a rounded snout and ears. The fine knife-finishing on the rattle surface has been further smoothed and polished by a great deal of handling.

apparent in the sculpture of the birdlike image on the globular rattle (fig. 4.11). The figure on the related mat (4.10b), featuring a large body, strongly curved beak, and rather small, straight wings, is related to the thunderbird images also seen (though much less frequently than whales) on Nuu-chah-nulth and Makah whalers' hats.

An archaic handling of eyelid forms in the circle-and-trigon style can be seen on a humanoid face mask (fig. 4.12). The sculpture of the face overall and the asymmetrical distribution of the painting are comparable to later masks from this area (see fig. 5.35), but the oval-and-trigon eye styling is distinctly connected to very early historic examples. The combination of lobed positive forms and rectilinear lines in the painting is seen in many examples of Nuu-chah-nulth two-dimensional design. Here, as related to the historic northern tradition, positive forms are painted, and painted finelines define negative design spaces. The sculptural surfaces of this mask are subtly contoured and finished with very fine knife strokes. The paint pigments are all of the Native mineral type. The painting is designed asymmetrically, and was done with both solid and "dry" brush strokes, a technique that frequently appears in Nuu-chah-nulth two-dimensional work, and which continues in the contemporary period. Structurally different, however, from northern formline styles, this evolutionary branch of the proto–Northwest Coast concepts can be seen on masks, canoe models, and woven hats, such as the hat illustrated in figure 4.13.

This hat has many characteristics that relate it to early documented pieces, such as the similar hat evidently collected by Lewis and Clark in 1805 (Wright 1991:86, fig. 39) on the lower Columbia River, far from its origin in northwest Washington or southern British Columbia. Usually attributed to either Makah or Nuu-chah-nulth First Peoples, a hat of this style was also recorded in a Straits Salish house near Fort Victoria by Paul Kane in 1847 (Harper 1970:262, fig. 198), though that hat may have arrived in its location by intertribal trade, as did the Lewis and Clark piece.

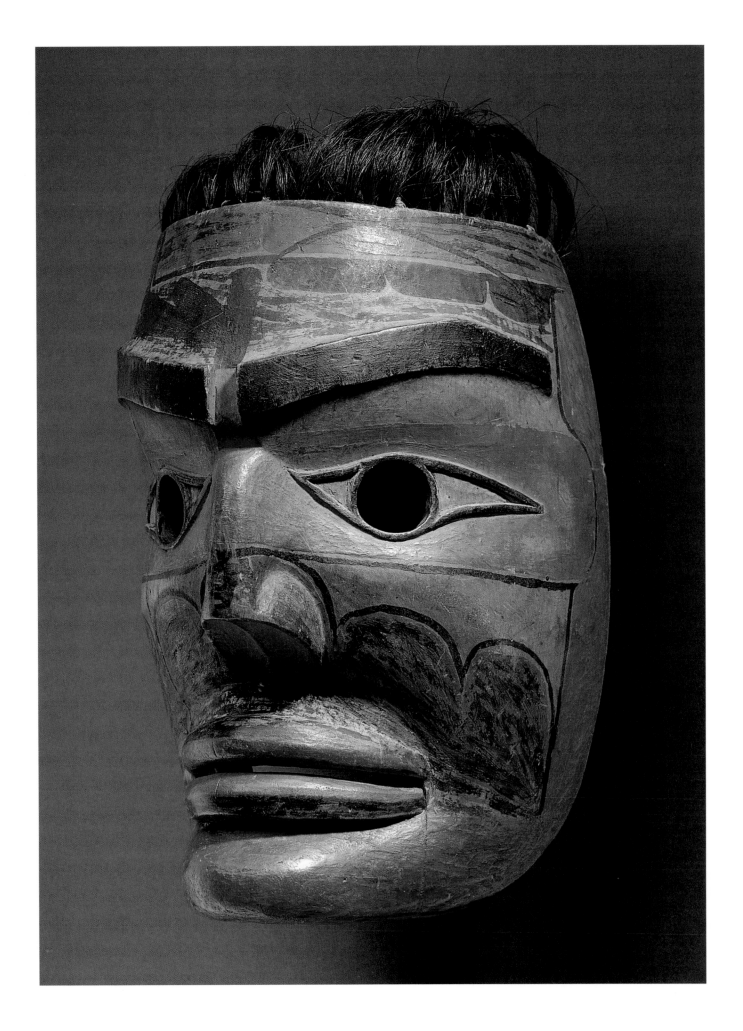

Similarities between these hats and figure 4.13 include the materials used, the black-painted rim, and the distribution and general style of the painted design.[8] Hats from the southern Northwest Coast woven in this style are made double, as two hats matching in shape, joined either at the inner headband or the finish of the rim. Some of the hats in this shape are twined of all redcedar bark material, while others, like this one, are redcedar and spruce root combined (Lobb, pers. comm., 1996). This hat is made of a spruce root outer form with the inner crown made from redcedar bark. Only a relatively small number of the many existing hats of conical form display painted designs. The finely conceived and painted design on this hat is very abstract, though it depicts an eye form on each side of the composition and possibly a mouth on the front. Though painted in black and red, the relationship of the two colors is quite different from that in the northern tradition. Here, red is enclosed by black, but without the formline hierarchy of northern-style work. In fact, while the red and black are spatially balanced, each is applied to forms of very different shape. Related to both the historic Coast Salish and northern Northwest Coast two-dimensional styles, the design on this hat illustrates yet another evolutionary variant from the proto–Northwest Coast core tradition.

4.14. *Nuhlamahla*
(Foolish Dancer mask)
Kwakwa̲ka'wakw, Guskimukw, or
Gwatsinukw, *c. 1830. Alder, brass,*
hair, opercula. 10.5″ H × 8″ W × 6″ D.
SAM 91.1.27

Masks of great age from the
Kwakwa̲ka'wakw are very rare, owing
perhaps to limited early collection.
The Guskimukw and Gwatsinukw
once lived on the northwest side of
Vancouver Island, not far by sea from
Nootka Sound, and likely saw more
outsiders than did bands living on the
northeast side or the adjacent islands
and mainland.

This fine old mask may show the
influence of Euro-American ship
carving in its catlike depiction of the
Kwakwa̲ka'wakw tradition known as
the Foolish or Reckless Dancer
(Brown 1994:234, fig. 88).

4.15. *Canoe model*
Nuu-chah-nulth, *c. 1810–1840.*
Alder, paint. 44″ L × 8″ W × 7″ D. SAM 93.80

The hull of this canoe reflects an early style by exhibiting a low-profile configuration in the design of
the bow figure. The carved faces of the people in this canoe show strong sculptural similarity to masks
acquired by James Cook's third expedition (1776–79) carved in the Nuu-chah-nulth style
of the late-18th century (King 1979:44–46, figs. 34, 37, 38). The headgear of the canoeists appears very
archaic and differs from the majority of related objects collected historically. The man and woman in
the center of the vessel have been identified as a wedding couple. They are hitsnóop *(David 1993).*

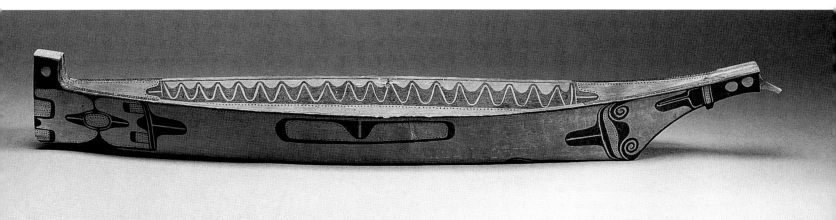

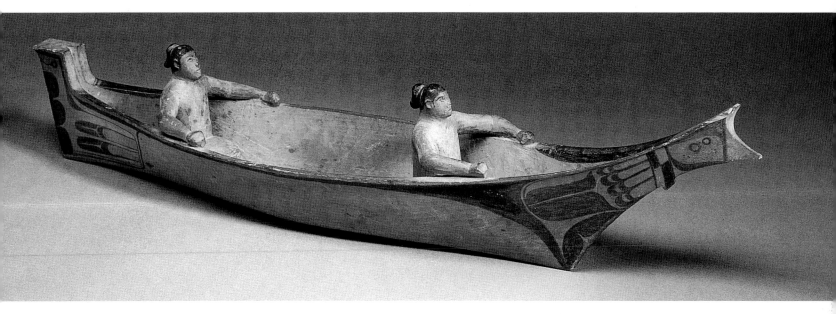

4.16. *Canoe model*

Nuu-chah-nulth, *c. 1850. Alder, paint. 4″ H × 33″ L × 5″ W. Collection of Allan and Gloria Lobb*

This canoe's archaic painting style is based more on geometry than representation. The true significance of the dotted lines is unknown. The wavy negative line below the interior gunwale (formed by the black positive painting) compares in shape and position to the hide thong that lashes the center lateral portions of the split-skin cover of an Eskimo umiaq to the boat frame's horizontal stringers (Holm 1983a:92, fig. 155).

4.17. *Canoe model with two figures*

Makah, Nuu-chah-nulth, *c. 1860–80. Alder, paint. 6″ H × 25″ L × 5″ W. Collection of Allan and Gloria Lobb*

The two human figures show the bound-up hair style used by old-time Makah and Nuu-chah-nulth whalers. The bow shape of this canoe and the painting on its exterior suggest that it was made in the second half of the 19th century. The upsweep of the bow is fairly extreme in this example. The painting shows an open, somewhat northern-influenced style that is very different from the older, dotted geometric style seen on such early canoe models as figure 4.16.

The Birth of "Classic" Northern Northwest Coast Art: New Concepts in Two-Dimensional Styles

Even a cursory comparison of northern two-dimensional designs of the early historic era with images produced during the mid-nineteenth century reveals the magnitude of design development that flourished in a relatively short period in the region. Within a couple of generations, roughly half a century, the elemental design system apparent in the earlier work flourished from its basic structural foundation into a myriad of highly mature and conceptually inventive substyles over a wide geographic area. Change itself was epidemic in the nineteenth century, and the art of this period can be seen to reflect this principle in innumerable ways.

The principles and conventions of the tradition, invented and nurtured by the ancient masters, have always held the seeds, the pure potential for all the visual manifestations of style that have or may ever come about. The immensity and wisdom of their creation is astounding. No matter how perceivable the differences may be between early and classic styles, or between the arts of any two historic periods, the changes to the visual tradition involved are conceptual, not truly structural, in terms of formline conventions. The basic structural precepts of the system have remained unchanged throughout the ongoing metamorphoses. Were this not so, the design tradition itself would have ceased to exist, altered little by little until it was no longer comparable to its early roots. But this is not the case: the essential conceptual threads have kept the evolving continuum stitched together.

The timeless consistency of the powerfully understated structures and the visual austerity of the older work can lend us symbolic glimpses of what these original societies may have been like for the average members of the communities.

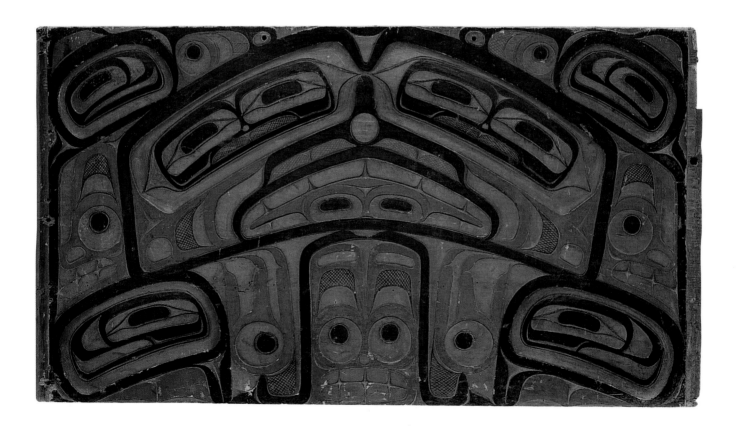

4.18 a, b, c. **Chest front**
Haida, Tsimshian, or Haisla,
c. 1840–1860. Yellowcedar, paint.
18″ H × 30″ W × 1″ D.
Collection of John Putnam

*The design image on this chest panel
is so powerful and so immaculately
carved that it's a minor tragedy that
the other three sides are unknown.
Compared with very early chest panel
designs (fig. 3.3), the increases in
ovoid eccentricity, non-parallelism
of horizontal formlines, and the size
of negative areas all indicate that this
chest was created in a much later
period, though likely within the first
half of the 19th century.*

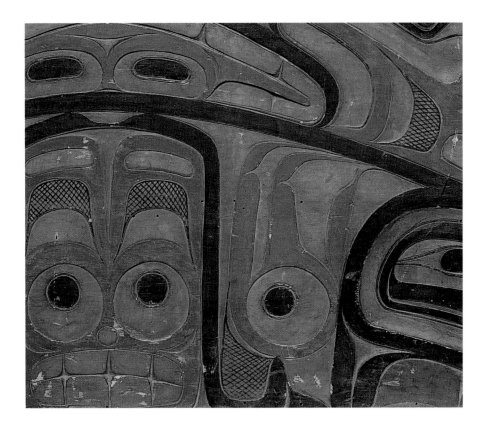

The angularity of the movements, the visible weight of individual design forms (as well as the overall structures), and the aristocratic nobility of the images all convey something both beautiful and terrifying about the qualities of life in the millennia of pre-history. In many ways, and to many people, the earliest examples of Northwest Coast art are by far the most intriguing, perhaps owing in large measure to the sense of mystery communicated by the work's tone and temper, by the perception of the unknowable.

By contrast, the perceivable feeling of mid- to late-nineteenth-century or classic period formline art is considerably lighter and less austere in character. Open spaces exist in these design patterns as if helium has been pumped into the negative areas, lifting the weight of horizontal formline structures and stretching each positive line thinner and thinner as more gaseous distance separates the painted primary and secondary forms. As the positive lines become thinner and more drawn out, the sheer visual elegance of their curves and junctures becomes more apparent. The tension inherent in the fabric of the formline system becomes palpable. Big, powerful primary movements are reduced to thin, delicate tips where they touch each other. Broad, meandering rivers of painted line are reduced to torrential currents, compressed into narrow canyons between wide, graceful negative forms. The clear sensuality of some work is remarkable, like a reflection of the delicate dance between sea and shore, the movement of a butterfly in the path of a brown bear, or the thin membrane of reality between a fish and the ocean.

> Where form touches form, the line is compressed, and the tension almost reaches the breaking point before it is released in another broad flowing curve. (Bill Reid, Haida, 1967)

By turning the principles of the basic tradition inward, and by applying the same organizational conventions to the inner layerings of design structure as operate on the outer layers, new versions of itself are created. This parallel—between these fairly simple revelations of detail and the infinite self-reproductive manifestations of the mathematical equation known as the *Mandelbrot Set* (a perceptual key to the diversity of life which has been called the "thumbprint of God")—demonstrates the relationship between this means of elaboration and that of the natural environment. Within the formline system over time, red secondary complexes began to reflect the structures and appearance of the primary networks. Subsecondary elements appeared within secondary complexes that reflected the relationship of secondary to primary forms. Ultra-primary elements were employed which superseded the establishment of the primary patterns. The bi-level, positive-negative structure of the proto–Northwest Coast styles gave way in stages to new multilevel conceptions of design space. By being attentive to this conceptual phenomenon (in those objects that are the bridges between styles), the incremental steps in the innovative process make for fascinating observation. Comparisons among objects serve to illustrate how these ideas have been set down in wood, horn, ivory, silver, argillite, and pigments. Some of the clearest illustrations of design development can be seen on the decorated surfaces of boxes, chests, and bent-corner bowls.

Among the earlier examples of classic-period objects, the large (probably Haida) chest front-panel is a case in point(fig. 4.18). The primary formline design in black follows quite closely the essential structure of the very early chest panels illustrated in figure 3.3, as regards the central head, the placement of ovoids in the upper and lower corners, the body design below the central head, and so on. The fact that this design contains the double-eye elaborations, a two-step face structure, teeth in the mouth, and claws on either side of the body area indicates that this was most likely the front of the original chest (Holm 1997). The image itself is a typically ambiguous chest design, though the red claws are styled like a bird's feet. There are no obvious wings or beak, however, that would more clearly identify the creature depicted. George MacDonald (1996) has stated that chest designs represent the being known in Haida as Konankada (Gonakadeit, in Tlingit), the chief of the undersea world and the ultimate source of all wealth, based on the notes of Emmons and others.

In assessing the positive-to-negative design ratio of this later chest panel, one would be inclined to see it as nearly fifty:fifty on average, where the red and black positive (painted) forms take up about half of the total surface area. The formlines are proportionately much thinner, relative to the overall size of the design space, than are those of the earlier chest panels. In this design, negative areas are not limited to narrow slits and V-grooves, but are incorporated and relief-carved as broad background and tertiary areas where the unpainted wood shows through. The tertiary areas in this panel appear not to have ever been painted the typical blue-green color. All of the trigons, crescents, circles, and negative ovoids employed in this design are much larger in relative scale than their eighteenth-century counterparts.

In addition, the overall feeling of the design has opened up considerably through the expansion of the visual role of the red secondary design elements and complexes. The difference in this aspect alone between this panel and the ones of the early historic chest is quite remarkable. And yet, all the powerful potential for these developments is encapsulated in the earlier design conventions. The placement and essential function of the secondary designs is unchanged, but their role within the design has been so significantly expanded that the visual effect is one of great transformation. In the same locations where a single red element or a small group of three U-shapes filled the space in the older style, this design exhibits highly developed formline complexes of ovoids and U-forms working as harmonious units. Several of these incorporate cross-hatched black sub-secondary elements that add another conceptual layer to the design. Only the paired solid U-forms below the lower corner ovoids recall the straight-up simplicity of the earlier style.

Another development that greatly affects the appearance of this design has two related components: non-parallelism and non-concentricity (Holm 1965:75, 87). Each of these principles may be observed in the early historic period styles, exhibited in varying degrees from the work of one artist to another. Their influence is subtle and elemental in the early work, however, and, like the principles behind other design conventions, required the free expression of later generations in order to see and realize their full visual potential. As seen in this mid-nineteenth-century chest fragment, made about a hundred years after the earlier chest panels, the idea of eccentricity in the placement of inner ovoids can be seen in a fairly extreme

expression. The circular inner ovoids are very small, and are positioned well above the centerline of each of the negative spaces that they occupy. The main eyes and other elaborated inner ovoids are also eccentric, though not so extremely as the smaller ones. The total effect of this principle in action lends the design field the impression of being lifted or floating upward, a quality that would not be apparent were the ovoids placed concentrically.

Across the whole composition, two main conceptual lines can be seen to arch symmetrically from edge to edge. One runs out along the eyebrow lines of the central head and through the lower border of the upper corner ovoids to the side of the design field. The other passes through the lower jaw line of the head and the primary formline tops of the lower corner ovoids. These arched lines divide the space into three interrelated fields. Another less obvious conceptual line passes through the lower edges of the two bottom corner ovoids and the line of four inner ovoids in the claws and the formline face within the body. Each of these three consecutive lines, from the bottom of the field to the top, has an increasing amount of arc, the result being that no portion of any of the lines is quite parallel to any other. This effect also brings a sense of lightness and lift to the total composition, qualities that are largely opposed in the early historic style by the visual weight of the formlines and the more parallel structure of the compositions. Though such concepts are present in all varieties of two-dimensional formline designs, the principles are often so subtle in the earlier examples that their influence is not so readily apparent. Their effect is perhaps most obvious in larger two-dimensional designs, such as house screens and these types of chest and box compositions.

4.19. *Bent-corner dish*
Tlingit or Haida, *c. 1820–1840.*
Yellowcedar, redcedar. 22″ L × 17″ W.
Collection of Allan and Gloria Lobb

The very noble bearing of this large bent-corner bowl derives in part from the bold angularity of the two-dimensional design style, the character of which is reflected in the shape of the bowl itself and the overall design. The undecorated border below the rim of this dish may originally have been overlapped by a woven cedar-bark cover made especially for the container.

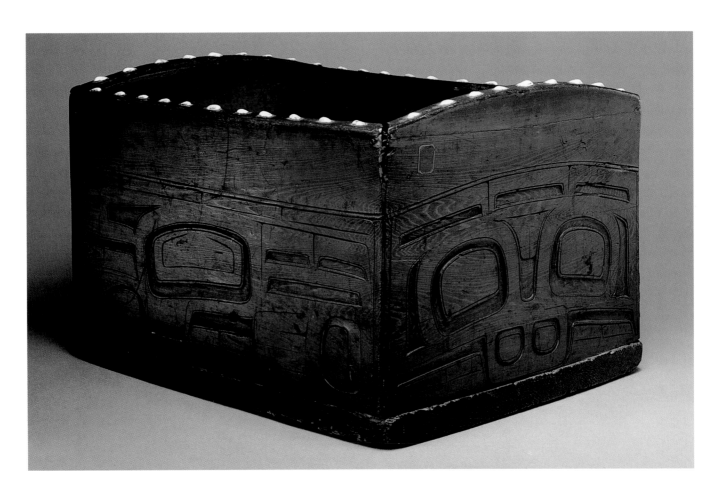

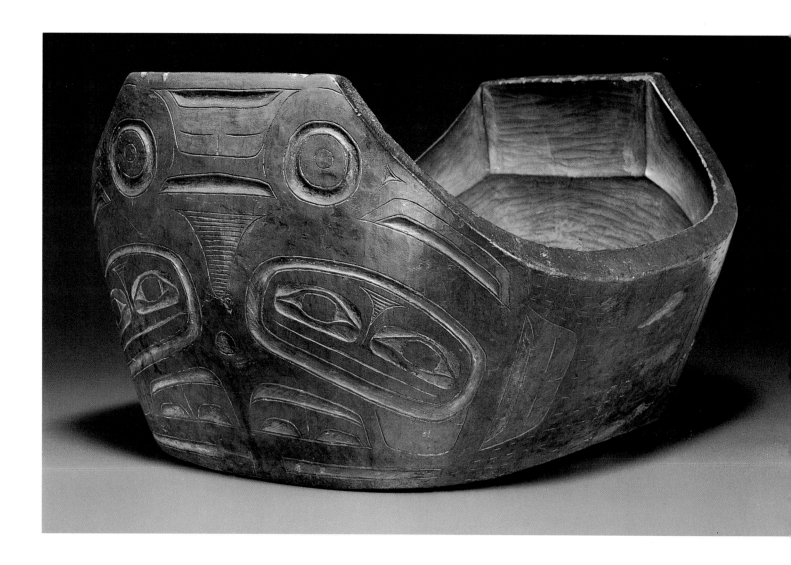

*4.20. **High-end dish***

Tlingit*, c. 1820.*

Alder. 15.5″ L × 13″ W.

Collection of Allan and Gloria Lobb

*Illustrating one of several highly con-
ventionalized northern carved dish
forms, this comparatively large exam-
ple displays a two-dimensional design
typical of many in its general layout.
A broad-formline symmetrical face-
design is oriented to each raised end
of the bowl, creating a quadrilaterally
symmetrical design overall.*

Bent-corner bowls also offer artists a large, continuous surface area on which to
compose their formline patterns. Many options are open to the artist in terms of
arranging the composition, and these have all been explored by a variety of design-
ers in different periods. The older and larger of two bowls attributed to this time
period is shown in figure 4.19. The increased complexity of the design and the size
of the bowl are the most apparent differences between this and the eighteenth-cen-
tury examples, while conceptual differences in the designs themselves require closer
examination. The general character of the formlines on this bowl is one of angular-
ity in both ovoids and U-shapes, and is reflected as well in the lines of the overall
composition. Inner ovoids are large, and tertiary zones are evenly distributed but
are not extensive in size. Formline scale can be described as medium weight, and
secondary elements are few and very simple in form. The thinner quality to the
formlines, though, when compared with the eighteenth-century examples, has facili-
tated an increase in complexity in the designs of each side of the bowl. The balanced
distribution of even these small tertiary areas has resulted in a more open quality in
the design patterns. The style is comparable to documented artifacts of the late eigh-
teenth and early nineteenth centuries. This bowl may once have had a woven cedar-
bark lid or cover that was made to lap down the sides, covering the undecorated
band that parallels the upper edge of the bowl.

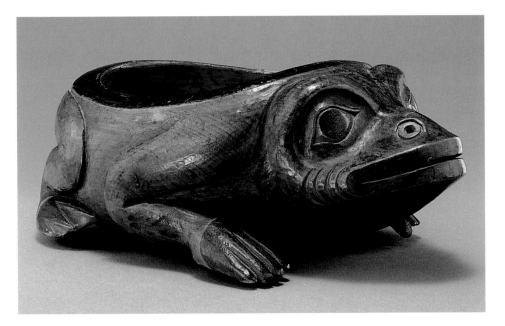

The very large, high-ended carved bowl (fig. 4.20) displays a character of design
that is suggestive of eighteenth-century style, and may in fact have been made ear-
lier than the 1820 date attributed to it here. Only the exceptionally good condition
of the piece (end-grain checks notwithstanding) leads one to believe that the bowl
may have been carved in the early nineteenth century. Tertiary areas in this design
are very minimal, though their inclusion within secondary elements gives the design
a somewhat open feeling. The secondary designs are limited to single, double, or
stacked triads of elements, and show the same very slim negative crescents and divi-
sion-cuts as are employed within the positive forms. The formline pattern on each
end of the bowl terminates at the tips of the sideways-stacked U-shapes on either
side of the face structures. There, the positive formline U surrounding the secondary
area extends into a broad, textured zone that meets at the centerline of each side with
the mirror image of itself from the other end of the bowl. Many later bowls of this
traditional shape fully extend their formline structure to the center of the vessel,
while in this one, the artist seems happy to let the pattern rest in an uncluttered side-
field. The small, dashed lines in these side areas can be seen as a skeuomorph of
birchbark textures (Bill Holm, pers. comm., 1997). Similarly, the carved ridges on the
inside of the bowl seem to be the vestiges of folds and structural features in birch-
bark containers (Holm 1974). The negative spaces in the design are very minimal,
and primary formlines taper from being very wide on the tops of ovoids to fairly
thin across the bottoms. Secondary designs are simple in form, and inner ovoids
show little eccentricity. The fine parallel grooving carved in the trigons between the
brow formlines in the main face and double-eye ovoids is seen with some frequency
in early historic period objects.

A number of other pieces illustrate a similar stage of design principles at work,
including the frog dish (fig. 4.21), the seal grease dish (fig. 4.22), the ladles and spoons
(figs. 4.23, 4.24, 4.25, 4:26, 4.27, and 4.28), the ivory amulet (fig. 4:29), the bone soul-
catcher (fig. 4.30), the wooden comb (fig. 4.31), and the two northern square dishes
(figs. 4:32, 4.33).

The Tlingit frog dish shown in figure 4.21, dating about 1850, is a fine example of the blending of animal form and bowl function. As seen in most northern-region animal bowls, the legs of the frog are tucked in along the sides of the dish. The typical southern-region animal bowl would likely show the legs extending down below the bottom of the bowl (see fig. 4.9) (Holm 1987:69). The sculpture of the frog's head and the handling of its feet are reminiscent of certain Stikine-area Tlingit carvings. The red dashing around the rim of the bowl is not as common in Tlingit carving as it is in Tsimshian style. The combination of traits suggests a central southeast Alaska origin for this contented amphibian image.

The square carved dishes of the northern Northwest Coast share certain distinctive attributes that are almost unvarying from one example to another. Relief-carved formline face designs are nearly always present on the end grain of the dishes, and the wide rims and characteristic arch-and-sweep undulation of the ends and sides are ingrained in the archetypal form. A very few of these dishes display sculptural faces or body parts incorporated into the vessel's shape.[9]

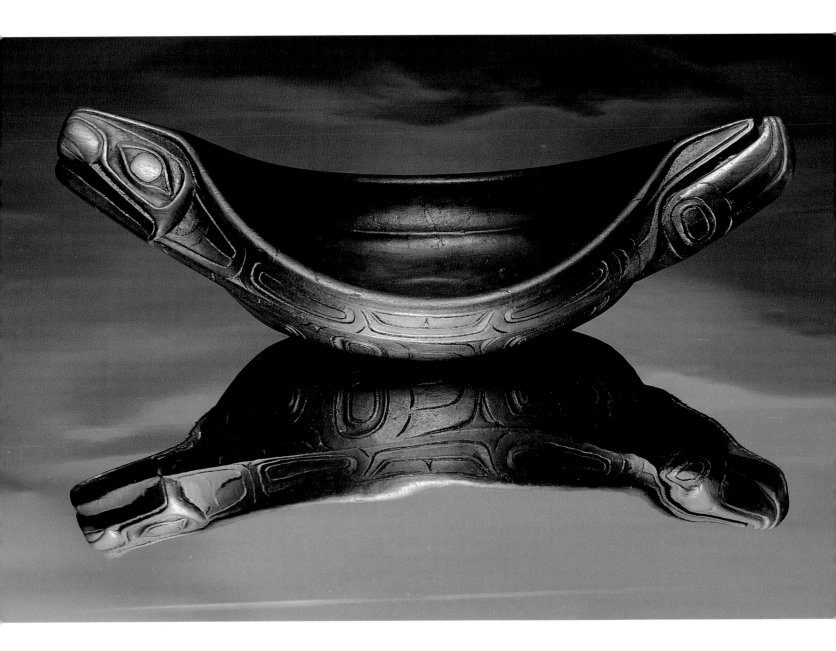

Size, general proportions, the degrees of side-flare angle, and the amount of curvature in the lines of the dishes differ with the influence of their individual makers. The structural similarity of the end-grain formline face-designs on so many of these square dishes suggests that, like the design of the high-ended bowl discussed previously, they may represent the same image most commonly depicted on chest and box designs: that of Gonakadeit, the undersea source of power and wealth. Like the chests and boxes, these dishes were also made to contain the materials of wealth and power, of which food is a prime example. Used to serve quantities of food at feasts and potlatch gatherings, these bowls among the Tlingit were passed to a group of guests, emptied, and then held up high with a whoop of victory by the recipients (Dauenhauer 1990:65, 66).

Certain universal features on the sides of the dishes include a fine groove, cut parallel to the edge just below the rim, and vertical lines of parallel grooving adjacent to each corner, the lower ends of which terminate in another V-groove that angles down toward the end of the dish. These precisely defined and textured geometric shapes have been compared to the construction details of certain types of birchbark bowls made in the Athabaskan interior of Alaska and British Columbia (Holm 1974:28,29). In the bark dishes, folded gathers at each corner of the container appear similar in shape and geometry to the textured panels on the wooden forms. The bark dish rims are stiffened by wrapping a splint in place along the top edge, which gives the rim a wider, flared top also replicated in the wooden bowl. Even the undulating curves seen in the wooden bowl rims appear in the birchbark vessels, which are higher on the ends than on the sides due to the gathering of the corner folds.

Spoons and ladles of horn and wood are the natural companions to such dishes. Figure 4.23, a Haida two-piece horn spoon, includes a very inventive juncture. The lighter-colored horn of the bowl (of either Dall sheep or domestic cow) extends into the handle hollow and is pinned in a common style of joint, but has also been carved with an abalone shell inlaid face that is visible below the chin of the largest creature on the black horn handle. The outer perimeter of the horn at the base of the handle was deftly carved into a small frog image, connected by its long, thin tongue to the mouth of the tiny bear figure protruding from the large mouth above it. Cut free from the remaining circumference of the goat horn, the frog and its tongue have been flexed down and pinned to the surface of the bowl horn, a very unusual and masterfully executed arrangement.

In figure 4.24, a Tlingit two-piece horn spoon, the delicacy of the images and the unusually large amount of pierced area in the design leaves very thin sections of horn that are the wolf's tongue and the staff held by the human figure. The reversed direction of the fully three-dimensional wolf's head is a most atypical configuration, and the small overlap in the bowl-to-handle riveting suggests that the maker was attempting to overcome some limitations in the size of the materials.

Figure 4.25 is a Haida sheep horn ladle in which the formline image employs rounded and finely defined design shapes, and is sculpturally relieved by fairly prominent tertiary and other negative forms. The tip of the ladle has been left smooth, and the warm honey color of age and use has permeated the translucent horn material. The Tsimshian or Haisla wooden ladle shown in figure 4.26 displays fine interior painting. The painted pattern lacks any specific, literal references to creature repre-

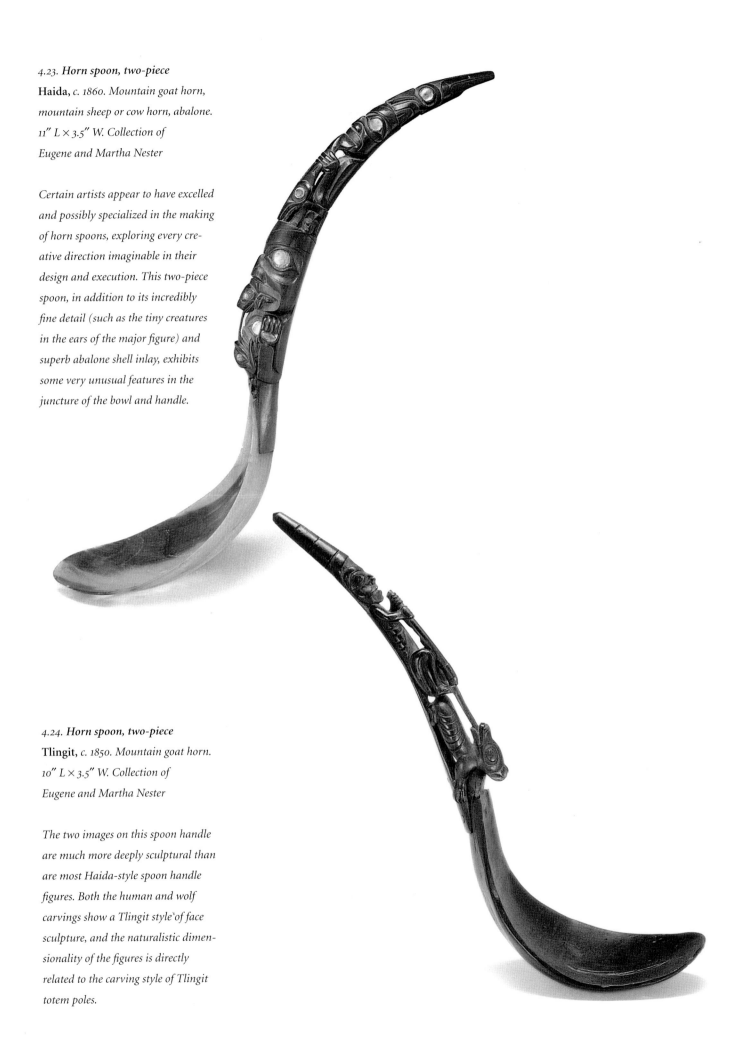

4.23. Horn spoon, two-piece
Haida, *c. 1860. Mountain goat horn, mountain sheep or cow horn, abalone. 11″ L × 3.5″ W. Collection of Eugene and Martha Nester*

Certain artists appear to have excelled and possibly specialized in the making of horn spoons, exploring every creative direction imaginable in their design and execution. This two-piece spoon, in addition to its incredibly fine detail (such as the tiny creatures in the ears of the major figure) and superb abalone shell inlay, exhibits some very unusual features in the juncture of the bowl and handle.

4.24. Horn spoon, two-piece
Tlingit, *c. 1850. Mountain goat horn. 10″ L × 3.5″ W. Collection of Eugene and Martha Nester*

The two images on this spoon handle are much more deeply sculptural than are most Haida-style spoon handle figures. Both the human and wolf carvings show a Tlingit style of face sculpture, and the naturalistic dimensionality of the figures is directly related to the carving style of Tlingit totem poles.

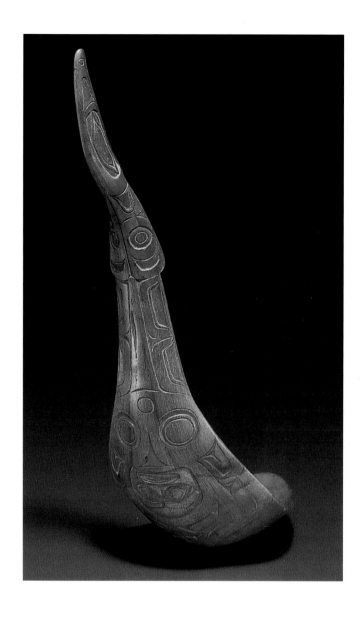

4.25. Sheep horn ladle

Haida, *c. 1850. Dall sheep horn. 13.2″ L × 3.2″ W.*

Collection of Eugene and Martha Nester

Thinly carved and displaying graceful, delicately curved lines, this ladle makes evident the mastery of its maker. The thin handle section is turned back from the curvature of the original horn shape, and the sculpture of a raven's head forms the end finial. A beautifully balanced formline design representing the body, wings, and tail of the bird embroider the outside of the ladle to about midbowl.

4.26. **Wooden ladle**

Tsimshian or Haisla, *c. 1860.*

Maple or birch, paint. 13″ L × 4″ W.

Collection of Mr. and Mrs. R. T. Ohashi

At one time common household objects, fine and elegantly shaped spoons such as this demonstrate how artistry permeated the Northwest Coast culture. Many beautiful examples exist which possess these kinds of fair, delicate lines and movements, perfectly balanced in weight and design. Relatively few display the type of fine interior painting present in this spoon, its design obscured somewhat by the dark surface patina.

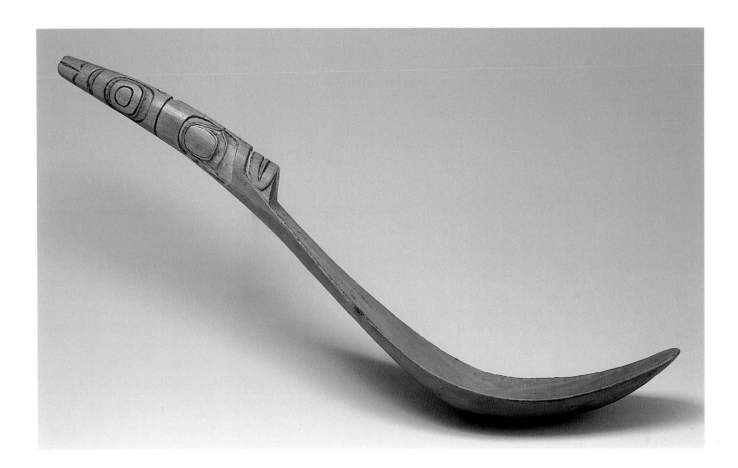

4.27. Wooden ladle

Tlingit, *c. 1850. Hardwood*
(red birch ?). 15.5″ L × 3″ W.
Collection of John Putnam

There exist a number of similarly narrow, thin, and graceful wooden spoons with handle finial carvings that are very closely related to the style and iconography of this example, indicating strongly that perhaps several matching sets of such spoons were once at large in Tlingit country. The family history of one surviving partial set states that the spoons originated in the Chilkat River valley near Haines, Alaska. Perhaps one or more Chilkat or Chilkoot artists specialized in making these beautiful sets of eating spoons for noble families.

sentation, but exhibits imaginative, highly refined formline movement and flow. The very thin black and red formlines and very small inner ovoids leave a large amount of tertiary and other negative area unpainted. This thinness of positive line and roundness of ovoid shapes connect this painting to the design styles of the northern British Columbia mainland.

In the wooden ladle shown in figure 4.27, the tapered cylindrical form of the handle is wrapped with a two-dimensional relief carving, illustrating again the conceptual relationship of flat design and sculpture. A large number of one-piece goat horn spoons extant appear to be related in design style to this wooden piece. The two-dimensional pattern employs the early, positive-dominant style of formline design, implying that, despite this spoon's fine and bright condition, it may be much older than one might conservatively suppose.

The formline design in the sheep horn ladle (fig. 4.28) is very unusual in style and configuration, and is composed to fit smoothly in just the upper half of the bowl. Nearly round ovoids are joined with largely square-cornered U-shapes in a design that may represent a dogfish, inverted in relation to the orientation of the bowl and handle. Fine cross-hatching in certain tertiary and background (negative) areas sets off the positive design against the color of the horn. This use of cross-hatching is related to its similar application in argillite and silverwork, where the design and the background are also the same color.

A large ivory amulet (fig. 4.29) and a soul catcher (4.30) also appear to date from this period. The amulet's central image seems to be a whale-like sea creature, indicated by a large head, profile tail flukes, and a clawed foot. A number of small spirit

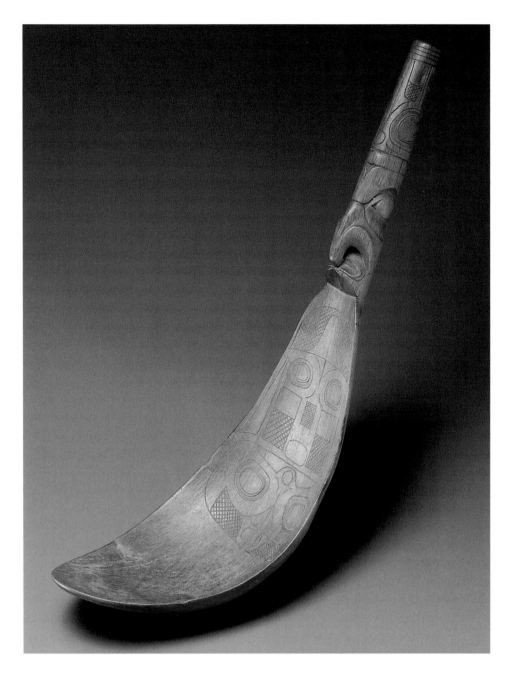

4.28. Horn spoon
Tlingit, c. 1850. Dall sheep horn.
11.5″ L × 3.5″ W.
Collection of Bill and Marty Holm

This sheep horn ladle is clearly related in handle configuration and design to figure 4.27, though certain stylistic details suggest the two were made by different carvers. The weight of the formlines and the eye-relief details of the handle in this ladle display subtle but clear differences in carving style.

4.29. Ivory amulet
Tlingit, c. 1830–1850. Sperm whale tooth. 2.5″ H × 6.5″ W × .5″ D.
Collection of Allan and Gloria Lobb

This big ivory pendant, visually rich in its carving and its surface patina, has been made from the side section of a large sperm whale tooth. It is comparable to the numerous similar pendants documented as having been the spiritual charms of Tlingit shamans (Wardwell 1996:nos. 195–208). Like this example, many of these integrate a very early style of two-dimensional design with strong sculptural features.

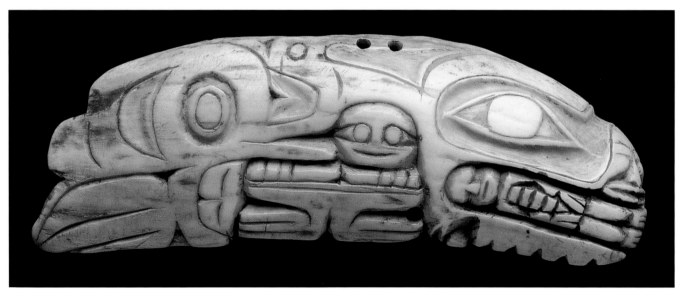

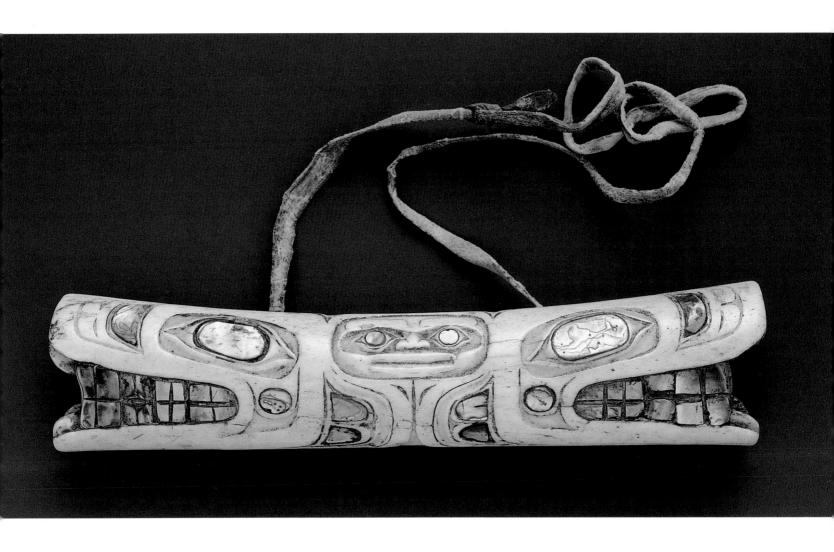

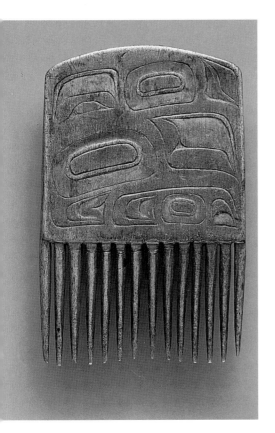

4.30. **Soul catcher**

Tsimshian or Tlingit, *c. 1820–1840.*

Bone, abalone, leather. 7″ L × 5″ W × 1.5″ D. Collection of John Putnam

This materially rich object is somewhat unusual among soul catchers in the relative simplicity of its two-dimensional formline design. Only the most basic elements of the terminal heads and central sculptural face are present, and the carved-out negative areas are minimal. Primary formlines are fairly heavy, and secondary elements are few and simple. These indications suggest that this soul catcher may be one of the earlier versions extant.

4.31. **Wooden comb**

Haida or Tsimshian, *c. 1850*

Maple. 5″ H × 3″ W. Collection of Eugene and Martha Nester

The design style of this delicate comb is comparable in its formline concepts and relative complexity to that of the large chest panel (fig. 4.18) or the bent-corner bowl (fig. 4.19). The creature represented appears to be a bird, though of which particular species is open to debate. It may depict a raven, though the tip of the beak is turned down in the corner of the design field and may indicate an eagle or other raptor.

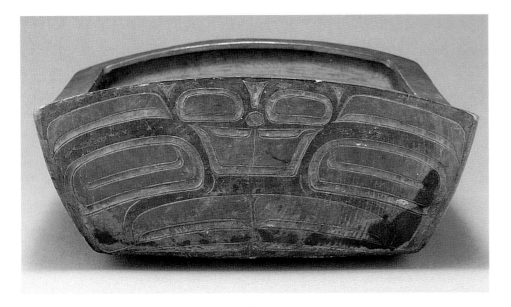

4.32. Square dish

Kaigani Haida, *c. 1840. Alder, paint.*
5″ H × 15.5″ L × 12″ W.
Collection of John Putnam

The end design on this bowl shows a
very balanced distribution of numer-
ous red secondary elements, including
red inner ovoids (which are usually
black). The color-shifting of black to
red ovoids is a feature often seen on
square dishes, an artist's choice made
in favor of the overall balance of the
two colors.

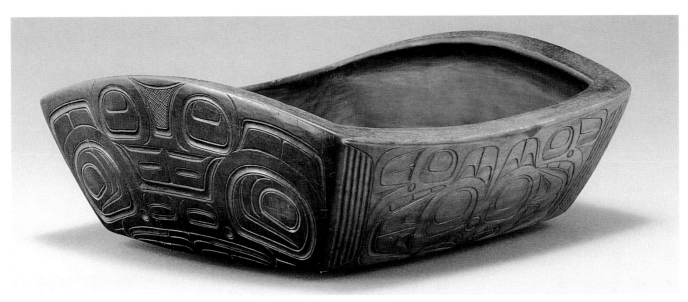

beings are blended into the composition as if they were woven through the major image. A small face is carved into the snout of the main figure, while an emaciated human being appears in its mouth, its vertebrae exposed. An animal-like spirit being is nestled within the body structure of the sea monster image. The formlines are broad and heavy throughout. Though deceased sperm whales occasionally drift ashore on the Northwest Coast, this tooth may also have been acquired from Yankee whalers, who were actively hunting throughout the Pacific in the early nineteenth century.

The relative simplicity of the design exhibited in figure 4.30 indicates perhaps an earlier version than most extant soul catchers. The lack of prominent ears or feet associated with the terminal heads and the presence of fin-like U-shapes extending from the heads toward the center of the piece suggest that a sea lion or whale is being represented. The central face, which shows very Tlingit-style characteristics in its sculpture, may represent the whale's blowhole. The raw material for this charm may have come from the femur of a brown bear. The reverse side of the pendant is not carved.

4.33. Square dish

Haida or Haisla, *c. 1860.*
Alder. 4″ H × 13″ L × 12″ W.
Collection of
Eugene and Martha Nester

This carved dish is unusual in several
respects, though the artist has con-
formed to the essential characteristics
of the typical square dish form. One of
only a few such dishes to display relief-
carving on its sides, this bowl nonethe-
less still includes the skeuomorphic set
of parallel grooves near each corner,
an indication of the persistence of that
design feature.

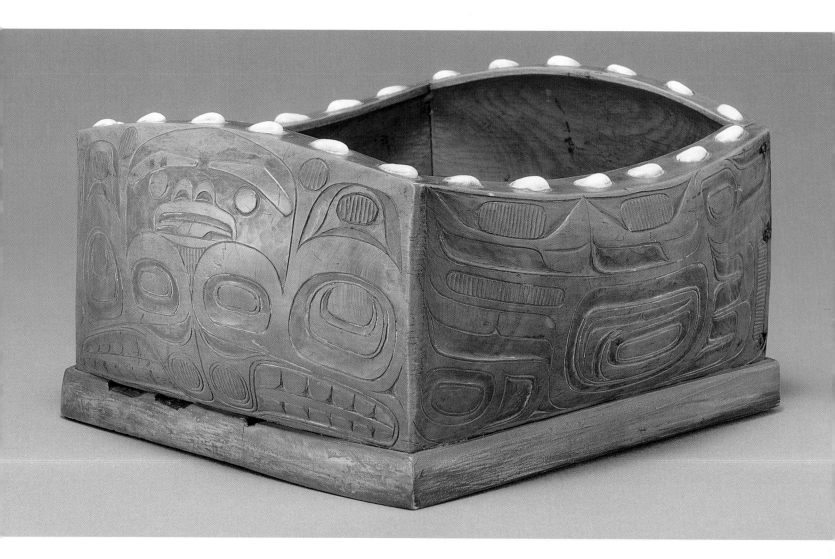

4.34 a, b. **Bent-corner bowl,**
relief carved
Coast Tsimshian, Haisla,
c. 1860. Yellowcedar, pine (?),
opercula. 6″ H × 11″ L × 10″ W.
Collection of Sylvia and Phil Duryee

The mastery of the formline system
exhibited by the maker of this dish
quickly becomes apparent to an expe-
rienced eye. The graceful adaptation
of rounded, flowing forms to the recti-
linear design field appears effortless,
yet requires a good helping of ingenu-
ity to accomplish. It appears that the
design of the four sides in total repre-
sents a sea monster, based on the
presence of certain characteristic
elements.

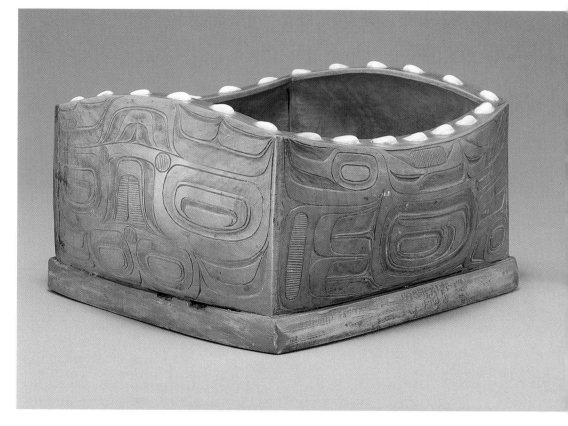

The surface of the bent-corner bowl (figure 4.34) is very elegantly designed and displays a great deal of development beyond the conceptual stage exemplified by the early historic period bowls (figs. 3.4, 3.7), and the previous early-nineteenth-century examples (figs. 4.19, 4.20). The roundness of its design elements are in marked contrast to the majority of the bowls observed previously, with the exception of the elaborate square dish (fig. 4.33), which exhibits similar shapes and design rhythms. The formlines employed in the designs on this dish are mainly of medium to thin weight. Some of them show a great deal of variance in width, such as between the top and bottom curves of formline ovoids, especially noticeable in the eyesocket and main tail-joint shapes. Unusual secondary elements and configurations indicate an artist with an inventive imagination. Many ingenious formline overlaps[10] are evident, and the proportionate scale of secondary designs and tertiary areas in the overall pattern separate this style from most of the bowls discussed earlier. The head, perhaps of a sea monster, is composed of joining profiles that feature tall ears and a wide mouth with teeth. Pectoral fin–like designs and a clawed foot span the sides of the bowl, and a whale-like, symmetrical tail design occupies the rear of the bowl, which is indicated by the presence of the joined or fourth corner of the bowl construction. In general representation, the image on this bowl corresponds to those of conventional chest designs, suggesting that a similar display of homage and protection from the "source of wealth" is intended. The stylized face set in a U-shape between the ears on the bowl front could either be seen as the blowhole of the creature or possibly the indication of a dorsal fin. In this object we see the use of fineline trigon "splits" in some of the tertiary areas, rarely seen in the earlier styles. The origi-

*4.35. **Head canoe model with paddles** Haida, c. 1850. Yellowcedar, paint. 7″ H × 34″ L × 6.25″ W. Private collection*

The hull design known in English as the "head canoe" is one of the most graphically interesting of all the traditional Northwest Coast watercraft. Most existing models are elaborately painted in this general manner, with a separate bow and stern design field together depicting an ambiguous creature image that is oriented to the bow.

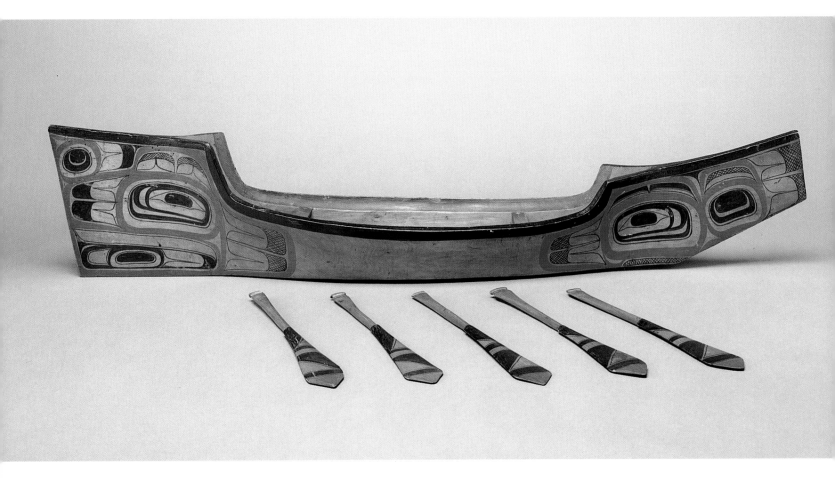

4.36. *Dagger pommel*

Tlingit, *c. 1830. Dall sheep horn,
abalone, leather. 7″ H, 2″ W, 2″ D.
Collection of Sylvia and Phil Duryee*

*The maker of this dagger hilt has used
the hard, plastic quality of the sheep
horn to best advantage in the firm,
strong edges and fine detailing of the
carving. The carved creases on the
nose, temples, and cheeks are some-
what unusual naturalistic traits that
are also occasionally seen on shaman's
masks and warrior's helmets, suggest-
ing that the intense grimace on the
subject's face is that of a Tlingit war-
rior (Holm 1983b:99).*

4.37. *Dagger*

Tlingit, *c. 1840–1860.
steel, abalone, cloth, leather.
20″ L × 2.5″ W × 1″ D.
Collection of
Mr. and Mrs. R. T. Ohashi*

*The warm color and polished shine
of the horn, the glint of the abalone
shell, and its balanced proportions
make this a beautiful example of a
terrible weapon. The finely placed
shell embellishments richly comple-
ment the color and form of this rela-
tively simple sculpture.*

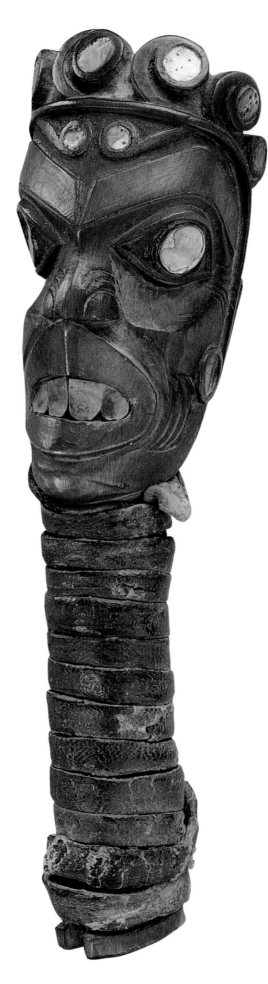

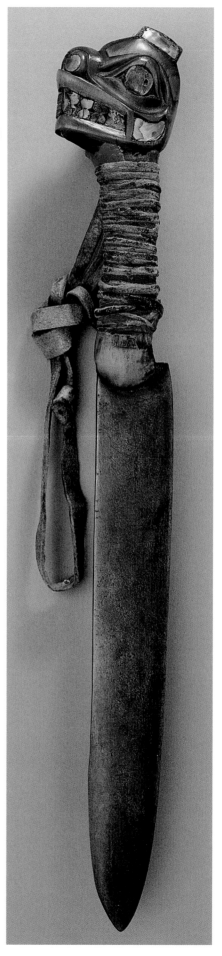

nal red cedar bottom piece has been replaced with one of fir or pine. Some visual conventions remain from the earliest period, such as the way that the general lines and curves of the individual panel designs harmonize with the undulating curves of the wide, inlaid bowl rim. The unknown artist who created this piece appears to have made a similar bowl at about the same time, which is now housed in the Canadian Museum of Civilization, Hull, Quebec (MacDonald 1996:47, pl. 29). The two-dimensional designs on each bowl are totally different in formline composition, but identical in terms of the artist's style.

An even more openly developed style of design and painting is represented in the model of the northern head canoe (fig. 4.35). With a visual impact much greater than its apparent level of maneuverability, this type of canoe was nonetheless used in its day over a larger geographic range than any other canoe style, from upper southeast Alaska to the west coast of Vancouver Island. With the advent of the "northern" canoe design (see fig. 5.10), apparently developed in the very early nineteenth century (Holm 1987:145–47), the era of the more visually elegant, if less practically efficient, head canoes with their accompanying blunt-pointed paddles began to fade. No full-sized examples seem to have survived into the era of photography, but early explorers' drawings illustrate them very clearly in a number of accounts spread over the aforementioned area (Henry 1984). The red primary painting on this model is composed of medium-thin formlines with a distribution of negative space that is about 50:50, including many large tertiary U areas wherein all but one contain painted trigon "splits". These attributes suggest a middle, rather than early, nineteenth-century origin.

The carved dagger hilt (fig. 4.36), minus its blade at least in recent memory, was acquired in the late nineteenth century by Lieutenant David Lyle, inventor of the lifesaving line-throwing Lyle gun (Holm 1983a:99). The broad eyebrows, wide lips, large eyes with short, wide eyelids, and short, rounded nose are all indications of Tlingit style.

The finely cut coils that crown the head may have been influenced by Victorian design, examples of which appear in argillite and silverwork with some frequency. The teeth, eyes, and other circles that are very cleanly inlaid with abalone shell shine with bright, cool color in contrast to the warm, dark hue of the mountain sheep horn. Of the ubiquitous Tlingit daggers, G. T. Emmons wrote, "Almost as important as a clan emblem, although more a personal possession, was the war knife which was a part of the equipment of every man" (1991:35).

In figure 4.37, the stout and compact image of a bear's head at the pommel of the dagger is carved in a bold and refined style. The relationship of sculptural forms to the two-dimensional design tradition is very clear in this example, and the visual punch with which the highly eccentric eye ovoid presses up against the upper eyelid and the brow is emphasized by the three-dimensionality of the forms.

Several raven rattles (figs. 4.38, 4.39, 4.40) illustrate a range of artists' styles from this general time period. By the early nineteenth century, the raven rattle form had become standardized, though within the conventionalization of the features can be seen some outstanding variations from one maker to another. This group of rattles shows a representative range of individual improvisations on the basic rattle form. In figure 4.38, the experience and skill of the artist are evident in the balance, pro-

4.38 a, b. **Raven rattle**
Northern Haida or Tlingit, *c. 1840.*
Maple, paint. 3.5″ H × 13.5″ L × 4″ W.
Collection of John Putnam

Within the constancy of the raven rattle tradition, many unique innovations exist that individualize the creations of particular artists. In this exquisitely conceived and executed example, a bear's head is set on the humanoid body, and a frog figure is perched on the belly of the rattle, holding the recurved beak of the breast face in its mouth.

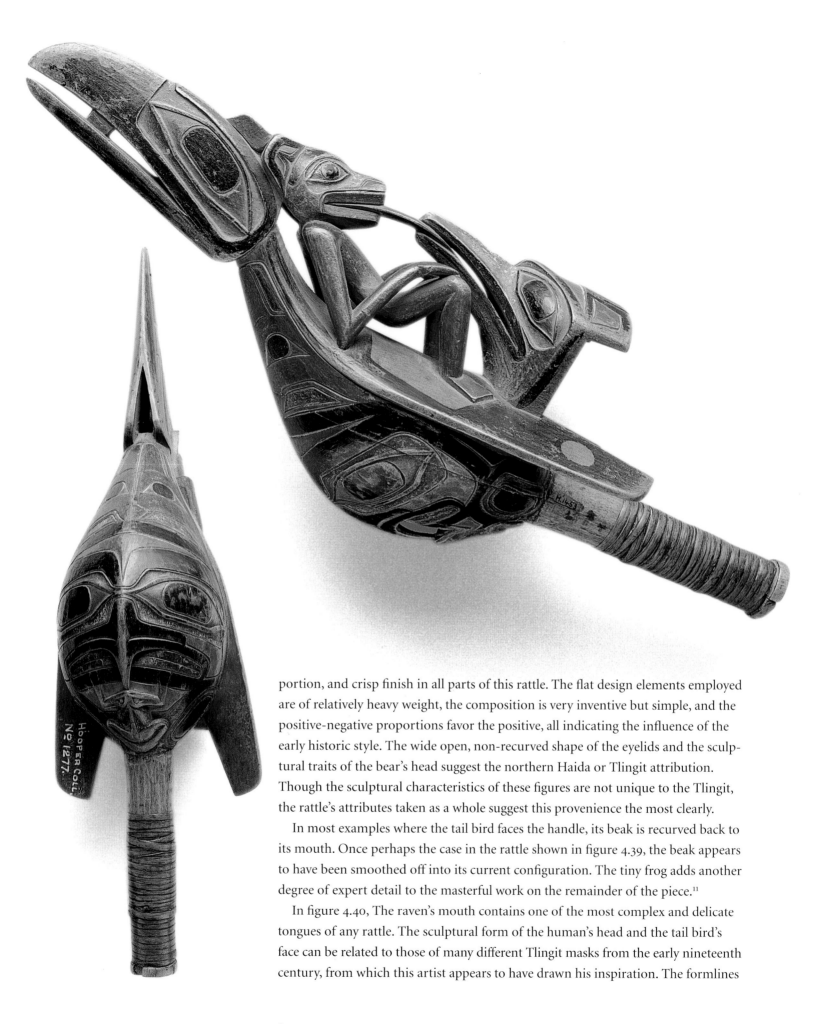

portion, and crisp finish in all parts of this rattle. The flat design elements employed are of relatively heavy weight, the composition is very inventive but simple, and the positive-negative proportions favor the positive, all indicating the influence of the early historic style. The wide open, non-recurved shape of the eyelids and the sculptural traits of the bear's head suggest the northern Haida or Tlingit attribution. Though the sculptural characteristics of these figures are not unique to the Tlingit, the rattle's attributes taken as a whole suggest this provenience the most clearly.

In most examples where the tail bird faces the handle, its beak is recurved back to its mouth. Once perhaps the case in the rattle shown in figure 4.39, the beak appears to have been smoothed off into its current configuration. The tiny frog adds another degree of expert detail to the masterful work on the remainder of the piece.[11]

In figure 4.40, The raven's mouth contains one of the most complex and delicate tongues of any rattle. The sculptural form of the human's head and the tail bird's face can be related to those of many different Tlingit masks from the early nineteenth century, from which this artist appears to have drawn his inspiration. The formlines

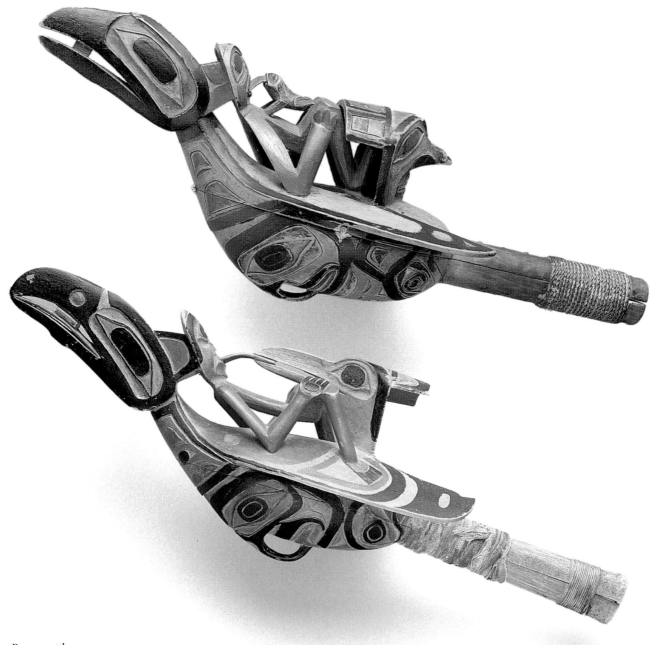

4.39. Raven rattle

Tlingit, *c. 1850. Maple, paint. 4″ H × 13″ L × 4″ W. Collection of Jack and Jane Curtright*

Attribution of Tlingit manufacture to this rattle is based on the eyelid shapes (wide open with little recurve), the artist's choice of flat design elements, including full-ovoid eye reliefs, and the style of the humanoid face. This type of two-dimensional rendering of the facial sculpture relates this rattle to such objects as the early Tlingit frontlet (fig.3.9).

4.40. Raven rattle

Tlingit, *c. 1860. Maple. 5″ H × 14″ L × 5″ W. Collection of Eugene and Martha Nester*

Though essentially the same size as the previous rattles (figs. 4.38, 4.39), each portion of this example gives the impression of a composition more elongated than most. The raven's head and neck, its thin, rounded body, and the slim features of the human's torso and limbs all contribute a sense of elongation.

4.41. *Raven dish*

Haisla or Heiltsuk, *c. 1860–1880.*
Alder, paint. 11″ L × 7″ W × 3″ D.
Collection of
Mr. and Mrs. R. T. Ohashi

The adaptation of raven rattle imagery to a small dish form has been undertaken by many northern Northwest Coast artists, each interpreting and applying the typical rattle figures to one of the many northern grease dish shapes in his own way. Central Northwest Coast stylistic features in this dish indicate that it was probably created by an inventive Haisla- or Heiltsuk-speaking artist in the third quarter of the 19th century. The rise of the raven's neck and head, the face on its breast, and the extended tail feathers derive from the rattle conventions.

4.42. *Raven and sun clapper*

Tsimshian, *c. 1840–1860. Maple or birch, paint, spruce root.*
3″ H × 11″ L × 2″ W.
Collection of John Putnam

Clappers are percussive instruments which appear to have been more common among Tsimshian-speaking First Nations than in other areas of the Northwest Coast, based on the stylistic similarities of existing examples. Clapper handles are narrowed down to be quite thin just ahead of where the two pieces are bound together, enabling the hollowed halves to snap open and shut as the instrument is shaken to accompany a dance. The round, red image of the sun is carried here on the raven's back, alluding to the mythological origin of daylight in the stories of the raven cycle.

are of medium weight, and negative areas are relatively large. Full ovoid eye reliefs also suggest Tlingit style in the design of this period.

Raven rattle imagery has been adapted to the form of a grease dish by a fairly large number of artists in different areas and time periods. The example illustrated here shows the style characteristics of the central British Columbia coast (fig. 4.41). These appear in the deep relief of the eye orb in the sculpture of the tail face, the liberal use of positive cross-hatching in red as a design element, and some unusual design configurations in the black formlines.

The composition of the image depicted in the raven-carrying-the-sun clapper (fig. 4.42) appears related to the raven rattle tradition in the lines of the raven's head (though the head on the clapper is wider than the head on the typical rattle), and in the placement of figures on the bird's back (in this case, the sun with a humanoid face). Two-dimensional principles govern the carving of the raven's head, as well as the formline embroidery of the wings. Northern British Columbia mainland style

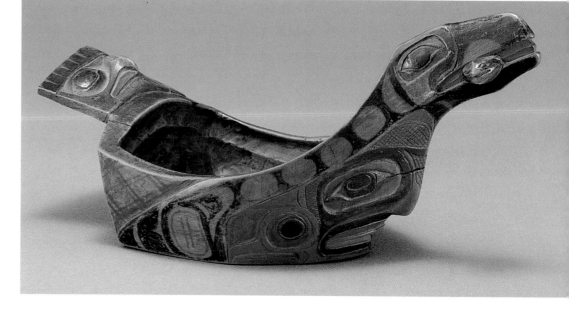

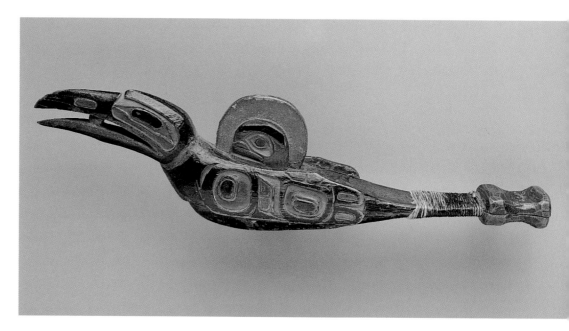

traits appear in the carving of the bird and the wing details, such as the graceful slimness of the raven's head, the full roundness of the formline ovoids, the small and very eccentric inner ovoids, and the imaginative complexity of the formline structure in the wings. Clappers in general seem to be a freely conceived group of sculptures, created without the compositional standardization of the raven rattle tradition. Perhaps this indicates a relatively new concept, introduced in a period when free expression was more readily condoned and when the shape and iconography of the instruments was governed solely by imagination and the practical constraints of function.

In contrast, the classic composition of the raven rattle is evidently a very early archetype that has undergone a long and broadly distributed development. The oldest, most complete examples extant illustrate that the conventions of the major forms—the raven's head and body, the raised tail feathers (usually elaborated into a second bird face), the reclining human or humanoid figure, and the face on the raven's breast—were already well established at the onset of the historic period.[12] G. T. Emmons collected the fragments of certain extremely archaic-looking versions of these rattles from shaman's graves in southeast Alaska. Now housed in the Burke Museum, University of Washington, these very early examples display a human figure that is not raised off the raven's back but is instead carved in high relief with its back resting directly on that of the raven.[13] The origin of the raven rattle tradition is located by oral history on the Nass River, in the Nishga territory of the northern British Columbia coast. If the Tlingit examples acquired by Emmons significantly pre-date the nineteenth century (or perhaps even the eighteenth), as their condition and appearance suggest, then it would follow that the concept itself must be much older than even those examples, in order for it to have spread such a distance from its original source in the Nass valley. Taken from another perspective, Tlingit historians recite tales of ancient migrations from the Nass valley northward to their current home territories at the end of the last glacial period, about nine to ten thousand years ago (de Laguna 1990:206). It is possible that the raven rattle concept traveled with them, finding expression in evolving incarnations through time (Brown 1995:52, cat. 12).

Globular rattles are a Northwest Coast tradition with a very wide variety of representations, their iconography apparently motivated by innumerable individual histories and emblematic expressions. The shark rattle in this collection (fig. 4.43) is a most interesting representation of this type, though the body of the rattle is so small and slim as to be considered globular only in the most general sense of the classification. Its compositional relationship to a certain group of Tlingit battle helmets representing the shark image is clear, but the reasons for its existence and the exact nature of its use are unknown.

The flat design image on the back of the rattle exhibits relatively small negative areas and simple secondary elements. The face of the two-dimensional bird image above the shark's head is a great illustration of seamlessly blending sculpture and flat design. Numerous areas of finely grooved texture also connect this work to many early nineteenth-century pieces.

The arrangement of figures in this object, so unusual for a rattle, is evidently due to the association of this piece with a particular Tlingit helmet. There are three

*4.43 a, b. **Shark (helmet) rattle** **Tlingit**, c. 1830. Wood, paint, hair. 8.5″ L × 3.25″ W × 2.5″ D. Collection of Eugene and Martha Nester*

The primary image of this small and delicate rattle is a shark, represented in the typical Tlingit style as if one were looking up at the underside of the shark's head. The creature's eyes would actually be on top of the head, so the artist has allowed the nostrils to substitute for them in this frontal orientation. A small frog protrudes from within the mouth of the shark, its forearms resting on the frog's lower lip.

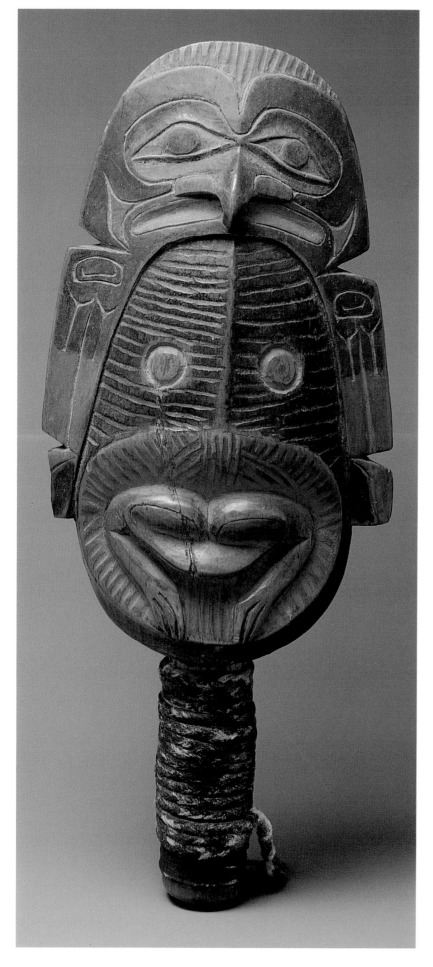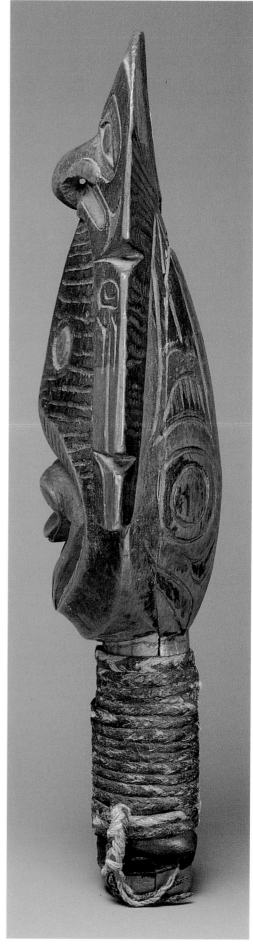

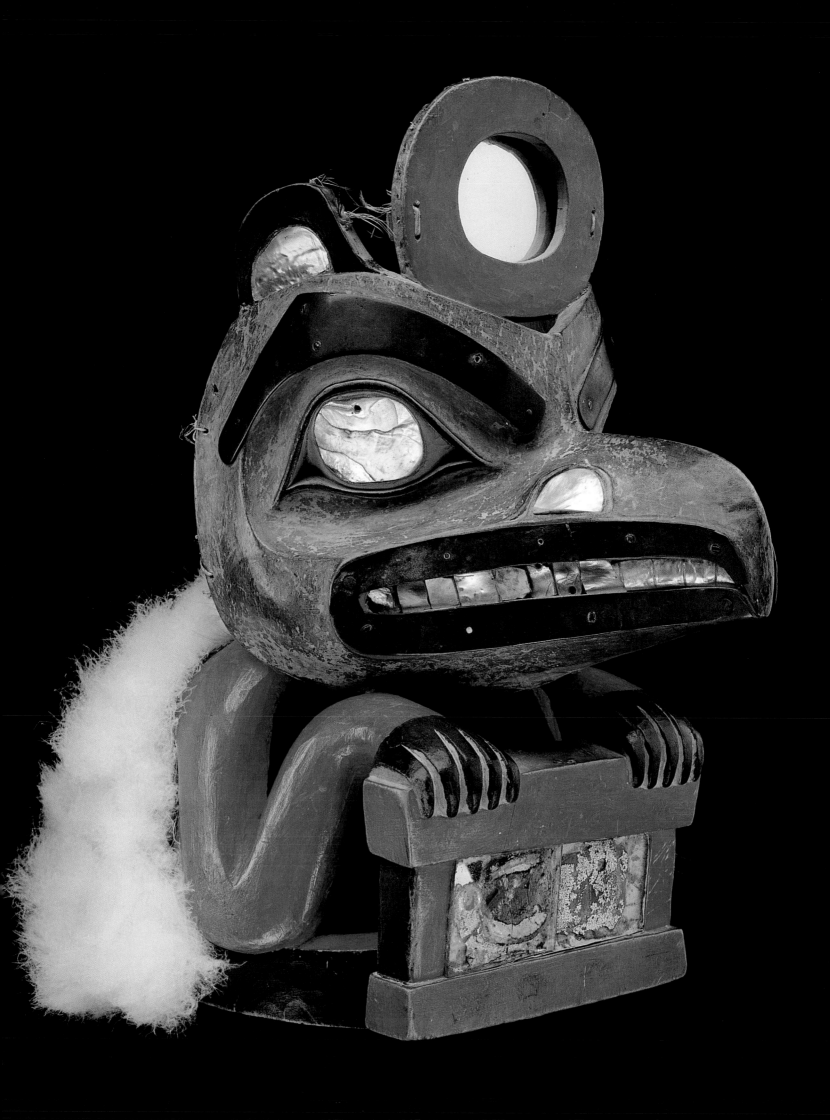

4.44. *Box of Daylight raven hat*
Tlingit, *c. 1850. Maple, abalone,*
paint, copper, mirror, bird skin, flicker
feathers. 12″ H × 8″ W × 12″ D.
SAM 91.1.124

One of a small number of upright,
fully sculptural (as opposed to front-
let-type) Tlingit ceremonial headgear
depicting major mythological figures,
this headpiece displays a combination
of materials astounding in its rich-
ness. There are no fields of formline
design here to analyze for evolution-
ary traits, but the degree of relief in
the eyes and eyesockets, and the depth
and volume of the total sculpture
suggest that this piece was created
during the middle 19th century.

4.45. *Bear frontlet*
Tsimshian, *c. 1860. Maple, abalone,*
paint. 7″ H × 6″ W × 2.5″ D.
Collection of Sylvia and Phil Duryee

Oral history places the origin of the
headdress frontlet concept on the Nass
River (Swanton 1909:170–73), and the
carvers of the Tsimshian-speaking
First Nations (Nishga, Gitk'san, Coast
and Southern Tsimshian) have sculp-
turally explored the tradition and
refined its details more than have any
other Northwest Coast artists. In this
example, the tiny ear figures, the per-
fection of minute inlays, and the fine-
ness of the total finish clearly highlight
the mastery of the artist who created it.

apparently related shark-image war helmets in as many museums, each made of a wooden form over which has been stretched a thick sea-lion hide[14] (often identified as walrus, an animal not native to the Northwest Coast). Each of these depicts a shark's head in the same upright attitude, its wide mouth across the front and its eyes and other features represented with two-dimensional designs relief-carved into the thick hide over the rear of the helmet. A separate piece of material (two employ wood, and one uses hide) forms a thin, vertical rim attached across the arch of the shark's forehead. The shape and iconography of the rim is reproduced in the rattle, which shows the face of a bird with a sculpturally developed recurved beak. This rim is similarly relief-carved in all three helmets and, like the designs on the rear of the helmets, exhibits the positive density, formline angularity, long eyelid forms, and minimal relief elements of the very early design styles.

A certain tendency toward more ambitious sculpture can be noted among objects dated in the early to mid-1800s. Steel tools have been present on the Northwest Coast for several centuries (Quimby 1985; Daugherty and Friedman 1983:188), but

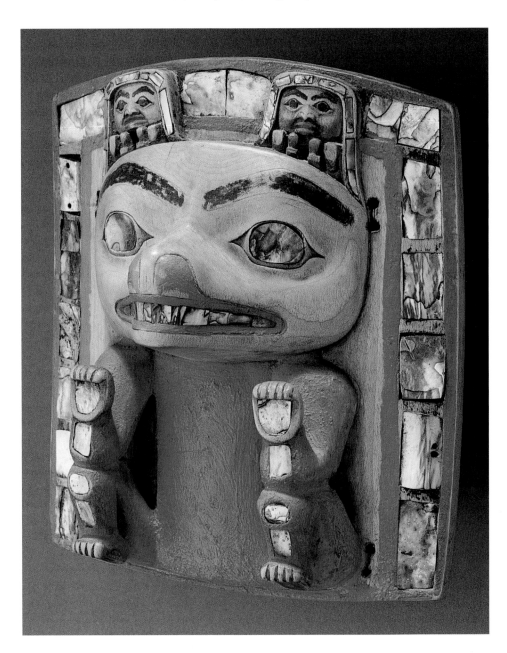

certainly the numbers of tools and tool materials proliferated greatly after direct Euro-American contact. As the carver's potential became more fully released through increased tool facility, the conceptual abilities of the artists naturally would expand in the same direction, leading to larger and more ambitious undertakings in all fields from canoes and totem poles to chests, dishes, and headgear. The full sculpture and elaborate piercings of the Box of Daylight raven hat (fig. 4.44) demonstrate this concept very clearly.

In figure 4.45, a carved frontlet, no formline designs are present, but the influence of the two-dimensional tradition is particularly apparent in the sculptural format of the central bear's face. When viewed as a flat design overlay of three dimensional form, the thin eyebrows and lips, highly recurved eyelid lines, and very open negative space in the eyesockets all relate directly to the formline style of middle to late nineteenth-century Tsimshian artists. In the Nuxalk headdress and frontlet shown in figure 4.47, the artist has adopted the northern coast symbols of prestige that accompany the tradition, copper and abalone shell, to elevate the visual impression of the work. The compact nature of the sculpture and the small inlays on the rim imply that this carving was created earlier than many from the Nuxalk area. The ear and cheek inlays appear to have been added later, perhaps when it reached Kwakwa̱ka'wakw territory (Holm 1983b:24). Nuxalk style is evident in the short, very recurved eyelid lines, prominent eyebrows, and the characteristic sculptural echo of the outer eyelid line in the cheeks of the thunderbird and human faces. This feature may have evolved from the two-dimensional principle of rhythmic patterns of crescents and trigons seen in proto–Northwest Coast and historic Coast Salish design.

4.46. Bear hat headpiece
Tsimshian, *c. 1840. Birch (?), abalone, copper. 16″ L × 8″ W × 6.5″ D. Collection of Sylvia and Phil Duryee*

Characteristics of the Tsimshian style in this sculpture include the short, recurved eyelids, the thin lips, the very rounded head and snout, the rounded modeling that suggests an underlying bone structure about the eyesocket, the thin limbs, and the liberal use of line-dashing on the body to represent the long, reddish hair of the grizzly. This emblematic headgear is hollowed out on the underside to accommodate the wearer's cranium.

4.47. Headdress and frontlet
Nuxalk, *c. 1860. Frontlet: Alder, paint, abalone, copper, glass. 9.5″ H × 6″ W × 5.5″ D. Headdress: baleen, ermine skins, swan skin, cedar bark, cloth. 28″ L. Collection of Bill and Marty Holm*

The classic duo of thunderbird and whale, representing the power of the natural world, is symbolized by the abbreviated imagery of this great frontlet. The dancing headdress concept reverberated about the coast from its source on the Nass River; reaching as far south as west Vancouver Island in the 19th century.

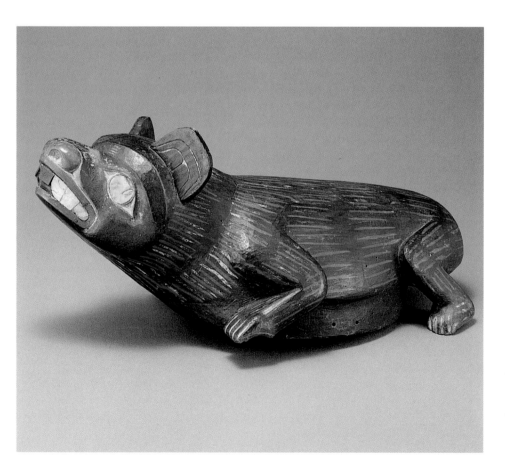

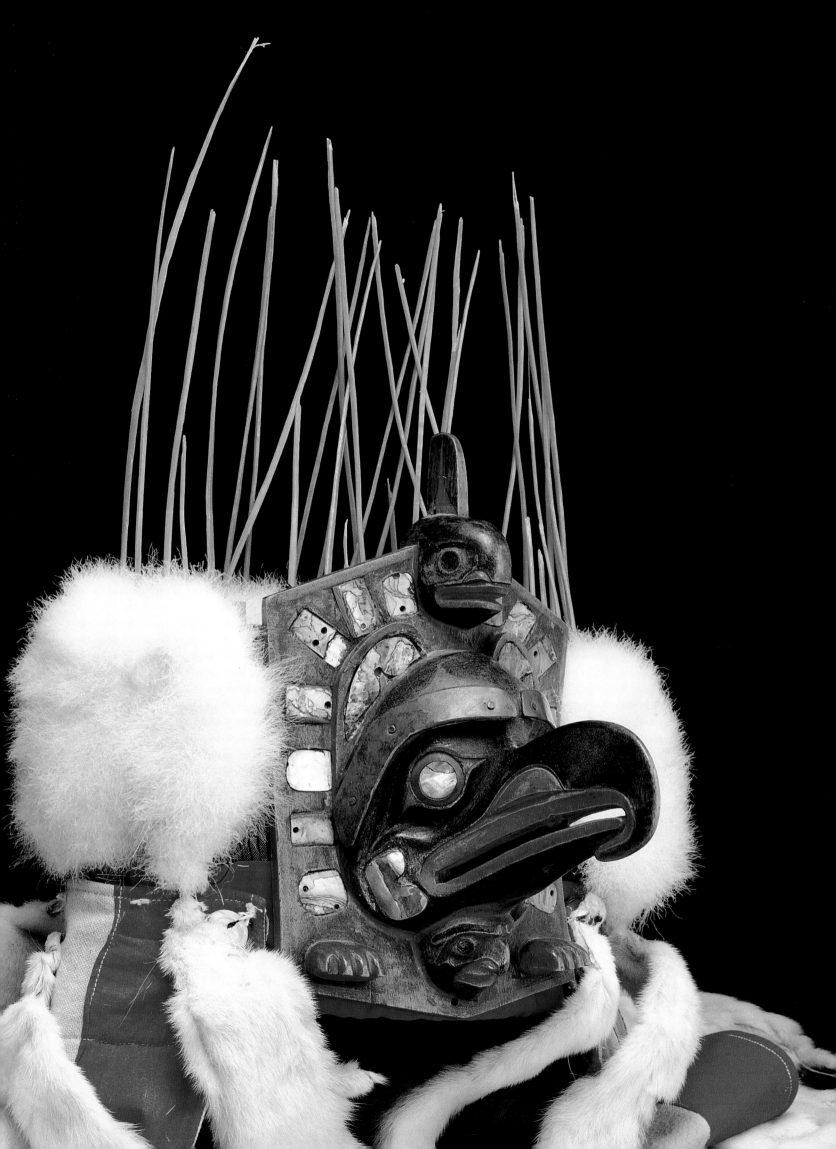

Haida Argillite: Shaping a Carver's Dream

Because the products of the Haida argillite carving tradition were made almost exclusively for sale to outsiders, argillite is sometimes viewed today as a tradition apart from Haida culture, when in fact argillite carving is inseparable from it. Northwest Coast artists have apparently always responded to many different motivations in the creation of their art, and the objects of the historical record are able to document this process (see figs. 4.14, 4.35, 4.41; also Brown, ed., 1995:234, cat. 88). The same artists who made the bowls, spoons, masks, chests, and other objects of very traditional use have also created the same kinds of pieces for sale, and have applied the same evolving artistic conventions and standards of quality to their production, whether executed in wood or argillite. Objects made for sale have included nearly all types—masks, bowls, spoons, wooden pipes, model canoes, model totem poles and houses, and bent-corner boxes and bowls—and such objects may be distinguished only by the fresh condition of their surfaces when they left the Northwest Coast. Depending on the relative skill of the particular artist, they may be as finely made as any piece created for Native use.

The earliest argillite carvings clearly emulate the established sculptural styles of wood, ivory or bone, and goat horn, though the freedom offered to the carver by the fiberless, homogenous composition of argillite appears to have been quickly realized by the ingenious Haida artists. Argillite is soft enough to shape easily with knives made for wood, or with gravers designed for silver, ivory, or bone (which are noticeably harder). Argillite measures in at 2.5 on the geologist's hardness scale of 1 to 10 (Macnair and Hoover 1984:17), distinctly harder than soapstone (talc is scale 1) but somewhat softer than Catlinite, or red Minnesota pipestone, its closest geological relative in this hemisphere. The consequent ease with which a carver can shape out complex figures and execute delicate piercings is balanced nonetheless by the artistic control and restraint necessary to refine the precise definition of sculptural and two-dimensional forms. Personal experience has demonstrated that even the carver's own heartbeat can interfere with the clean execution of a fine line in this smooth and responsive medium. As in most old Northwest Coast work (regardless of medium), the final surface of argillite carvings is often refined with sharp tools in ever-finer strokes and patterns that are visible on close inspection, and which allow appreciative viewers to visualize the finishing movements of the carver's hands.

Each of the argillite pipes illustrated here helps to suggest the conceptual progression through which the sculptures evolved in this historical period, from about 1825 until 1870, when panel pipes utilizing Haida motifs and also the Euro-American ship types apparently ceased being made (Wright 1977:104). The smaller, more compact example (fig. 4.48) exhibits early nineteenth-century stylings in both the sculpture and flat design aspects. The hollowed areas of its sculptural eyesockets are as minimal and compact as the hollowed tertiary areas of the two-dimensional designs. The apparent reference to raven rattle imagery in the human, tongue, and bird's beak sequence depicts a remarkable spiritual concept. The bird's beak is the sculptural extension of a chest front, of which the lid and bottom pieces are set off with parallel grooving. U-forms depicting the bird's wings are carved on each side of the little chest, which also contains the functional pipe bowl cavity. Wooden pipes assist in

funeral observances by carrying the thoughts and prayers of the participants to the sky-bound spirits of those deceased, through the medium of rising tobacco smoke. The rattle image reproduced here appears to illustrate this transfer. A message of intimacy and communication is conveyed in the human's extended tongue, and picked up in the beak of the bird, that alludes to the chest in which Raven acquired the light of the world. The chest in this case is also the bowl of the pipe, from which the tobacco smoke rises to carry the message to the spirit world. The raven's formline-embellished wings flow beneath the human's arms. The U-shaped elements appear to be both part of the wing, and feathers that spring from the human's elbow. The recurved beak of the large face on the bottom of the pipe draws the comparable image from the breasts of raven rattles into the composition, possibly representing Raven at the Head of the Nass (Brown 1991:78) from whom Raven purloined the infamous box. The unusual figure at the front of the pipe combines a short, recurved beak, abbreviated "horns," and tall (apparently very sensitive) ears. Certain Haida people claim the owl as a crest emblem, which may be what is indicated by the features of this image (Douglas 1992).

As the market for the carving of pipes in argillite expanded, so did the concept of the pipes as panels of sculpture. Such an evolutionary step is illustrated by the shape and composition of the pipe in figure 4.49, an elongated panel that maintains the conception of its form as a piece of hand-held sculpture. The genius and imagina-

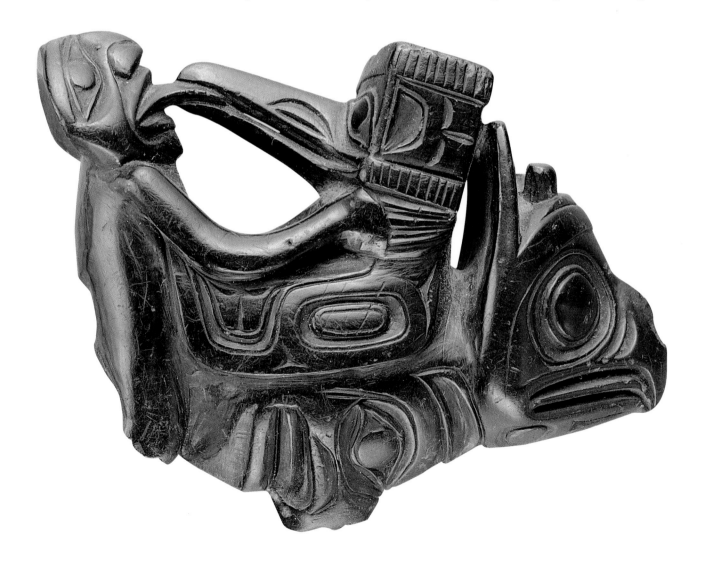

tion with which this pipe is designed and composed are remarkable. The figures are carved around a physical and conceptual core, which is the cylindrical shaft of the pipestem, perpendicular to the pipe bowl located in the head of what appears to be a raven figure. Especially well animated is the appearance of the small raven-finned whale at the bowl end of the pipe. The raven-head dorsal fin and large pectoral fins can also be seen as a separate bird figure that is smoothly integrated with the whale image. The two-dimensional design features of this pipe display a much more open positive-negative ratio than that of the previous example, formed by the inclusion of larger tertiary design elements in the formline patterns. The object is more or less oval in cross-section, and the figures are sculpted with the traditional proportions of wooden pipes in terms of their thickness. The pipe is carved in the round (on all sides), and the core of the sculpture (the stem of the pipe) extends visibly through the carving from the pipe bowl in the raven's head to the end of the piece.

As time passed, argillite carvers began to minimize the functionality of pipes and to emphasize their delicate pierced-panel format. In later examples, as the two pipes in figures 4.50 and 4.51 illustrate, the panels became much thinner. The bottom edge became straight and flat, and the bowl and stem-hole of the pipes often assumed the form of vestigial, small-diameter drillings not truly functional as pipes for smoking. Figures 4.50 and 4.51, two of the four argillite sculptures in the early classic period of this collection, were made by the same artist. Judging by their nearly identical styles, they were evidently created in fairly close succession. In the absence of a known proper name for artists of the earlier historic periods, art historians have commonly attached a descriptive tag to the carvers, indicative of some characteristic of their work. Each of eight known pieces by this artist in this period contains a particular design feature that has led him to be dubbed the "Master of the Long Fingers" (Wright 1983:140). The earliest documentation of the acquisition of a pipe by this masterful carver is dated 1867 or 1869 (Wright 1983:140). The style of these panel pipes has been identified as that of the 1840s and 1850s, though perhaps the two-dimensional features of these particular pieces suggest a somewhat later origin, closer to the documented collection dates. Two-dimensional designs on these panel pipes show a strong preference for very thin, positive formline features. The whale's pectoral fins and tail on figure 4.50 in particular demonstrate how this artist would sacrifice the positive formlines almost completely in favor of large, open tertiary areas. The extent of this departure from earlier 19th-century styles might indicate an origin for this piece closer to 1860. That this artist conceived his two-dimensional design elements from the negative (or inner) edge of the positive forms is clear from the sole incised line on the wing of one figure (top center, fig. 4.50), and from the way the outer edges of the formlines in general appear to have been trimmed off by the shaping of the surfaces they embellish. The placement of the tertiary ovoid elements is so unusual as to somewhat distort the conventional balance of the primary formline widths.

In figure 4.50, the two-dimensional design embroidery of one figure is unfinished, suggesting that the pipe may have been exchanged a bit prematurely from the artist's point of view. (Though ears in this artist's work are sparely embellished, all the bird's wings or whale pectorals save this set on four of his pipes are two-dimensionally decorated). The bird image whose very long, turned-down beak forms the upper

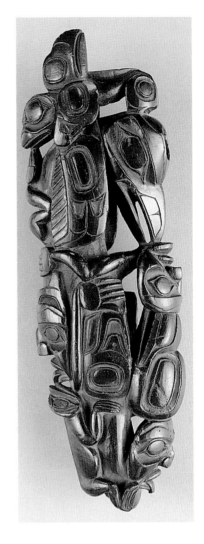

4.49. Xaɬiidaa.u (argillite pipe) **Haida,** *c. 1835. Argillite. 3.5″ H × 8.5″ L × 1.5″ D. Collection of Eugene and Martha Nester*

This larger and more heavily pierced composition is also from the first decades of the argillite tradition, when pipes of Haida subject matter were carved with an oval cross-section and were still being sculptured fully in the round.

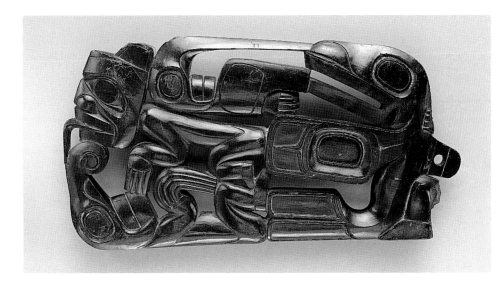

4.50. Xaɫiidaa.u (argillite pipe)
(fragment)
Haida, *c. 1860. Argillite. 4″ H × 8″ L × 1″ D. Collection of John Putnam*

One of two argillite carvings in this assemblage by the same artist (see fig. 4.51), these two examples serve to illustrate the consistencies of style that are common in a single carver's work in a given period. This artist has been dubbed the "Master of the Long Fingers" (Wright 1983:140), based on the digits of the curled-nose figure on the lower left. The original panel would have been twice this length (relative to fig. 4.39) had it not been broken where the whale's head and body met the next figure.

4.51. Xaɫiidaa.u (argillite pipe)
Haida, *c. 1860. Argillite.*
5″ H × 17″ L × 1″ D.
Collection of Bill and Marty Holm

The conceptual evolution of these pipes from dense, compact sculptures with little or no piercing to wide-open, highly pierced, essentially two-dimensional panels that are visually very light in appearance seems to parallel the related trend in the formline tradition through time.

edge of the panel shows a wing surface with only the inner edge of the ovoid formline incised. The feature is lacking any inner ovoid relief-carving or U-shape development of the extended wing feathers that meet the lower jaw of the whale at the right end of the composition.

In figure 4.51, a nearly pristine example of the work of "Long Fingers," the long, narrow, and very thin composition illustrates the extent to which the tobacco pipe tradition evolved away from decorated function in the direction of nearly pure sculpture. The conservatism of even such innovative carvers as these is shown by the inclusion of very minimal holes drilled for this panel's pipe bowl and stem. (Each hole in this panel pipe is about 4mm in diameter; Holm 1983a:106.)

It seems that one could make a case for the parallel evolution of the panel pipe sculptures and the formline tradition. As the makers of the older, more dense and compact argillite pipes moved away from the conceptual limitations of the wooden pipe tradition, the freedom of expression allowed by the material helped to facilitate the release of conceptual restrictions on the forms of the sculptures. The tendency to illustrate mastery of the argillite pipe form with progressively more light, open, and delicate compositions might be analogous to the evolution toward similarly lighter and more open two-dimensional compositions in the formline tradition. Certainly the work of Mr. Long Fingers, as one of the artists of exceptional mastery who have elevated this art form in many different ways and periods of time, captures the essence of both these concepts in a clear and highly refined manner.

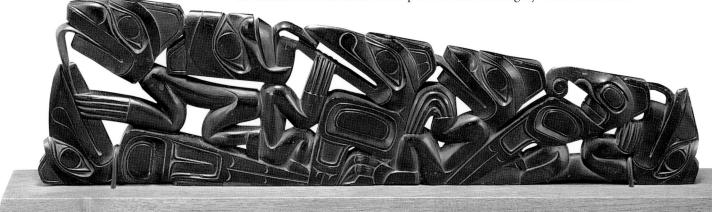

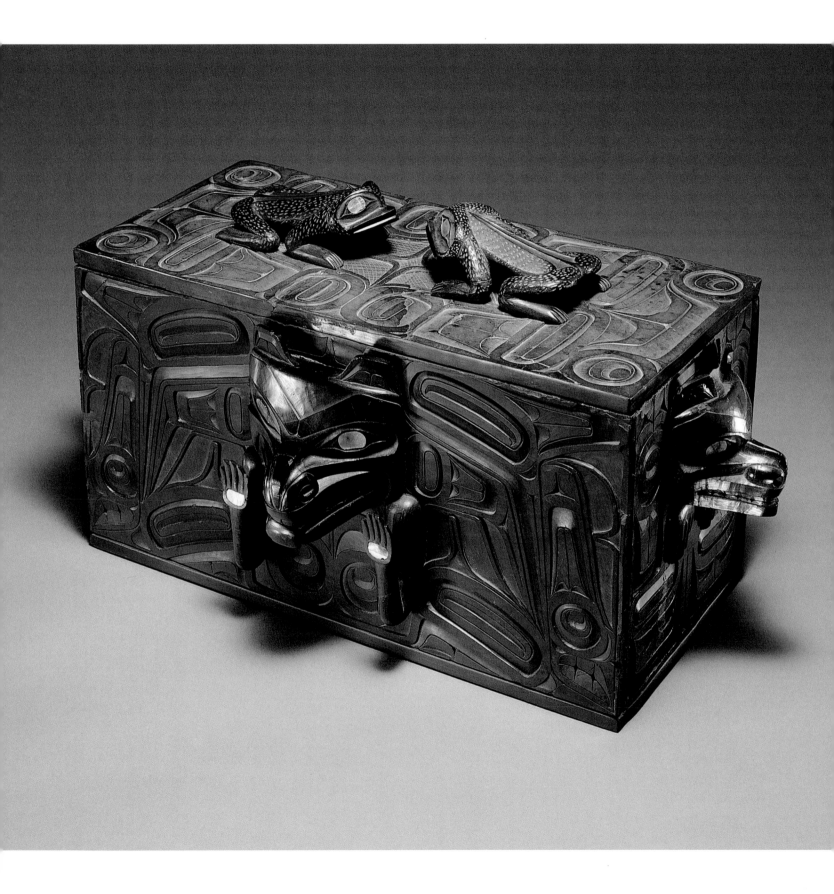

CHAPTER 5

Expanding Traditions

Art of the Late Classic Period
1865–1920

*Every possible change was rung on every theme, and the
result was a monumental calligraphy which could wander
back and forth from two dimensional design to sculptural
form, exploring all combinations between.*

—Bill Reid, Haida (1967)

THE DECADES INDICATED IN THE DESCRIPTION OF THIS HISTORICAL
period correspond with the approximate years of Charles Edenshaw's productive
career. Tahaygen, his Haida name, was born in 1839 and passed on in 1920 (1924 in
some literature). By 1865 he would have been a mature artist, working with his
maternal uncle and others who imbued in him the conventions and techniques of
traditional Haida art. More than any other artist's, Edenshaw's work exemplifies this
most experimental and conceptually advanced period of the Northwest Coast art
continuum, (see figs. 5.10–5.17). During these decades the most significant concep-
tual innovations that have been incorporated into the northern formline tradition
seem to have made their appearance. At this time, certain imaginative artists appar-
ently felt free to put their most eccentric ideas down in paint and on wood, and their
visions were often picked up by others of equal inventiveness who explored them
even further.

In some 'schools' of design style, innovation meant a type of simplification, a
slightly different direction than the general trend toward elaboration evident in the
first half of the nineteenth century. Charles Edenshaw was among such innovators,
and in his work can be seen a hallmark style of poetically efficient design conception,
composed without redundant or unnecessary lines and movements. Edenshaw
always seemed to imbue a playful character in his animal images, in contrast to the
austere quality of much older work. Other artists continued to explore the formline
thinness principle, creating images that reversed the traditional color distribution
hierarchies and proportions. Still others arrived at a design style where asymmetry
and free-form designs often replaced the conventionalized design fields of earlier

styles, while others altered formline structures to the point that they can not be described in mainstream terms, eluding the structural language of Holm's inclusive analysis. And yet, even these very radical design conceptions maintained the underlying principles of the northern Northwest Coast tradition, such that the artists may be considered inventive geniuses, who stretched design concepts beyond the perceived borders of the style without breaking important threads, without unraveling the fabric of the design tradition they worked with. That would come later, after this group had set down their knives and paintbrushes for the last time.

Among the survivors of the virulent 1862 smallpox epidemic (which claimed 90 percent of the Haida population), the artists who remained in this period were of the first generation of Haidas (and other First Nations) who received English names from the mission leaders and government agents. Due to the work that certain of these artists performed on behalf of early ethnographers, their individual names and identities have been directly associated with their carving styles. Haida names like Charles and Isabella Edenshaw, Albert Edward Edenshaw, Charles Gwaytihl, Simeon Stilthda, John Robson, Tom Price, John Cross, and others, were recorded by ethnologists and collectors (such as John Swanton, Franz Boas, Marius Barbeau, and Charles Newcombe) in reference to objects they acquired that were eventually placed in museums. Marius Barbeau and Tsimshian translator/ethnographer William Beynon also recorded the Native names of many nineteenth-century carvers from the northern British Columbia mainland who produced the great monuments from the villages along the Nass and Skeena Rivers, as well as the outer mainland coast (Barbeau 1950). Tlingit ethnologist Louis Shotridge recorded the names of many Tlingit artists in his object documentation and narrative transcriptions for The University Museum in Philadelphia (University of Pennsylvania), made between 1918–1929. Carvers identified through Shotridge include Kadjisdu.áxch´ II, the late-eighteenth-century artist of the Whale House and Chief Shakes house posts; and in the early nineteenth century, Shkiłakáa, who carved the interior screen of the Whale House, Klukwan; and Nakush´taa, carver of the Frog House posts, screen, and hats (Shotridge, n.d.). It is through these kinds of efforts that we of today have such names (and in some cases photographic images of the individuals) to connect with the objects that these masterful artists created. Those objects made by anonymous artists, which make up by far the existing majority, can be related to pieces of known origin and approximate date in order to place them meaningfully in the evolutionary continuum.

In the northern culture region, these decades also saw the effective discouragement and dismemberment of traditional values and cultures. Civil and religious authorities gained power over the First Nations through the expansion and entrenchment of supporting legal infrastructures and non-Native populations. Previously the First Peoples had outnumbered the outsiders and had possessed resources capable of overwhelming them. But the results of the epidemic decimations of Native populations, the wholesale influx of non-Natives (spurred on by a series of gold rushes along the coast), and the arrival in numbers of civil and military authorities had tipped the scales against the indigenous cultures. In Canada and the United States, the institution of the reserve/reservation policy and the establishment of residential schools oversaw the unfolding of divide-and-conquer strategies. With the passing of the last generations of northern Northwest Coast artists traditionally trained in the

esoteric philosophy and structural principles of the visual arts, succeeding generations were being driven away from traditional influences by the tide of pressured assimilation. Individuals who filled the roles of artists in some cases had to do so without the background and training of their predecessors, winging it with little insight into the makeup of the two-dimensional tradition, but with great respect for the value of the histories and images that they did their best to represent.

In the central and southern regions of the Northwest Coast, where in some cases the population decline had been less severe and the fabric of Native society less completely altered by the new incoming cultural regimes and religions, a larger measure of traditional culture managed to survive through the most difficult periods.

This "slender thread," exemplified by artists and ritualists such as Mungo Martin, became the foundation on which much of the cultural and artistic revival of the late twentieth century was built. Tenaciously clinging to those cultural institutions that gave value and purpose to their lives, the late nineteenth and early twentieth-century Kwakwaka'wakw traditionalists defied the orders of Indian agents. They endured various penalties, incarcerations, and artifact confiscations, and conducted their traditional potlatch business "underground," traveling to remote village locations in secret in order to avoid the eyes of certain persistent and unrelenting government agents (see Cole 1991:135–68).

Potlatch and traditional ceremonial gatherings were declared illegal in the 1880s under Canadian laws that were spottily but rigorously enforced through the early twentieth century. The antipotlatch provisions were eventually dropped in 1951, but not until after a great deal of cultural damage had unfortunately been done. American legal attitudes were embodied in Bureau of Indian Affairs policy, which mirrored the Canadian situation and was just as effective in pulling the plug on the most outward expressions of Native traditional culture in the middle years of the twentieth century.

In the years between 1865 and 1920, however, before the results of these scenarios had played out, those who carried the knowledge and skills of the esoteric traditions did their best to keep the visions alive, whether they were applied to objects of ceremonial use or to ones that were produced for exchange in the developing colonial economies. Early ethnologists commissioned pieces from certain artists for display in urban museums, and collectors from varied backgrounds and nationalities came to the Northwest Coast to acquire the artistic trappings of what they saw as vanishing cultures. Native artists made gifts for presentation to respected dignitaries and authorities who came and worked among the First Peoples in many areas, and model canoes, model totem poles, and examples of basketry were carried to many corners of the world by missionaries, travelers, and governmental or commercial agents as mementos of their Northwest Coast duties and adventures.

Owners of curio shops in Juneau, Sitka, northern British Columbia, Victoria, and Seattle purchased old artifacts and new creations from Native artists and suppliers, or sent agents and buyers into the field to assemble artifacts for the continent-wide market. Many of these types of objects have made their way into museum collections in the years following their removal from the Northwest Coast, while others have remained in private hands, passed down through successive families. A certain number of these kinds of pieces continue to arrive on the commercial mar-

ket every year, offered for resale by private dealers, auction houses, and collectors seeking to develop and upgrade their holdings. The objects in the Native Visions collection have been acquired through nearly all of these various means, and now reside with those who have generously made them available for public display and academic study. Many collectors of Native American art are also deeply interested in the particular histories of their objects and have been able to assemble valuable information about certain pieces in their collections. As the result of years of interest and study, many collectors are especially knowledgeable about historic artifacts and the cultures that produced them, and their expertise has been invaluable to other collectors and professionals alike. Such expertise has been liberally drawn upon to provide details for this exhibition.

Formline Fantasy: Varieties of Individual Mastery in Late-Nineteenth-Century Northern Design

It was in this historic period that the most diverse and inventive varieties of northern two-dimensional style were spawned and developed. The Native Visions collection includes several examples of these uniquely innovative styles, illustrating creative formline variations, design structure improvisations, and work by several important individuals whose facility with traditional design continues to inspire Northwest Coast artists today.

Bent-corner containers from the later nineteenth century remain some of the best and most accessible examples of northern two-dimensional painted design, illustrating the stylistic signatures of many individual artists. The great number of painted boxes extant, for example, demonstrate the myriad possible improvisations that can

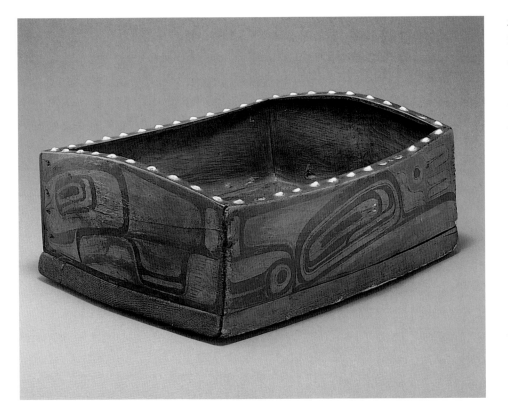

5.1. *Bent-corner bowl*
Northern British Columbia,
c. 1870–90
Yellowcedar, redcedar, paint, opercula.
6″ H × 14″ L × 12″ W. Collection of
Eugene and Martha Nester

The formlines on this bowl are very much thinner than those seen on typical early works, and the tertiary and negative areas have been composed to spatially dominate the design fields. Secondary development is relatively minimal, though the side panels include a secondary area of complex formation and unusual position.

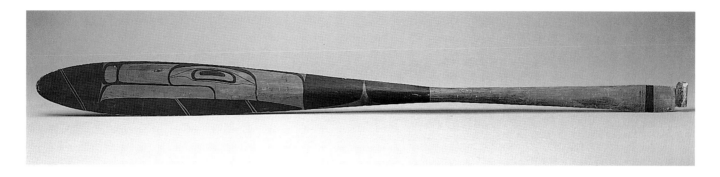

5.2. Canoe paddle

 Heiltsuk (General Dick?),

c. 1890–1900 Yellowcedar, paint.
53″ L × 6″ W × 2″ D. Collection of
Eugene and Martha Nester

Although the functional concepts of
blade and handle are common to all
canoe paddles, each of the Northwest
Coast First Nations developed the
flowing lines and curves of these
simple instruments into distinct, tra-
ditionalized forms with subtle shapes
and features that can help to distin-
guish the paddle styles of different
groups. The shape of this paddle is
typical of the Nuxalk/Heiltsuk, cen-
tral British Columbia mainland style,
and the painted image also reflects
this heritage. The style of a very simi-
lar paddle, collected by the Rev. R.W.
Large at Bella Bella, c. 1900 (ROM
23140), indicates that the same artist
made this example (Black 1997:57,
162–63).

be applied to even very similar primary design structures. Certain artists seem to have created what could be termed a series of similar objects, varying their design patterns relatively little from one piece to another. The maker of the low-sided bent-corner bowl in this collection (fig. 5.1) may have been such a creator of multiples, as this bowl appears to have a number of surviving stylistic cousins.

In this set of painted-only design images, the ends of the bowl are both composed as profile heads, indicated by the eye, snout, cheek designs, and mouth areas, while the side panels show profiles of body features. The heads depict very whale-like characteristics in the form of the mouth and snout, and the body designs appear to denote fin-like shapes as well as a clawed foot. These combinations of whale and land mammal features often appear in chest and box designs of the type said to represent the chief of the underseas, Gonakadeit (see fig. 4.18).

One of the most apparent features of the painted designs on this bowl that distinguish it from the majority of earlier examples is its asymmetry. The longer side panels of such a bowl are often not symmetrical, but the end panels most often are, particularly in bowls from the pre-1850 period. It is even fairly common in early examples to see symmetrical designs on each side of a bowl of this type. In this example, as is true of many, design asymmetry applies to the corresponding or opposite sides as well, meaning that each painted image and the one on its corresponding opposite surface may display nearly the same primary design composition, but will differ importantly in the use of secondary forms. In this painting, each end and each side panel design is nearly the same as its opposite, but each also exhibits certain deliberate, minimal differences in both black and red aspects.

Both the primary and secondary designs on this bowl are structurally simple, with large, open tertiary and negative spaces evenly distributed over slightly more than half the total design area. Most of the secondary elements are limited to single or double shapes, with the exception of one in the upper end of each side panel. Interestingly, this secondary complex is enclosed on just two sides by primary formlines, with the remaining two sides bounded only by the edges of the panel on the top and end. This secondary usage illustrates a significant conceptual development that releases the red formlines from the typically enclosed "secondary" status. This type of conceptual change gives the artists freedom to compose red formlines on an equal design level with black primary lines, and becomes important to the subsequent development of really experimental free-form, tradition-stretching formline designs.

The types of compositions painted on many northern canoe paddles may have influenced the development of the ultra-primary design concept as it has been

applied to box surfaces, (see fig. 5.7), where large non-formline units of positive space are painted on the surface of an object to create a kind of frame, within which formline images are composed. The canoe paddle illustrated in figure 5.2 has black ultra-primary areas that are relieved by pairs of narrow, unpainted stripes crossing them diagonally. In the resultant negative design field, roughly rectangular in its shape, extremely thin formlines have been arranged in a face structure that suggests perhaps an eagle. Somewhat broader red elements are painted in the secondary zones, but still the positive forms in this composition make up only about thirty percent of the total design area.

Formlines of comparable thinness are employed on the square box in figure 5.3, in a design with similar element proportions and movement characteristics as well, suggesting that these two objects originated in the same general cultural area. The horizontal lines of this painting have been laid down with an angular peak at the center of the designs which lends the composition an almost three-dimensional quality. In this fine-formline box design pattern, the relationship of the primary image structure to the traditional chest design format is readily apparent (Holm 1997). When this composition is compared to the very early box in figure 3.2, the

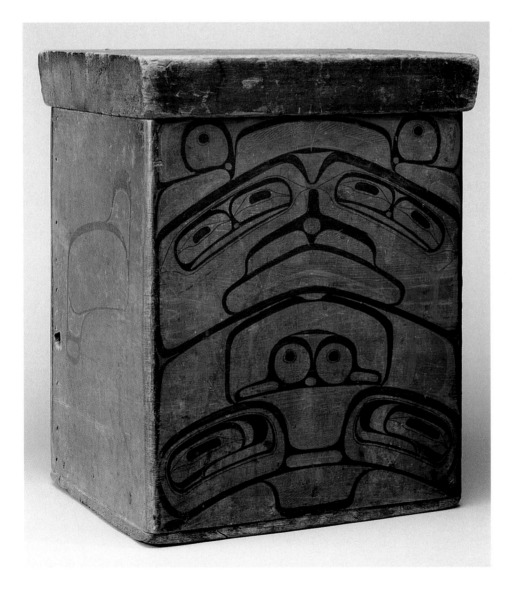

5.3. *Bent-corner box*
Heiltsuk, Haisla, *c. 1870. Redcedar, paint. 20″ H × 14.5″ W × 13″ D. Collection of Alan and Jeanette Backstrom*

The principle of non-parallelism is expressed extremely well here, where the highly arched horizontal lines of the composition are in direct contrast to the rectilinear box form. The clean lines and fine delicacy of the painted forms of this work are outstanding.

5.4 a,b. **Kookʷ (bent-corner chest)**
Heiltsuk (Captain Carpenter ?),
c. 1875. Yellowcedar, redcedar, paint.
21″ H × 36″ W × 20.5″ D. SAM 86.278

This bent-corner chest was acquired from a Tongass Tlingit chief's family in the 1970s, though it is painted and carved in the style of certain Heiltsuk artists of the 1860s and 70s. Evidently moved northward through trade, the chest displays designs that employ extremely thin formlines and large, expansive negative areas. The characteristics of this design indicate the style of a Heiltsuk artist known as Captain Carpenter (see Black 1997: 110–13).

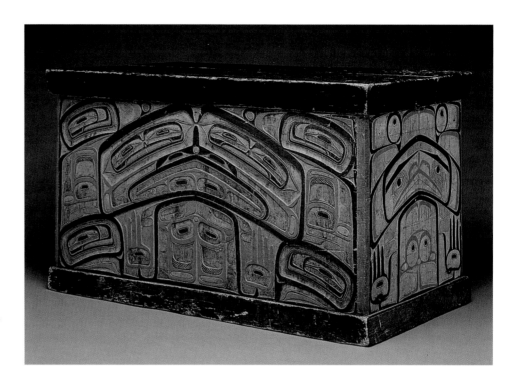

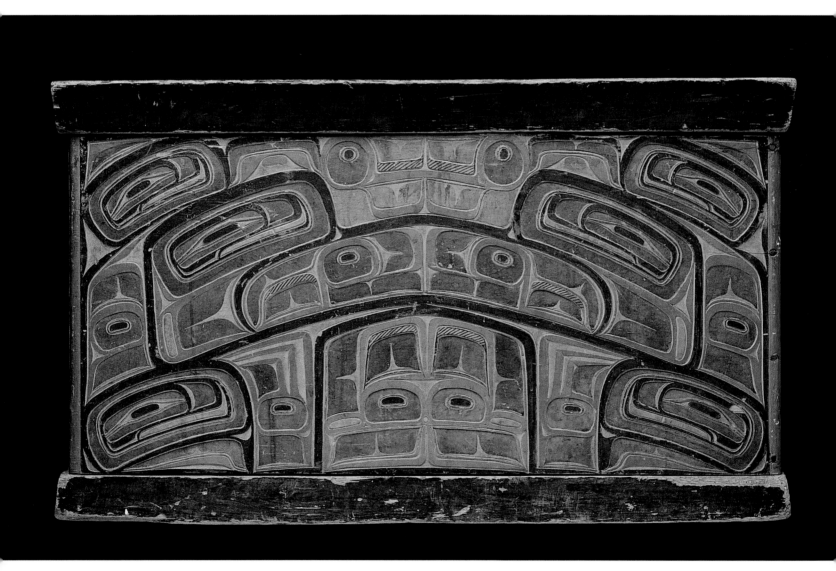

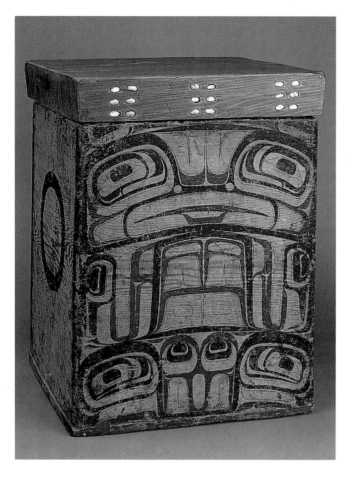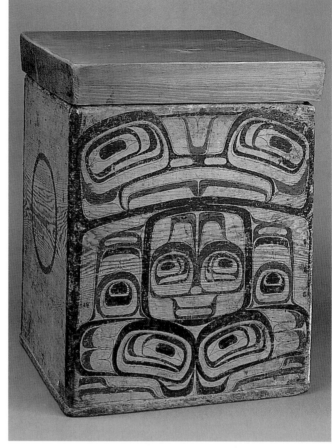

differences in formline style are remarkable, even though the basic primary layout is essentially similar. Here the thinness of the black formlines and the spare application of the equally thin, red secondary formlines has resulted in a positive-negative ratio of about 30:70, where the unpainted ground of the box is the dominant aspect of the design field. Elaborated inner ovoids display similarly thin formline structures, and the solid, very eccentrically placed circular inner ovoids are so small that the tertiary areas in which they float far outweigh them in terms of spacial dominance.

The large chest in figure 5.4 also exhibits a related design style, featuring thin positive formlines and a rich blue color in the tertiary areas. The spatial role of the tertiary forms is so dominant in this composition (at least 70:30) that the blue color is the predominant hue of the design field. Form and proportion in the elaborated inner ovoids, including certain characteristics of the eyelid lines, connect this design work to many extant objects from the Bella Bella region. Here the upper and lower eyelid lines do not actually meet at their rear points, but terminate parallel to each other at the edge of the eyesockets. Many painted containers with this general design character have been documented from the Heiltsuk region. This particular chest was acquired among the southern Tlingit, indicating the distances over which traditional objects were sometimes transported and traded.

Figures 5.5–5.7 illustrate distinctly heavier formline weights, though the images have incorporated large areas of negative space as well. Painted by three different artists, these boxes nonetheless show a general similarity of style, possibly the result of regional influences. In these compositions can be seen a number of common

5.5 a, b. Xooda (bent-corner box) Haida, c. 1875. Redcedar, paint, opercula. 23.5″ H × 15.5″ W × 15.5″ D. Collection of Eugene and Martha Nester

The designs on the front and back of this painted box both display the single-eye or one-step face structure in the head compositions (Holm 1997). The formlines are not as thin as in earlier examples, lowering the positive-negative design ratio to about 40:60. The combination of mammal features, including claws on the front (a), and whale-like features on the back (b), suggests the Gonakadeit or Konankada image as depicted in similarly composed chest designs (figs. 4.18, 5.6).

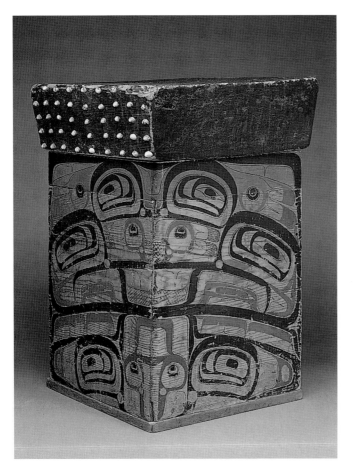 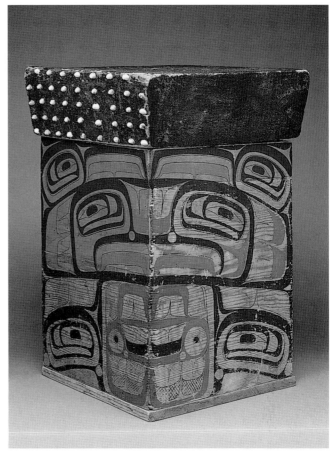

5.6 a, b. X̲ooda (bent-corner box), corner-oriented design

Haida, *c. 1875. Redcedar, paint, opercula. 23″ H × 15″ W × 15″ D. Collection of Bill and Marty Holm*

Boxes with a corner-oriented image display the same types of design formations as those on traditional chest formats. Very early examples indicate that the arrangement of images in this way was innovated considerably before the historic period. The overall painting and design style of this box is similar to the previous container (5.5), though not enough in detail to indicate the same artist's work.

mid-nineteenth-century design concepts such as subsecondary elements, cross-hatched positive forms, and the frequent employment of painted trigon splits in the tertiary areas within U-shapes.

In figure 5.6, the artist has structured the formline patterns in very creative ways, particularly on the sides marked (a), where a highly developed conception and use of both primary and secondary areas has resulted in an especially imaginative design pattern. The main head's formline structure and the ovoid and paired U-shape secondary complexes combine to suggest a bird image on side (a), while the more ambiguous design on the (b) side conforms to the more conventional chest design/ Konankada image. Extreme inner ovoid eccentricity exists on the (a) side, though with the (b) side ovoids, this is much less so.

In the box shown in figure 5.7, the secondary areas have been composed to leave them broad and open, with very minimal development of secondary and subsecondary formlines. The result is a composition in which tertiary and negative space predominates, showing a large amount of the gray-toned box surface behind the painting. The most rare aspect of this centrist design image is the use of a positive, floating ovoid within the finelined, tertiary "S" shapes below the cheek areas, an element that is almost never seen outside of a formline ovoid in the mainstream tradition. Bill Holm has noticed that this ovoid and the red elements adjacent combine to form an unusual profile face, made up of eye, nostril, and upper lip. The ascendancy of painted trigon "splits" in this period of the formline tradition is well illustrated in this and the previous box.

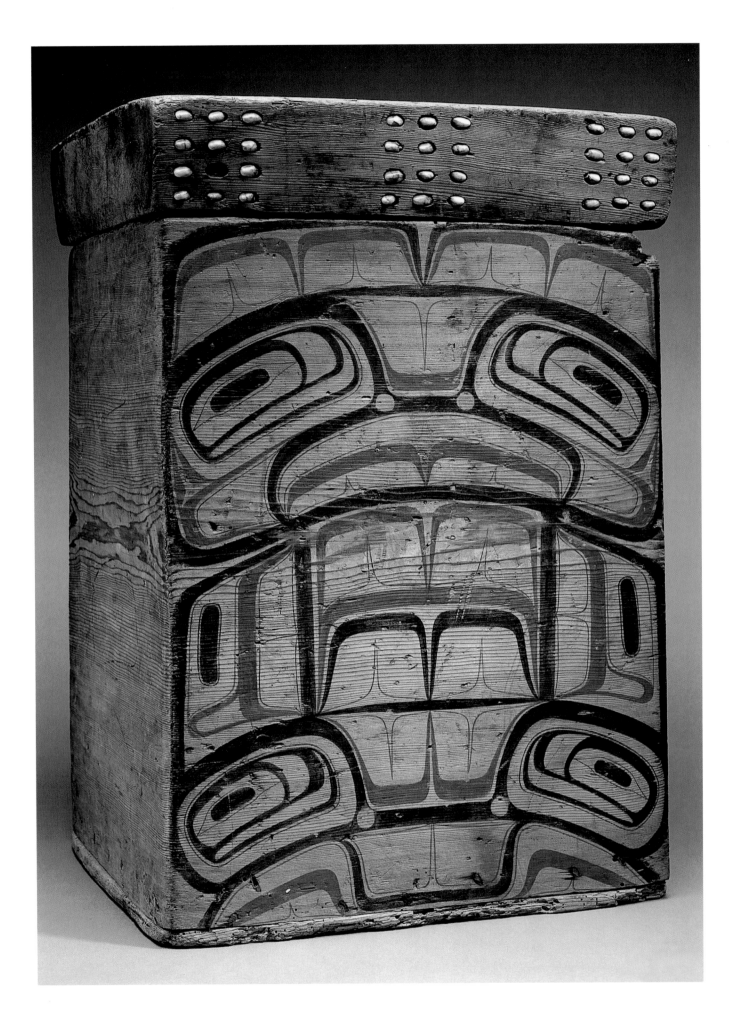

5.7. X̱ooda (bent-corner box)
Haida, *c. 1880. Redcedar, paint.*
28″ H × 19″ W × 19″ D.
Collection of Allan and Gloria Lobb

*Utilizing somewhat thinner formlines
than those seen in the previous boxes,
this artist has also thinned and elon-
gated many of the design forms, which
lends an added sense of refinement
and elegance to the composition. The
thinner formlines are most apparent
in the elaborated inner ovoids, though
the primary design movements also
reflect this more delicate construction.*

The most inventively designed container in this collection is illustrated in figure 5.8, asymmetrical on all four sides and exhibiting imaginative composition and precise, refined painting. There may have been a "school" of Haida artists that excelled in making these kinds of experimental design structures, though a number of artists from the northern British Columbia mainland also contributed a great deal to this type of design conception. For reasons that are only intuitively apparent, the body of images painted on these tall bent-corner bowls (as opposed to boxes with a lid) has a much larger percentage of highly innovative design compositions than does any other form of Native container. The designs historically applied to bent-corner bowls were much less conventionalized than those of square boxes, and it appears that this conceptual freedom was transposed into a taller, more flat-sided form of the object, creating a large field of expression that was independent of the traditions commonly applied to lidded boxes and chests. Usually made up of four asymmetrical, independently-designed panel compositions, such tall "bowl" surfaces often include non-formline bands (usually of the secondary color) that exclude the traditional formline patterns from sections of the design field, like the narrow ribbons of red that parallel the bottom edge of each panel on this bowl. These are the types of painted field borders that have been termed *ultra-primary* in Holm's terminology (though the name postdates the *Analysis*), based on their position superseding the painting of primary designs.

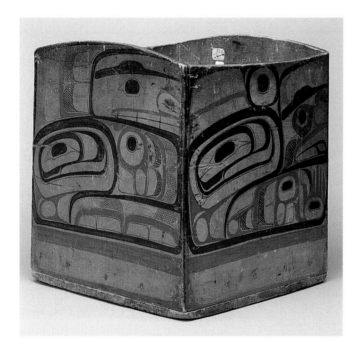 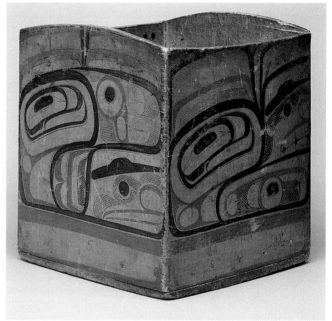

5.8a, b. Bent-corner bowl

Haida, *c. 1880. Redcedar, paint. 15″ H × 14″ W × 14″ D. Collection of Jack and Jane Curtright*

*This tall bent-corner bowl exhibits four wonderful examples of the kind of free-form, highly innova-
tive, asymmetrical design compositions frequently seen on such containers in this period. Each panel is
an independent "canvas" on which the artist has exercised as much design invention as he thought
appropriate, relying only minimally on traditional formline structures or formats. Parts of this design
are illustrated in Holm 1965 (figs. 35a, 42a #12, 59a, 59b).*

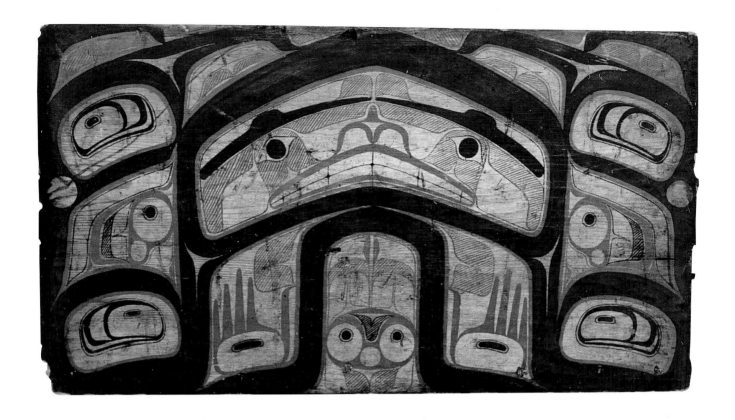

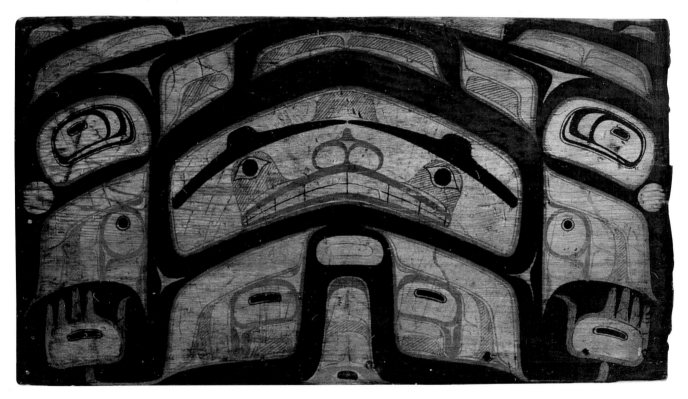

On some examples, the ultra-primary movements were very broad and often differed in shape from one side of the bowl to another. In others, the ultra-primary fields were laid down as limited areas of background, and monotone formline patterns in the opposite color were freely applied over them. Only very rare examples of red-on-black painting can be found in the early formline tradition (Holm, pers. comm.), while such innovations became much more common in the late nineteenth

ParSCORE™
SCORE SHEET

| | T F | | | T F | | | T F | | | T F | | | T F | |

1–10, 11–20, 21–30, 31–40, 41–50 (A B C D E / T F)
51–60, 61–70, 71–80, 81–90, 91–100
101–110, 111–120, 121–130, 131–140, 141–150
151–160, 161–170, 171–180, 181–190, 191–200

TEST FORM (A) (B) (C) (D)

SUBJ SCORE 0 1 2 3 4 5 6 7 8 9

NAME
SUBJECT
HOUR/DAY
DATE

ParSCORE™
STUDENT ENROLLMENT SHEET

I.D. NUMBER 0 1 2 3 4 5 6 7 8 9

PHONE NUMBER AREA CODE 0 1 2 3 4 5 6 7 8 9

CODE A B C D E F G H I J K L M N O P Q R S T U V W X Y Z

LAST NAME **FIRST NAME** **M.I.**
A B C D E F G H I J K L M N O P Q R S T U V W X Y Z

SCANTRON FORM NO. F-1712-PAR-L © SCANTRON CORPORATION 1998 ALL RIGHTS RESERVED. 06 M12 0303 999 1211 10 9 8 7 6 5 4 3 2 1 To reorder call 1-800-722-6876 www.scantron.com

century. A number of highly interesting variations of design style, illustrating major departures from the historic mainstream, have been "discovered" in museums and private collections, many in just the last two or three decades. Certain of these are amazingly inspired paintings and carvings that represent the greatest extent to which the original principles of the Northwest Coast tradition were stretched in the historic period. The currently anonymous artists who created these designs raised the tradition to a high point of imagination and design evolution, unequalled until the last ten to fifteen years of contemporary artistic development. One such example has been referred to by Wilson Duff as the "Final Exam" in northern Northwest Coast art (Duff et al. 1967:cat. 293 [AMNH 19–1233]).

Figure 5.9 illustrates a chest panel with one of a number of highly innovative design styles that appear to have developed in the northern British Columbia coastal villages. These remarkable pieces incorporate a catalog of design techniques that appear in only a fraction of existing Northwest Coast paintings: the combining of very heavy and very light formlines in the same design; the use of red lining on the edges of black formlines; and the application of red designs directly on top of black painted areas. A handful of objects painted in this general style have come to light in the last twenty years, many revealed through the research of Bill McLennon and his associates in the infra-red photography project at the University of British Columbia Museum of Anthropology.[1]

One Man, Many Traditions: The Art of Charles Edenshaw

The Native Visions exhibition is fortunate to include several examples of the very inventive style of Charles Edenshaw, also known by his Haida name, Tahaygen (figs. 5.10–5.17). As is perhaps true of most artists, Tahaygen's style of two-dimensional art changed over time, influenced in part by the adaptation of his formline designs to a variety of media—wood, ivory, and particularly argillite and silver (Davidson 1995:142), each with unique compositional textures that can profoundly influence the flow and movement of a carver's tools. Tahaygen's earlier work exhibits the formality and angularity typical of the pre-1865 period in northern formline art, while his later work is much rounder, softer of line, and more inventively and playfully flowing in composition. He often altered or simplified the standard formline structures of creature's heads and bodies, whether to reduce redundancy of line in very small scale jewelry or to define his own personal vision. He also frequently shifted traditional color usage, as is seen in the red lips of an otherwise black primary frog on the spruce root hat in figure 5.14. This most likely reflected his conception of the interplay between flat design and sculpture, as exemplified in the structure of faces on the yew wood model pole (fig. 5.11). Here one sees three-dimensional faces with typically red lips that also display formline structure on their eyebrows, temples, and cheeks, a very old concept at the heart of the Northwest Coast tradition (see fig. 3.7).

The paintings applied to the exquisitely formed canoe model in figure 5.10 display characteristics similar to those on the previous boxes in terms of formline weight and positive-negative distribution, as well as in the semi-angular quality of the ovoids and U-shapes. These paintings were probably done in the earlier half of

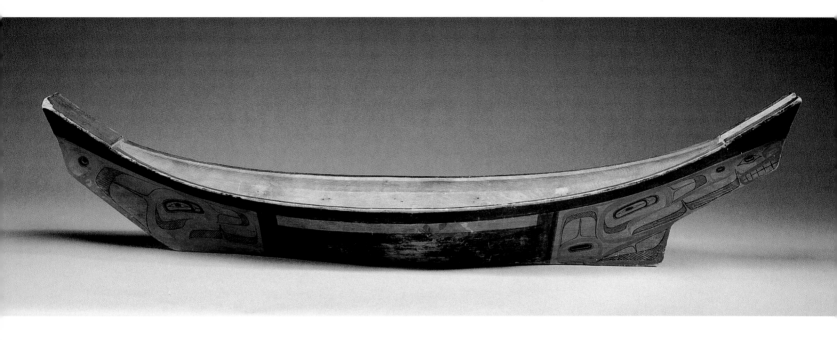

Tahaygen's career, before his style evolved to the more rounded, soft-cornered elements of his later formline work (figs. 5.12–15). Done in red primary formlines, the designs employ single and cross-hatched black secondary U-shapes and very open tertiary areas that expose a lot of background wood surface. The designs are skillfully composed to adapt to the multifaceted shapes of the canoe's bow and stern, with each representative but ambiguously simplified image oriented to the front of the vessel.

Tahaygen is said to have worked in conjunction with other artists and craftsmen, such as the Davidson brothers, Alfred and Robert, Sr., who made full-size canoes, models, and chests and boxes on which Tahaygen applied his inventive formline designs (Davidson 1993).

As one of the truly outstanding model totem poles ever carved, Tahaygen's yew wood masterpiece (fig. 5.11) makes a wonderful comparison with one of the same artist's argillite totem poles (fig. 5.12). It is clear how the freedom of dimensionality offered by the medium of argillite has influenced the carving of the wooden model poles, exemplified by these fine miniature monuments.

> The early carvers of argillite were . . . wood carvers, so they directed the wood style to argillite. . . . They were able to be a lot more fluid with this medium than with wood. When Edenshaw started developing his slate style, you could actually see it reflected in his wood carving. Wood carving in turn became influenced by argillite style. (Davidson 1995:144)

Both of these skillfully refined models display deep dimensionality, with a lot of under cutting and piercing in the sculpture of their individual images, in which Tahaygen has masterfully demonstrated his ability at depicting playful characterizations of traditional Haida figures. Pacific yew (scientifically classified as a coniferous softwood) is one of the harder native Northwest Coast carving woods, though it has a marvelously plastic quality when it is carved green, as this pole doubtless was when

5.10. Canoe model
Charles Edenshaw and Alfred Davidson (attr.), Haida, *c. 1885. Yellowcedar, paint. 9″ H × 44″ L × 9″ W. On loan from John Muir Elementary School, Seattle. SAM L93.1*

This exquisitely refined and sculpted model of a classic 19th-century northern or Haida-style canoe is nearly a twin to one housed in the Burke Museum (#1–3004). This model differs mainly in its inclusion of an unpainted rectangle within the black area covering the center section of the hull. The painted designs on the two canoes are nearly identical, and have been attributed to Haida master Charles Edenshaw (Holm 1987:144, cat. 56). The canoes are attributed to Alfred Davidson (see MacDonald 1996, 133-35).

5.11 a, b. **Totem pole model**
Charles Edenshaw *(1839–1920),*
Haida, *c. 1890. Yew, paint.*
36″ H × 5″ W × 4″ D.
Collection of Allan and Gloria Lobb

This large model totem pole has a level of dimensionality more akin to that of argillite carving than of the typical full-size Haida totem poles. Edenshaw worked in both media, and expertly transferred the lessons gleaned from the argillite tradition onto the creation of totemic figures with highly animated, fully developed personalities like those on this outstanding miniature monument (Davidson 1995:144).

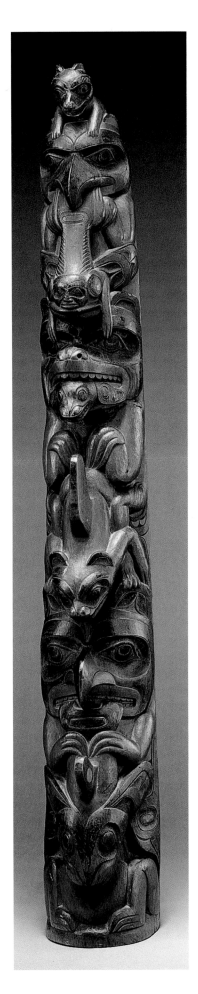

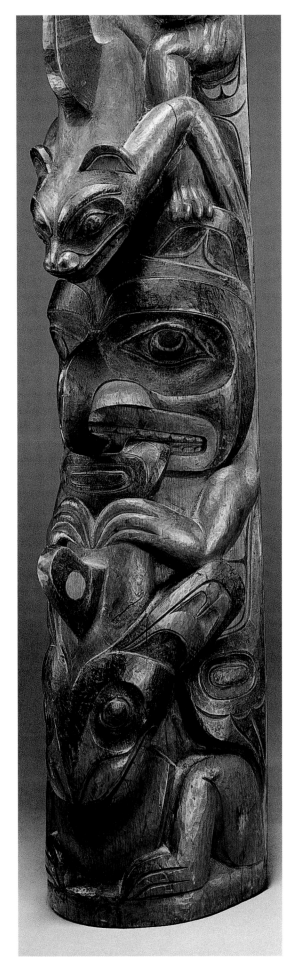

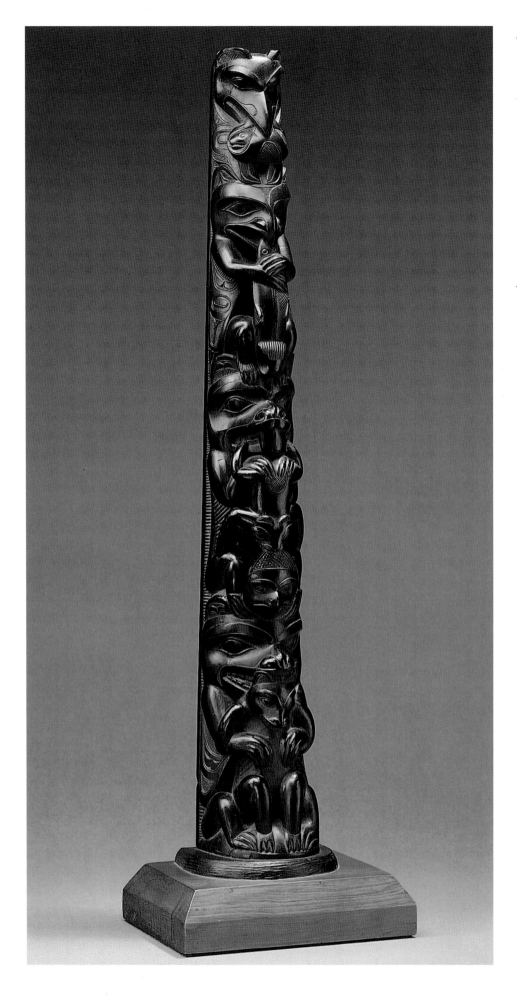

5.12. *Qwa.a gyaa.angaa (argillite totem pole model)*
Charles Edenshaw, Haida, *c. 1910.*
Argillite. 21″ H × 3.5″ W × 2.5″ D.
Collection of Bill and Marty Holm

The medium of argillite allowed Haida artists to increase the depth of relief in and around the various fig- ures, a major change from the full-size totem pole tradition that evolved as a much-less-deeply-relieved cylindrical form. The sculptural relationship of this argillite pole to the wooden pole by this artist (5.11) demonstrates how the experience of argillite sculpture influenced the further evolution of the woodcarving styles on which the argillite poles were originally based.

5.13. Qwa.a qiiłaa (argillite plate)
Charles Edenshaw, Haida, *c. 1885.*
Argillite, wood (center peg).
13″ Dm × 2″ D. SAM 91.1.127

In even his simplest pieces, Edenshaw could imbue his images with a playfulness and free spirit that was a substantial departure from the majority of the older Northwest Coast tradition. In this very complex, multiple-image design, this aspect is still refreshingly prominent and clearly communicates the divinely humorous spirit of the mythology.

it was shaped out. The final refinements and finished surfaces would have been accomplished as the wood slowly dried. Hollowing in the back of this model functioned much as it does for full-size poles, allowing the wood to dry more evenly and minimizing the possibility of severe cracks or checks developing on the sculptured front of the carving.

Tahaygen's flair for perfection can also be seen in the accurately circular form of one of three argillite plates that he decorated with a narrative depiction from Haida mythology: the creation of human females (fig. 5.13). A small-diameter drilled hole, filled by a wooden pin, served as the axis around which Tahaygen "turned" the piece of argillite to create the plate's perfect shape and border lining (Davidson 1993). The role of Haida artists in perpetuating the imagery and content of Haida mythology paralleled that of the first ethnologists who journeyed to Haida Gwaii to record songs, stories, and other details of Haida oral literature (Wright 1995:135, 137–38). The subtle forms of the canoe are succinctly represented, and the somewhat more austere, conservatively traditional style of its two-dimensional embellishments con-

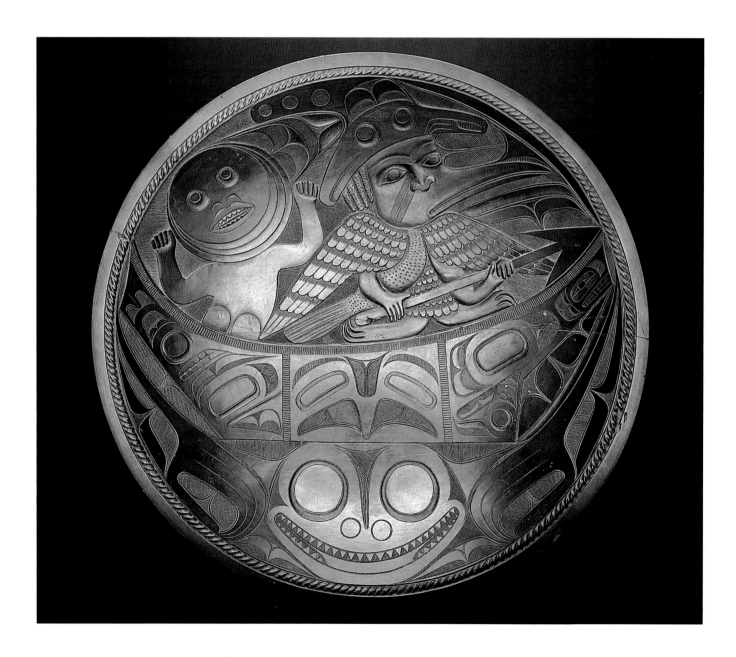

veys the essence of cultural context for the illustration of the story. The playful rendering of the half-human hero, Raven, with hunting spear and ingeniously conceived crest hat, is delightfully surreal in its animated three-dimensionality. The simplicity of the shelf fungus as steersperson is humorously appropos. Whether the round-eyed, toothed image below the canoe represents a sea monster or the sea itself, it conveys a paradoxically benign ominousness that somehow suits the total composition.

Tahaygen's ability as a formline designer and the very inventive personal styles he developed in his decades of dedicated effort are but a part of his important legacy. Three fine examples of his later painting style are also illustrated here, as the final embellishments adorning three woven pieces created by his equally masterful wife, Isabella (figs. 5.14, 5.15, 5.16). Two images are painted on finely made semi-conical hats of traditional form, and one fills the circumference of a beautifully woven cylindrical basket. Each is a remarkable example of Haida weaving style, a skill that survives today in a new generation which includes Isabella's great-granddaughter, the contemporary weaving master Isabel Rorick (see fig. 7.11), whose instruction in the techniques was passed down through the preceding three generations of her family. The frog, killer whale, and sea wolf that Tahaygen painted on these examples of his wife's weavings illustrate his special skill in depicting Haida images with as few formlines and design shapes as necessary, capturing important aspects of each of the animals in the lines and movements of his compositions.

In figure 5.14, the wide-mouthed, red-lipped frog spans from brim to crown around the circumference of the hat, though a large amount of background space shows through between the various parts of the frog's body. The frog's head and limbs, which are relatively naturally proportioned, are made up of very simple design elements. Particularly masterful and concise is the way the U-shaped movement of the hind leg and foot enclose a typically proportioned secondary U-form and tertiary area. The switch from black to red primary in the coloring of the lips reflects Edenshaw's handling of two and three-dimensional aspects in sculptural pieces (see fig. 5.10; and Holm 1965:17, fig. 13).

5.14. *Xaad dajaangaa*
(painted woven hat)
Charles and Isabella Edenshaw,
Haida, *c. 1890. Spruce root, paint.*
6″ H × 18″ Dm.
Collection of Allan and Gloria Lobb

In decorating most of the gracefully shaped and technically refined hats woven by his wife, Edenshaw seems to have preferred the type of design conception that Holm labeled "expansive" (1965:12). This style of image distribution addresses the total surface field of the object (edge to edge) without completely filling it with positive design structures.

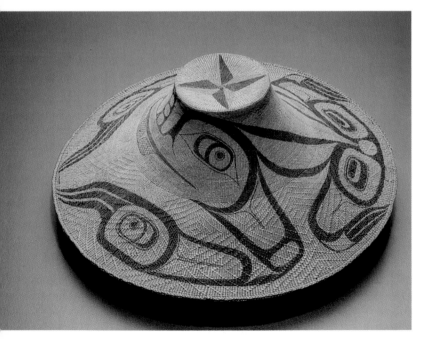

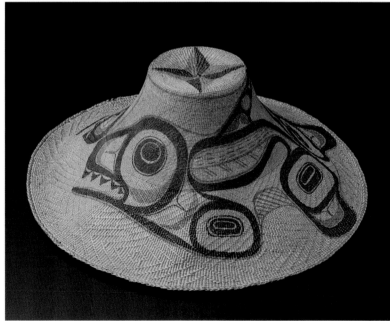

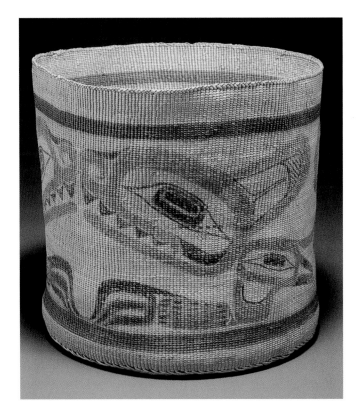
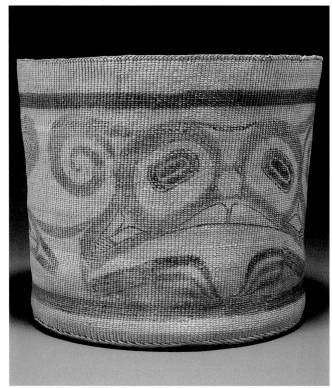

5.16 a, b. **Painted basket**

Charles and Isabella Edenshaw, Haida, *c. 1900. Spruce root, paint. 9.5″ H × 9″ D.*
Collection of Allan and Gloria Lobb

Haida baskets most often do not feature the kinds of elaborate designs applied by false embroidery that are typical of Tlingit basketry traditions, instead employing the more subtle techniques of self-patterned weaves and dyed weft bands to augment the visual effect of a container (Holm 1987:164, cat. 66). Charles and Isabella Edenshaw often collaborated in making heirloom objects for sale, and this finely painted basket illustrates the inherent harmony of their efforts.

5.15. Xaad dajaangaa
(painted woven hat)
Charles and Isabella Edenshaw,
Haida, *c. 1895. Spruce root, paint.*
5.5″ H × 17″ Dm. SAM 83.226

In this depiction of a contented killer whale, Edenshaw has reduced the number of design elements to the absolute minimum required to fulfill the image and span the hat surface. His free and relaxed sense of the flow and movement of both the whale image and the design structure illustrate his mastery of the tradition.

In figure 5.15, Edenshaw's desire to balance the distribution of ovoids may have led him to terminate, rather than initiate, the pectoral fins with this design element. This reversal of ovoid and U-form roles ingeniously avoids any monotonous duplication of structure between the tail flukes and the fins. His use of red finelines to define the boundaries of the whale image and enhance the negative background areas was probably developed by his experience in silver and argillite, where his use of double-cut lines to separate a formline image from the textured ground can be seen (see figs. 5:13, 5.17).

Figure 5.16 is an example of woven basketry. Lacking the upper field of patterned weaves often seen in Haida baskets of this shape and limited to two broadly spaced bands of dyed weft, this container was made to be painted. The wolf design embracing the circumference of the basket illustrates the simplicity of form that is typical of Edenshaw's later work. It is made up of essentially single-unit structures that pattern the flow of the image composition with Haiku-like efficiency.

The least traditional object (in terms of its form and use) is the walking cane, one of approximately a dozen that Tahaygen carved between about 1880 and 1910,

each conforming to the essential model of this example (fig. 5.17). Made as gifts for respected friends and dignitaries (Hoover 1995), and sometimes in pairs, these canes are spectacular assemblages of exotic materials and imagery. Most display Haida figures in their sculpture and the two-dimensional designs on the silver ferrules, but other kinds of imagery made their way into his cane work, including foliate silver designs and a sculptured ivory elephant's head, possibly drawn from a photograph of Jumbo, the highly publicized pachyderm of the day (Hoover, pers. comm., 1993–1995:47, figs. 3,4). Tahaygen chose to illustrate three different canes with the same essential imagery seen on this ivory finial. The first, made in 1883 and purchased by James G. Swan, is now in the collection of the Jefferson County Historical Society in Port Townsend, Washington, where Swan made his home in the later part of his life (Doig 1980:179–80; JCHS 78.11.868). In that piece, the body of the snake is laid right against the hand and wrist, without the more delicate piercing seen in figure 5.17, which is probably the second of the three existing finials of similar design. The third hand-and-snake finial resides in a British Columbia private collection and was prob-

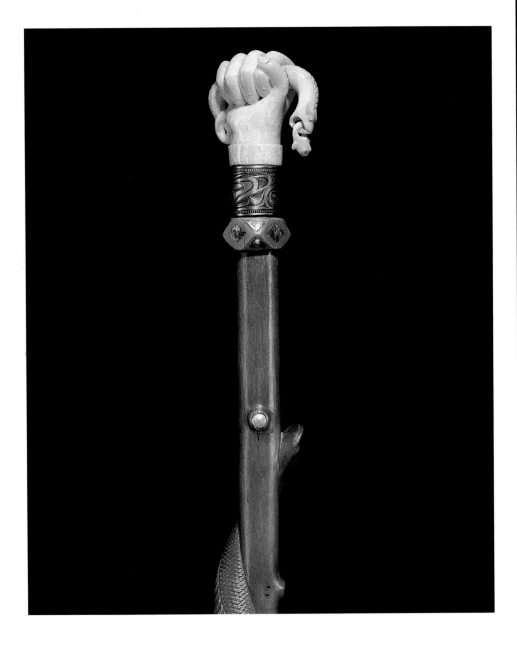

5.17 a,b. Presentation cane
Charles Edenshaw, Haida, *c. 1906.*
Crabapple, walrus ivory, abalone,
coin silver. 42″ L × 4″ W × 2″ D.
SAM 93.5

Edenshaw created about twelve or so
of these special canes in his career,
many of which took this general form:
a crabapple wood shaft carved with a
spiral snake, abalone-inlaid geometric
collar, silver ferrule, and ivory finial.
Except for the commonality of the
snake image, each of the canes differs
in the iconography represented and
the specific characteristics of its sculp-
tural components.

ably created after the other two, as it depicts the snake's body with an extra coil at each side of the hand, even more delicately pierced than the version exhibited here. Swan records that Tahaygen ascribed the meaning of the image to the Greek tale of Laocoön, indicating that the Haida master's education embraced classical mythology as well as the legends of Haida Gwaii (Doig 1980:190–91).

Each of Edenshaw's canes is a unique, handmade creation that differs in the place-ment of the carved "branch nubs," the proportions of the inlaid diamond shapes of the collars, and other specific details. This example displays the engraved image of a long-beaked bird on the silver ferrule, perhaps a heron or crane, a depiction that appears on several of the artist's silver bracelets.

The tiny dangling frog (carved of one piece with the snake head and hand), is an especially delicate touch that Edenshaw also included in other cane sculptures (RBCM 18677, 18176). A photograph taken about 1906 of Edenshaw at his window-lit work table shows the finished shafts for two canes against the wall (Brown, ed. 1995:144; RBCM PN5168). The particular patterns and relationships of the snake and the carved and inlaid branch nubs of this cane exactly match those of one of the shafts in the photo, and match the other not at all, suggesting that this cane was very possibly made from the matching shaft.

Further transitions and developments in Haida culture and its relationship to the outside world are illustrated in figures 5.18–5.19. The decade of the 1880s saw the first creation of Haida-style chests in the argillite medium (Macnair 1984:129), possibly in response to the interest in the old containers displayed by the many zealous museum collectors of the period. The fine example illustrated here (fig. 5.18) has been attrib-uted to Tom Price (Holm 1981:193–97), a carver living at Skidegate who was Eden-

5.18. **Qwa.a xudee** *(argillite chest)*
Tom Price (attr.), Haida, *c. 1885.*
Argillite. 11″ H × 21″ L. × 5″ D.
Collection of Bill and Marty Holm

The decade of the 1880s saw the intro-
duction of the model chest format into
the Haida argillite repertoire (Mac-
Nair and Hoover 1984:129), based on
the concepts of full-size painted and
carved wooden chests. Quarried slabs
of argillite are hewn flat, relief-carved,
and fastened either edge-to-edge or to
inner wooden forms to create such
model containers. Sculptural figures
are added in some cases, such as the
bear's heads and forelimbs and the
naturalistic frogs that have been
adhered to the sides and top of this
fine example (see also p. 98).

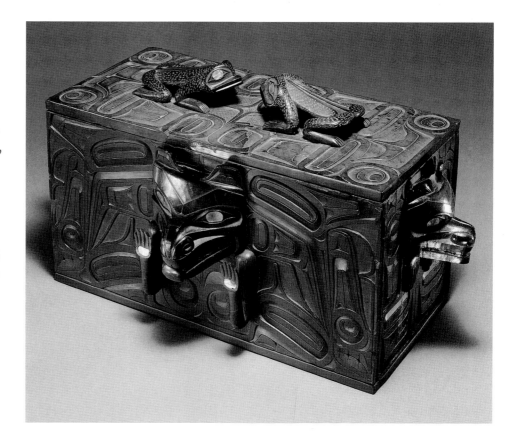

119 EXPANDING TRADITIONS: THE LATE CLASSIC PERIOD, 1865–1920

shaw's and Robson's contemporary. This chest features six very refined sculptural additions representing grizzly bears and frogs, emblems of opposite moieties in the Tlingit social system, but complementary ones in that of the Haida. The combination of flat design and sculptural representation on bent-corner chests goes way back in Northwest Coast tradition (see fig. 3.1), and also recalls the flat panels with full-sculptured heads often seen on noble Haida burials.

In figure 5.18, the sculptural and two-dimensional designs on the chest front and back combine to depict the types of design images common to the traditional chest format (as seen in fig. 4.18). Here the head and forelimbs of the bears take the place of the central head and forelegs of the conventional formline chest design. The adjacent formline designs on either side of these sculptural heads very closely replicate the essential structure of the standard design types. The formlines are quite thin in this example, with fairly large tertiary areas that are carved back with abruptly flat bottoms. The most prominent tertiary finelines are formed as distinct, flat ridges that are unusually broad, but uniform in width around every curve and design shape. The sculptural style of the bear heads, formed of several related, harmonious planes and hollows, is closely derived from the totem pole traditions of the southern Haida. The surviving peoples of the southern islands of Haida Gwaii, severely reduced in number by the 1862 smallpox epidemic, left their ancestral villages and relocated in the area of Skidegate, where this chest was probably made.

The lively argillite chief figure (fig. 5.19) and the group illustrating scenes from the bear mother story (fig. 5.20) are fairly typical of the representational and narrative turns taken by Haida sculpture in the late nineteenth century, when the practice of Haida ceremonial life was actively discouraged. The same public figures and authorities that forbade Haida ceremonialism also allowed, and perhaps encouraged, the depiction of ritual practices represented by figures of chiefs, shamans, and mythological characters in objects made for sale (Macnair and Hoover 1984:145).

Such figures as chiefs and shamans had occasionally appeared on full-size Haida totem poles in the height of their glory a few decades earlier, but these types of subjects became fairly common in the volume of argillite sculpture produced for sale in the late nineteenth century. By the 1880s and 90s, the influence of missionaries and government agents had quelled the traditional expressions of Haida culture (Davidson 1995), and enabled museum collectors to gather up as much of the material culture and art as they could acquire (Cole 1985). It has been said that "The missionaries saved our bodies [from the epidemics], but they killed our spirits." (Poole 1980). At this phase of the Haida argillite carving tradition, the structural integrity and prominence of the two-dimensional system had been significantly diminished in some examples, eclipsed by the representation of sculptural forms. While a handful of artists like Edenshaw, Robson, Price, and others maintained the essential integrity of the flat design conventions through this time period, a new generation of artists was coming up that apparently lacked an equivalent level of training in two-dimensional design principles. These artists either loosely copied the major forms of the two-dimensional tradition without fully comprehending the underlying and unifying structures (as can be seen in fig. 5.19), or left them out entirely in favor of naturalistic representations, such as the texture of bear fur (as seen in fig. 5.20). On each end of this composition (5.20), crouching bears illustrate

5.19. *Argillite chief figure*
Haida, *c. 1890. Argillite, ivory, abalone, sea lion whiskers, bird down. 11″ H × 3.5″ W × 3″ D. Collection of Bill and Marty Holm*

This little dandy is decked out in the full regalia of a Haida chieftain, including a fringed apron, a Chilkat robe, a neckring of cedar bark, a frontlet headdress topped with sea lion whiskers and shell inlay, and a raven rattle made of ivory (a reconstruction by its current owner). The finely sculptured face and frontlet, and the lively stance of this small figure set it apart from many other such pieces. As the grand past of the Haida traditions faded, perhaps the creation of these kinds of images aided the survivors' transition to an uncertain future by serving as tiny memorials to those who outwardly expressed the greatness of Haida culture.

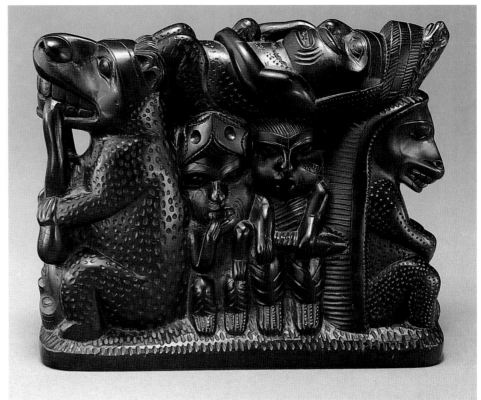

5.20. *Argillite figure group*
Haida, *c. 1890. Argillite.*
6″ H × 8″ L × 2″ W.
Collection of Bob and Betty Stott

In the late 19th century, the argillite
tradition saw the opening up of
traditional subject matter to include
narrative illustrations of Haida
mythology and depictions of shamanic
dress and practice. This dense figure
group appears to include both.

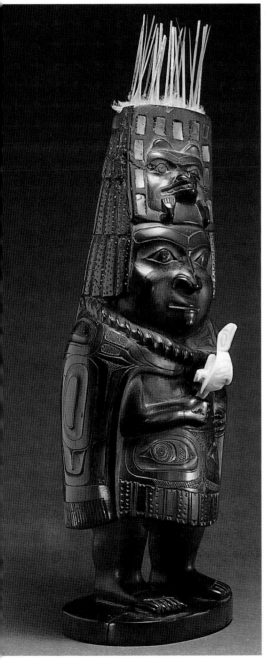

images from the Bear Mother myth. On the left a large male has captured a human, whose inverted position and pupilless eyes indicate that life has left him. On the right is a bear that appears female, draped within what is either a cascading headpiece or a representation of the bear's den. Between the bears two humanoid figures may represent the brothers of the woman who married a bear. Lying on top of the group is the image of a shaman, indicated by a bone nose ornament and a headdress of typical shamanic form embellished with the sculpture of a frog.

Over time, the subjects and configurations depicted by the argillite carvers narrowed to primarily those of the model totem pole genre, though these sometimes took the form of narrative representations of mythology (rather than traditional crest display) in a vertical, totemic format. After the passing of Edenshaw and his immediate contemporaries in the first decades of the twentieth century, argillite carving of this type became the surviving backbone of Haida artistic production, carried on by men such as Henry Young and others (Wright 1995:140). These men created their art during the darkest years of the Depression and World War II, when the interests of most Haidas and other peoples of the world were focused on basic economic and personal survival.

The Far North in the Late Nineteenth Century

On the most northern Northwest Coast, a fairly similar history was being played out, though the remote territorial status of Alaska and its proportionately high Native population may have mitigated the impact of federal Indian policy as it was applied among the First Nations of the lower forty-eight states and Canada. No treaties were made between the Alaska Native nations and the federal government, and no reservations were set aside except for the Metlakatla Indian Community reserve on Annette Island, fifteen miles south of Ketchikan, Alaska, not far north of the British Columbia/Alaska border.[2] Land claims with Alaska Natives were not successfully resolved until 1971, with the passage of the the Alaska Native Claims Settlement Act (ANCSA) establishing Native regional and village corporations and granting the selection of lands and a cash settlement. These have since been administered by the Natives themselves on a commercial and corporate basis.

In the late nineteenth century, traditional Tlingits carried on their ceremonial life in much the way it had been done previously, although with a greater emphasis in the more remote villages of predominantly Tlingit population, where an abbreviated but vigorous ceremonial practice has continued through the twentieth century. In Sitka, Alaska, foreign influence had been strong since 1804, when the Russian Ameri-

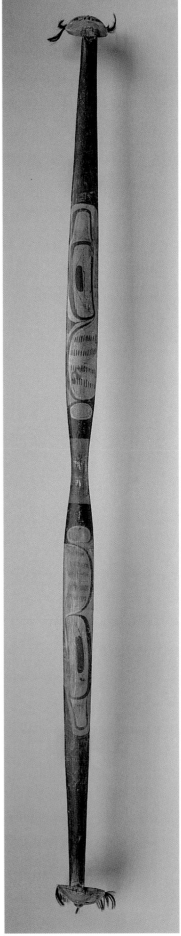

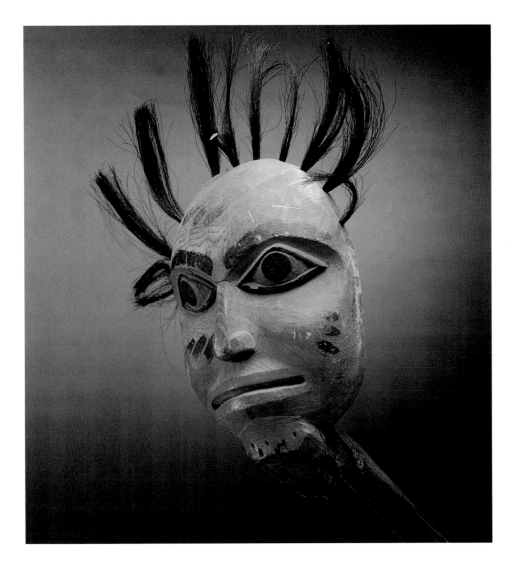

can trading company won back in battle with the Kiks.adi clan their foothold on Baranof Island, lost to Tlingit attacks in 1802 (see fig. 3.9). Transfer to American military control in 1867 changed little for the Tlingit population at first, though the seemingly inevitable gold rushes and a burgeoning fishing industry in the late nineteenth century brought a great deal of alteration in even the more isolated locations. Attrition, disease, and the social pressures of Americanization eventually took the old traditional artists out of the continuum without passing on their esoteric knowledge, as had been done in the not-so-distant past. The delicate balances of the two-dimensional northern art style were altered in some important ways long before the decrease in traditional art production reached its peak in the mid-to-late twentieth century, although some late nineteenth-century Tlingit artists maintained quite well their knowledge of the style (Brown 1994).

These trends can be seen in three very interesting and unusual objects in this collection, each an object from either the fringes of the mainstream Tlingit art tradition or its geographic distribution (figs. 5.20–5.22). Figure 5.21 illustrates an immense configuration of the traditional style of hunting bow, one of perhaps five or six examples extant, to which has been added a carved human face at each end of the object. These outsized and symbolic images are said to have been used as weapons by Tlingit (and Haida) shamans in their battles with malevolent spirits (Wardwell 1996:227, fig. 336; de Laguna 1988:275), though this usage may have faded along with shamanic influence generally in the late nineteenth-century period. They were also apparently employed as dancing staffs on some occasions as is evidenced from photographs of at least two events that took place well after the decline in shamanic practice. One of these pictures appears to include this particular bow, held by a regalia-clad dancer in the stern of the Chief Shakes Killer Whale canoe as it travels across Wrangell harbor (probably 1940).

The two-dimensional designs painted on the outer surface of this bow are totally traditional in style, though very sparsely applied compared with some examples (SAM 91.1.66, collected in Haines, Alaska, late 1970s). The making of this unusual sculpture is attributed to Toya.áat, a Tlingit artist from the Stikine or Wrangell area of central southeast Alaska, who was killed in a tragic intertribal altercation in January of 1880 (Emmons/de Laguna 1991:331). The sculptural composition of the faces on this bow can be readily related to the faces carved on totem poles and other objects from the Stikine region which are more directly related to the life of Toya.áat (Brown 1994).

The very uncommon object in figure 5.22 appears to have been created as a kind of rattle, or possibly a power object employed by a shaman in his curing or divining practice. It appears to combine an early nineteenth-century shaman's figure of a small human or spirit image with a late nineteenth-century salmon sculpture that has been hollowed out to enclose the smaller figure, probably illustrating the Tlingit tale of the Salmon Boy, in which an errant boy was taken among the salmon people to teach him respect for their kind. Later returned among his people at Nakwasina Bay, he became a powerful shaman. Exactly how or by whom this remarkable piece was used is not readily apparent.

Tlingit artists also created model totem poles and house posts in this historic period, along with many canoe models and other saleable kinds of objects. By the

1870s, visitors to the Sitka area were buying Euro-American-style fork-and-spoon salad sets carved with totemic figures and were sending them home as mementos of Alaska (Holm, pers. comm., c. 1974). The degree of adherence to earlier formline design traditions varied a great deal in these objects made for sale. In general, though, by 1900 it appears that the sculptural traditions of Tlingit style were better maintained than the two-dimensional conventions. This was accomplished by artists who essentially had to teach themselves merely through observation of surviving old pieces, without much direct training from earlier generations of knowledgeable artists. The house post model illustrated in figure 5.23 exhibits a very strong Tlingit sculptural style, and yet the typically two-dimensional aspects of the imagery have been minimized or not included at all by its creator. This particular piece hails from Katalla, at the extreme northern end of Tlingit cultural influence, however, which is also a factor in the appearance of the work in its case.

Katalla was a nineteenth-century village of the Eyak peoples (of Athabaskan language stock), situated between the mouth of the Copper River and Cape Suckling on the Gulf of Alaska coast northwest of Yakutat Bay. Around the turn of the nineteenth century, the Eyak moved into this area when they and Tlingitized Eyak from the Yakataga and Yakutat areas drove the Chugach Eskimo from Controller Bay (west of Cape Suckling), beyond the Copper River and into Prince William Sound (de Laguna 1990:189). Intermarriage with and adoption of Tlingit traditions by the southeastern Eyak groups produced a hybrid culture eventually dominated by Tlingit language and traditions. A house of the eagle moiety supported by two house posts stood at Katalla. Figure 5.23 is a model of one of these. Illustrations of the full-size posts appear in *Monuments in Cedar* (Keithahn, L., ed., 1963:57). An eagle with a proportionately large head stands on top of a face that may represent the eagle's nest, or a figure from the history of the house group.

A profile face, isolated secondary U-shape elements, and other forms depict the joint and feathers of the eagle's wings. A relief-carved, inverted face enhances the joint of the eagle's tail, extending from between the wing tips at the front of the post.

The decline in the old-style traditions of carving and painting among male artists was neither as pervasive nor as absolute among the creators of traditionally female Tlingit arts such as basketry and weaving, which continued in much the same status and visual condition in the hands of a precious few individuals through the middle twentieth century. A few of the basket and Chilkat-style weavers who learned their techniques beginning in the late nineteenth and early twentieth centuries survived into the late 1900s, and their long-isolated skills were passed on to newly interested generations of young Native women through a variety of means (of which more will be discussed later). The Chilkat style of weaving had been traditionally applied to aprons, robes (both full- and child-size), shirts and tunics, leggings, hats, and other regalia objects, either woven originally in these forms or assembled from cut pieces of Chilkat robes distributed at potlatch giveaways. Today, these techniques are also applied to vests, pouches, flat bags, wall hangings, headpieces, and carved mask or headdress accompaniments.

The continuation of Tlingit ceremonial life through the turn of the twentieth century called for the renewal and replacement of woven robes that had either been placed on the graves of their owners, cut up and distributed after their deaths, or

5.22. Salmon rattle

Tlingit, *c. 1880 (salmon), c. 1840 (inner figure). Alder, paint. 7″ H × 25″ L × 4″ D. Collection of John Putnam*

Stylistically, this piece is a composite of two periods. The small human figure within the salmon's body appears to have been carved in the first half of the 19th century, as it is very similar in sculptural form to shaman figures dated comparatively to that era. The split and hollowed salmon is embellished in the style of the 1880s, as is seen in Tlingit carvings made to replace heirloom objects destroyed by the U.S. Naval bombardment of Angoon village in 1882 (Emmons 1991:334).

5.23. House post model

Tlingit, Katalla, *c. 1880. Spruce, paint. 30″ H × 7″ W × 5″ D. Collection of Bob and Betty Stott*

This model may have been made by a Tlingit carver, or a carver from among the Katalla Eyak who was thoroughly familiar with Tlingit traditions. The sculptural forms are traditionally Tlingit in character, though the two-dimensional work, as seen in many sculptures from this period, is lacking in conventional primary formline cohesiveness.

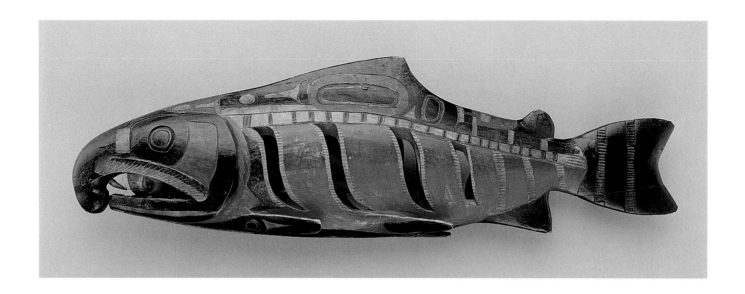

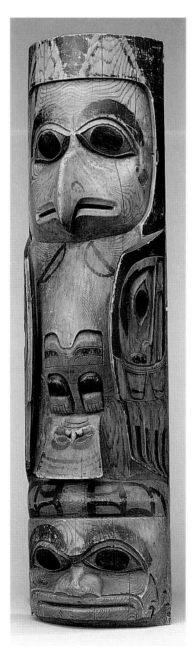

sold. Others had been acquired early on by museums and private collectors.[3] The repeated duplication of certain Chilkat robe designs may have been motivated by a shortage of fresh, unique pattern boards in a period when artists with requisite knowledge of traditional formline conventions were being diminished by natural attrition and disease, and by pressure from civil authorities to assimilate.

At the end of the nineteenth century and into the early twentieth, some of the remaining weavers began to create their own designs to fulfill continuing commissions for woven pieces of crest display art. By the early twentieth century, some such designs departed significantly from the early nineteenth-century formline traditions, and focused instead on a more simplified, silhouette image style with a few secondary and tertiary design forms incorporated into the individual figures or the background field. Some weavers, though, exemplified by the longest-lived member of their fraternity, Jenny Thlunaut (1891–1986), had absorbed sufficient knowledge of the formline tradition through their work that they were able to keep a large measure of the design structure intact in their own compositions.

The three examples of this complex art form represented in figures 5.24–5.26, display the early nineteenth-century formline conventions as clearly as any within the tradition. The shirt or tunic exhibits a formline design that was employed in the making of a woven tunic on more than one occasion. Three of these are still in existence (Brown, ed., 1995:64, cat. 18). The formline style of this bear image maintains the design proportions and structures of the earliest Chilkat-style weavings, and yet the spatial distribution of the bear's body and limbs incorporates a great deal of negative design area into the overall composition. The resultant openness of the design field leaves a lot of white background yarn visible between the black primary formlines of the bear image, and represents a distinct departure from the mainstream Chilkat robe design tradition of the earlier nineteenth century. Chilkat restoration artist Katy Pasco has pointed out that the two-ply yarns of this shirt are of sheep's wool, spun in the opposite direction to most Native-made yarns, and probably commercially produced. The unusual blue yarn color may come from unraveled trade wool, or may have been created using newly available commercial dyes. The yarns of two slightly differing blue dye lots are visible.

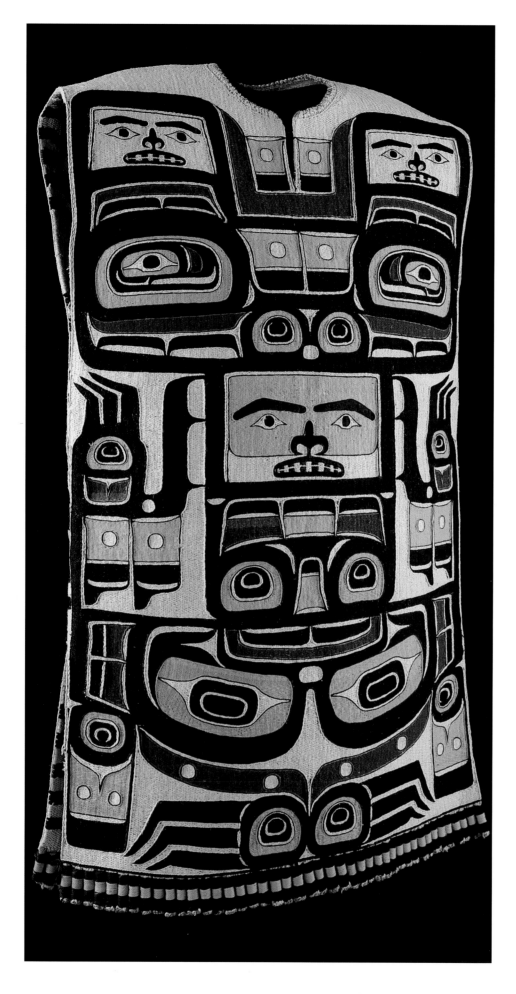

5.24. *Xoots naaxein k'oodas (bear Chilkat shirt)* **Tlingit,** *c. 1875. Mountain goat's and/or sheep's wool, yellowcedar bark, wood plugs, dye. 43″ L × 25′ W. SAM 91.1.137*

This woven sleeveless shirt (or tunic) is exceptional in its skillfully composed design and the highly refined quality of the weaving techniques. The concept of such a garment appears to be based on the tradition of moose or elk hide shirts with painted crest images on the front, many of which were employed as battle armor (Holm and Vaughn 1982:85, fig. 49). The bands of geometric patterns often seen on the rear of woven shirts have been related to the porcupine-quill embroidered designs of very early Tlingit moose-hide shirts (Thompson 1991:66–76). (See also p. viii.)

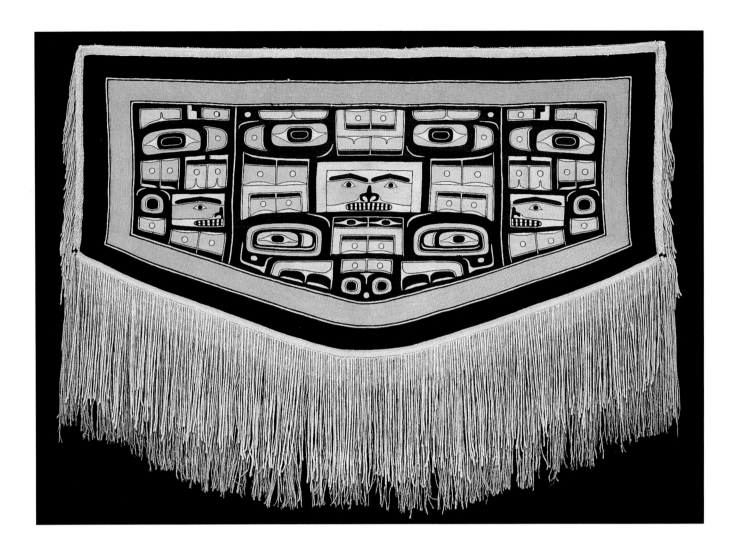

5.25. *Naaxein (Chilkat robe)*
Tlingit, *c. 1880. Mountain goat's wool, yellowcedar bark, dyes.*
59″ L × 67.5″ W.
Collection of Bill and Marty Holm

The experienced hands and refined weaving of the maker of this robe reproduced the painted formline style almost as perfectly as could be imagined. The structure, flow, and movement of the formline patterns have been retained through the arduous processes of re-creating them in warp and weft from a painted pattern board. The design represents a diving baleen whale in the center and a profile whale in each side panel.

The two woven robes or blankets exemplify designs that were frequently duplicated by an apparent succession of weavers. Both of these robes were woven by individuals who clearly had long experience and great mastery of the techniques, as is evidenced by the nearly perfect design shapes and elements, the continuity and flow of the curvilinear primary formline patterns (despite the technical limitations and difficulty of the weaving process), and the overall fineness of the Native-spun materials. The diving whale design of figure 5.25 is one variant of a related group of often-duplicated Chilkat robe designs. A robe of this design pattern is illustrated in "The Chilkat Blanket," by G. T. Emmons (1907: fig. 564a of the section "Notes on the Blanket Designs," by Franz Boas, p. 374). Two other related variations of this design image (appearing in the same text as figs. 566a and 567), are perhaps the most commonly duplicated design patterns among the dozens of unique formline images ever employed in the history of the tradition (Holm, pers. comm., 1997). While this design image is visually pleasing and in every way successful, it is difficult to say why it was duplicated more frequently than were any of the other designs utilized in the past. Perhaps the board on which its pattern was painted was the only one available in a crucial period, kept in the hands of some extremely prolific weavers and passed among them as needed. Pattern boards were painted by male artists with facility in composing formline images that adapted to the woven design traditions of form and structure. In some instances, more than one woven article was produced from

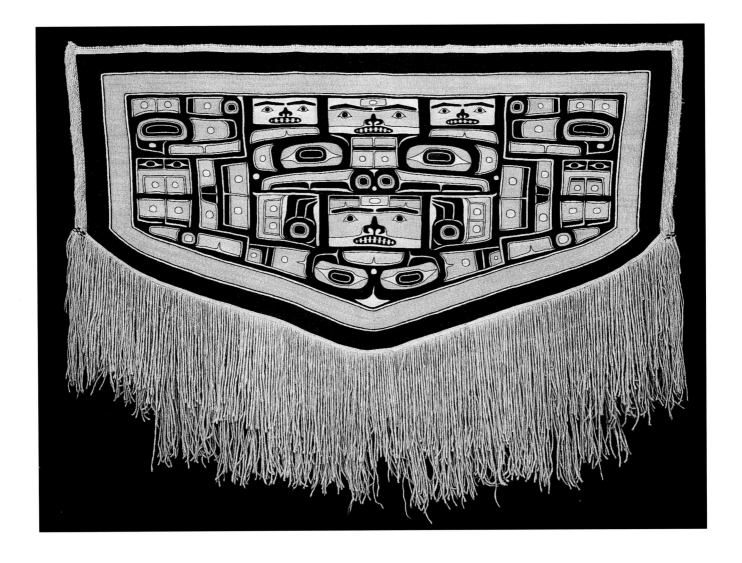

the same pattern board. In the late nineteenth century, Tlingit weavers produced a
large number of weavings from a small number of painted patterns. A number of
related cousins to this design exist that alter minor aspects of the overall formline
image without changing the essential anatomical layout of the whale. The differences
in some cases may have been incorporated by inventive and design-savvy weavers,
while more substantive and consistent variations may indicate other extant pattern
boards. All the most closely related diving whale patterns appear to represent a
baleen whale, emblem of the raven moiety in the Tlingit social system. Some of the
diving-whale designs on Chilkat robe center panels clearly depict a tall, prominent
orca-type dorsal fin (see Emmons 1907:382; figs. 572 a, b), while this one does not,
suggesting that it depicts instead one of the baleen whale species, probably a hump-
back).[4]

The second robe image (fig. 5.26) is also a design that was duplicated with some
frequency in the middle to late nineteenth century (see Emmons 1907:352; figs. 546 a,
b). This design appears to represent the Gonakadeit, the sea-monster wealth-bringer
being noted as the prominent feature of bent-corner chest and box designs. Here the
central head features large ears with humanoid faces within them, and another face
between the ears over the forehead. The body area also contains a face, and is flanked
by the depiction of mammalian claws. Coupled with the whalelike tail-fluke design

at the center bottom of the image field, these claws indicate that a combination of sea and land mammal characteristics is represented in the total image. This juxtaposition of sea and land imagery denotes that a mythical being such as the Gonakadeit, rather than a brown bear or other land mammal, is being represented. The side panels appear to depict a profile of the central figure.

Late-nineteenth-century Chilkat robes often contain sections of Native-dyed commercial wool yarns, identifiable by their multi-ply composition and the much rougher texture of commercial sheep's wool as compared with the silky-smooth feel of handspun mountain goat wool yarns. The commercial yarns were incorporated primarily into the black and yellow bands that make up the outer borders of the traditional blanket or robe form, though they were occasionally also used in some of the larger black formlines of the main design areas. In these two robes, the commercial yarn is limited to the border bands, areas which consumed a great many yards of hard-to-come-by material. This is most commonly the case when non-Native yarns are used. The literally thousands of yards of hand-spun material required to weave a robe of this kind naturally prompted the weavers to employ the ready-made commercial yarns where it seemed appropriate. The yarns of the borders didn't need to be finely spun in order to execute the straight lines of the weaving in those sections.

The designs of baskets and the patterns applied to them appear to have been altered through this period mainly in terms of function rather than design details, although the simplification of basketry surface designs became common over time. Baskets once used for food gathering and storage were in many cases replaced over the generations of the nineteenth century by containers more easily acquired through trade. The making of Native basketry was eventually refocused on the markets that developed in the territorial cash economies of southeast Alaska towns like Sitka, Juneau, Douglas, and Skagway/Dyea. Fineness of weave and false embroidered designs became more highly valued than were the baskets' traditional functional qualities. The examples included here illustrate some of the styles that evolved from indigenous models partly in response to the interests and demands of the competitive marketplace (figs. 5.27, 5.28). These types of baskets reflect the desires of Victorian purchasers, who sought pieces that would show well in curio cabinets back home or would hold articles the owner employed in her own craftwork, such as materials for embroidery, crochet, or tatting.

In figure 5.27, in the pattern on the outer basket (or cover), the wide bands can be seen to represent (using Emmons's numbers) either the *leaves of the fireweed* design (10) in an unusual barred version, or the *rainbow* design (11) without singly alternating color bars. On the inner basket are three designs; the narrow band near the rim is a simplified *leaves of the fireweed,* the three widest bands are the *waves* pattern (37, showing a color-banded "object" floating on the peaks and troughs of sea waves), and the two narrower bands are the pattern called *double tying* (39), representing two strings wound in opposite directions around a body. The small rectangular elements of this pattern are said to have been copied from the porcupine quillwork of the Athabaskans, a technique adopted and employed by Tlingits on certain early hide garments (Emmons 1903 [1993]:263–77). Small covered baskets of traditional design (fig. 5.28) were expanded to appeal to buyers' tastes. This type of basket has

enclosed small pebbles or shot into the handle knob to create a rattling sound "likened to the noise of the stones on a shingle beach, as they roll one over another with each receding wave" (Emmons 1903:254).

The turn-of-the-century market in Native baskets, however, never came close to equitably remunerating the makers for the innumerable hours involved in gathering, preparing, and weaving the materials of their tradition, and this inequity has more or less persisted to the present day, despite an enormous increase in the purchase price of fine basketry. Until fairly recently, a collector could acquire a fantastic old basket for relatively little cost, partly because the originals were so undervalued from the beginning. Modern Native weavers were in many cases unable to create a new basket as cheaply as one could buy an old example, which tended to discourage

many from taking up this inherently difficult tradition, a situation that has begun to rectify itself only in the last ten or fifteen years.

Beadwork followed the older techniques of quillwork through the mountain river passes from the Athabaskan interior and down to the coastal areas and islands of the Tlingit (Alexander) Archipelago. The style of flat bags with eight tabs, known as "octopus bags," most likely originated by the Red River Métis (Duncan 1989:91–93), were perhaps the first regalia objects of their general type to be incorporated into the Tlingit beadwork repertoire. The beading on these bags mainly employed the general style of foliate designs standard to the type, with uniquely Tlingit developments in the specific pattern forms. Certain cloth shirts were made in the nineteenth century using dentalia shells sewn down in formline patterns, a concept that could have preceded the similar utilization of beadwork in regalia designs. In the turn-of-the-century period, beaded octopus bags, shirt cuffs and borders, and large collars or bibs appeared in large numbers among Tlingit performers (see Emmons 1991: cover photo, American Museum of Natural History, Merrill photograph 1904). Figure 5.29 shows a typical version of one of these regalia collarpieces, with a design style based on the painted formline tradition rather than the foliate styles or geometric techniques adapted from other Native regions. Color use and design structure in such designs were adapted to the beader's preferences and familiarity with the two-dimensional traditions, which produced a wide variety of individual expressions of this type. The design of this richly colored example appears to be related to two painted screens by a Tsimshian artist, part of the clan treasures of the Killer Whale House of Klukwan village. Several aspects of these designs are similar to this beaded pattern, particularly the humanoid spirit that streams out of the blowhole (one of the screens is illustrated in Jonaitis, 1986: fig. 6, Blankenburg photo, ca. 1895).

5.29. Beaded collar

Tlingit, *c. 1910. Wool cloth, glass beads. 8.5″ H × 12.5″ W. Collection of Mr. and Mrs. R. T. Ohashi*

In the turn-of-the-century period, beaded octopus bags, shirt cuffs and borders, and large collars or bibs became standard in Tlingit ceremonial regalia. Bags and shirt borders most often employed foliate patterns, while collars or bibs usually depicted crest-type figures, such as this killer whale. The beaded crest-image style incorporates many shapes and designs from the painted formline tradition, though with varying degrees of adherence to these forms in terms of color use and design structures.

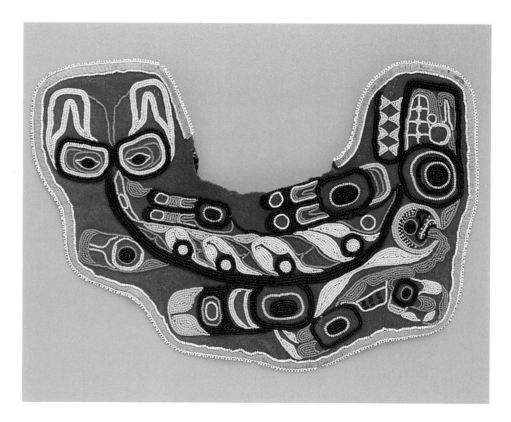

Central and Southern Art from the Late Nineteenth and Early Twentieth Centuries

On the central Northwest Coast in the late nineteenth century, the production of traditional artifacts for ceremonial use appears to have continued with some strength, and in some regions more so than was generally the case farther north or south. More remote locations, removed from the surge in populations and activity that gold rush frenzies brought to other areas, may have sheltered these pockets of continuing tradition for a longer period. The primary commercial intrusions into this region (after the mid-19th century decline in the fur trade) centered first on salmon packing and later on the logging industry (Hilton 1990:320). Despite growing pressures opposing Native potlatch and ceremonial activity at the end of the nineteenth century, the area from Milbanke Sound to northern Vancouver Island appears to have remained traditionally vital, producing new artifacts for ceremonial purposes as well as for sale to outsiders that demonstrate a continuation of traditional design

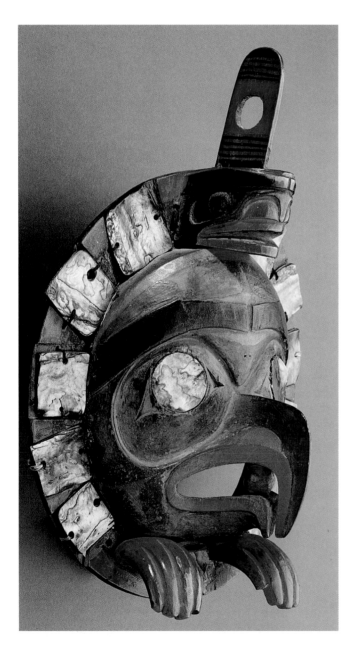
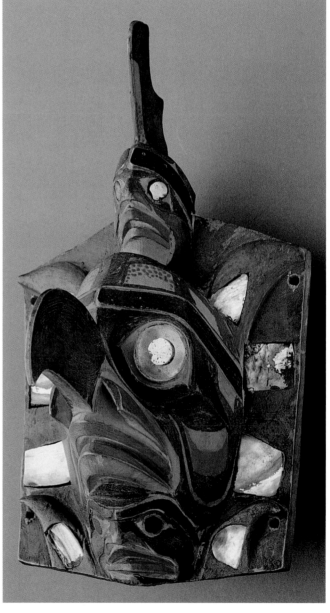

5.30. Headdress frontlet
Heiltsuk, Haisla, *c. 1880. Maple, paint, abalone. 10.5″ H × 7.5″ W × 3.5″ D. Collection of John Putnam*

Iconographically related to the earlier Nuxalk frontlet (4.47), this later example illustrates a more northern-influenced conception and style. A small killer whale image surmounts the head of a bird with a strongly recurved beak. A carved sphere is positioned between the mandibles of the bird, reminiscent of raven and sun images, but the powerful hook of the beak plus the associated whale figure strongly suggests representation of a thunderbird. The sculpture's volumetric refinement, as seen in the large talons and the extreme degree to which the wood is hollowed from the interior of the bird's head and beak, implies that this was probably carved in the early fourth quarter of the 19th century.

5.31. Headdress frontlet
Nuxalk (Bella Coola), *c. 1890. Alder, abalone, paint, brass, glass. 9″ H × 6.5″ W × 6″ D. Collection of Eugene and Martha Nester*

The upthrust of the humanoid bird's beak in this example is a common expression of Nuxalk style, as is the pentagonal shape of the frontlet's rim, the deep-blue color with red and black details, and the placement of subsidiary figures above and below the central image. The downturned tip of the long, beaklike nose of the central face may identify the image as Sharp-nose, and connects this figure to related depictions from throughout the central and northern British Columbia coast.

principles. Populations declined into the twentieth century, instigating the amalgamation of disparate villages into more centralized locations, a necessity that occurred more or less coastwide in this period.

Wakashan-style sculpture is often characterized as the most exuberant style of the Northwest Coast, and certainly the sculptural compositions of Heiltsuk and Nuxalk headdress frontlets readily illustrate this visual property. The headdress and frontlet tradition expanded outward from its place of origin, identified by Native oral history as the Nass River valley of northern British Columbia (Swanton 1909:170–73). The formalized, vertical compositions of northern frontlets(figs. 3.9, 4.45) contrast with the more commonly round or tapering rims and abruptly angled attitudes of Heiltsuk and Nuxalk frontlet design and sculpture, seen in figure 4.47 and in the examples from this general period in figures 5.30 and 5.31.

The vibrant combination of deep blue and vermilion paints is often seen in central Northwest Coast art, and is most well known among the Nuxalk peoples. In figure 5.30, the shallowly relieved ovoid shape of the eyesocket and the shell inlay of the eyes give the clearest indications that this is the work of an artist who was most likely Heiltsuk or Haisla. A Nuxalk carver would have been more likely to employ an eyesocket relief style with angles more deeply cut and emphasis on a cheekbone bulge forward of the temples. Full-eye abalone shell inlays were not common in nineteenth-century Nuxalk sculpture (see fig. 5.31). The painting style seen here could be from either of these First Nations, and shows an interesting relationship to proto–Northwest Coast design principles. The large blue-painted areas represent the positive design spaces, with trigons and crescents (both painted red and unpainted) positioned on the cheeks, below the corner of the mouth, and about the forehead. These reflect exactly the placement of negative elements in the largely unpainted positive fields of the proto–Northwest Coast and Central Coast Salish art traditions. This illustrates a different evolutionary development from the archaic style, in terms of two-dimensional design applied to sculpture, than was taken in the far northern coast. Fairly large pieces of abalone shell are tied to the circular rim, rather than being inlaid in the more usual technique. This attachment method is rare, but it can also be seen on a Tsimshian-style circular frontlet with a raptor image that was acquired among the Kwakwaka'wakw (Brown 1995:158, fig. 58).

Figure 5.31 is a very lively example of the vigorous styles of Nuxalk sculpture in headdress frontlets, depicting an unusual and intriguing image with a stylistic character rarely seen in frontlets from other areas. Nuxalk sculpture of the *sisoak* ceremonial tradition (such as frontlets and certain masks) often employ the kind of inlaid eye form seen here, a piece of mirror glass covered by a brass or copper disk with a circular pupil opening. The rich cosmology and sculptural vitality of the Nuxalk artistic tradition has produced a wide range of unusual figures and strong, visually powerful images such as this one. The composition is similar to the thunderbird and whale image of figure 4.47, though the particular figures represented appear to have different but unknown identities.

Traditional cultural activity remained strong into the twentieth century on Vancouver Island, despite the pressures of some of the most fervent attempts to discourage the practices of the potlatch traditions directed at any of the First Peoples (see

Cole 1990). The Kwakw<u>a</u>ka'wakw of the late nineteenth century were tenacious about maintaining their ancestral ways, and the individual artists who produced the objects employed in traditional pursuits were an important part of their cultural endurance (Cranmer-Webster 1991, 1995). The small number of objects from the region and period represented here are indicative of the volume of material created in what were some very difficult and challenging times (figs. 5.32, 5.33). Of these, the heron headdress stands as one of the most remarkable and inspiring of its type produced in any part of the coast at any time. Crest images of clan and family history worn atop the head are frequently seen among the regalia objects of many Northwest Coast First Peoples (see fig. 4.47), though few of those extant surpass this example for the lively presence and artistic vision of its great blue heron imagery. Constructed of seven or more individual sections of wood, this exceptional headpiece conveys the sense of grace, regality, and awe associated with these ancient spirit dwellers of the coastal environment. The cast of the head and neck, with the curve of its flexible sixth vertebrae sensitively depicted, the lift of the broad wings, and the lowered extension of the tail feathers all combine to bestow upon the wearer of this piece the respected qualities of this large wading stalker of the coastal beaches and wetlands.

The southern Wakashan artistic tradition has sometimes been unfairly characterized as merely disjointed or demented northern-style work, a perspective that fails to recognize the individual origins and evolutionary histories of the two widely separated traditions. The ancient proto-Northwest Coast style evolved in different directions in various regions of the coast, and what has become known as the Nuu-chah-nulth territory of western Vancouver Island produced some of the most interesting variants on personal and regional styles to have developed from the ancient principles. By the late nineteenth century, Nuu-chah-nulth and Makah artists were in fact incorporating those aspects of the northern formline tradition by which they were inspired, but they always adapted what they saw to the different sense of structure and color usage that was the essence of evolutionary tradition in their own region.

A similar perspective in some ways also applies to the creation of sculptural objects, as is seen in the ravenlike rattle in figure 5.34. Very finely crafted, this rattle shows the breast face and collected imagery on the back of the bird that are drawn from the northern rattle archetypes, though each aspect of the sculpture and embellishment here is handled in a characteristically Nuu-chah-nulth manner. The carving displays the same type of abbreviated, undecorated wings seen in the earlier Nuu-chah-nulth bird rattle (fig.4.11). The artist has depicted a humanoid figure in concert with three animal spirits (possibly a wolf, a bear or otter, and a frog), probably representations of the spirit helpers gathered by the commissioner of the rattle. The breast face replicates the general distribution of eyesockets, mouth, and tertiary forms seen in many northern raven rattles, though the color use and details of the design structure indicate different concepts of two-dimensional forms and conventions. Since the southern Northwest Coast styles did not always conceive of interconnected positive design forms in the precise, highly conventionalized manner of the northern formline system, it follows that these artists would not feel obligated to represent such, even in their own versions of northern-inspired objects such as this. The group of figures on the back of the bird/rattle represents particular spiri-

5.32. Kikw'bidu, (totem pole model)
Kwakwa̱ka'wakw, *c. 1890. Redcedar, paint. 32″ H × 4.5″ W × 3″ D. Collection of Sylvia and Phil Duryee*

The deep-relief dimensionality of this model pole is very unusual, though it is drawn from the essence of the ancient Wakashan and other southern coast traditions, and appears at the heart of all Kwakwa̱ka'wakw styles. This pole stands out among the many for its extreme depth of relief and the uncommon representations of its sculpture: the nursing mother and the man battling the octopus are images rarely seen in the totem pole tradition. Full-relief figures against a nearly flat panel background can be seen on house posts and other standing images from the Central Coast Salish area northward, with the fullest relief of this type being common in the southern region (see fig. 3.20).

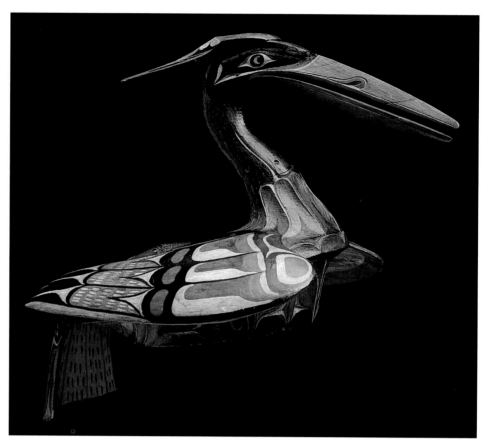

5.33. Kwak'wanig̱a̱mł (heron headdress)
Kwakwa̱ka'wakw, *c. 1890. Redcedar, paint, iron nails. 15.5″ H × 12.5″ W × 22.5″ D. SAM 91.1.31*

This fantastic image is imbued with the visual power to transform the wearer into an extraordinary vision (Brown 1995:240, cat. 91). The flat design patterns of the wings, body, and tail illustrate the uniquely Kwakwa̱ka'wakw development of two-dimensional art that, in this period, draws fairly equally from both the southern (or proto-Northwest Coast) and historic northern traditions.

5.34. Koxmin (makes noise)
bird rattle
Nuu-chah-nulth, *c. 1890. Maple (?). 5″ H × 13″ L × 4.5″ W. Collection of Jack and Jane Curtright*

Related to both the early Nuu-chah-nulth bird rattle (fig. 4.11) and the northern raven and oystercatcher rattle traditions (figs. 3.13, 4.38, 4.39, 4.40), the composition of this instrument illustrates the late-19th-century Nuu-chah-nulth artists' willingness to incorporate those aspects of northern design that they wished to adapt to their purposes.

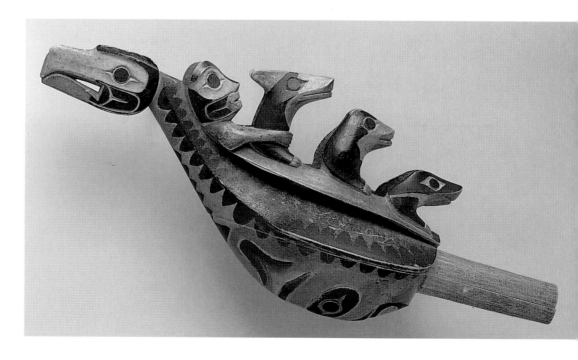

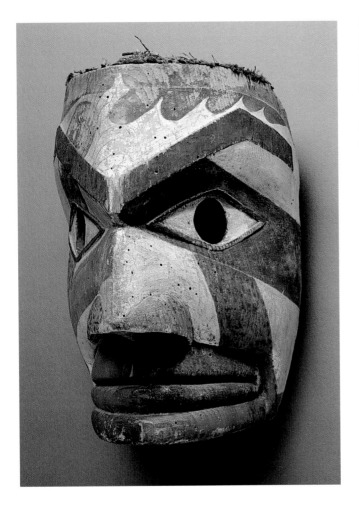
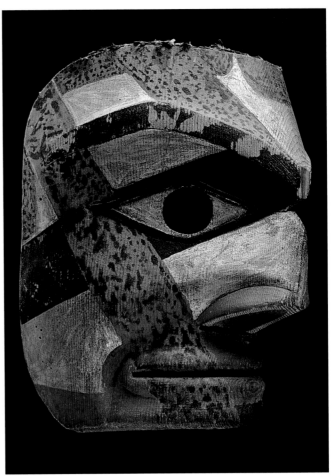

tual imagery that is unique to this piece, drawn from the background and spirit life of the original owner and maker. Each of these refined little figures is pierced through from front to back with a deep trigon form, and the surface from which they rise is cut away from the back surface of the bird's body. Both of these techniques lighten the instrument and create a sharper sound, though the significance of the latter may be equally concerned with a spiritual concept or representation.

The humanoid face masks in figures 5.35 a and b are known to have been made as a pair, though the artist's name and the specific representations intended by the masks have remained the prerogatives of the family who owned them. The bold and abstractly human sculptural style of these masks is comparable to the much earlier-looking Nuu-chah-nulth mask in figure 4.12, but the more aggressive artist's style of sculpture and painting in this mask are indicative of its later nineteenth-century origins. The diagonal lines and geometric quality of the painting in each of this pair of masks is drawn in part from similar qualities in the ancient styles from the southern area, a clear and distinctive departure from the evolution of two-dimensional art in the northern Northwest Coast regions. Bill Holm (unpubl.) has described the historic Nuu-chah-nulth sculptural style in humanoid faces as starting from a triangular wedge principal form, into which the deepest cuts are made at eye level, below the nose, and below the cheek bulge around the outer edges of the mouth. These masks (5.35 a, b) clearly exemplify this approach, as well as the kinds of modeling and refinement applied to this form by masterful Nuu-chah-nulth artists. Acknowl-

5.35 a, b. **Ho'koma (humanoid mask)** **(paired set)**
Nuu-chah-nulth, Nitinat, *c. 1870.*
Redcedar, paint, redcedar bark.
11.5″ H × 8″ W × 8″ D. Collection of Allan and Gloria Lobb(a).
SAM 91.1.23 (b)

This artist has used bold, contrasting tones and line movements in the painted decorations, and both a white background and commercial silver paint to embolden the overall appearance of the mask image. The precise representation of this character and its mask-mate (Brown 1995:261, cat. 97) were not recorded at the time of their acquisition in the late 1970s.

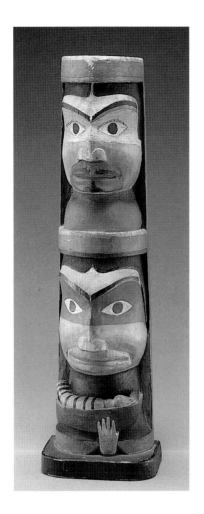

edging the differences of individual artist's styles, both this mask and figure 4.12 illustrate the same sculptural concepts, and certain of the painted characteristics as well, such as the asymmetry of the composition and the use of stippled or dry brush strokes.

A sculptural conception of the human face similar to that of the two masks can be seen in the Nuu-chah-nulth totem pole model (fig. 5.36). This model also displays a certain degree of the deep-relief sculptural concepts exemplified in the model pole in figure 5.32, though limiting the images to little more than a finely sculptured head and shoulders. The apparent ease with which the artist may have elected to represent a foreign subject matter in a totally traditional style illustrates an important aspect of the manner in which certain Euro-American concepts and traditions were welcomed and adapted in many situations into the First Peoples' cultural mainstream.

5.36. *Totem pole model*
Nuu-chah-nulth, *c. 1870. Redcedar, paint. 16″ H × 4″ W. Collection of Bob and Betty Stott*

The provenance for this pole includes the name of the Reverend Charles M. Tate, who accompanied the Reverend Thomas Crosby in mission activity on Vancouver Island between 1870 and 1874. The current owner of this pole researched this information and suggests that the three figures (male at the top, female, and child) represent Joseph, Mary, and the baby Jesus: possibly carved and presented as a gift to Rev. Tate during his tenure among the Nuu-chah-nulth First Peoples.

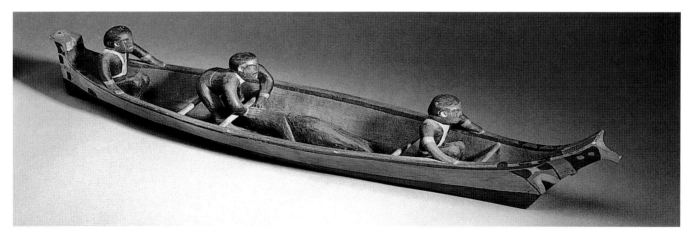

5.37. *Canoe model with three figures and seal*
Makah, *c. 1890. Alder, paint. 7″ H × 36″ L × 7″ W. Collection of Allan and Gloria Lobb*

This canoe model depicts three successful hunters on their return trip from the offshore sea mammal hunting grounds, with one large seal as their quarry. The figures are made as one piece with the canoe. The lines of the canoe are as graceful and accurate as some of the best models, and include all the traditionally carved detail features of the full-size canoes. The shape of the prow illustrates the additional lift or upsweep in the gunwale line characteristic of late-19th-century Nuu-chah-nulth and Makah canoes, and the painting is greatly simplified and less closely related to older styles of two-dimensional designs from this area (see figs. 4.15, 4.16, 4.17).

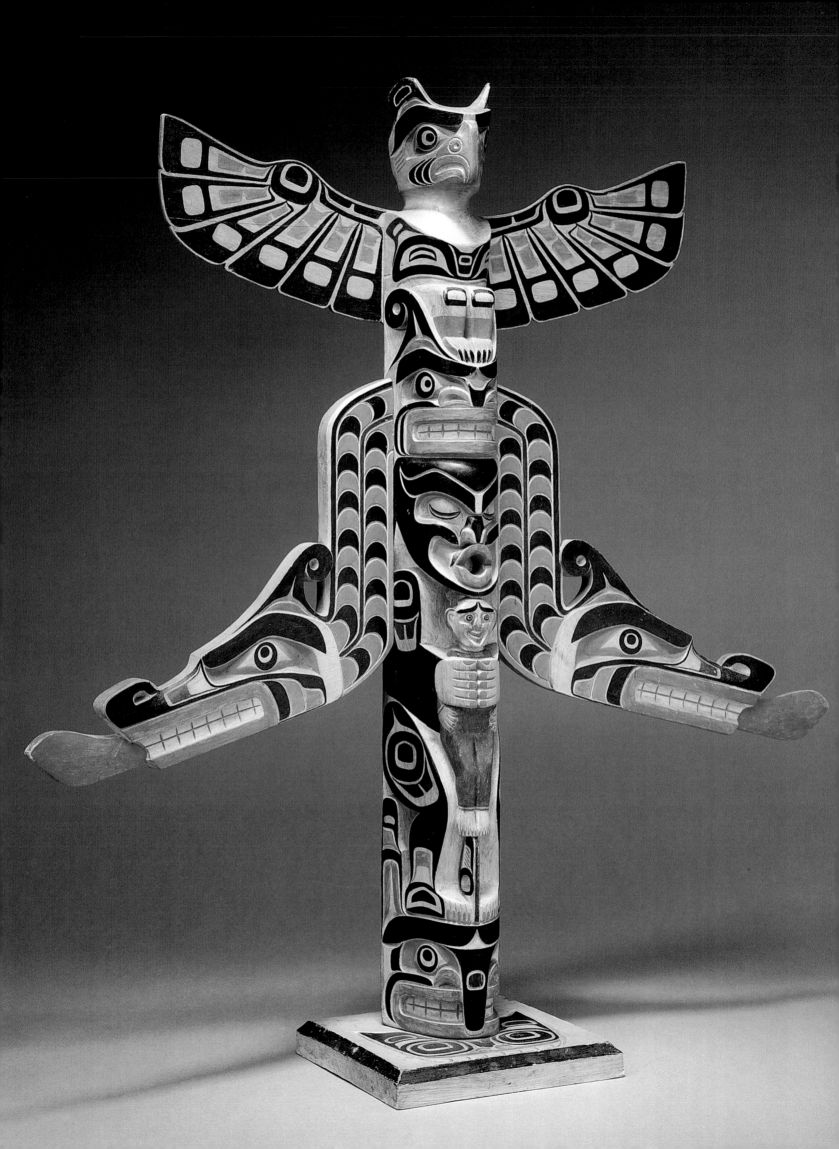

Bridging Generations

*Northwest Coast Art in the
Middle 20th Century, 1920–1965*

*Their great triumph was [the] continued affirmation of the
exploring spirit of mankind, unquenched by the limitations
of the physical world and the restrictions of their own society.*
—Bill Reid, Haida (1967)

Ebb tide: Northern Art in the Middle 20th Century

THE PASSING OF CHARLES EDENSHAW AND OTHERS OF HIS GENERATION
marked the end of a particularly inventive and inspired segment in the history of
Northwest Coast art. The levels of skillful craftsmanship, artistic vision, and imagi-
native development of the art form that were common in the late classic period were
not truly equalled again until the last two decades of the contemporary period.
Although, in the quotation above, Bill Reid addresses the classic period masters, his
remarks can also be said to apply in a slightly different context to the diminished
numbers of artists who carried on the work of the old masters through the middle
years of the twentieth century. Due to many of the influences discussed previously,
the remaining artists of this period worked against and in spite of a strong opposing
current. The carvers and weavers of these generations were a distinct cultural min-
ority, for the most part not widely celebrated or generously remunerated for their
work, who nonetheless did their best to continue affirming the explorative visions
of their predecessors, to keep the stories, the techniques, and the joys of traditional
arts and culture alive. Though only a few displayed some degree of the awe-inspiring
talent and artistic genius of the best of the old masters, this group as a whole man-
aged to keep alive the spark of interest in and knowledge of the traditions,
unquenched by the limitations and restrictions that the outside world had either
directly or indirectly imposed upon them.

An important factor is often overlooked when modern hindsight evaluates the
work produced in this (or any) period of Northwest Coast art history. Bill Reid
points this out:

One thing has become apparent throughout my years of familiarity with the art of the Northwest Coast. . . . If these people were an artistic race, they were not a race of artists. The recurrently similar [individual] styles can lead only to the conviction that the high art of the region was the product of a few [artists] of genius. . . . It is possible that . . . the great works came from the hands of twenty or thirty men. (1967)

A critical perusal of any large museum collection will reveal a wide range of artistic quality among the many different kinds of objects produced by Northwest Coast First Peoples, whether the pieces considered are from the late, middle, or early nineteenth century or even the eighteenth century. In every historic period, certain artists display significantly less facility within the two-dimensional tradition than do those artists whose work in this area is justly praised. A numerical count of even the most accomplished and ingenious works to which Reid refers might produce a stylistic list of individuals somewhat longer than the twenty or thirty proposed in his commentary, though much would depend on the actual group of objects analyzed for their styles, and what level of work, for these purposes, qualified as "accomplished and ingenious" or "the great" works. In any case, it is readily apparent that the full corpus of the Northwest Coast tradition was created by artists of widely varying degrees of genius, talent, and facility with the conventions and applications of the formline system. That it would be no different in the middle twentieth century, then, should come as no surprise.

It is also important to note that, perhaps in most cases, the "artistic quality" of any piece of work is relatively unimportant to its essential function as a ceremonial object, as a representation of historically significant imagery. Certainly, the works of the most skilled and accomplished artists were highly appreciated and were sought out even long ago by those who knew and discerned the visual qualities that distinguished them from the rest. But nonetheless, the true cultural functions of what the objects stood for: the historical, narrative qualities of the imagery; the direct physical and spiritual connection with generations past; the symbolic encapsulation of the strength, the sacrifices, and the spiritual vitality of those who took part in the establishment of individual crest emblems—all these qualities are in an important way separate from the mere outward appearance of any particular piece of what outsiders call "art." That these kinds of cultural and ceremonial functions of an object are not judged or quantified on the basis of artistic merit is demonstrated in part by the number of technically less-accomplished but culturally significant artifacts extant today, whether in historic collections or currently in use. The carvers who best incorporated the esoteric qualities mentioned above into their work clearly possessed a manifestational genius and skill that was expressed through the traditions of their particular cultures, and their work was valued for those qualities. Their media of expression were the styles within the sculptural and two-dimensional systems to which they were introduced by their mentors and major creative influences. But, a technically less-accomplished rattle, or amulet, or mask, for example, is inherently no less powerful or effective in the hands of an accomplished shaman than one which would today be considered a masterpiece in visual terms, and the same could be said for a chief's headdress, or a clan hat, or a decorated shirt or robe. True

geniuses are few and far between, and their numbers in some way reflect the social and spiritual status and vitality of the cultures and communities in which individuals with the potential for creative expression are born. For any seed, for any human being, to survive and flourish requires a fertile environment, and even the best seed in flinty soil does not a fine specimen make.

Unlike the cultural context in which artists of the pre-1865 period produced their work, the early twentieth century was the stage on which many threads in the fabric of Native life came unraveled. In the first several decades of the 1900s, rapidly changing social and political realities drew many of the most creative people away from traditional pursuits. Survival in a world with new boundaries and rules meant a wholesale refocusing of the efforts of many family leaders. The commercial development of rich coastal fisheries began in the late nineteenth century and grew fairly steadily in the first half of the twentieth. Native men adapted and applied their traditional maritime experience to new occupations, evolving from canoe carvers to boat builders, from subsistence fishermen to successful gillnet and seine boat skippers. Women and men spent summer seasons in the employment of canneries, where villages and cultures mixed together in a new social environment, away from the conservative structure and fabric of traditional communities.

Dismantling of the old-style houses, and their extended family social system, came by government mandate (U.S. Bureau of Indian Affairs policy) or natural attrition. This prompted their replacement with single-family homes, and more separation between individuals and generations. Boarding schools, which Native children were compelled to attend, were at best culturally sterile environments, designed to isolate the young from their languages and customs, as well as to educate them in Euro-American subjects for service and light-industry jobs. And too often, at their worst, such training schools were insular and outrightly abusive communities that left indelible marks on the minds and bodies of innocent students (NTC 1996). Outside their own communities, and even sometimes within them, Native peoples were openly considered second-class human beings (citizenship was not granted to Native Americans until 1924), and many worked hard to contradict who they really were, to be like (and therefore seen to be as good as) non-Natives. Often a sense of despair and futility motivated some to retreat into alcoholism, a plague that proved to be as contagious and destructive as smallpox had been a century before.

In addition to powerful civil and religious pressures to abandon Native traditions, a significant amount of motivation in this direction came from within Native society. In Alaska, for example, the Alaska Native Brotherhood and Sisterhood (ANB/ANS, founded in 1912 and 1921 respectively, the oldest existing Native political organizations on the continent) functioned as important and influential voices in Native communities and served as valuable political action organizations. The graduates of the Sheldon Jackson School in Sitka who founded the ANB/ANS actively promoted Western-style education and political involvement as the most direct roads to the improvement of social conditions for Native people. At the time, for better or for worse, the pursuit of traditional life was seen by many of these influential individuals as an outdated distraction and an impediment to much-needed political progress. Even the speaking of Native languages was not originally allowed at ANB/ANS meetings, which were conducted according to standard Euro-American rules of order (as

they continue to be today). From their concerted efforts, Alaska Native society obtained the right to vote in territorial elections in 1923 (similar status for Native Americans of the lower 48 was not secured until 1924), achieved equality and desegregation in public businesses and school education, and laid the groundwork from which developed the federal legal suit for the settlement of land claims that eventually culminated in the Alaska Native Claims Settlement Act of 1971 (ANCSA).

Preoccupation with these efforts, however, de-emphasized for a period the maintenance of traditional activities and art forms and opened a significant gap between the generations of the nineteenth century and those of the developing twentieth. The political success of the ANB/ANS in many important areas has been unquestionable, though the strength of the organization has been eclipsed in recent years by larger and more powerful Native groups and ANCSA corporations. Today, in contrast to the legacy of their first decades, the ANB/ANS and other Alaska Native organizations, like the Tlingit and Haida Central Council and the Heritage Foundation of the Sealaska Corporation, have been at the forefront of the work to maintain and encourage traditional Native culture and arts in Alaska.

There were, however, even in the mid-twentieth-century period, certain individuals who exemplified the persistent subcurrent of tradition, who each carried knowledge and experience of some part of the whole; carvers who loved to create in wood, or argillite, or silver; weavers who found peace in the gathering and preparation of materials as it had always been done, regardless of the relatively small value for which their work could be sold. In seemingly every surviving village there was someone who carved even a little bit, filling the occasional demand for ceremonial pieces or making mementos of the old Northwest Coast culture. In many cases, that meant model totem poles, model canoes, halibut hooks, baskets, Chilkat-style weavings, or silver bangles, brooches, and earrings. Some of these artists were outstanding for this period in their familiarity with traditional arts. Largely unrecognized by the urban outside world, such artists created the best Northwest Coast art that they knew how to do, during a time in which many people of today believe that no work of any traditional quality was being made at all. In my personal experience, I've learned of only a few of these unsung individuals by name. I have been fortunate to encounter their work during thirty years of interest in the subject, and fourteen years of residence in southeast Alaskan towns and Native villages, though the evidence of others exists elsewhere to be seen. There are, I believe, many such artists who were rarely known outside of their home town or region, loved by family members and cherished by the traditionally minded of their particular communities.

After the loss of his two sons, Charles Edenshaw shared his artistic skills and visions with several young artists who continued their craft long after his passage, including John Marks (a fine silverworker and the grandfather of Gerry Marks, a prominent Haida contemporary artist), Isaac Chapman (known for his argillite work), and Daniel Stanley (MacDonald 1996:219). Pieces made by some of these artists are sometimes mistaken for Edenshaw's work, as his influence and interpretation is apparent in their styles. At Tahaygen's passing in 1920, he left his tools to his nephew Charles Gladstone of Skidegate, the grandfather of Bill Reid (ibid., 221).

Most Haida carvers in this period focused their sculptural efforts on the medium

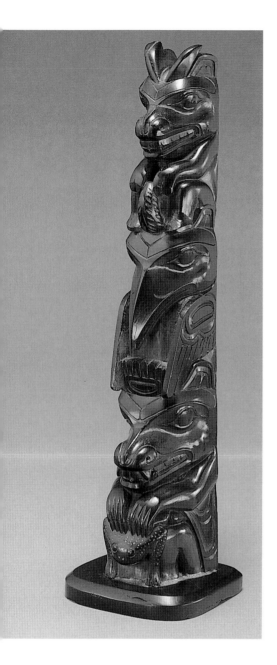

of argillite. Several valuable recent books on the subject include Drew and Wilson 1980; Sheehan 1981; and Macnair and Hoover 1984. The latter offers a very scholarly, annotated overview of the history of argillite study to date (pp. 201–7). Macnair and Hoover propose characteristics that distinguish between early (pre-1900) and later (1900–60) model totem poles, including relative height, sculptural dimensionality, and whether the back has been hollowed in the style of the wooden monuments (Macnair and Hoover 1984:111–26, 175–88). They note that Edenshaw's work spans both periods, as he continued to create his fine brand of traditional art until his passage. In their chapter on late model poles (pp. 175–88), the authors include a catalog of twenty-eight examples, unfortunately not specifically dated except for the time association of those attributed to known carvers such as Edenshaw and Captain Andrew Brown. Some of these exhibit wholly traditional two-dimensional formline designs (ibid.: figs. 193–205, 208–16), four out of twenty of which are attributed to Edenshaw. Several of these poles are noted for their similarity to Tahaygen's style, though the authors attribute them to carvers he had influenced significantly (ibid.: figs. 197, 211, and fig. 214 could also be included). Others (the minority, however) illustrate an incomplete conception of the two-dimensional formline traditions (ibid.: figs. 206, 207, 217–221).

Apparently not included in the collection represented in the Macnair/Hoover study is the work of John Cross (1867–1939), whose name and work is represented in Barbeau 1957, and in Drew/Wilson 1980. Like Edenshaw, Cross's work would fit in both the early and late model-pole categories of the Macnair/Hoover study, and the pole from his hands illustrated here (fig. 6.1) is tentatively dated to the cusp of these two periods. His career was productive through most of the 1930s, and he is certainly one of those artists whose concept of the northern art traditions was based soundly in the nineteenth-century styles (MacDonald 1996:221).

Drew and Wilson (1980:228–91) identify about thirty artists in argillite who worked between 1900 and 1940, though Macnair and Hoover propose that even "more than this number of personal styles can be identified on poles carved or collected in this period" (1984:177). One of these carvers was Henry Young (1872–1950), whose photograph appears in Wright (1995:140), taken about 1938. The argillite model pole on which he is carving in the picture exhibits sculptural and two-dimensional characteristics that reiterate the nineteenth-century traditions. A number of the many argillite carvers who worked in this period and lived into the middle or late twentieth century are listed in Drew and Wilson (1980). Some of these artists whose work is illustrated very clearly maintained the essential principles of the northern formline tradition, and formed a link of inestimable importance to the late twentieth-century revitalization of the art, including Jim MacKay (1890–1945), Henry Young, Lewis Collinson (1881–1970), George Smith, (1880–1936), and John Marks (1876–1952). George Smith collaborated on a very fine totem pole that stands today in Washelli Memorial Park in north Seattle. An artist born much later, but who nonetheless is cited by many as providing a very important link, is Pat McGuire (1943–70), whose work is not only excellent in terms of its level of refinement but also in its conception of the two-dimensional tradition (Drew and Wilson 1980:119; this plate is dated 1963).

In southeast Alaska, one of the important pivotal artists of this era was John Wal-

lace (1880–1950), the son of a renowned Kaigani Haida totem pole carver named Dwight Wallace (Kitkoojawus, c. 1822–1913) (see Abney et al. 1993:6–10). Though he worked most of his life in Hydaburg, Alaska, John Wallace was occasionally commissioned outside his own community to do carving and cultural demonstrations, such as at the San Francisco World's Fair in 1939, where he was introduced to Eleanor Roosevelt (ibid.:8; Wallace 1980). Among the many traditional creations of John Wallace were a number of small (14 feet long) but traditionally refined canoes made in the 1930s. These were painted with designs in a personal style that is fairly unusual, but that properly reflects the elements and structures of the formline tradition. Carved on commission for various buyers, one of these canoes is now in the Burke Museum, Seattle (2.5E887), and another is in the Alaska State Museum, Juneau (IIB–1893). Wallace also made models of Haida houses and totem poles,[1] and he was the lead carver when the Civilian Conservation Corps totem pole restoration project of 1938–1940 restored and reproduced approximately eighteen original Haida poles from several old village sites to create a totem park in Hydaburg. Wallace also was head carver for four monuments out of more than a dozen created for the Totem Bight park. The park was set up eleven miles north of Ketchikan, Alaska, by the United States Forest Service (which administered the Civilian Conservation Corps projects all through southeast Alaska). Lee Wallace, John's grandson, is now a prominent carver in the area, working regularly in the Cape Fox Corporation carving shed in the Tlingit community of Saxman, three miles southeast of Ketchikan. Lee's carvings and totem poles carry on the tradition of his grandfather's art, though he developed his carving and design skills in later life in association with Nathan Jackson (see fig. 7.1) and other Tlingit carvers, long after his ancestor's passage.

George Benson (c. 1900–1976), a Tlingit from Sitka, learned a lot about carving from John Wallace while living in Hydaburg. He brought his skills home to Sitka, where he continued carving on occasion in the 1950s and 1960s. Among other works, Benson created two traditional totemic pieces for the entryway of Sitka National Historical Park, and a fine canoe model now housed in the Centennial Building, Sitka. He also created very refined, small model totem poles, decorated with flat designs incorporating traditionally formed elements painted in Chilkat robe–type colors of black, yellow, and blue-green, adapted to serve as the bases of electric lamps (Burkhart 1982). Another skilled carver of this period was David Williams of Hoonah (c. 1910–1980), a Tlingit known for his masks and totemic figures that featured crisply-cut sculptural planes and perfect symmetry. Silver carver Billy Wilson of Hoonah also deserves mention here, as does Willie Marks, uncle of David Williams. These are but five men (whose work is unfortunately not included in this collection) from a small part of the northern coast, of the many who worked in the obscurity of the middle twentieth century. Few of this transitional generation lived long enough to be more than an important early influence in the lives of young men who have since grown to take an active part in the ever-expanding renaissance of northern Northwest Coast art which began in the 1960s.

Among many Tlingit carvers of this period, the traditional styles that distinguish classic period art survived more completely in terms of sculpture than in the two-dimensional tradition. In the first decades of the twentieth century, Tlingit artists in southeast Alaska were working on their own as far as the formline tradition was

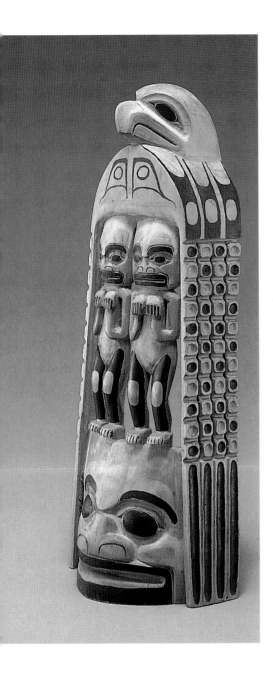

6.2. Model totemic sculpture

Jim Watson *(c. 1890–1930),* **Tlingit,**
c. 1925. Yellowcedar, paint.
10″ H × 4″ W × 2″ D.
Collection of Bob and Betty Stott

The sculptural faces on this piece
exhibit a strong influence of tradi-
tional Tlingit carving style. Like the
painting on many Tlingit carvings of
the 20th century, the two-dimensional
design aspects of this piece are mini-
mal and reflect less completely the
traditional formline structure of the
pre-1865 period.

concerned. Apparently very few individuals creating work for cultural use had much significant training or familiarity with the structure and principles of the classic styles of two-dimensional art. Sculpturally, however, their work reflects a major influence of old-style Tlingit carving. Unlike some of the artists discussed previously, many others acquired less accurate insight into the nuances and conventions of classic northern Northwest Coast flat design, though their efforts have been highly valued and respected for their function in a traditional cultural context. One of the artists of the early 1900s was Jim Watson, who carved model poles in a very distinctive style (fig. 6.2). Watson lived in the Haines/Klukwan area, and was related to the well-known elder carver Dan Katzeek of Klukwan,[2] who appears to have been a considerable influence on Watson's carvings. A relatively large number of Tlingit model poles carved in the late nineteenth and early twentieth centuries exhibit the type of deep relief and highly pierced sculpture evident in this example. Some of these follow the general totem pole form, with the addition of some background areas pierced through, while this piece (fig. 6.2) departs more significantly from the typical totemic form to become a more freestyle sculpture. This sculpture represents an unidentified story from Tlingit oral history, and includes an octopus, a pair of human or spirit figures, and a large spirit face that may represent a rock, an island, or other major physical feature. The tentacles of the octopus frame the composition, its suckers alternatively painted red and black. The exaggerated beak and small hood or mantle of the animal give it a very birdlike appearance. Perhaps the artist intended this as a punning image.

Basketry is a traditional art form that has been maintained through the twentieth century by a dwindling number of dedicated practitioners who created and sold basketry pieces to an unfairly depressed market, and yet who managed to survive economically with the help of the incomes produced from their art. Basket weavers of several northern First Nations produced their art all through this mid-twentieth-century period. When calculated out on the basis of the time required to gather, prepare, dye, and weave together the materials of fine basketry, these artists were realizing only pennies an hour for their efforts.[3] Still, some fantastic woven creations were produced in this period, and the requisite skills have since been passed on (through individual study, formal classes, and apprenticeships) to younger artists, who have inherited the patience, dedication, and love of their work exemplified by their predecessors.

Some pivotal individuals lived long enough to pass their skills directly to a handful of relatives and students, who in turn have led a fairly complete recovery of the techniques and refinements that distinguished the best classic-period work in these traditions. These valuable cultural treasures were carried by the hands of artists such as Selina Peratrovich (Haida) of Masset, British Columbia and Ketchikan, Alaska (mother of Delores Churchill, one of the most dedicated teachers of the last twenty years), Florence Davidson (Haida, daughter of Isabella Edenshaw, mother of Primrose Adams, and grandmother of Isabel Rorick, an unbroken chain of important and highly skilled weavers), Flora Mather (Tsimshian) of Metlakatla and Ketchikan, Alaska, Ida Kadashan (Tlingit), and many others, from various areas, with whom I am not familiar by name. The basketry of this period is but nominally represented by the covered glass bottles in figure 6.3a, b.

6.3 a, b. Basketry-covered bottles

Tlingit, *c. 1930 (?) . Spruce root, grass, glass. (a) 10″ H × 3″ Dm; (b) 6″ H × 3″ Dm.*

Collection of Bob and Betty Stott

*The designs on these beautifully covered bottles are typical of the varied basketry decoration through-
out the historic period of Tlingit weaving. The zigzag designs on the taller bottle (a) are the "mouth-
track of the woodworm" (Emmons 1903: #1, fig. 315). The shorter, oval bottle (b) displays an upper and
lower band representing "water drops" (ibid.: #25, fig. 338e), and a wide center band with
a design that is closest to one known as "shaman's hat" (ibid.: #36, fig. 349a). The straight single or
paired lines of false embroidery on each of these bottles could be identified as "fish-drying frame cross-
piece" (ibid.: #20, fig. 334).*

The Inter-Tidal World: Southern Art in the Middle 20th Century

On the central coast, particularly among the Kwakwaka'wakw, artistic production and cultural expression were driven underground by governmental suppression of the potlatch and the dancing and ceremonial paraphernalia that were inseparable from it. A number of artists from this era have nonetheless become well known and admired for their contribution to the survival, continuing development, and graphic refinement of the Kwakwaka'wakw art traditions. The grand period of Kwakwaka'wakw art was in many ways this very era, in spite of severe repressions, which included jail sentences for some potlatch participants.

Charlie James, Mungo Martin, Willie Seaweed, and many others who carved masks and regalia for traditional use, as well as articles for sale (such as model totem poles), provided the important, surviving link between the artists of the nineteenth century and those of today. Mungo Martin died in 1962, and Willie Seaweed in 1967. By this time, the beginning of the contemporary revitalization of the whole Northwest Coast tradition was getting strongly under way.

Several authoritative discussions of the art, artists, and the evolving cultural traditions of the twentieth-century Kwakwaka'wakw have been published in recent years, each of which is more comprehensive and exhaustive than this comparatively brief presentation can attempt to be (Hawthorne 1967/1983; Nuytten 1982; Holm 1983c; Cranmer-Webster 1991, 1995). Many artists stand out in this area and period, a number of whose names are well known via the art historical literature or through family descendants. Though culturally depressed by the same host of outside influences as the rest of the Northwest Coast First Nations, the Kwakwaka'wakw nevertheless were able to maintain a viable and inventive artistic and ceremonial tradition in the face of great opposition and pressure to abandon the most central socializing event of Kwakwaka'wakw life, the potlatch. Perhaps, in fact, their studied determination to present a persistent and unflinching response to these unrelenting, single-minded pressures (originating locally from an ambitious Kwakiulth Indian Agency official named William Halliday; see Cole 1990) may have helped to solidify their cultural and ceremonial perseverance in an important way. Perhaps their unfazed persistence in cultural expressions may not have been so ultimately successful were it not for the paradoxically unifying and motivating influence of such blatantly disproportionate opposition to their old ceremonial ways. Their determination prompted Halliday to refer to "the incorrigible Kwakiutl," and ultimately provided them with a strong foundation on which to build the powerful cultural revitalization of the last thirty years (Jonaitis, ed., 1991, Cranmer-Webster 1991).

Among the artists who were most influential in this area in the early twentieth century was Charlie James. James's Kwakwaka'wakw name was Yakudlas, and he was the stepfather and artistic mentor of Mungo Martin, who, in turn, was perhaps the best known and most influential of the mid-twentieth-century Kwakwaka'wakw traditionalists. Yakudlas was a very prolific carver who made a great number of masks, dance paraphernalia, totem poles, house posts, grave figures, and, of course, model totem poles (Nuytten 1982). He often made numerous models based on figures he had created for full-size poles, and he carved asymmetrical images more often than any other artist (fig. 6.4). The sculpture of many of his totem pole mod-

*6.4. **Kikw'bidu,** (totem pole model)*
Charlie James *(c. 1867–1938),* **Kwakwa̱ka'wakw,** *c. 1930. Yellowcedar, paint. 10″ H × 6″ W.*
Collection of Bob and Betty Stott

This pole depicts a Kolus (a type of Kwakwa̱ka'wakw thunderbird) and a man, holding a fish or eel, standing on an animal-like head that may represent a rock or island. James (Ya̱kudlas) employed a flat design style influenced by the northern-style formline tradition of the Bella Bella, who have many cultural ties to the Kwakwa̱ka'wakw. Ya̱kudlas's version of the form, however, displays considerable freedom and originality, particularly in his use of color. The outstretched wings often seen on Kwakwa̱ka'wakw poles and house posts became the signature element of totem pole art to the American and Canadian public, via the advertising media and tourist bureaus.

*6.5. **Kikw'bidu,** (totem pole model)*
Arthur Shaughnessy (attr.)
(c.1880–1946), **Kwakwa̱ka'wakw,**
Dzawada̱'enux̱w *(Kingcome Inlet),*
c. 1920. Redcedar, paint.
25″ H × 4″ W × 2″ D.
Collection of Bob and Betty Stott

Arthur Shaughnessy (Hemasilak̫ʷ) is renowned as a carver of house posts and traditional objects with a bold carving style. This tall, thin model, however, displays a refined conservation of sculptural effort, relying on the high contrast of painted forms and a light background tone to emphasize the minimal dimensionality. The Kolus, killer whale, bear, and raven are essentially two-dimensional designs, exhibiting a typically Kwakwa̱ka'wakw blending of northern and southern design elements and structures. The whale's dorsal fin is painted on the center of its back, a narrow U-shape flowing down from the red-centered circle that represents the blowhole.

els made for sale was frequently simple and direct, with minimal sculptural development of eyesockets and similar details, often defining such elements with painted forms only. In his larger or more elaborate models, James carved with the type of full sculptural treatment seen in his full-size poles, whether these were made for Native use or commercial sale (Nuytten 1982; pls. 5, 25, 27, 30, 32).

Another very influential though somewhat less well-recognized artist from this region and period had the English name of Arthur Shaughnessy (1880–1946) and was known as Hemasilakʷ in Kwakwala. He had a very bold and often deeply sculptural style that has inspired many contemporary Kwakwa̱ka'wakw artists. The set of four houseposts he carved for John Scow's Raven House in 1907 are now in the Seattle Art Museum (Brown 1995:243–51, cat. 93, 94). These were purchased by John H. Hauberg from the late owner's son, William Scow, in 1966, after the original house had been dismantled and the houseframe had weathered for many years. Restored in 1969–72 for a reconstruction of the Sea Monster House (a previous incarnation of the Scow family bighouse at Gwasyasdums village) at the Pacific Science Center, Seattle, these posts were relocated to the new downtown Seattle Art Museum in 1991. Another outstanding set of four house posts carved by Shaughnessy once stood on Gilford Island (where the painted surface weathered off), and are now on display at the Royal British Columbia Museum, Victoria (RBCM 14680, 14681). Still another set of house posts, commissioned by George Hunt on behalf of the American Museum of Natural History, New York City, were completed in 1924 and now stand in the great Northwest Coast Hall of that museum (AMNH 16.1/1815).

The model totem pole by Shaughnessy included here (fig. 6.5) shows a very trimmed-down style of carving, one that reveals little of the typically deep sculptural prowess that this artist employed in his larger pieces made for traditional use. It is so efficiently minimized, however, that one gains a great respect for the artist's ability to condense sculptural form and to depict traditional imagery with expertly conceived painting and very little dimensional relief.

Willie Seaweed (c. 1873–1967) was an artist of the 'Nak'waxda'xw band, from the mainland village of Ba'aas, across Queen Charlotte Strait from present-day Port Hardy, British Columbia. The "Blunden Harbour style" is an amalgamation of the interrelated traits of several prominent artists who lived and worked in this remote and highly traditional village in this general period, including Chief George, Charlie George, Sr., Charlie George, Jr., Willie Seaweed, Joe Seaweed, and others. Willie Seaweed mastered the existing Kwakwa̱ka'wakw art styles of his village and region, and further distilled them into one of the most technically refined and easily recognizable personal styles of the Northwest Coast tradition (Holm 1983c). Seaweed, also known by the names Hiłamas (Right-maker) and Kwagitola (Smoky-top) carved a large number of sculpturally refined model totem poles (figs. 6.6, 6.7) (Holm ibid.: figs. 13–17), as well as many full-size poles that still stand in Kwakwa̱ka'wakw communities such as Kingcome Inlet and Alert Bay, British Columbia. In figure 6.7, the added terminal heads of the Sisiutl which spread out to each side create a highly unusual image that distinguishes this fine model pole among the many. Standing on the central head of the Sisiutl is the Kolus, the painting on its outspread wings blending smoothly with the face design on the bird's breast. Framed by the scaly bodies of the Sisiutl is the head of a Dzunukwa, her pursed lips and closed eyes the

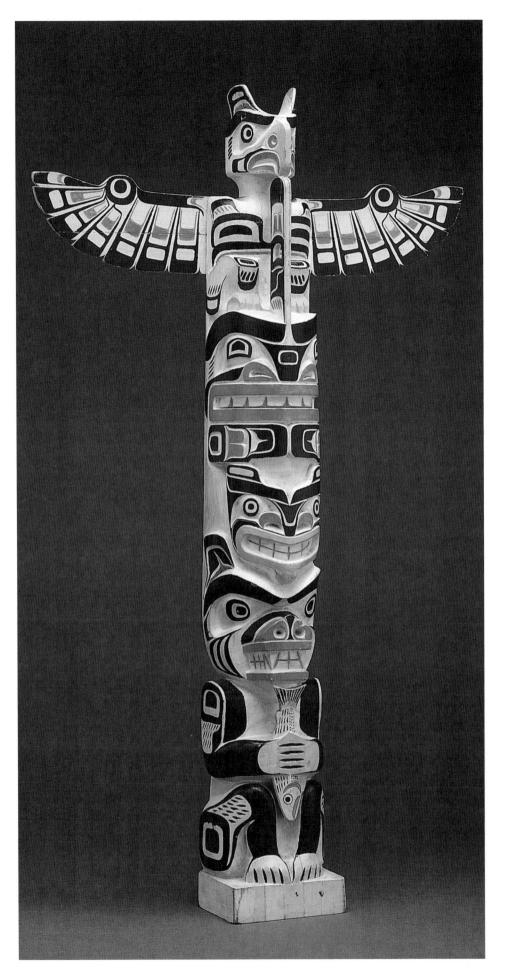

6.6. *Kikw'bidu (totem pole model)*
Willie Seaweed *(c. 1873–1967),* Kwak-
waka'wakw, 'Nak'waxda'xw
(Blunden Harbour), c. 1940.
Yellowcedar, paint.
24″ H × 12″ W × 3″ D.
Collection of Bill and Marty Holm

*Willie Seaweed (Hiłamas) was very
much a graphic artist. His three-
dimensional work is strongly influ-
enced by his two-dimensional style, a
trait especially noticeable in his han-
dling of the killer whale figure in this
fine model. The whale's head, pectoral
fins, and tail are easily seen as relief-
carved flat designs wrapped around
the cylindrical form, with the body
itself not clearly defined. The dorsal
fin extends from the peak of the
whale's head to the beak tip of the
Kolus. The grizzly bear and Kolus
figures are much more deeply sculp-
tured and defined in bodily form,
though the conceptual influence of
Seaweed's two-dimensional work is
just as clear.*

6.7. *Kikw'bidu (totem pole model)*
Willie Seaweed, Kwakwaka'wakw,
'Nak'waxda'xw, *c. 1940. Yellowcedar,
paint. 29″ H × 14″ W × 4″ D.*
Collection of Allan and Gloria Lobb

*One of Willie Seaweed's largest and
most elaborate model poles, this piece
clearly demonstrates his mastery of
traditional sculpture and design. The
eyesockets and many of the ovoids are
modified into signature Seaweed-style
shapes, and the interplay of his sculp-
ture and two-dimensional design is
as ingenious here as it has ever been
developed (see also p. 138).*

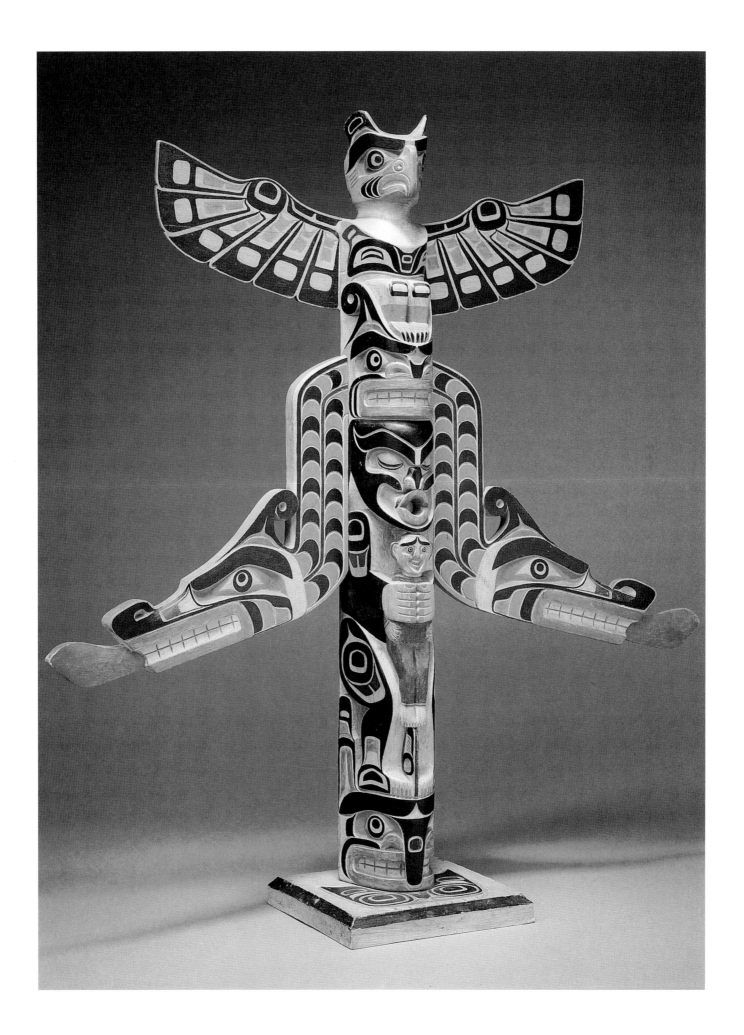

trademark of her species. This forest giant grasps a frightened human child, one who must have strayed too far into the woods. She stands on the head of a killer whale, with its pectoral fins extending up behind her legs and the dorsal fin between her feet. The tail of the whale is painted and carved on the flat supporting base of the model.

Hiłamas also carved many sets of masks of the Hamat'sa tradition in his career, as well as a great variety of face masks. He sometimes collaborated in making sets of masks in tandem with his son Joe (c. 1910–1983), whose work in this period is essentially indistinguishable from that of his father (Holm ibid.: 164–65). Each unique, successive mask of his making is a fascinating continuation of his creative exploration of graphic and sculptural forms (figs. 6.8, 6.9, 6.10). His propensity for refined forms called for the use the of compass-drawn circles (Holm 1983b), and the three perfectly balanced spirals of the mask in figure 6.8 illustrate the fluidity with which he incorporated such shapes into an image. This mask is one of the first on which Hiłamas added the curled ears or horns (made of thin plywood) that right away became a kind of standard of his and other artist's work. The perfect, scribed circles and ruler-straight lines of this and others of his masks do not freeze the image as they well might in lesser hands, but rather Hiłamas was able to harmonize all the graphic

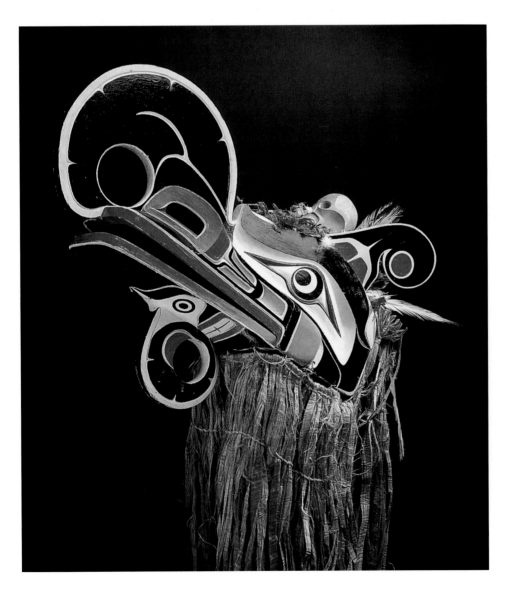

6.8 a, b. **Galukw'amł**
(Crooked Beak mask)
Willie Seaweed, Kwakwaka'wakw,
'Nak'waxda'xw, *c. 1940. Redcedar, plywood, paint, cedar bark, steel spring. Mask: 26" H × 38" L × 12" W; cedar bark: 26" L.*
Collection of Bill and Marty Holm

Willie Seaweed created many versions of the Crooked Beak mask, encompassing a wide variety of incarnations, and the body of his work on this subject has become the veritable definition of the type. Seaweed said that the image of the curled horns appeared to him in a vivid dream (Holm 1983c:111). He mounted the wooden skull on top of this mask with a steel bedspring, so that it would jiggle and sway with the actions of the dancer.

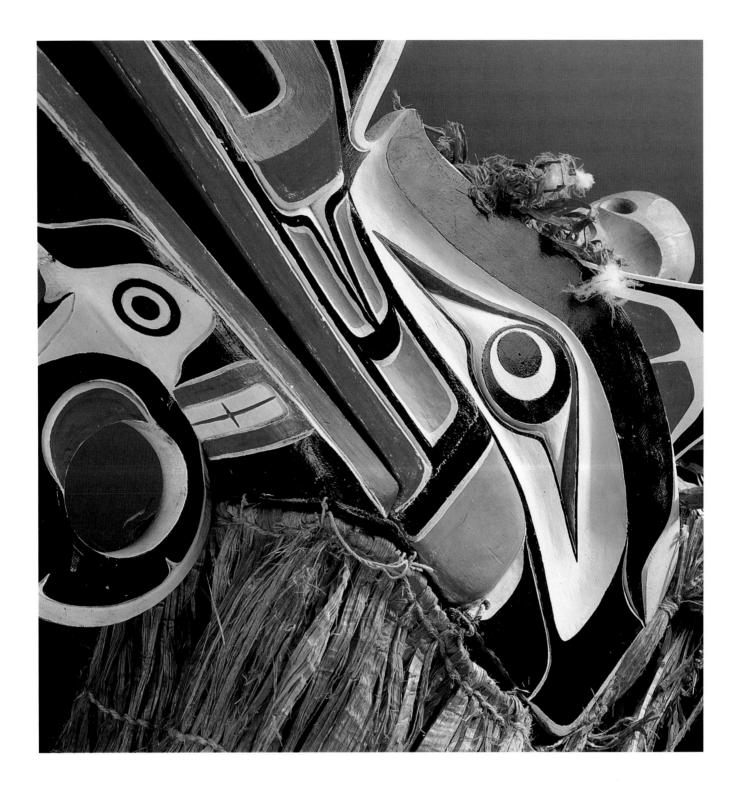

lines of his work with transitional curves and non-parallel forms that keep the viewer's eye flowing about the compositions. Like other Kwakwaka'wakw artists of his generation, Hiłamas employed commercial enamel paints that would shine in the firelight of the performance houses of his day. Though maintaining the traditional Native primary colors of black and red, he would also incorporate shades of yellow, orange, and brown when he saw fit. The prodigious artistry of Willie (Hiłamas) Seaweed readily influenced his early- to mid-twentieth-century contemporaries, and the various elements of his style continue to reverberate among many Kwakwaka'wakw and other Northwest Coast artists today.

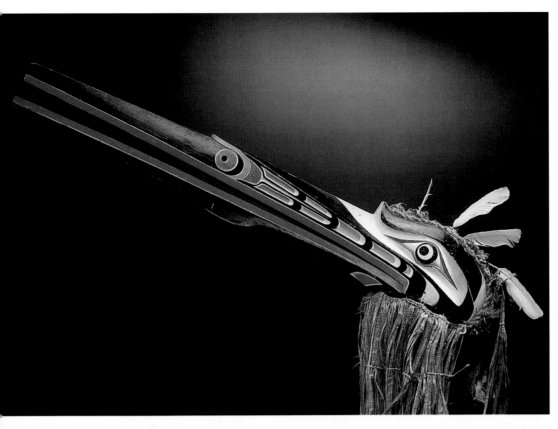

6.9. *Huxwhukwamhl*
(*Huxwhukw mask*)
Willie Seaweed, Kwakwa̱ka̱'wakw,
'Nak'waxda'x̱w, *c. 1940. Redcedar,*
paint, cedar bark. Mask: 12″ H
× 66″ L × 10″ W; cedar bark: 26″ L.
Collection of Bill and Marty Holm

Willie Seaweed saw the Huxwhukw as
a very long and narrow-beaked crea-
ture, enhancing the terrifying image
of a people-eating bird monster. Not
his longest Huxwhukw mask, this one
nonetheless draws the inevitable thin
tip of the skull-breaking beak out to a
chilling conclusion. In his later work,
Hiłamas usually employed the 20th-
century Kwakwa̱ka̱'wakw standard
of a white-painted background, to
increase the degree of contrast and the
prominence of his graphics in firelight.

6.10. *Giḵa̱mł (chief's mask)*
(*Dzunukwa mask*)
Willie Seaweed, Kwakwa̱ka̱'wakw,
'Nak'waxda'x̱w, *c. 1940. Yellowcedar,*
paint, hair. 11″ H × 8″ W × 6″ D.
Collection of Roger Lohrer,
SAM L91.13

Willie Seaweed carved a number of
Giḵa̱mł, or chief's masks, each an
expression of the evolution of his style
over time (see Holm 1983c: figs.
116–19). The hollowed cheeks, the
pursed lips, the dark color, and the
deep-set, nearly closed eyes are image
features of the Dzunukwa, who is
known to fall asleep easily. The
human hair that slightly obscures
the face symbolizes the reclusive, shy
nature of the Dzunukwa. The inside
of this piece, like the majority of Sea-
weed's masks, is hollowed into the
same kinds of smooth, clean surfaces
as the exterior.

Jack James is one of a handful of lesser-known Kwakwaka'wakw artists of the middle to late twentieth century who carved for traditional use as well as for sale, producing masks and other small carvings throughout his life (Holm 1983c:148). The two masks of his making in this collection each display a very different esthetic, due in part to the characteristics of the images represented, and in part to the different times in which they were made (figs. 6.11, 6.12). The Dzunuk'wa mask is traditionally a less-elaborated type, and is also from a somewhat earlier period in Kwakwaka'wakw art, made before the more flamboyant styles of the 1950s and 1960s had developed. Other artists of this time period not previously mentioned include Jimmy and Blackie Dick, Henry Hunt, Henry Speck, Ellen Neel, Charlie George, Jr., Charlie G. Walkus, George Walkus (fig. 6.13), Doug Cranmer, and many others who upheld the traditions of the Kwakwaka'wakw style in this part of the twentieth century (see Hawthorne 1967/1983).

6.11. Dzunukwąmł
(Dzunukwa mask)
Jack James *(1902–80),* **Kwakwaka'wakw,** *Gilford Island, 1935–1945. Redcedar, paint, hair. 10.5″ H × 10″ W × 7″ D. Collection of Bob and Betty Stott*

This mask may also have been used as a Gikąmł (see fig. 6:10), and is attributed to an early time in James's career (Holm, c. 1987, pers. comm. to owner). James has included the major characteristics of the Dzunukwa image, including the heavily protruding brow, the hollow cheeks, the infamous pursed lips, and the deep-set eyes, which are here depicted as wide-open and more alert than many of the type. The eyes are not large, however, and the deep, white eyesockets exaggerate their diminutive scale and emphasize their expressive qualities.

6.12. Bąkwąs'ąmł, (Bąkwąs mask)
Jack James, Kwakwaka'wakw, *Gilford Island, c. 1960. Redcedar, paint. 12.5″ H × 10″ W × 6″ D. Collection of Bob and Betty Stott*

From a later period of Jack James's artistic life, this Bąkwąs image was carved in a much less conservatively traditional style than was the earlier example (fig. 6:11). The influence of Henry Speck and other flamboyant artists of this period can be seen in the repetitive use of white background design in the painted composition. The emphasis of white paint, the shape of the nose, and the closed center of the mouth are traits attributable to a Gilford Island style of the 1960s and 1970s, evident also in the work of other artists from this area, such as Sam Johnson.

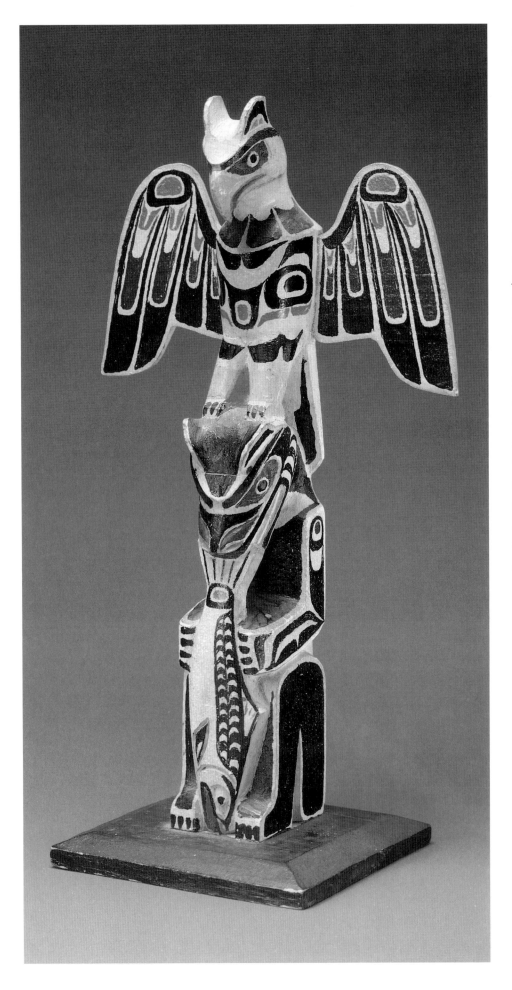

6.13. *kikw'bidu (totem pole model)*
George Walkus *(c. 1875–1958),*
Kwakwa̲ka̲'wakw, Gwasila
(Smith Inlet), c. 1945. Redcedar, paint.
18″ H × 3″ W. Collection of
Bob and Betty Stott

Chief George Walkus was known as a
wise and resourceful individual and
artist. This fine, small pole by Walkus
was made during the time when Willie
Seaweed's creativity was at its most
flamboyant peak, and the two artists
seem to have developed somewhat
similar styles. Also evident are
Walkus's personal touches, such as the
slightly downward, sensitive cast to the
head of the Kolus and the bear. The
ovoid and feather designs on the wings
are Walkus in their detail, where a
slightly more northern structure pre-
vails in the layering of the feather
shapes than is typical of Seaweed's
style. Walkus's Smith Inlet home is one
of the most northern Kwakwa̲ka̲'wakw
villages, adjacent to the Heiltsuk area
of influence.

Henry Hunt (fig. 6.14) was the son-in-law of the influential Kwakwaka'wakw artist and ceremonialist Mungo Martin, and the father of well-known artists Tony, Richard, Stanley, and Henry Hunt, Jr. The many extended-family members have been the backbone of the Kwakwaka'wakw artistic revival in the contemporary period. Henry's career began in earnest as the assistant to Mungo in the Royal British Columbia Museum's carving program, starting in 1954 (Macnair, Hoover, Neary 1980:183). Martin and Hunt worked mainly in the carving shed in Thunderbird Park, producing original poles and reproductions of old works for the museum and for commissions that have distributed their work worldwide. Henry's career spanned from a time when his masks sold in Victoria's tourist shops for less than $100 (the going rate for top work, pre-1969), through the rising tide of the artistic revival, when his pieces brought several thousand dollars apiece.

*6.14. **Humanoid eagle mask***
Henry Hunt *(1923–85),*
Kwakwaka'wakw, Kwaguhl, *c. 1965.*
Redcedar, paint.
13″ H × 10″ W × 8″ D. Collection of Eugene and Martha Nester

This mask illustrates a relatively early Henry Hunt style, embodying a sculptural approach seen in much Kwakwaka'wakw carving from the Victoria area, especially before about 1975. The mask has a basic cylindrical form with protruding beak and semi-angular relief about the eyesocket and mouth areas, a style drawn from historic Kwakwaka'wakw sculpture. Hunt's style avoided the common 20th-century Kwakwaka'wakw use of a white background, opting for the subtler effect of traditional colors on bare wood. Strong northern as well as traditional Wakashan influences can be seen in the two-dimensional design work.

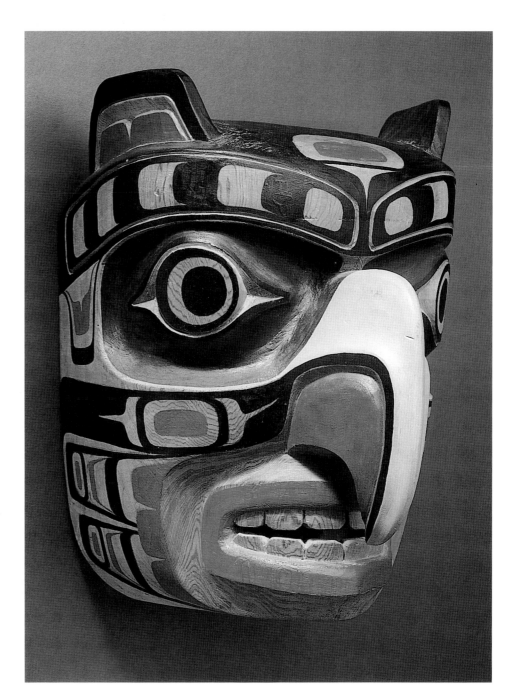

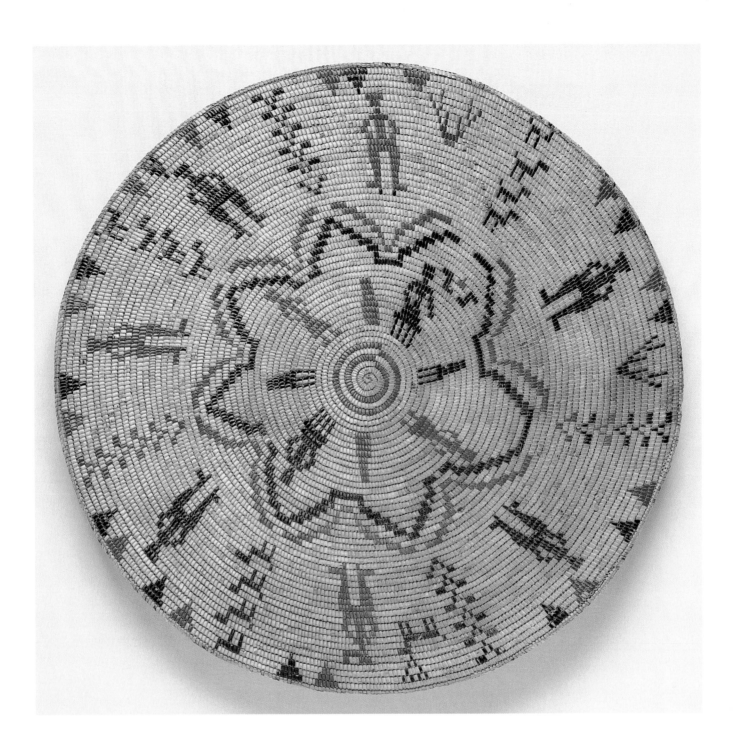

Henry's son, Tony Hunt, claims an artistic legacy as Mungo's grandson, though their relationsip is familial, not biological. (Tony's mother, Helen Hunt, was raised by Mungo and his wife, Abayah. Biologically speaking, Tony is Abayah's great-grandson by her first husband. Mungo was her second.) The paternal, artistic relationship of Mungo and Tony, however, was grandfatherly in character. (Holm, pers. comm.) Tony grew up in the midst of the carving program at Thunderbird Park and the ongoing revitalization of ceremonial culture that began in earnest after 1951, when the anti-potlatch language was dropped from the Federal Indian Act in Canada. As a young boy, Tony took part in the first public "legal" potlatch, held after anti-potlatch laws were revised. Mungo Martin and the then Provincial Museum of Victoria (now

the Royal British Columbia Museum) put up the three-day event in the bighouse Mungo had built adjacent to the museum and carving shed in Thunderbird Park in 1953 (Macnair et al. 1980; Nuytten 1982:75–128). By the mid-1960s, Tony had also become an internationally known artist like his father and grandfather, working in wood, silver and gold, and a then-new medium in which Northwest Coast designs have since enjoyed a considerable success, the silkscreen serigraph (Hall, Blackman, Rickard 1982). The Arts of the Raven gallery of Victoria, B.C., founded in 1970 by Tony, his brother Richard, non-Native artist John Livingston, and others, became a very important focal point in the resurgence of Kwakwaka'wakw art and dance of the last twenty-five years. Numerous artists, some of whom are represented in this exhibition, got their most influential training through the workshop associated with the gallery, including prominent artist Tony Hunt, Jr. Through this venue, they learned about the creation, marketing, and performance of the visual traditions of their ancestors, and the Arts of the Raven gallery continued to be an important spot on the contemporary Northwest Coast map until its closing in the early 1990s.

Like other First Nations weaving traditions, Salish basketry adapted to suit new demands and applications as the market for Native handwork evolved (fig. 6.15). Sometime in the first half of this century, an imaginative business owner in southern British Columbia commissioned the creation of a number of large circular weavings like this one to serve as table tops in a Fraser valley cafe. The style of weaving and the design techniques are those of traditional Salish basket makers, who are known for creating large baskets, lidded trunks, baby cradle boards, and large open trays in the same general style of work.

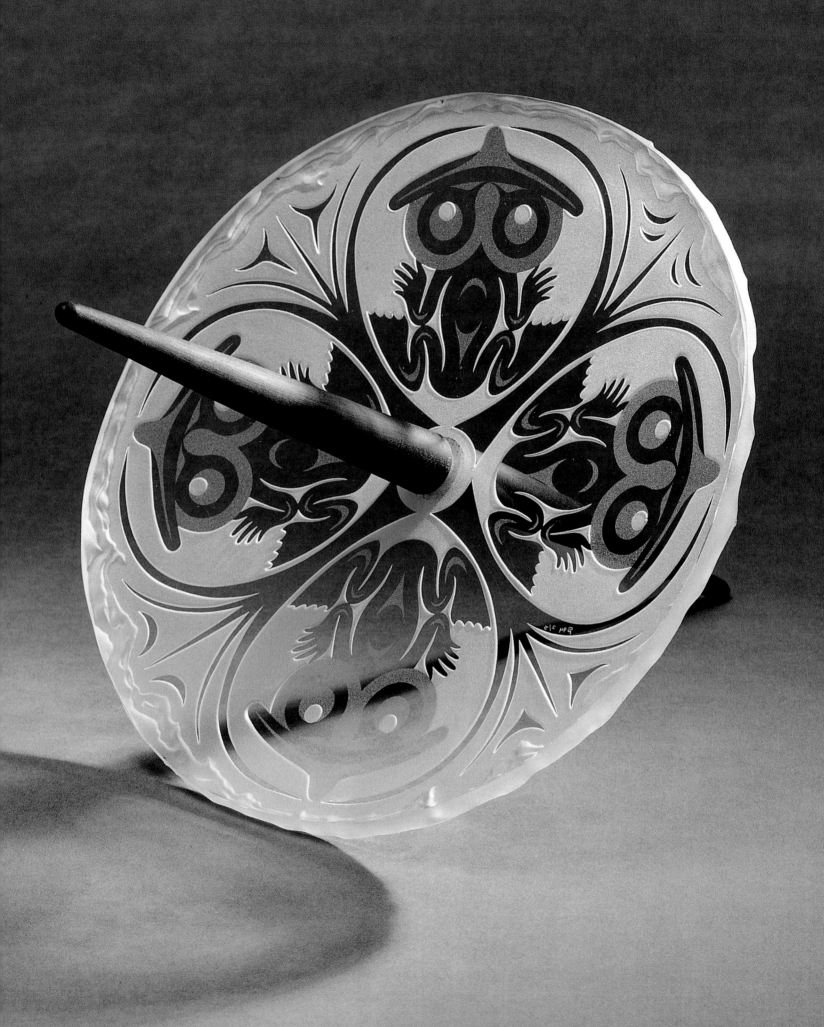

The Spirit of the Masters

Northwest Coast Art in the Contemporary Period, Since 1965

*If the impact [of Euro-American contact] had been kinder,
who can tell in what new channels the old powerful stream
of the arts of the Northwest Coast may have flowed?*
—Bill Reid, Haida (1967)

The Tide Turns: Northwest Coast Art from the Late 1950s

BILL REID IS PARTICULARLY WELL SUITED TO DISCUSS THE INQUIRY above because of the innovative and central role he and his work have played in the revival of Northwest Coast art in the contemporary period. In 1948, Reid decided to follow the artistic involvement of his grandfather, Charles Gladstone, as an artist working in gold and silver (Macnair et al. 1980:186). Prior to 1956, Reid, the son of a Haida woman from Skidegate and a non-Native father, was a professional radio announcer for CBC Radio in Vancouver, a career that was set permanently aside that year when he began work on his first professional carving project at the University of British Columbia (UBC) Museum of Anthropology, a program led by anthropologist and art historian Wilson Duff (Duffek 1981; Shadbolt 1986; MacDonald 1996:225).

There he worked in brief association with Mungo Martin (who was reproducing totem poles in Haida and Tsimshian style in his work for both UBC and the Royal British Columbia Museum) and Doug Cranmer. Working on his own, Reid was responsible for carving seven Haida-style poles and constructing two traditional Haida houses for the museum's collection, completing the project in 1962. Based in most cases directly on original poles that had been retrieved from old village sites (under the first phase of the Duff/UBC project), these poles beautifully replicated both the sculptural and two-dimensional traditions represented in those great original works from the middle nineteenth century. In this way the active continuity of the Kwakwa̱ka̱'wakw artistic traditions and technology found a skilled and willing new counterpart in a member of the northern Northwest Coast community. From

these kinds of bare beginnings, the contemporary revitalization of northern Northwest Coast art soon became firmly established in Canada.

Dr. George MacDonald (director/president of the Canadian Museum of Civilization Corporation, Hull, Quebec) has noted, in explanation of Bill Holm's description of the northern style formline as "calligraphic," that: "There is an implicit grammar at play in each work that determines the message of the piece" (MacDonald 1996:225). In its essence, this commentary forms the distinction on which the "traditional quality" of various examples of northern Northwest Coast art has been judged and discussed by art historians. The esoteric quality of the northern tradition is such that if this *grammar,* or design syntax, is not properly structured, then the *message,* the total visual conveyance of an image, becomes somewhat garbled. Dr. MacDonald has further described the resurgence of the Northwest Coast art traditions with these words: "In a wonderful interplay between anthropologists, art historians, and the new generation of artists, this grammar has been revived and extended" (ibid.: 225). The UBC and Royal British Columbia Museum totem projects are specific instances of such an interplay.

The example of Bill Holm, an American art historian of Reid's generation whose work is the foundation on which this and many other analytical studies of Northwest Coast art are based, offers another aspect of the interplay of which Dr. MacDonald has spoken. Holm's important first book, *Northwest Coast Indian Art: An Analysis of Form* (1965), was first drafted in 1958. It represented the culmination of several years of study and structural analysis of the northern style artistic conventions. Conceived as an academic study, not a "how-to" book, Holm's *Analysis* has nonetheless assisted countless individuals, both Native and non-Native, with its clear insight into the northern two-dimensional design system. Holm's design nomenclature has been employed by artists and art historians alike in discussing the elements and traditions of this art form. Though this work has occasionally been accused of 'limiting the concepts' of Northwest Coast art by permanently casting it in a relatively narrow nineteenth-century timeframe, such has never been its intent. It is not *The Chicago Manual of Style.* Holm clearly states in the *Analysis* that he is describing a representative sample of nineteenth-century two-dimensional work, and that "no system could ever, of itself, produce the masterworks of Northwest Coast art that are the inspiration and the object of this study" (1965:93).

In his related article for the Vancouver Art Gallery's *Arts of the Raven* exhibit catalog (Duff, Holm, Reid, 1967, no page numbers) Holm further states: "In the end it is [the] personal interpretation of the art tradition which elevates the masterworks to their place over the many competent but less inspired examples." Given the amount of highly innovative contemporary work created since the *Analysis* was published, it would seem that the best artists do not feel limited by Holm's description of the mainstream nineteenth-century conventions. The tradition has continued to expand and develop just as it did in the centuries prior to the timeframe of Holm's study.

Some speakers, though, perhaps go too far in their assessment of the role this informative work has played in the contemporary revitalization of the art. By attempting to place full responsibility for the revival on its publication, they make an assertion that may be as unfairly stated as is the previous one. There were, certainly, highly traditional examples of twentieth-century Northwest Coast art produced by some of

the aforementioned artists prior to the release of Holm's study. To try to discern which influence on which artist was more important than another seems of little true value. His book has clearly served as a conceptual doorway to the art for many interested people, including Native artists, but especially perhaps for urban non-Natives, including this author.

The conventions of this art, however, were apparently understood by a small but important collection of individuals before the publication of Holm's book, and their influence has been passed from hand to hand among each artist's community. In addition, the invaluable role that the old museum pieces have played in the study and revival of this art by contemporary artists is at least as important an influence to take into account (Holm, pers. comm.). From my personal experience, many Native artists of the early 1970s had well-used copies of *Analysis of Form* at hand, though they got more use from its illustrations than its heavy, term-complex, analytical text. No other books available in the 1960s and 70s featured the number and quality of two-dimensional designs reproduced in Holm's book, and these have conveyed its message well, in lieu of its complex wordage.

Regardless of the source of one's introduction to these traditions, the wonderful, productive interplay between the various individuals involved in the current universe of Northwest Coast art has been an experience shared by many people, both Native and non-Native. Many of the great projects that have assisted in the expansion and advancement of the art form have been organized and funded by non-Native institutions, without whose patronage the market for even the best artist's work would not be so large or so universally visible. The interplay of individuals and cultures has been expressed in innovative museum programs, such as co-custodianships, which have increased access to the old examples by Native artists and ceremonialists for study or traditional use; or the reconstruction and reproduction of old pieces, which have extended artists' skills. Such concepts have been pioneered at the Royal British Columbia Museum, the UBC Museum of Anthropology, the Alaska State Museum, and other such institutions. The publications programs of various institutions and presses highlighting the art and the artists from this area have added immeasurably to the level of public knowledge and appreciation of the art form as well. The funding and support offered such efforts through the institutions of government have indicated a significant turn-around from previously oppressive policies. This has been tremendously important to the success of many undertakings. In short, the interplay of which Dr. MacDonald wrote is a many-faceted one, engaged in on many levels and in many kinds of expressions and degrees of participation.

Direct participation in this art form on various levels by non-Native artists has had its influence as well, and has sometimes been a point of contention. This question has many perspectives, nearly a different one for each person who engages in the creation of the art form. For the most part, the positive influences of those artists who have worked in association with Native communities, including Bill Holm, Duane Pasco, Cheryl Samuel, John Livingston, Steve Brown, Loren White, the late Scott Douglas, and others, has been welcomed and appreciated by those with whom these individuals have studied and labored in mutual respect and the love of creation. The intent of this exhibition has been to highlight the evolving journey

that Northwest Coast Native art has taken through time, to follow the threads of continuity and evolution that are woven through the Native traditions coastwide. Influences on that continuity have been discussed and highlighted along the way, and the occasional participation of non-Native artists within this tradition is also acknowledged, but this is not an aspect that has been included in the exhibition for a variety of reasons. That there have been many important influences in the latter part of this century from the non-Native community which have affected the overall revitalization of the Northwest Coast tradition is clear. Classes, appprenticeships, and books on the art forms have all been influential. That this is well and good, particularly in light of the past history of the meetings of these cultures, is also clear. The revitalization itself is a natural, karmic return of the tide, a backswing of the pendulum of time. It is also apparent, to anyone who looks objectively at the whole picture, that this revitalization would have taken place at its own pace, with or without the participation of non-Native artists.

Flood Tide: The Northern Renaissance

By the late 1960s, arguably the moment in history when the true appreciation and a sense of the indisputable value of Native American peoples, culture, religious and spiritual concepts, and art first came to the fore in non-Native North America, the energy of the Northwest Coast revitalization was already strong and steadily expanding. Bill Reid's sense of refinement and craftsmanship was being echoed in the work of Robert Davidson, great-grandson of Charles Edenshaw and formerly an apprentice with Reid, and in the works of other up-and-coming artists. In 1969, Davidson raised the first totem pole in generations to be carved and dedicated in his home village of Masset, British Columbia (one of the totem pole forests of the nineteenth century that had been harvested of its treasures by museum collectors and church leaders around the turn of this century). Knowledge and demonstrable skill in the art forms was passed from hand to hand among Northwest Coast artists so quickly and broadly that within ten years there were hundreds of individuals practicing the traditional forms of the art in nearly all areas of the region.

Representative of this explosive and tenacious revitalization are the objects included in this exhibition. These are but a few, necessarily limited examples of the kinds of work that have been done in the last thirty years of Northwest Coast history. Certainly not all of the best-known or most influential contemporary artists are or could be included in this or any group of materials, but the collectors who have so generously loaned their pieces to this effort have gathered together many fine selections of newer works, and these are the collections from which the pieces highlighted here were assembled.

In the far north, the first and most consistently prominent name to reach around the globe has been that of Nathan Jackson, an energetic and richly good-humored artist born in Tenakee Springs, Alaska, who began carving initially during a period of physical recuperation, and found the pursuit more satisfying than other available occupations in the region. He soon found an appreciative audience for his work, examples of which are to be seen in nearly every southeast Alaskan city or village,

both as public monuments and as treasured objects reserved for traditional use (fig. 7.1). Jackson became an important master, willing to tackle many different forms of the Tlingit art tradition, and willing to spend a great deal of time working with numerous apprentices who have continued on in their own work. Jackson's most recent apprentice has been his son, Stephen (b. 1976), now a fine carver and designer of totem poles in his own right.

The late James Schoppert is an artist, unfortunately not represented in this collection, whose own inquiring, creative spirit motivated him to constantly expand and recast old, traditional ideas in new and different ways. His memorable and inspiring series of unitized design fragments, such as the piece entitled *Blueberries* (Anchorage Museum of Art; see Nicholls 1997) calls upon viewers to expand their vision of Northwest Coast design concepts, and focuses attention on the minute curves, massive lines, and fine junctures of the tradition as if seen through a microscope. Schoppert held an MFA in sculpture from the University of Washington, and his highly inventive work stands as a true inspiration and example of seeing the world with fresh and open eyes.

Artists from many areas of the Northwest Coast have contributed wonderful examples of the northern style to the collective contemporary tradition, from

7.1. Carved panel
Nathan Jackson *(b. 1939),*
Tlingit, *1979. Redcedar, paint.*
48″ H × 54″ W × 2″ D.
Collection of John H. Hauberg

Nathan Jackson is one of the first Tlingit artists of his generation to truly capture the essence of the old-style tradition. His work is heavily influenced by the numerous surviving examples of Tlingit art of the very early classic period in the Haines/Klukwan area of upper southeast Alaska.

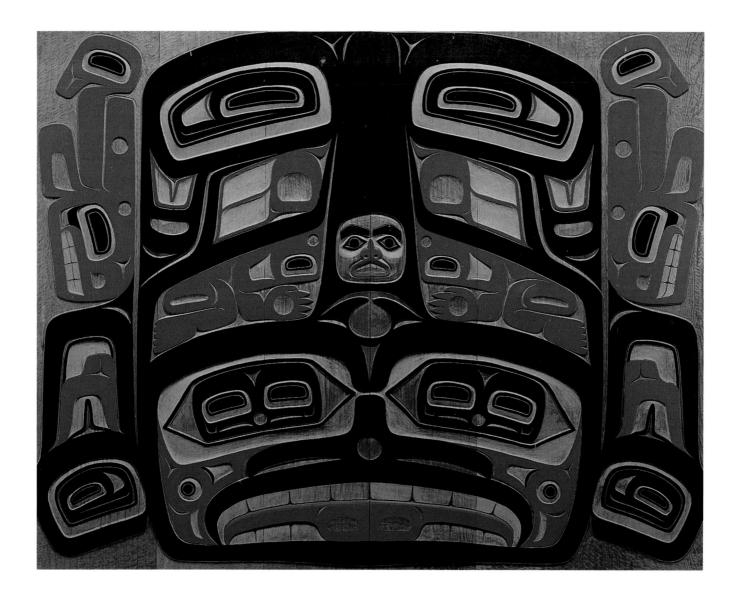

Kwakwa̲ka̲'wakw artist Joseph Wilson's innovative blend of northern, southern, and his own unique design style, to more traditional but highly inventive and creative artists such as Joe David, originally from the west coast of Vancouver Island near Tofino, British Columbia. Joe's pieces in this collection (figs. 7.2, 7.3) illustrate his early sculptural facility and his mature flair for very creative design work in both northern formlines and his particular interpretation of the most interesting old Nuu-chah-nulth styles. Early in his carving career Joe worked in close association with Duane Pasco, whose influence is seen in the headdress frontlet included here, and who continues to be a respected colleague.

7.2. Headdress frontlet
Joe David *(b. 1946),* **Nuu-chah-nulth, Tla̓oquiaht,** *1973. Alder, paint, abalone. 7″ H × 6″ W × 2″ D. Collection of John and Janet Creighton*

Joe David is one of the most stylistically fluent of the contemporary Northwest Coast artists. He enjoys creating great pieces in many different First Nations styles in addition to his native Nuu-chah-nulth traditions. This piece was carved during a period of work David spent in association with well-known artist Duane Pasco of Seattle, and it reflects aspects of Pasco's interpretation of Tsimshian sculptural style.

*7.3 a, b. **Mussel shell rattles (pair)***
Joe David, Nuu-chah-nulth,
Tla'oquiaht, *1987. Yellowcedar, paint.*
(a) (b): 11″ H × 4″ W × 3″ D.
Collection of Carla Holm (a).
Collection of Karen Holm (b)

These rattles graphically illustrate the
similarities and differences between
the northern formline system (on
right: Haida style) and David's inter-
pretation of the southern coast two-
dimensional tradition of the Nuu-
chah-nulth region of Vancouver
Island's west coast (on left). Both
designs represent a whale, using a
different two-dimensional "grammar"
for each. The pair of images and their
current owners appeared to the artist
in a prescient dream.

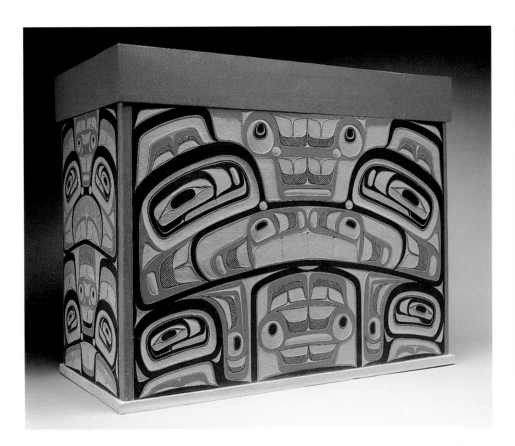

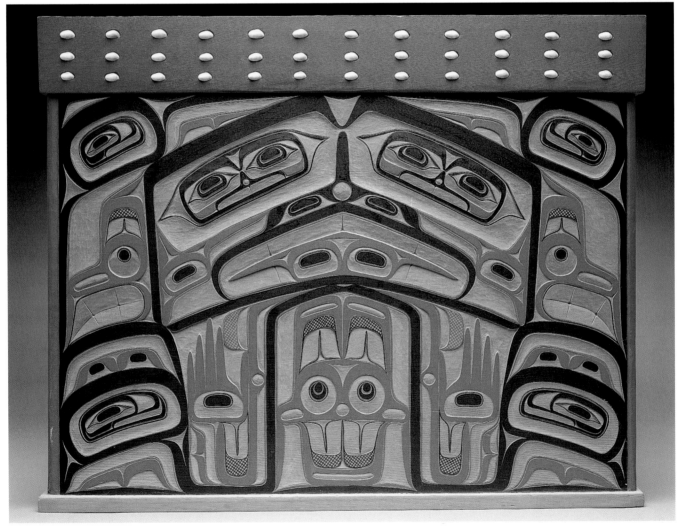

7.4. Hawk-man globular rattle
David Boxley, Tsimshian, *1989.*
Alder, paint. 11″ H × 5″ W × 5″ D.
Collection of John and Janet Creighton

David Boxley began carving in his home village of Metlakatla, Alaska, in the 1970s, and soon after retired from schoolteaching. His numerous totem poles (he has carved more than 40) have been shipped to many parts of the globe. Boxley works diligently to maintain the essence of Tsimshian style in his sculptural and graphic work, each of which is exemplified in this fine rattle.

7.5 a, b. Bent-corner chest
David Boxley, Tsimshian, *1994.*
Redcedar, paint, opercula. 29″ H × 36″ W × 18″ D. Collection of John and Janet Creighton

The middle-19th-century Tsimshian style of thin formlines and large negative areas is beautifully represented in this large bent-corner chest. Boxley is well known for his flowing and often narrative serigraph designs, executed in a similarly proportioned formline style.

David Boxley's work is in great demand in the Seattle area and elsewhere as is evidenced by his extensive list of commissions across the country (figs. 7.4, 7.5). Boxley's home community of Metlakatla, Alaska, was largely devoid of traditional influence when he grew up, but the town has since become a stronghold of pride and good feelings associated with traditional dancing and cultural expression. Most of the resurgence in visual art traditions there is the result of the work and influence of Tsimshian artist Jack Hudson, a very refined carver of masks, rattles, and relief panels, who began carving in Seattle around 1970. The twenty-plus years that Jack Hudson has taught in the school program at Metlakatla have raised the general level of traditional art awareness in the town far above that of most communities. His work has contributed a great deal of experience to a skilled and knowledgeable population of graduates from his classes in the region, a number of whom have followed diverse careers in traditional art on their own.

Northern British Columbia artists Dempsey Bob (fig. 7.6), Norman Tait (fig. 7.7), and Chuck Heit (fig. 7.8) are experienced in fine sculptural work, from large poles

7.6. Eagle spirit face mask
Dempsey Bob *(b. 1944),* **Tlingit, Tahltan,** *1989. Alder, paint, hair. 8″ H × 11″ W × 5″ D. Collection of Dr. Lloyd J. Averill*

Dempsey Bob began carving in association with the Gitenmax School at Hazelton, British Columbia, and soon forged a very refined and distinctive personal style that draws from old traditions of both Tlingit and Tsimshian First Nations. Composite imagery is a favorite subject in Bob's sculpture.

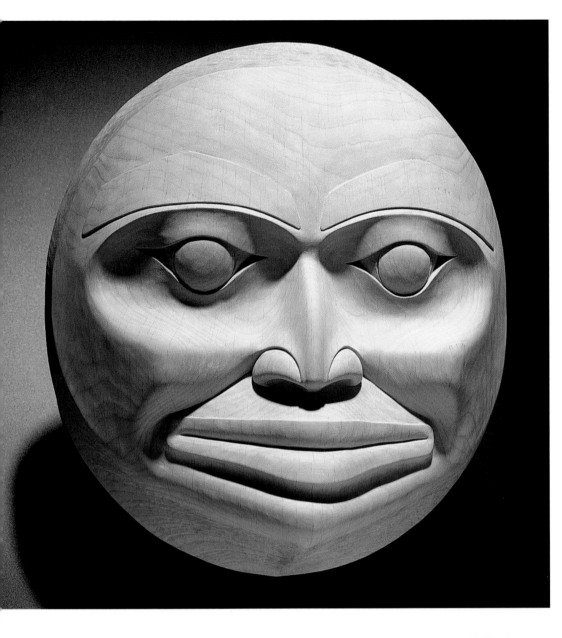

7.7. Moon mask

Norman Tait *(b. 1941)*, **Nishga**, *1985.Alder. 15″ H × 13.5″ W × 6″ D. Collection of John and Janet Creighton*

Norman Tait is from Kincolith village between Portland Canal and the Nass River in northern British Columbia, and he has led a powerful movement in the recapturing of classic-period Nishga sculpture. His sons and other associated artists share his refined interpretation of old-style sculptural and design work (Jensen 1993).

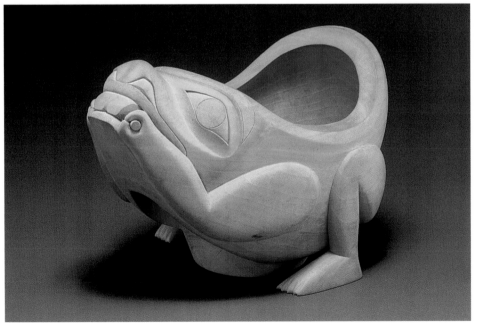

7.8. Beaver bowl

Chuck Heit *(b. 1959)*, **Tsimshian**, *1991. Alder. 7″ H × 16″ L × 12″ W. Collection of Charles and Jan Sleicher*

Heit developed some of his carving skill as an apprentice to Robert Davidson on the Three Watchmen totem triad carved for the College Park development in Toronto in 1984. This bowl is a playful blend of traditional and contemporary sculptural style and imagery.

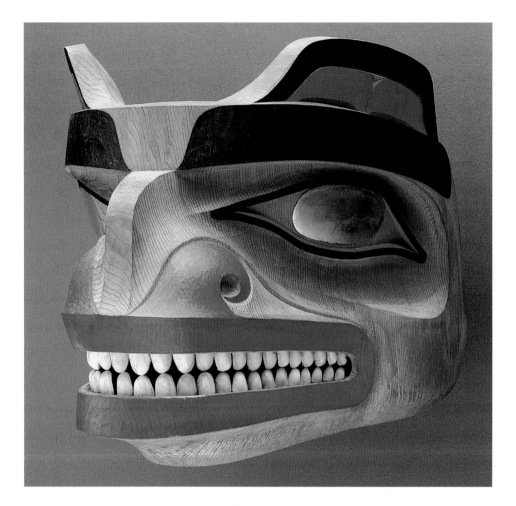

to masks, bowls, and regalia headpieces. Tait and Bob have been particularly active in helping to bring new artists into the field, from among both their family and clan relations. Each has literally traveled the world in the execution of his art, and has had the honor and privilege of his work's inclusion in major media venues, from books to video programs. The well-established and high-profile nature of a number of major British Columbia Native art galleries has added a great deal to the exposure and audience available to artists from Canada over the span of the contemporary period.

Haida artist Robert Davidson's outstanding work (fig. 7.9) has been documented in many publications. He has taken a leading role as an articulate spokesperson for his art and for the history and traditions of the Haida and other First Peoples of the coast (Stewart 1979; Thom, ed., 1993; Davidson and Steltzer 1994; Brown, ed., 1995). In addition to his own remarkable contributions to the evolving visualization and aesthetic advancement of the Northwest Coast tradition, Davidson has worked diligently with a number of apprentices over the years, all of whom have contributed back to the tradition from their own imaginations and inspired creativity. Davidson's brother Reg Davidson, Jim Hart, Don Yeomans, Larry Rosso, Chuck Heit, and his close associate of many years, Joe David, all have grown and have expanded their artistic vision as a result of their work with Davidson as well as other artists. All have continued and have passed their experiences on through the ever-expanding network of the contemporary tradition.

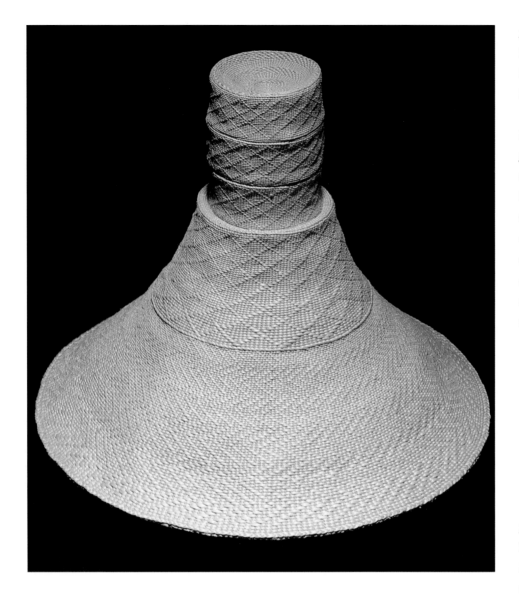

Davidson's grandmother, Florence, was the daughter of Charles and Isabella Edenshaw (figs. 5.14, 5.15), and this creative family has included a long line of fine traditional weavers, of whom Isabel Rorick is one of the most outstanding and accomplished in terms of her extension and refinement of traditional forms and elements (fig. 7.10). Preceded by her mother, Primrose Adams (Brown 1995:106), and her grandmother, Florence, Rorick has mastered the traditional forms of Haida weaving and carried their techniques along further steps of refinement in scale and design application.

Don Yeomans has developed as a most influential and imaginative contemporary artist, producing highly refined and exquisitely finished work (figs. 7.11, 7.12). An accomplished sculptor and jeweler, Yeomans has also distinguished himself as a creative designer, bringing inspiring new ideas and applications to the Northwest Coast tradition that have been adapted by many into their own work. Beginning in the late 1970s, Yeomans began to experiment radically with the "negative" design field, and produced some of the most innovative designs to appear in the tradition since the time of the old masters exemplified in figure 5.9. His pioneering development of the concept of negative formlines (Brown 1997) has been picked up by a large number of

practicing artists, and has now been seamlessly enfolded into the traditional design catalog of visual techniques. Seen here in a masterful drum painting (fig. 7.11), the negative formlines are the unpainted design elements, primary in some areas and secondary in others. The traditionally negative areas have been painted black, while the primary formlines in this technique are not painted at all, appearing as the background color of the deerskin drum head. The effect of this section is like a true photographic negative, a total reversal of the traditional color system and a technique that, to this extent, did not exist prior to the contemporary artistic renaissance.

The red formlines on black background have precedence in the nineteenth century, but the development of formlines from unpainted space is an innovation from the contemporary period that also has small roots in the work of Haida artist Bill Reid. In the early 1970s, certain of Reid's serigraph designs occasionally employed painted negative crescents and trigons, something unknown to the old mainstream Northwest Coast tradition. These in a way foretold the potential of the photographically negative image style pioneered by Don Yeomans. Yeomans's development is said to have taken place at the urging of the late Bud Mintz to "do more with your negative areas!" (Phil Janzé, pers. comm., 1995). As one of the most significant new evolutionary advancements in the ongoing Northwest Coast tradition, this technique is now employed by artists who are new to the tradition as well as by more experienced masters like Robert Davidson.

7.12. Killer whale hat

Don Yeomans, Haida, *1992.*

Alder, paint, horsehair, opercula.

10″ H × 19″ L × 15″ W.

Collection of The Seattle Times

In this piece, based on the sculptural concept of an old Tlingit clan hat (Kaplan and Barsness 1986:183, fig. 196), Yeomans has totally recast a masterfully classic image in his own powerful style of representing Haida sculptural and two-dimensional traditions.

7.13. Gold bracelet

Bill Reid *(b. 1920),* **Haida,** *1969.*

22k gold. 2″ H × 3″ D.

Collection of John H. Hauberg

Formally trained in European metalsmithing, Bill Reid has applied repoussé techniques to traditional concepts of bracelet design and has created many deeply sculptural, monumental pieces of this kind, blending flat design with three-dimensional work in the image of many old Northwest Coast masterpieces such as bentcorner bowls and sculptural chest designs.

7.14. Gold pendant

Bill Reid, Haida, *1976.*

22k gold. 3″ H × 2″ W × 1″ D.

Collection of John H. Hauberg

The full ensemble of this pendant replicates the sculptural concepts of certain old Haida globular rattles in the rich medium of fine goldwork. The masklike face and intricate rim were made in repoussé and engraving, and the tiny post and stand on which the piece is displayed complete the handle of the rattle concept.

The fine goldwork of Bill Reid is a privilege to feature in any exhibition of Northwest Coast art, both for the excellence of his sculpture and craftsmanship and for the pivotal role he has played in the overall resurgence of the art form (figs. 7.13, 7.14). Celebrated in many one-person exhibits and in numerous publications, Reid's work is a real glory to behold and makes a rich and complex statement on the high visionary art and potential of all human beings. His eloquent writings on the art, some of which have been excerpted here, capture in prose the visual flavor of the best old works (Reid 1967, 1971, 1987, 1993).

Children of the Masters: Kwakwaka'wakw Continuity

Founded on the cultural background of many individuals discussed in the previous chapter, the Kwakwakwa'wakw artistic revitalization came about more strongly in the first years of this period than was the case in most other areas of the coast. The slim but unbroken chain of artists and cultural practitioners who carried the traditions into the 1960s transferred the artistic vitality of their generation to the new artists who came up to take their places and to expand an already solid base of knowledge and experience. The numbers of Kwakwakwa'wakw artists at work today is amazing and gratifying, with several continuous family lines in evidence. The artists are able to produce for an active and vigorous ceremonial tradition, which has inspired many to create the kinds of complex mechanical masks and figures that were often employed in historic Kwakwakwa'wakw performances. The concept of the button robe has seen its most elaborate incarnation among the historic Kwakwakwa'wakw examples, rivaled only in recent years by the new elaborations applied to the type by Robert Davidson, Dorothy Grant, and others who have followed their lead incorporating design images in the robe borders. Button designs worked out on wide borders is an old Kwakwakwa'wakw style, and many very elaborate pieces can be seen in historic collections. The button robe in this collection, sewn by Maxine Matilpi and designed by John Livingston, reflects this tradition in an open and uncluttered design (fig. 7.15).

*7.15. **Button robe***
Maxine Matilpi *(b. 1956),*
Kwakwaka'wakw, Ma̱mtagila-Tlaoit-
sis, *1992. Wool cloth, shell buttons.*
54″ H × 54″ W.
Collection of Microsoft Corporation

Maxine Matilpi, granddaughter of Chief Henry Speck, comes from a family that has played an active and important role in the maintenance of Kwakwaka'wakw ceremonial traditions. She has participated thoroughly in many aspects of traditional culture. Maxine is the domestic partner of non-Native artist John Livingston, who designed the breaching killer whale image for this fine fabric piece.

7.16. Wa-sa-na, (ghost mask)
(Heiltsuk style)
Beau Dick (b. 1955),
Kwakwaka'wakw, 1989. Alder,
paint. 10″ H × 7″ W × 5″ D.
Collection of Bob and Betty Stott

Beau Dick is a very versatile artist who frequently works in Heiltsuk and Nuxalk styles as well as the less commonly seen Kwakwaka'wakw styles of the 19th century. His technical facility makes him equally adept at carving in many stylistic traditions, as is demonstrated by his work on several pieces done in an old Tlingit sculptural style.

7.17. Ghost face mask
Mervyn Child (b. 1956),
Kwakwaka'wakw, 1991. Redcedar,
paint, hair. 16″ H × 14″ W × 8″ D.
Collection of Microsoft Corporation

Mervyn Child is the grandson of Thomas Hunt, whose grandfather was George Hunt, the well-known half-Tlingit ethnographer from Fort Rupert, British Columbia, who collected objects and information for Franz Boas during the turn-of-the-century period. Child developed his art in association with his many relatives of the extended Hunt family of Victoria and Fort Rupert.

The masks from this area included here illustrate a variety of imagery and ceremonial use, leading off with those usually associated with the winter dance, or Ts'eka series of performances, often called the cedarbark dances. Beau Dick's ghost mask, carved in one of the many First Nation styles in which Dick is sculpturally fluent, exhibits a strong Heiltsuk influence in the sculpture of the face and in the painting (fig. 7.16). The subtle, fairly naturalistic style of this mask is in sharp contrast to the ghost mask also seen here, made by Mervyn Child (fig. 7.17), the grandson of Thomas Hunt. This very large mask is about as full of sculptural forms and painted detail as it could possibly be, and conveys very well an impressive, fearsome image with its skull-like, humanoid form. Large masks of this type are sometimes performed with a full dancer's outfit to complete the picture.

7.18. *Galukwiwe' (crooked beak forehead mask)*
Dwayne Simeon *(b. 1960),*
Kwakwa̱ka'wakw/Haida, *1991. Red-cedar, paint, cedar bark.*
20″ H × 33″ L × 11″ W.
Collection of Microsoft Corporation

Dwayne Simeon has focused on a number of different substyles within the historic Kwakwa̱ka'wakw tradition, many of which are largely overlooked by other artists in their search for inspiration. This fine small piece is more mainstream, clearly in homage to the work of Willie Seaweed, whose sense of design and refinement are reflected in the lines of this equally masterful piece. It is of the type worn by a female Hamat'sa attendant, or Heligaste'.

7.19. *Huxwhukwa̱mhl (Huxwhukw mask)*
Simon Dick *(b. 1955),*
Kwakwa̱ka'wakw, *1988. Redcedar, paint, cedar bark. Mask: 10″ H × 55″ L × 10″ W; plus cedar bark: 24″ H.*
Collection of Jim and Dorothy Hussey

Simon Dick is from the remote village of Kingcome Inlet, where Kwakwa̱ka'wakw traditions and language were his first influences in life. His most recent work has illustrated an inclination to extend the concepts and the catalog of materials associated with traditional work, though this earlier piece is done in the style of the middle 20th century.

The Hamat'sa tradition, the highest-ranking dance privilege among the Kwakwa̱kwa̱'wakw and usually the first to be performed (sometimes following a ghost dance), is represented here by a small forehead mask of the type worn by the female Hamat'sa attendant as she dances ahead of the tamed Hamat'sa during his last dance of the series (fig. 7.18). Made by Dwayne Simeon, this fine mask shows the distinct influence of Kwakwa̱kwa̱'wakw ('Nak'waxda̱xw) artist Willie Seaweed (see fig. 6.9, and Holm 1983c:117). Though it is not a direct copy of any one mask by the latter artist, it employs the grammar of Seaweed's style, and demonstrates the way in

which the work of a powerful artist is given respect and acknowledgment by those who know and love his work. The Huxwhukw mask by Simon Dick (fig. 7.19) combines the influences of many artists, Willie Seaweed primary among them.

In spite of a vital ceremonial history, many Kwakwa̱kwa'wakw traditions have lain dormant over the years of suppression, to be sometimes nearly forgotten. The consultations for the *Chiefly Feasts* exhibition at the American Museum of Natural History in 1991 brought out some old pieces that kindled the memories of some of the elders present. One such object is interpreted here by Tom Hunt (fig. 7.20),

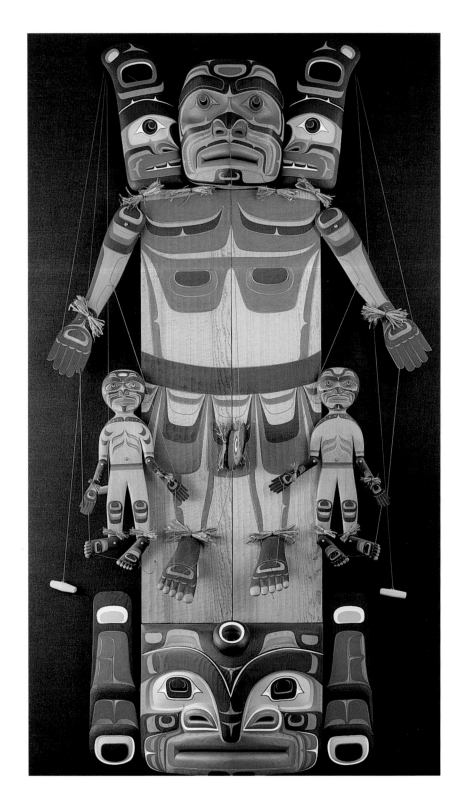

7.20. Nuła̱mista screen/puppet
Tom Hunt *(b. 1964),*
Kwakwa̱ka'wakw, Kwaguhl, *1990.*
Redcedar, paint, cedar bark.
96″ H × 40″ W × 3″ D.
Collection of Microsoft Corporation

This large and very unusual ceremonial piece is based on a wood and cloth assemblage that is housed in the American Museum of Natural History (Jonaitis 1991:62, fig. 1.36). This version uses wood in place of the cloth, and replicates the articulated, dramatic character of the older piece. Photo by Eduardo Calderón.

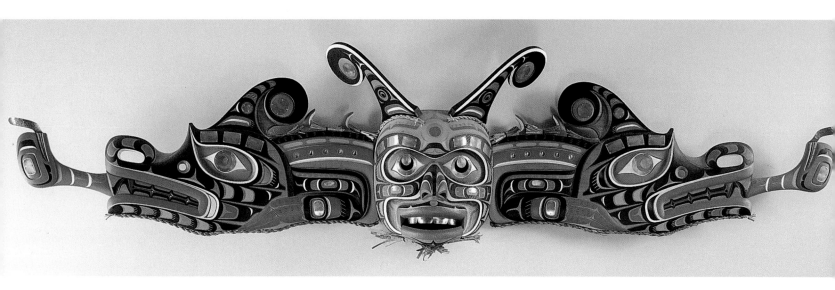

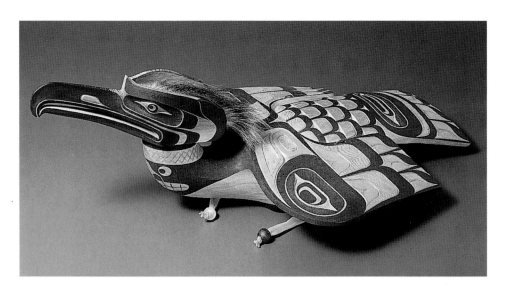

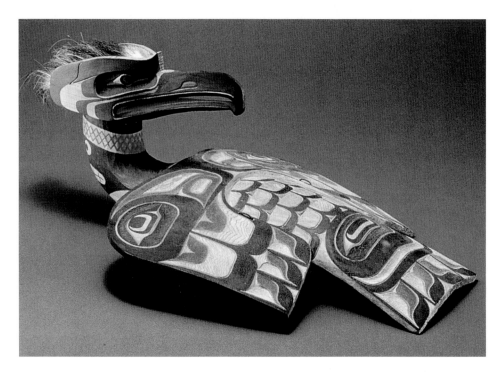

*7.22 a, b. Cormorant crest hat with
swiveling head.*
Richard Hunt *(b. 1951),*
Kwakw<u>aka</u>'wakw, Kwaguhl, *1985.
Redcedar, paint. 7" H × 16" L × 13" W.
Collection of John H. Hauberg*

*Richard Hunt, the son of Henry Hunt,
is very well known for his fine seri-
graph designs, his exceptional sculp-
ture, and the ceremonial objects that
he has created over the years for use in
traditional events in Kwakw<u>aka</u>'wakw
communities from Campbell River to
Alert Bay to Fort Rupert, his home
village.*

7.21. Sisiutl Mask
Tom Hunt (*b. 1964*),
Kwakw<u>a</u>ka'wakw, Kwaguhl, *1993.*
Redcedar, paint, cedar bark, abalone
shell, copper. 28″ H × 112″ W × 16″ D.
Collection of Microsoft Corporation

This large Sisiutl image by Tom Hunt
is a personal interpetation, with some
spectacular technical developments,
based on historical masks. Earlier
Kwakwa̱ka'wakw styles have included
elaborate mechanical performance
pieces, transformation masks, and
special images that have inspired such
contemporary expressions. A sculpture
of impressive size with elaborate
painting and inlay work, this piece
illustrates some of the new directions
taken by today's artists who are
extending and embellishing, as well as
skillfully reiterating, the traditions of
their ancestors. Photo by Eduardo
Calderón.

a Nułami'sta dancer's apparatus that went with a dance privilege owned by his great-aunt Agnes Cranmer. The dancer's theatrical display is culminated by the appearance and operation of the moving parts of this mechanical screen (Jonaitis 1991:62).

Performed in this generation soon after or the day following the Ts'eka dance series, the dances of the Tla̕sula follow a different ritual pattern, and were once the features of a separate event held traditionally in the spring. The regalia associated with the Tla̕sula differs from that of the Ts'eka, and often includes masks that are of the complex, transformational type. The elegantly conceived crest hat of a cormorant (fig. 7.22) by Richard Hunt, son of Henry Hunt, is of a type that would be worn by a family leader who owned the right to show the cormorant emblem (see fig. 5.33). The opening mask, which represents a transformation from an image of the being Born-to-Be-the-Sun (Tlisulagilak^w) to a human spirit, is the work of Calvin Hunt (fig. 7.23), an artist known for his elaborate, full outfits of dance costume based on the small number of examples collected in the turn-of-this-century period. The dancer would appear, showing the outer face of the image, and at the appropriate moment during the accompanying song, the dancer would open the mask to display the inner face, completing the transformation. Wayne Alfred's spectacular mask of Kumugwe', the chief of the undersea beings (fig. 7.24), incorporates a movable bird image, two sculpins whose tails are made to flip upward, and a pendant copper, a symbol of the wealth known to flow from this powerful mythological image.

7.23. Sun transformation mask
Calvin Hunt (*b. 1955*),
Kwakw<u>a</u>ka'wakw, Kwaguhl, *1987.*
Redcedar, paint.
40″ H × 40″ W × 10″ D.
Collection of Charles and Jan Sleicher

Calvin Hunt began carving at an
early age with his cousins Tony and
Richard Hunt in Victoria, producing
great new pieces for sale and for tradi-
tional use in potlatch events in the
early 1970s. This mask is one of a large
number of complex and mechanical
pieces he has produced over his more-
than-thirty-year career.

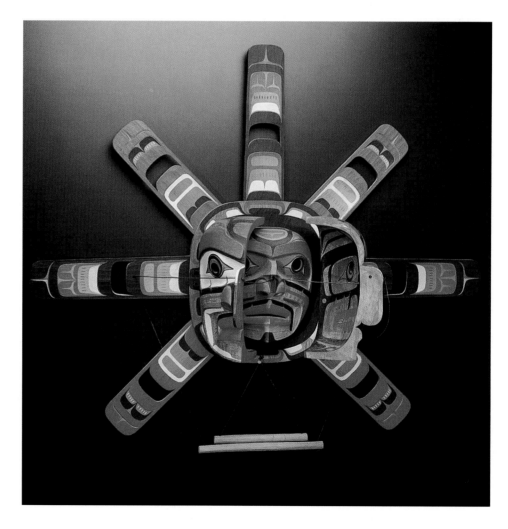

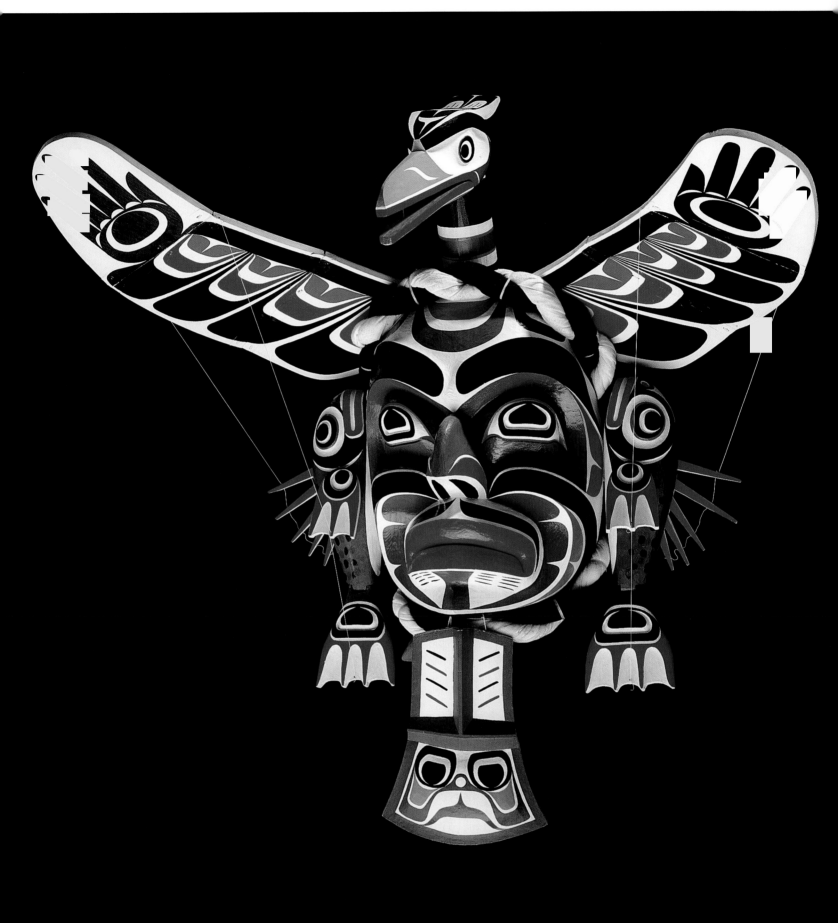

7.24. Kumukwaml (Kumugwe´ mask)
Wayne Alfred *(b. 1958),*
Kwakwaka'wakw, 'Namgis, *1988.*
Redcedar, paint.
36″ H × 40″ W × 18″ D.
Collection of John H. Hauberg

*Wayne Alfred's very refined and
detailed work contains influences
from such historic artists as Arthur
Shaughnessy, Mungo Martin, and
Willy Seaweed, combined with his
own sense of Kwakwaka'wakw tradi-
tion. Alfred is also well known as a
singer and participant in traditional
ceremonial culture.*

7.25. Crawling Wolf Mask
Art Thompson *(b. 1948),* **Nuu-chah-
nulth, Ditidaht,** *1982. Redcedar,
paint, copper, redcedar bark, cordage.
10″ H × 22″ L × 10″ W.
Private Collection*

*Well known for his superb serigraphs
and large, complex sculptural pieces,
Thompson here demonstrates his
facility with traditional Nuu-chah-
nulth mask imagery. The crawling
wolf is one segment of the Klookwana
ceremonial (Ernst 1952). This mask
image is sleek and smooth, subtle in
decoration and dynamic in sculptural
form.*

One of the most technically refined artists of the Nuu-Chah-Nulth art tradition
is Art Thompson, originally from the Nitinat Lake region of Vancouver Island. Well-
versed in many coastal styles, his work is identified with extremely fine carving and
sinuous, delicately painted lines. Art Thompson's two wolf masks (figs. 7.25, 7.26),
are both carved in expressive, animated style. Thompson has produced very master-
ful work in a variety of Northwest Coast styles in addition to his native Nuu-chah-
nulth traditions. His work has also evolved one of the most innovative and
distinctive two-dimensional styles to date, refining and extending the influences of
the old Nuu-chah-nulth masters and his cultural contemporaries, who include Joe
David, George David, Tim Paul, and Ron Hamilton. Thompson excels at both sensi-
tive, complex sculpture and refined, superbly executed paintings.

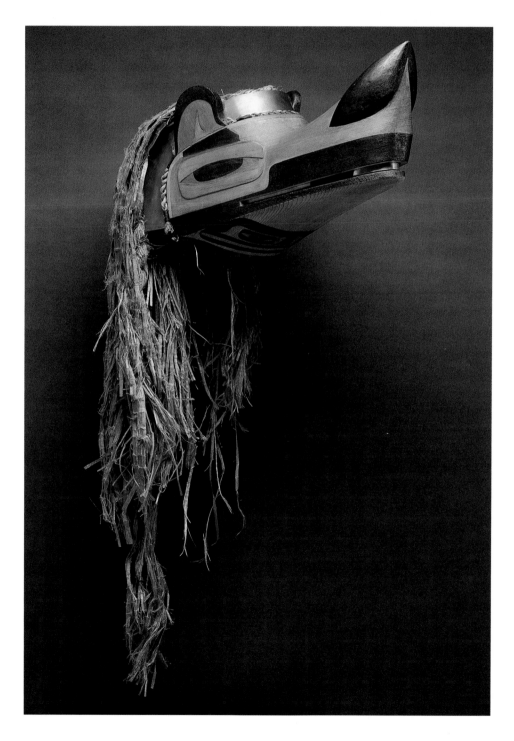

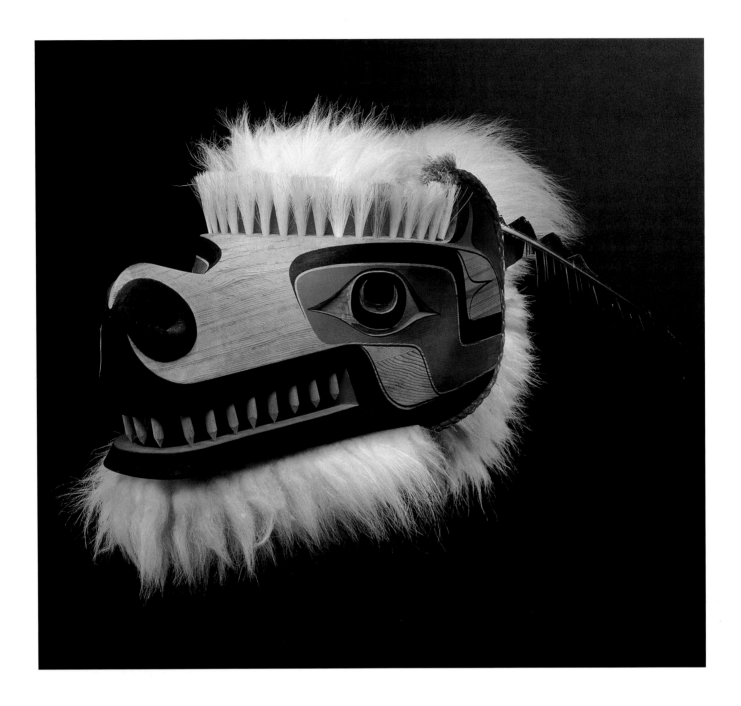

Many Nuu-Chah-Nulth artists were involved in the reclamation of west Vancouver Island art styles, including Ron Hamilton, Tim Paul, Patrick Amos, and many others, following in the mid-twentieth-century footsteps of elder artists like mask and totem pole carver Jimmy John. The Nuu-Chah-Nulth and Makah stylistic traditions are also represented here by Greg Colfax's version of a drowned man who has returned to a kind of half-life, known as *Pook-ubs* in the Makah and Ditidaht dialects of the Nuu-Chah-Nulth language (fig. 7.27). Often portrayed as pale and purely white on its face, Colfax has used the spare application of white paint to create a ghostly image. His mask depicting a wolf dreamer (fig. 7.28) is carved in the sculptural style of many old Makah and Nuu-Chah-Nulth masks (see figs. 4.12, 5.35), though the painted designs he has employed reflect his own personal interpretation of the representative imagery from the Ozette village materials and the flowing forms of historic Makah artists.

7.26. Old Father Wolf Mask
Art Thompson, Nuu-chah-nulth, Ditidaht, *1988.*
Redcedar, paint, hide, redcedar bark.
10″ H × 21″ L × 10″ W. Collection of Microsoft Corporation

The Old Father Wolf Mask incorporates natural materials that help to convey a feeling of age and dignity in the represented spirit.

7.27. Pook-ubs mask
Greg Colfax *(b. 1948 ?)*, **Makah**, *1983.*
Redcedar, paint, redcedar bark.
24″ H × 10″ W × 10″ D. Collection of
Jim and Dorothy Hussey

Greg Colfax began carving in the middle 1970s, and he drew much of his early inspiration from the rich collection of ancient Ozette objects housed in the Makah Cultural and Research Center, Neah Bay, Washington. He quickly evolved his own interpretation of Nuu-chah-nulth and Makah design traditions in association with Art Thompson, George David, and artists of the Neah Bay community, where Colfax takes an active part in traditional ceremonies.

7.28. *Wolf dreamer face mask*
Greg Colfax, Makah, *1987.*
Redcedar, paint, hair.
17″ H × 10″ W × 10″ D.
Collection of John H. Hauberg

Greg Colfax's style of sculpture and two-dimensional design extends the concepts of traditional Neah Bay and Ozette styles of Makah art, while maintaining a very strong connection to the most ancient visual and repre-sentational aspects of these traditions. An articulate speaker and writer as well as artist, Colfax has taught in the Native American studies programs of the Evergreen State College at Olympia, Washington.

Back to the Roots: Rebirth in the Central Coast Salish Style

In a 1983 article entitled "Incised Relief Carving of the Halkomelem and Straits Salish," art historian Norman Feder wrote: "only recently have a few Central Coast Salish artists become interested in rediscovering the principles of older Central Coast Salish styles. If the trend continues . . . the next ten years should see a revival of the older Coast Salish art in carvings, prints, and silver engraving." At that time, very few artists of Coast Salish heritage had seriously experimented with the two-dimen-sional traditions that were native to their cultural area. A great deal of focus and interest in the central and northern coastal traditions had permeated the Vancouver-Victoria-Seattle landscape for the previous fifteen years, but much less attention had been spent upon the Native art styles that were in fact indigenous to this particular geographic region. Certain artists such as Rod Modeste and Stan Greene had created pieces of silver or woodwork that drew upon the ancient traditions of their Salish ancestors, but many artists of Salishan First Nations elected to work primarily in

186

7.29. Spindle whorl
Susan Point *(b. 1952),* **Coast Salish, Musqueam,** *1995. Etched glass, wood. 10″ H × 16″ Dm.*
Collection of Anne Stevenson

Susan Point has been one of the most inventive and prolific artists to have taken up the Central Coast Salish style of sculpture and two-dimensional design, producing masterful works in silver, block prints and serigraphs, large wooden sculpture, and architectural pieces incorporated in major buildings of British Columbia and Washington state (see also p. 160).

the more northern styles that were in demand from the buyer's marketplace.

As more examples of the best old work from the Coast Salish tradition have become better known by the public at large, and as Coast Salish artists have become more and more experienced and masterful within the style, a wonderful expansion of the techniques and applications of Coast Salish art has taken place. Weavers such as Robyn and Debra Sparrow, Krista Point, and Leila and Wanda Stogan have relearned the roller-bar loom techniques of the old-time wool workers. They are producing spectacular blankets and robes that reflect the largely geometric designs of this tradition (Gustafson 1980; Johnson and Bernick 1986). Painters and printmakers utilizing the Coast Salish style in recent years include Joe Wilson, Manuel Salazar, Lyle Wilson, Andy Wilbur, Shaun Peterson, and Roger Fernandes.

Susan Point, from the Musqueam band of the Halkomelem Salish, has excelled for many years in her work in silver, woodcarving, and printmaking. Point has developed some wonderful interpretations of Coast Salish style in the medium of wood block prints, combining colors that are new with textures that are familiar to the tradition. Her many serigraphs have explored shadings of pastel colors along with the

7.30. *Cast glass face*
Marvin Oliver (b. 1946), **Quinault, Isleta,** 1995. *Glass, iron. 20″ W × 4″ D. Collection of Mr. and Mrs. William H. Dills*

Marvin Oliver has created this moon-like image by the technique of casting glass in an iron mold, made in turn from a wooden original. Marvin is known for his innovative designs in sculpture and printmaking, for the adaptation of northern and southern Northwest Coast design to modern media, such as major bronze castings, and for the incorporation of multiple media (glass, bronze, copper, and wood) in pieces as traditional in form as totem poles (see also p. vi).

bold forms of Coast Salish two-dimensional design. Her architectural work includes large outdoor murals, major castings in iron for use as streetside tree gratings, huge panels of backlit aluminum pierced with geometric patterns, and cast concrete building panels that splash Coast Salish design elements over entire exterior walls (Averill and Morris 1995). One of her more recent commissions took the form of a huge (16–foot diameter) spindle whorl in wood for the international arrival terminal of the Vancouver International Airport, which is sited on traditional Musqueam lands. Two large totemic sculptures of a type known as "welcome figures" are also located at this airport, carved by Salish/Nuu-chah-nulth artist Shane Pointe along with Nuu-chah-nulth artist Ron Hamilton. Susan Point also recently installed a 20-foot figure and two 10-foot houseposts on the grounds of the UBC Museum of Anthropology in Vancouver.

Susan Point's work in glass has created some very successfully inventive applications of Coast Salish style, using the simple technique of etching on a polished glass surface. The results of some of these experiments are a series of glass spindle whorls, such as the one in figure 7.29. She has also used this basic technique to produce larger, shaped panels of glass with etchings on both sides that create a shadowed, third element to the traditional positive and negative design aspects.

Marvin Oliver is the son of Emmett Oliver, a highly respected Native educational leader and administrator, an MFA graduate of the University of Washington, and a former canoe puller from the Quinault First Nation of southwest Washington (see Wright 1991:248–50). Emmett Oliver also served as the project coordinator for the "Paddle to Seattle" canoe celebration for the Washington State Centennial Committee in 1988–89. Marvin's mother is from the Isleta Pueblo of New Mexico. Marvin Oliver earned an MFA at the University of Washington in 1973 and has taught Northwest Coast design and sculpture at that institution since 1976. In his own work, he has combined flat designs of northern Northwest Coast style with a low-relief embossing technique to produce some of the most interesting and successful serigraphs and note cards of recent years. His love of major sculpture has brought about some truly spectacular large works in glass, wood, and bronze, including a twenty-five-foot-high cast bronze dorsal fin, standing in a landscaped setting near 14th Avenue East and Remington Street in Seattle. Oliver's interest in innovative techniques has produced several pieces in cast or blown glass, from a Tlingit battle helmet to pieces that have been inlaid into large bronze and wood sculptures. Casting produced the Salish-style design of a glass dorsal fin featured in the masterpiece gallery of the Burke Museum's *A Time of Gathering* exhibit (Wright 1991:145) as well as the moonlike human face illustrated here in figure 7.30. Adopting some of the sensual, naturalistic features of traditional Tsimshian-style sculpture, an iron mold was cast from a wooden, positive original, and into this was poured the molten glass to create this piece. The resulting sculpture applies the concept of the translucence in traditional carved faces of mountain sheep horn to the seemingly hard and unyielding material of glass.

Epilogue

In the contemporary revitalization of Northwest Coast art, a few innovative masters have ploughed new grounds that have since become fresh additions to this centuries-old design system. These additions have taken the form of new media, new applications, and, more rarely, totally new design concepts that enhance the overall structure of the tradition, such as the negative-formline design and painting concepts pioneered by Don Yeomans. This innovative technique, incorporated into the tradition by Yeomans and his peers, is now as much a part of the design tradition as is the painting of blue in tertiary spaces, a concept that in its day may have been a radical innovation. This seems to repeat the pattern of the past, when a small number of innovators initiated new ideas that inspired their peers, who followed along in the new directions established by the expressions of the most creative individuals. It is this kind of initiation and innovation that has expanded the essential tenets of the Northwest Coast tradition, from its roots as proto–Northwest Coast style through the elaborations and new applications we see emerging for the first time in our generation.

Also as in the past, many contemporary artists prefer to employ only the mainstream design styles and are not concerned about working with any of the more eccentric historic variations, or expanding the tradition through new design innovations. In fact, the successful incorporation of new ideas in this tradition is so rare in part because it is so difficult to innovate, to do truly new things with these shapes and patterns which harmonize appropriately and successfully with the core concepts and principles of the art form. Robert Davidson, one of the most accomplished and innovative artists, has said: "I have a drawer full of ideas that didn't work" (Davidson 1995:106). It takes a master's understanding of the essential principles to successfully envision such new directions that these forms may take, and the spirit of play to try them out: "Once you become used to working with the forms, you can become more spontaneous" (ibid.). Playful mastery has yielded the greatest new ideas to come along, and their adoption by others has morticed each new concept within the edifice of the style.

Ideas from other cultures and Native traditions are also occasionally incorporated into contemporary Northwest Coast work, a kind of exchange that has always taken place in North American First Nations art and other indigenous forms. One such example can be seen in the blending of Northwest Coast design with Celtic knotwork, practiced by this writer, Don Yeomans, Len McGookin, and, most completely, by Tsimshian artist Henry Green. For a 1996 show in Vancouver, Green painted a drum entitled "Shaman and Cranes," in which negative-formline Northwest Coast-style cranes are sinuously woven into a Celtic-knotlike border design surrounding the image of a Tsimshian shaman. Here the Celtic imagery is not merely present in the same space, but its influence has been enfolded into a traditional formline image.

This kind of infusion is not unlike the employment of Victorian-style foliate designs in nineteenth-century Northwest Coast silverwork and other media. The bold spirals, leaves, and blossomlike forms seen on Victorian furniture and other sources were incorporated into the carving of pipes, plates, and bowls in wood and argillite, totem poles, settees, and other forms. Sometimes explored on its own, as

seen in the all-foliate bracelets that were common in that period, or smoothly combined with traditional design forms and images, these ideas from outside the culture were embraced by innovative artists willing to explore new territories. The combining of Northwest Coast sculptural forms with Maori tattoo design has been explored recently in wood and bronze by Nuu-chah-nulth artist Joe David, and similar work has been done by Salish artist Ed Archie Noisecat. The cross-Pacific pollination of ideas is still active and influential in today's artistic field. The Northwest Coast tradition, like the running numbers of the Mandelbrot Set, is continuously evolving, changing, and expanding within itself to become something different than it was before. There will be no "last word" on this subject until the last Northwest Coast artists lay down their paintbrushes for the last time.

NOTES

Introduction

1. In essays such as "The Decorative Art of the Indians of the North Pacific Coast" (1897) and "Notes on the Blanket Designs" (1907), both of which appear in Jonaitis 1995, Boas endeavors to interpret the complex northern design styles. In retrospect, one becomes aware that Boas had only a rudimentary understanding of the conventions of northern Northwest Coast art and was evidently not aware that certain differences in style are indicative of older designs, created prior to the historic period and distinguishable from those created in the middle or late nineteenth century. Although this approach to historical analysis developed through Bill Holm's scholarship, his 1965 study does not include such discussion. On page 3, under the heading of "Historical Background," Holm states: "Although it is not within the scope of this study to enter the field of historical speculation, a brief investigation of the state of development of northern Northwest Coast two-dimensional art at the beginning of the historical period is pertinent." The book goes on to cover the most typical design conventions of the nineteenth-century design styles quite thoroughly.

2. Certain conscientious field collectors, notably Emmons, Newcombe, Swanton, and Barbeau, recorded where and when a particular object was collected, even if only within the range of a few years. Louis Shotridge, a Tlingit ethnologist working for the University of Pennsylvania, frequently noted not only the collection date of an object, but also such important information (when known) as the object's Native name, the maker's name, the event and generation for which a piece was made, and who the original owner or caretaker was. Marius Barbeau (1950; 1957) recorded the names of many Tsimshian and Haida artists of the 19th and 20th centuries, with the help of William Beynon, a Tsimshian interpreter. Detailed documentation of this type is rare in Northwest Coast ethnology, for the most part due to the unsystematic manner in which most ethnographic objects were acquired.

1. Ancient Roots: Prehistoric Perspectives on Northwest Coast Art

1. A number of papers that were presented at an important 1982 conference on the antiquity of Northwest Coast art (held at Simon Fraser University, Burnaby, British Columbia) have been published collectively as *Indian Art Traditions of the Northwest Coast* (Carlson, ed., 1983). Several of these essays are listed by individual author under Sources in the present volume. In addition to other publications that address this subject, Aron Crowell briefly discusses certain important artifacts in "Prehistory of Alaska's Pacific Coast," pp. 130–40, in *Crossroads of Continents* (Fitzhugh and Crowell 1988).

2. The Alaska State Museum, Juneau, is custodian to the evidence of two baskets of this antiquity that were recovered archaeologically. Both are from waterlogged sites that enabled the preservation of perishable materials. The best-preserved specimen is an openwork spruce root basket (about 60% intact) that came from the mouth of the Thorne River, Prince of Wales Island, southeast Alaska, and has been dated between 5400–5500 years B.P. Only fragments remain of the second basket, made of hemlock branches and roots with some openwork, dated at 4900 years B.P. The eleven sections of this object were recovered from the area of Redfish Bay, southern Baranof Island, southeast Alaska (Steve Henrikson, pers. comm., Alaska State Museum, 1996).

3. See George MacDonald, "Prehistoric Art of the Northern Northwest Coast," pp. 99–120, in *Indian Art Traditions of the Northwest Coast,* Roy Carlson, ed., Burnaby, B. C.: Simon Fraser University, 1983.

4. The term *trigon* was first applied to these intriguing elements by Haida artist

Robert Davidson. See "Observations on Northwest Coast Art," in *The Spirit Within,* S. Brown, ed., Seattle/New York: Seattle Art Museum/Rizzoli, 1995.

5. A drawing of this object can be seen in Carlson, ed., 1983b:205. The piece was excavated by the Hoko River Archaeological Project, Dale Croes, director, and has been identified as a cattail mat creaser. The object differs from historic mat creasers in the shape of what would be its working edge, however, and may just as likely be an object handle of some sort, such as for a ground slate fish knife.

6. See *Indian Art Traditions of the Northwest Coast,* Roy Carlson, ed., 1983b:197–205; and "Prehistoric Art of the Lower Fraser Region," Charles E. Borden, pp. 131–65, in *ibid.,* Carlson 1983b.

7. A rare type of southern Northwest Coast artifact collected by late 18th- and early 19th-century explorers in the area is the mountain goat horn bracelet, usually incised with ovals, crescents, and trigons in rhythmic, flowing surface designs. Undocumented examples of these in older European museums have sometimes been mistakenly attributed to New Guinea Native cultures on the basis of their design style (Bill Holm, pers. comm.). Given the prevalence of extremely similar surface decorations incorporating ovals, crescents, and trigons in flowing patterns on masks and other objects from New Guinea, this would seem an easy mistake to make. Very closely related designs can be seen incised into the surfaces of lime spatulas (and other objects) from the Massim cultural district of the Trobriand Islands/eastern New Guinea regions. For further discussion, see Philippe Bourgoin, "Lime Spatulas from Massim," *Tribal Arts Magazine* 1(4):35–46. A short article on Oceanic art collector Harry Beran illustrates additional Massim objects, including a human-figure carving with sculptural and two-dimensional features readily comparable to (but distinct from) those seen in southern Coast Salish styles. See Bill Evans, "Harry Beran," *Tribal Arts Magazine* (Summer 1996):78–80.

8. The Pacific Ocean continues to cast up on the Northwest Coast all manner of floating materials. The dense tropical hardwood hull of an 18–foot Micronesian-style canoe has been displayed near a filling station and convenience store eleven miles east of Neah Bay, Washington, since it was found adrift in the Strait of Juan de Fuca some years prior to 1975.

9. " . . . a curious carved spear, made of some solid, heavy wood, which had floated from the East Indies and stranded on Alaskan shores. He used the spear as a sign of chiefly authority." (S.H. Young, *Hall Young of Alaska, "The Mushing Parson": The Autobiography of S. Hall Young,* p. 223)

10. Some sixty-plus occasions of this type are documented in Katherine Plummer's *The Shogun's Reluctant Ambassadors: Japanese Sea Drifters in the North Pacific.* One of these is the account of a ship carrying rice and porcelain, the *Hojun-maru,* that was damaged and blown out to sea by a typhoon in October of 1832. The drifting ship and 14–man crew were carried eastward by the *Kuroshio,* or Japanese Current, with the seamen subsisting on the rice cargo, rain and distilled seawater, and perhaps some fish for fourteen months. In January of 1834, three survivors were washed up near Ozette village on the Washington coast. Their ship was pillaged and destroyed, and the sailors were enslaved. Later taken by Hudson's Bay Company fur-trading men to Fort Vancouver, lower Columbia River, the three eventually made their way back to Japan.

11. See Sources listings for Miguel Covarrubias (1954), Aron Crowell (1988), William Fitzhugh (1988), Robert Heine-Geldern (1966), George I. Quimby (1985), Carl Schuster (1951), and Carl Schuster and Edmund Carpenter (1996).

2. Curious Visions:
Northern Northwest Coast Art in the Historic Period

1. The paradoxical phrasing of "less non-concentricity" derives from Holm's use of the term *non-concentricity* as an attribute of general Northwest Coast Style in his *Analysis of Form* (1965:87). Selection of this term by Holm over the synonymous *eccentric* was

perhaps due to other, unrelated uses of that word. Both terms will be employed in this discussion as appropriate.

2. Several of the last items on this list describe conventions commonly seen in the designs of Chilkat weavings. Since it appears from the overall historical record that the techniques of this weaving style were developed in Tsimshian country and disseminated about the northern region in the late 18th and early 19th centuries, it follows logically that the woven designs reflect the late 18th-century two-dimensional styles. It is often presumed that the angularity of many forms and the square corners of most U-shapes in the weaving tradition are part of the adaptation of the painted tradition to the grid structure of the weavings' warp and weft strands. The circles, ovoids, and other rounded corners present in the weavings, though, made possible by the intricacies of the braiding techniques in this complex art, tend to disrupt this perspective. The existence of extreme angularity and square-cornered shapes in the carving and painting traditions of the *early* 18th century, exemplified by the Perez, Dixon, and other early pieces, makes it clear that the woven designs were in fact replicating the predominant design style of the time, unhampered by any perceived limitations of the fabric techniques.

3. Captain James Cook and his ships sailed along the Northwest Coast and made contact with Native peoples in 1778. The expedition returned with a great number of artifacts from the area, few of which affect this stylistic analysis of northern design work except in a general fashion. Cook's landfalls and First Peoples contacts were at Vancouver Island and Prince William Sound, each beyond the frontiers of the "northern" art and culture region extending from Yakutat Bay on the Gulf of Alaska southward to about Milbanke Sound on the British Columbia coast. Certain Pacific Eskimo objects acquired by Cook show the distinct influence of Tlingit design conventions (Holm 1988:281–93), indicating an established relationship to early eighteenth-century Northwest Coast art. Cook-collected pieces from Nootka Sound, Vancouver Island, indicate the characteristics of Nuu-chah-nulth (Nootkan) art styles of the mid-eighteenth-century period (see fig. 3.19).

Evidently the early Spanish explorers' collections were not maintained with much specific documentation. Some materials thought to have been acquired by Malaspina have since been attributed to the Perez expedition. Since Spanish activity on the Northwest Coast came to an end by 1800, it is nonetheless confirmed that, regardless of who acquired what, the Spanish material was created prior to the end of the 18th century (Holm 1988:105–6).

4. Bill Holm has proposed that the maker of this helmet also created a remarkable headdress frontlet acquired on this expedition (see Feder 1977:43, fig. 4). Both the sculptural and two-dimensional details of these objects make this a possibility. A bent-corner dish in the Museum für Volkerkunde, Berlin[IV-A-359] also displays a formline style that may connect it to the same artist's repertoire (see Burke Museum slide videodisk 22133).

5. Pacific Eskimo spruce root hats collected in the 18th century by Cook and others illustrate the same essential convention, though the painted designs differ in significant ways from the Tlingit formline system. See Bill Holm "Art and Culture Change at the Tlingit-Eskimo Border," pp. 281–93 in *Crossroads of Continents*, Fitzhugh and Crowell, 1988.

6. Four examples, probably from the 18th or early 19th century, are published in Wardwell, *Tangible Visions,* 1996: (1) Tshimshian globular rattle collected at Aiyansh, British Columbia; National Museum of the American Indian, Smithsonian 1/4184, fig. 379; (2) Tsimshian rattle, collected by Donald Mackay before 1905, private collection, fig. 372; (3) Haida globular rattle, collected on Haida Gwaii, 1889, by W. B. Anderson, RBCM 114, fig. 369; (4) Tsimshian globular rattle, purchased from G. T. Emmons in 1922, National Museum of the American Indian, Smithsonian 11/3846, fig. 368. Other examples of very early northern style that display broad formline characteristics, illustrated in MacDonald, *Haida Art* (1996): a bent-corner bowl, said to have belonged to Chief Klue of Tanu,

pl. 27, p. 46; a box with corner-oriented design, pl. 95, p. 128; a carved interior house screen from Howkan, pl. 149, p. 203.

3. Sleeping Treasures: Northwest Coast Art of the Late Prehistoric Period

1. The Burke Museum at the University of Washington houses a large Haida chest collected by George Emmons from the Gaanaxteidí Tlingit before 1905 (#2291, Holm 1987:148, cat. 58). Emmons's notes of the owner's information identify the image on one side of the chest as Gonakadeit, the other as a bear. The Gaanaxteidí clan leader Coudahwot stated that the chest was acquired from the Haida in trade. The brown bear (of the Tlingit eagle moiety) is not a Gaanaxteidí (raven moiety) crest emblem.

2. The edges may have been left smooth as an adaptation to the ladle's use as a food vessel, though this would not have been necessary. Interestingly, undecorated voids (a different kind of negative space) are not uncommon in early historic artifacts. Notice, for instance, the plain red rectangle at the center bottom of the side panels of the early chest in figure 3.3. This particular form of undecorated area can be seen on a number of very early box and chest designs, the full significance of which is unknown (see chap. 3, n. 8, below).

3. Soapberries (*Shepherdia canadensis*) can be found from upper southeastern Alaska down to Washington State, though only in limited areas (with drier climatic conditions than the generally rain-heavy coastal margins), such as the interior river valleys (like the Chilkat, the Nass, and the Skeena) and the rain-shadow regions of the San Juan Islands of Washington. The fruit itself is small (less than .25″ Dm) and ripens to an orange-red in late spring/early summer, though some Native people remark that the berries whip up more stiffly when picked green (Helen Abbott Watkins, Tlingit, pers. comm., 1992).

4. Such a spoon box is in the Burke Museum collection, acquired by George Emmons at Haines, Alaska, before 1909 (#2101).

5. This characteristic blue color is a pigment that appears to have been derived from celadonite, a soft iron ore found in occasional deposits on the coast such as the shore of Masset Inlet, Haida Gwaii (Queen Charlotte Islands) (Bill Holm, personal communication, 1992). Often reported in older literature to be derived from copper, more recent scientific analysis has shown that, at least in the majority of cases examined, the color is composed of an iron ore such as celadonite (CCC report, 1985).

6. Tlingit ethnologist Louis Shotridge recorded information at Klukwan before 1925 which attributes a group of Gaanaxteidí artifacts to a Dak'laweidi carver named Naakush'ta (Shotridge, n.d.). These objects, the "Little Frog" headpiece, the Frog Shadakoox, the Frog house posts, and the Frog-Emerging-from-Its-Den grave marker, all share certain stylistic traits with this frontlet, and may have been created by the same hands. Illustrations of these objects can be found in the following locations: Little Frog (Jonaitis 1986:fig. 18), Frog Shadakoox (Furst and Furst 1982:117), Frog house posts (Jonaitis 1986:figs. 9, 10, 11), and Frog grave marker (Wyatt 1989:103, #58). The Little Frog illustration cited is a frog headpiece that has been associated in this century with the other Gaanaxteidí artifacts mentioned. A small frog headpiece that is more clearly the work of the same artist as the Frog Shadaakoox is located in the National Museum of the American Indian storage collection. The eye and eyelid forms, head sculpture, and inlay style of this object are all directly comparable to the other artifacts listed. It may be that the National Museum of the American Indian frog forehead piece is the proper "Little Frog" noted by Shotridge.

7. The third example of a related image appears in an 1895 Winter and Pond photograph of two Tlingit women in the Juneau area (Wyatt 1989:63). The staff in that picture is of similar size and shape, with the distinctive form of the shark's tail as the top finial. The length of the shaft, however, is carved in totemic-style figures, rather than the vertebrae-cylinders of the other examples. The style of the relief-carved flat design and the

sculpture on the Juneau staff is very late-19th-century in character. The staff is bright and unpainted, and appears to have been recently made at that time. This example may be a "copy," in the Native sense, of the staff, much earlier in style, illustrated here.

8. At least two examples can be found in the Burke Museum collection which show this rectangular solid-red center section of a formline design. Both were acquired by George Emmons before 1909 and are stylistically very early in appearance: #1342, a relief-carved square box collected at Angoon, Alaska; and #1735, one side panel of a relief-carved chest, collected at Klukwan, Alaska. These appear on the Burke Museum Collections videodisk.

9. All the Ozette materials are housed in the Makah Cultural and Research Center and Museum in Neah Bay, Washington.

10. Also published in Carlson, ed., 1983:67–87.

11. The Washington State University archaeological project at Ozette is documented in "An Introduction to Ozette Art," by Daugherty and Friedman, in Carlson, ed., 1983:183–95; See also *Exploring Washington Archaeology,* by Kirk and Daugherty, Univ. of Washington Press, 1978

4. Changing Times: Art of the Early Classic Era, 1820–1865

1. *A Haida Artist: Robert Davidson,* audiotape from the artist's 1993 Vancouver Art Gallery show. Davidson discusses at some length the largely nonverbal process through which his grandfather imparted his knowledge of traditional Haida sculptural style.

2. MacNair and Hoover 1984:17, 201–7; Wright 1995:133.

3. The Wishxam and Wasgo (Wasco) First Nations reside in the area of the Dalles, a geographic feature on the lower Columbia River that lies between the present states of Washington and Oregon. The language of these peoples has been called *Chinookan* (Schlick 1994:47), a term used in reference to the language of the Chinook tribe (sometimes distinguished as Lower Chinook), who live about the mouth of the Columbia on the Washington shore, and which is applied in general to the related languages of the Native people on the river between the Cascades and the Pacific Ocean. The Wishxam/Wasgo language has also been called *Kiksht,* seen as related to but separate from the Upper Chinookan languages of the Clatsop, Cathlamet, Multnomah, and Clackamas (Silverstein 1990:533–35). The Wishxam are currently one of the Yakama Confederated Tribes in Washington, and the Wasgo are part of the Warm Springs Confederation of northern Oregon.

4. Indigenous food roots like the bitterroot, caus, and camas were dug with special tools, called *kapin* in Sahaptian, then collected and stored in specially made full-turn twined soft baskets or bags. These cylindrical root-gathering and storage baskets are often called *Sally bags.* Several hypotheses exist to explain the source of the term (Schlick 1994:48–49). Perhaps the most likely of these stems from the English traders' name for the willow, *sallow,* the bark of which was used in the making of early bags. Coupled also with the bag's association with a renowned turn-of-the-century weaver named Sally Wahkiacus, the Sally version of the name stuck with the bags. The Chinookan/Kiksht name for the bags is *aqw'alkt,* which helps to explain why English-speakers preferred the name Sally bags. The Sahaptian term is *wapaas.*

5. The closely related appearance of two large early-19th-century Chinookan sculptures has been immortalized in two historic images. One is a drawing, by George Gibbs, of the stern-figure of a burial canoe seen on the lower Columbia River in 1850 (Silverstein 1990:542). Gibbs was a government emissary who gathered a great deal of ethnographic information for the Smithsonian Institution. The other is an oil painting by Canadian artist Paul Kane, who traveled down the Columbia River and through Puget Sound in 1846–47 and recorded a large amount of visual and field-noted information about the First Nations in the region. This painting depicts the interior of a Chinookan

cedar house on the lower Columbia River, and includes the representation of a carved house post and the two-dimensional relief carving of a wooden interior house screen (Harper 1970:195, pl. 37; Silverstein 1990:538).

6. The commonly held but fallacious notion that the Northwest Coast peoples produced such a volume of artwork because of their rich environment and abundance of leisure time can only be believed by someone who has not experienced the entire Northwest Coast environment at first hand. The northern coast, where by far the greatest volume of artifacts originates, is seasonally very productive of food resources but is extremely harsh and relatively inhospitable to live in year round. Intensive and skillful labor is required to survive and flourish. The Central Coast Salish region, in contrast, is much less extreme and more naturally hospitable, with a greater distribution of abundant resources and beneficent locations for dwellings and extended villages. If the generalization were correct, this area would have produced the greater volume of art. Many other factors, however, come into play which have influenced the historical realities, including the employment of slaves (captured from among southern First Nations) as a labor force among northern clans, and the ultimate cultural motivations for art production. These go well beyond simple concepts of available time (see Suttles 1983/1987).

7. The word *Nootka* was first applied to the body of water surrounding the island on which the Mowachaht village of Yuquot was located by Capt. James Cook in 1778. He evidently misunderstood a like-sounding Native term in research for his charting of the region (Winifred David, pers. comm., 1978; Eugene Arima and John Dewhurst in Sturtevant, ed., 1990, p. 410). The seventeen nation Nuu-chah-nulth Tribal Council coined their name in 1978 to apply to all the related First Nations speaking that language, in lieu of the historically applied but inaccurate terms, Nootka or Nootkan. The Makah of Washington State speak a division of the same language, but are separated from the Nuu-chah-nulth of Vancouver Island by the Strait of Juan de Fuca and the U.S./Canada boundary. Similarly, the term *Kwakiutl* is an English spelling of the Native name for one of fifteen existing First Nations speaking the Kwakwala language, and has inaccurately been applied as an umbrella term for all fifteen tribal groups. The Native term *Kwakwaka'wakw* (meaning "those who speak Kwakwala") was adapted to apply more or less equitably to the members of all fifteen groups (Helen Codere in Sturtevant, ed., 1990, p. 376).

8. Unfortunately a number of hats of the double-woven all-redcedar-bark type (perhaps as many as six are known), originally left plain by their weavers, have been recently painted with inaccurate copies of Haida artist Charles Edenshaw's northern-style hat paintings. The true value of the undecorated hats has been destroyed in the process. The inaccurate paintings have been done with little understanding of the original designs and are easily recognized as copies by an experienced eye. These "artifakes" appear to be intended to pass for old work, and are seen on the market from time to time. The black-rimmed hats like the one illustrated in figure 4.13 all appear to have been made of spruce root and redcedar bark, and are painted in old-style designs about the crown (Holm, pers. comm., 1997).

9. One such bowl features the head, legs and tail of a beaver so successfully grafted to the square-dish form that it is foremost a beaver dish, conceptually incorporating a square-dish-shaped body. See AMNH 16.1/21170; Burke Museum Holm/Wright videodisk 21197.

10. These are "overlapped" not literally but conceptually, a pre-historic convention within the formline system (Holm 1965:58, fig. 47A).

11. The small frog in the mouth of the bird represents a concept rarely seen in the rattle tradition, though the frog image is sometimes present on raven rattles in association with the human figure on the raven's back (see fig. 4.39). A frog appears in the same transverse orientation in the mouth of a very large raven rattle (45.7 cm long!) from the collection of the University Museum, University of Pennsylvania, Philadelphia [NA 3367] (Maurer 1977:292, fig. 443).

12. One very early documented rattle exists among the objects of the Malaspina col-

lection in the Museo de América in Madrid, Spain [13.907]. This rattle has raised tail feathers, but no bird face on the front of the tail form, and lacks the raised ears (or crest feathers) and vertical piercing of the usual raven's head. The head of the rattle, in fact, shows a defined eyebrow, and no formline-like definition of the eyesocket. There are incised lines at the rear edge of the beak line and three incised crescents on the forward end of the beak which strongly suggest the representation of a tufted puffin (*Lunda cirrhata*), rather than a raven (Holm 1989:109). A row of holes along the crest of the puffin's head indicate that inlaid hair or other material was used to represent the tufted puffin's prominent crest feathers. This rattle is illustrated in Garrido 1991:104, 140, cat. 73.

13. A small number of complete rattles exist that reflect this very early conception of the standard arrangement. One such rattle was offered at auction in December 1996 by Butterfield and Butterfield, San Francisco (Lot 651, shown in sale catalog on p. 15). A raven rattle in the collection of the Museum of Anthropology and Ethnography, St. Petersburg [238–4], shows a human figure just barely touching the raven's back with the end of his spine. This rattle exhibits great refinement in its sculptural forms and two-dimensional designs (from the Lisiansky collection, prior to 1806, illustrated in Siebert and Forman 1967:pls. 59, 60). This very early historic period documentation indicates the antiquity of the raven rattle concept, and assists in attributing the raven rattles in the present collection to relative dates of creation. Two other raven rattles that show the human figure touching the back of the raven are in the Peabody Museum, Harvard, illustrated in Holm and Vaughn 1982:figs. 85, 86. Figure 85 shows a rattle with very antique condition and old-style sculptural characteristics in addition to the attitude of the human figure, while rattle 86 appears to be of somewhat later origin, judging from the two-dimensional and sculptural characteristics other than the human's position on the back of the bird. An example of the raven rattle format that looks very early (though incorporating sculptured feet beneath the bird like an oystercatcher rattle) is illustrated in Wardwell 1996: 102, fig. 79 [NMNH, Smithsonian 73851]. There is no tail face, and the reclining human figure lies against the raven's back with an otter on his chest, lacking a tongue connection. The presumed shamanic origins of the raven rattle tradition are demonstrated by the archaic feel of this object and its distinctly shamanic imagery. Two other rattles that include the main figure touching the back, as well as other old-style design characteristics, are in the Canadian Museum of Civilization, Hull, Quebec (VII C 341, and VII B 856. The latter one is carved with an otter on the back in place of the more usual human figure).

14. Personal experience with one of these animals has shown that the skin around the neck cape of a large sea lion can be all of a half-inch thick over a large area, more than enough to employ in covering one of these wooden helmet forms and relief-carving the design details. Walrus hides could have been traded into the southeast Alaska region, as were some of the tusks, but it seems even more likely that the local sea lion populations were called upon to provide this material. Three museums housing shark-image war helmets are: Field Museum of Natural History, Chicago [79290]; National Museum of the American Indian, NYC/WaDC [no number available]; and University Museum, University of Pennsylvania, Philadelphia [29-1–1]. The Field Museum example, however, is the only one of the three that displays a frog in its mouth. This helmet appears in a photograph (October 1898), taken by A. C. Pillsbury, of a canoe-borne potlatch gathering on the Chilkat River, near Klukwan, Alaska (Henrikson 1993:59). The same helmet is shown in the cover photograph of *American Indian Art Magazine* 19(1), 1993, as the lead for an article on Tlingit war helmets by Steve Henrikson of the Alaska State Museum. Another shark helmet rattle also exists (formerly in a Chicago private collection), though it was made by a different artist and, lacking the frog, was apparently associated with one of the other helmets. Exactly what function either of these rattles performed in connection with the display or use of the helmets is not apparent, and other rattle and helmet combinations or relationships have not currently been identified.

5. Expanding Traditions: Art of the Late Classic Period, 1865–1920

1. McLennon and his team have photographed hundreds of flat-surfaced, painted Northwest Coast objects (mostly boxes, chests, and screens) with infra-red sensitive film, in order to highlight painted designs in the finished print that are often obscured by wear and surface patination. Several of the most successful and inspiring examples have been reproduced by Native artists for the University of British Columbia museum collection. These were exhibited at the UBC Museum of Anthropology along with photographic images of dozens of others in "The Transforming Image," a 1992–93 installation for which a published catalog is forthcoming.

2. The Metlakatla community was established in 1887 by the Rev. William Duncan and his Tsimshian followers from Old Metlakatla, British Columbia, and was developed as a model Native American, industrial, largely self-sufficient community dedicated to Protestant Christian social and religious principles. Those who organized with Duncan and relocated to the Annette Island harbor of Port Chester (previously the site of a Tongass Tlingit village known as Taquan, abandoned after a decisive attack by more northern Tlingits in about 1850) did so with the intent of leaving their traditional Tsimshian ceremonial life behind forever. The community has from its founding been successful in business and economics, and in the last twenty-three years has included a fine Native Art program in the community secondary school headed by Jack Hudson, a Tsimshian from the community who began carving on his own in the Seattle area around 1970. Hudson is an inherently talented craftsman who received some early support, encouragement, and exposure to the lessons of traditional artifacts through Bill Holm at the Burke Museum, and who later brought a high level of skill and artistic ideals to several generations of his students at Metlakatla High School.

3. An early-19th-century pre-classic Chilkat robe of unusual design, featuring a checkerlike pattern of rectangular faces and compact bird figures, is currently housed at the Manitoba Museum of Man and Nature, Winnipeg (H4.6–12; Burke videodisk 23536–42). This robe was acquired by Canadian artist Paul Kane in 1846 at Ft. Victoria, and appears to have been duplicated in a late-19th-century robe collected by the Rev. Thomas Crosby in northern British Columbia in the 1880s, now housed in the Canadian Museum of Civilization, Hull, Quebec (no number available; Burke videodisk 23582). (Illustrated in Bruggmann 1986:58, 59, fig. 16.)

4. Both whale species are Tlingit crests, though one is of the raven moiety (the humpback, known as *Yaay*), and the other of the eagle or wolf moiety (the orca, known as *Keet.*) They are crest emblems of the Gaanaxteiedí and Dak'laweidí, respectively.

6. Bridging Generations: Northwest Coast Art in the Middle 20th Century, 1920–1965

1. A house model and frontal poles made by John Wallace has been displayed for many years (not for sale) in The Trading Post gift shop in Ketchikan, Alaska.

2. Information on Jim Watson comes from Mrs. Hakkinen, the former director and curator emerita of the Sheldon Museum in Haines, Alaska, written to the current owner of this pole in response to a lead on the identity of the artist provided by the author.

3. The going price of a fine, traditionally woven spruce root hat by master Haida weaver Selina Peratrovich in 1969 was $70. By the time of her passage in the 1980s, her hats would sell for ten-fold that figure. In more recent years, Northwest Coast basket weavers have been able to realize an even more appropriate return for their efforts, receiving prices for very fine hats, for example, that are twenty to thirty times the 1969 figure.

SOURCES

Abney, Brenda et al.
> 1993 *Carving: A Cultural Heritage.* Ketchikan, Alaska Tongass Historical Museum.

Autry, John
> 1987 Personal communication. John Autry is a staff archaeologist for the U.S. Forest Service, Ketchikan, Alaska.

Averill, Lloyd, and Daphne Morris
> 1995 *Northwest Coast Native and Native-Style Art: A Guidebook for Washington State.* Seattle: University of Washington Press.

Averill, Lloyd, and Steven C. Brown
(manuscript) "A Brush with History: The Art and Paintings of Bill Holm."

Barbeau, Marius
> 1950 *Totem Poles.* National Museums of Canada Bulletin, no. 119, vols. 1, 2. Ottawa, Ontario.

> 1957 *Haida Carvers in Argillite.* Anthropological Series, no. 38. National Museums of Canada Bulletin, no. 139. Ottawa, Ontario.

Black, Martha
> 1997 *Bella Bella: A Season of Heiltsuk Art.* Vancouver, B.C.: Douglas & McIntyre; Seattle: University of Washington Press.

Boas, Franz
> 1955 *Primitive Art.* New York: Dover Publications.

Borden, Charles E.
> 1983 "Prehistoric Art of the Lower Fraser Region," pp. 131–65, in *Indian Art Traditions of the Northwest Coast,* R. Carlson, editor. Burnaby, British Columbia: Archaeology Press, Simon Fraser University.

Bourgoin, Philippe
> 1994 "Lime Spatulas from Massim," *Tribal Arts* 1(4):35–46.

Boyd, Robert T.
> 1990 "Demographic History, 1774–1874," in *Handbook of North American Indians,* vol. 7, W. Sturtevant, editor. Washington, D.C.: Smithsonian Institution Press.

Bradley, Herbert
> 1984 The late Herb Bradley was a Tlingit speaker and historian. Personal communication identified the Raven's Backbone staff.

Brown, Steven C.
> 1987 "From Taquan to Klukwan: Tracing the Work of an Early Tlingit Master Artist," in *Faces, Voices, and Dreams; A Celebration of the Centennial of the Sheldon Jackson Museum,* P. Corey, editor. Alaska State Museum Publications.

> 1991 "Art of the NW Coast," in *Selected Works.* Collections Handbook. Seattle Art Museum.

> 1994 "In the Shadow of the Wrangell Master: Photo Documentation of the Work of Two Nineteenth Century Tlingit Artists," *American Indian Art Magazine* 19(4):74–95.

> 1995 "Observations on Northwest Coast Art," pp. 269–81 in *The Spirit Within: The John H. Hauberg Collection at the Seattle Art Museum,* S. Brown, editor. New York: Rizzoli.

> 1997 "Formlines Changing Form: Northwest Coast Art as an Evolving Tradi-

tion," *American Indian Art Magazine* 22(2):62–83.

(book-in- Catalog of the Thaw Collection. New York State Historical Association,
progress) Cooperstown, New York.

Brown, Steven C., editor

 1995 *The Spirit Within: The John H. Hauberg Collection at the Seattle Art Museum.* New York: Seattle Art Museum/Rizzoli.

Bruggmann, Maximilien, and Peter R. Gerber

 1986 *Indians of the Northwest Coast.* New York: Oxford, Facts on File.

Burkhart, Will

 1982 Personal communication. George Benson's grandson, Will Burkhart permitted the author to photograph one of Benson's lamp base totem poles.

Calkins, Harry

 1977 "Art Legacy of the Coast Salish," *Puget Soundings* (April) 26–29.

Carlson, Roy

 1983a "Prehistoric Art of the Central Coast of British Columbia," pp. 122–30 in *Indian Art Traditions of the Northwest Coast,* R. Carlson, editor. Burnaby, B.C.: Archaeology Press, Simon Fraser University.

 1983b "Change and Continuity in Northwest Coast Art," pp. 197–206 in *Indian Art Traditions of the Northwest Coast,* R. Carlson, editor. Burnaby, B.C.: Archaeology Press, Simon Fraser University.

Cole, Douglas

 1985 *Captured Heritage: The Scramble for Northwest Coast Artifacts.* Seattle: University of Washington Press.

 1990 *An Iron Hand Upon the People: The Law Against the Potlatch on the Northwest Coast.* Vancouver, B.C.: Douglas & McIntyre; Seattle: University of Washington Press.

 1991 "History of the Kwakiutl Potlatch," pp. 135–168, in *Chiefly Feasts: The Enduring Kwakiutl Potlatch,* A. Jonaitis, editor. Seattle: University of Washington Press.

Corey, Peter L.

 1983 "Tlingit Spruce Root Basketry Since 1903," in *The Box of Daylight: Northwest Coast Indian Art,* by Bill Holm. Seattle: University of Washington Press.

Covarrubias, Miguel

 1954 *The Eagle, the Jaguar, and the Serpent: Indian Art of the Americas.* New York: Alfred A. Knopf.

Cranmer-Webster, Gloria

 1991 "The Contemporary Potlatch," pp 227–48, in *Chiefly Feasts: The Enduring Kwakiutl Potlatch,* A. Jonaitis, editor. Seattle: University of Washington Press.

 1995 "Contemporary Kwakwaka'wakw Potlatches," in *The Spirit Within,* S. Brown, editor. New York: Rizzoli.

Crowell, Aron

 1988 "Prehistory of Alaska's Pacific Coast," pp. 130–40, in *Crossroads of Continents: Cultures of Siberia and Alaska,* W. Fitzhugh and A. Crowell, editors. Washington, D.C.: Smithsonian Institution Press.

Dauenhauer, Nora Marks, and Richard Dauenhauer, editors

 1987 *Haa Shuká: Our Ancestors.* Classics of Tlingit Oral Literature, vol. 1. Seattle: University of Washington Press.

 1990 *Haa Tuwunáagu Yis: For Healing Our Spirit.* Classics of Tlingit Oral Literature, vol. 2. Seattle: University of Washington Press.

 1994 *Haa Kusteeyi, Our Culture: Tlingit Life Stories.* Classics of Tlingit Oral Literature, vol. 3. Seattle: University of Washington Press.

Daugherty, Richard, and Janet Friedman

 1983 "An Introduction to Ozette Art," p. 95, in *Indian Art Traditions of the*

Northwest Coast, R. Carlson, editor. Burnaby, B. C.: Archaeology Press,
Simon Fraser University.

David, Douglas
 1993 Personal communication. Douglas David is part of the Hyacinth, Sr., and
 Winifred David family, of Nuu-chah-nulth heritage from the Tla′oquiaht
 and Hupechesaht bands, which includes the well-known artists Joe David
 and George David.

Davidson, Robert
 1993 *A Haida Artist: Robert Davidson.* Audio tape from the artist's 1993
 Vancouver Art Gallery show.
 1995 "Reclaiming Haida Traditions," pp. 93–99 in *The Spirit Within: The John
 H. Hauberg Collection at the Seattle Art Museum,* S. Brown, editor. New
 York: Rizzoli.
 1996 "Art as a Catalyst for Reconnecting with our Spirits." Lecture, November
 1, at the Stonington Gallery, Seattle.

Davidson, Robert, and Ulli Steltzer
 1994 *Eagle Transforming: The Art of Robert Davidson.* Vancouver, B.C.: Douglas
 & McIntyre; Seattle: University of Washington Press.

de Laguna, Frederica
 1972 *Under Mount St. Elias: The History and Culture of the Yakutat Tlingit.*
 Smithsonian Contributions to Anthropology, vol. 7, parts 1–3. Washing-
 ton, D.C.: Smithsonian Institution Press.
 1988 "Tlingit: People of the Wolf and Raven," pp. 58–63, and "Potlatch Ceremo-
 nialism on the Northwest Coast," pp. 271–80, in *Crossroads of Continents,*
 W. Fitzhugh and A. Crowell, editors. Washington, D.C.: Smithsonian
 Institution Press.
 1990 "Eyak," pp. 189–206, in *Handbook of North American Indians,* vol. 7, W.
 Sturtevant, editor. Washington, D.C.: Smithsonian Institution Press.

Doig, Ivan
 1980 *Winter Brothers: A Season at the Edge of America.* New York: Harcourt
 Brace/Harvest Books.

Douglas, Georgiana
 1992 Personal communication. Georgiana Douglas is the wife of Julius Doug-
 las, both of Hydaburg, Alaska. Georgiana's traditional Haida clan claims
 the owl as one of its emblems.

Drew, Leslie, and Doug Wilson
 1980 *Argillite: Art of the Haida.* North Vancouver, B.C.: Hancock House.

Duff, Wilson
 1983 "The World Is as Sharp as a Knife: Meaning in Northwest Coast Art," pp.
 47–68, in *Indian Art Traditions of the Northwest Coast,* R. Carlson, editor.
 Burnaby, B.C.: Archaeology Press, Simon Fraser University.
 1981 "Mungo Martin, Carver of the Century," pp. 37–40 in *The World Is as Sharp
 as a Knife,* D. Abbot, editor. Victoria: Royal British Columbia Museum.

Duff, Wilson, Bill Holm, and Bill Reid
 1967 *Arts of the Raven.* Vancouver, B.C.: Vancouver Art Gallery.

Duffek, Karen
 1981 *Bill Reid: Beyond the Essential Form.* Vancouver: UBC Press.

Duncan, Kate C.
 1989 *Northern Athabaskan Art: A Beadwork Tradition.* Seattle: University of
 Washington Press.

Duncan, Kate C., and Barbara Hail
 1989 *Out of the North: The Subarctic Collection of the Haffenreffer Museum of
 Anthropology.* Studies in Anthropology and Material Culture, vol. 5. Prov-
 idence: Haffenreffer Museum, Brown University.

Emmons, George T.

1903/ "The Basketry of the Tlingit," in *Memoirs of the American Museum of*
1993 *Natural History,* vol. 3: 229–321. New York. Reprinted 1993, Sitka, Alaska: Friends of the Sheldon Jackson Museum.

1907/ "The Chilkat Blanket," with notes on the blanket designs by Franz Boas,
1993 in *Memoirs of the American Museum of Natural History,* vol. 3:329–401. New York. Reprinted 1993, Sitka, Alaska: Friends of the Sheldon Jackson Museum.

Emmons, George T., and Frederica deLaguna, editor

1991 *The Tlingit Indians,* edited and annotated by Frederica de Laguna. Seattle: University of Washington Press.

Ernst, Alice Henson

1952 *The Wolf Ritual of the Northwest Coast.* Reprinted 1980, Eugene: University of Oregon Press

Evans, Bill

1996 "Harry Beran," *Tribal Arts Magazine* (Summer):78–80.

Fair, Susan W.

1995 *Tradition, Innovation, Continuity: Native Art in the Public Eye.* Alaska State Council on the Arts.

Feder, Norman

1977 "The Malaspina Collection," *American Indian Art Magazine* 2(3):40–82.

1983 "Incised Relief Carving of the Halkomelem and Straits Salish," *American Indian Art Magazine* 8(2):46–55.

Fitzhugh, William W.

1988 "Comparative Art of the North Pacific Rim," in *Crossroads of Continents: Cultures of Siberia and Alaska,* W. Fitzhugh and A. Crowell, editors, pp. 294–312. Washington, D.C.: Smithsonian Institution Press.

Fitzhugh, William W., and Aron Crowell, editors

1988 *Crossroads of Continents: Cultures of Siberia and Alaska.* Washington, D.C.: Smithsonian Institution Press.

Force, R., and M. Force

1968 *Art and Artifacts of the Eighteenth Century.* Honolulu: Bishop Museum.

Furst, Peter T., and Jill Furst

1982 *North American Indian Art.* New York: Rizzoli.

Garrido, Araceli Sanchez

1991 *Indios de America del Norte (Otras Culturas de America).* Madrid, Spain: Museo de América.

Gustafson, Paula

1980 *Salish Weaving.* Vancouver: Douglas & McIntyre.

Hajda, Yvonne

1990 "Southwestern Coast Salish," in *Handbook of North American Indiáns,* vol. 7, W. Sturtevant, editor. Washington, D.C.: Smithsonian Institution Press.

Hall, Edwin S., Margaret B. Blackman, and Vincent Rickard

1982 *Northwest Coast Indian Graphics.* Seattle: University of Washington Press.

Hanlon, Eli

1988 Personal communication. The late Eli Hanlon was the Hitsáati (housemaster) of the Shark's Backbone House, Hoonah, Alaska.

Harper, J. Russell

1970 *Paul Kane's Frontier.* Amon Carter Museum, Fort Worth, Texas.

Hawthorne, Audrey

1967/ *Art of the Kwakiutl Indians and Other Northwest Coast Tribes.* Seattle:
1983 University of Washington Press.

Heine-Geldern, Robert

 1966 "A Note on Relations between the Art Styles of the Maori and of Ancient China," *Weiner Beitrage zur Kulturgeschichte und Linguistik* 15:47–68. Wein.

Henrikson, Steve

 1993 "Terrifying Visages: War Helmets of the Tlingit Indians," *American Indian Art* 19(1):48–59.

Henry, John Frazier

 1984 *Early Maritime Artists of the Pacific Northwest Coast, 1741–1841.* Seattle: University of Washington Press.

Hilton, Suzanne

 1990 "Haihais, Bella Bella, and Ooowekeno," *Handbook of North American Indians,* vol. 7, W. Sturtevant, editor. Washington, D.C.: Smithsonian Institution Press.

Holm, Bill

 1965 *Northwest Coast Indian Art: An Analysis of Form.* Seattle: University of Washington Press.

 1967 "The Northern Style: A Form Analysis," in *Arts of the Raven,* W. Duff, editor. Vancouver, B.C.: Vancouver Art Gallery.

 1974 "Structure and Design," in *Boxes and Bowls: Decorated Containers by Nineteenth Century Haida, Tlingit, Bella Bella, and Tsimshian Indian Artists,* W. Sturtevant, editor. Washington, D.C.: Smithsonian Institution Press.

 1983a "Form in Northwest Coast Art," pp. 33–46 in *Indian Art Traditions of the Northwest Coast,* R. Carlson, editor. Burnaby, B.C.: Archaeology Press, Simon Fraser University.

 1983b *The Box of Daylight: Northwest Coast Indian Art.* Seattle: University of Washington Press.

 1983c *Smoky-Top: The Art and Times of Willie Seaweed.* Seattle: University of Washington Press.

 1987 *Spirit and Ancestor: A Century of Northwest Coast Indian Art at the Burke Museum.* Seattle: University of Washington Press.

 1988 "Art and Culture Change at the Tlingit-Eskimo Border," pp. 281–93, in *Crossroads of Continents: Cultures of Siberia and Alaska,* W. Fitzhugh and A. Crowell, editors. Washington, D.C.: Smithsonian Institution Press.

 1989 "Cultural Exchange Across the Gulf of Alaska: Eighteenth Century Tlingit and Pacific Eskimo Art in Spain," in *Culturas de la Costa Noroeste de América.* Madrid: Museo de América.

 1997 "Variations on a Theme: Northwest Coast Painted Boxes," *American Indian Art Magazine* 22 (2):52–61.

Holm, Bill, and Bill Reid

 1975 *Form and Freedom: A Dialogue on Northwest Coast Indian Art.* Houston: Institute for the Arts, Rice University. Reprinted (1976) as *Indian Art of the Northwest Coast: A Dialogue on Craftsmanship and Esthetics.* Seattle: University of Washington Press.

Holm, Bill, and Thomas Vaughn

 1982 *Soft Gold: The Fur Trade and Cultural Exchange on the Northwest Coast of America.* Portland: Oregon Historical Society.

Hoover, Alan L.

 1983 "Charles Edenshaw and the Creation of Human Beings," *American Indian Art Magazine* 8(3):62–67, 80.

 1993 "Bill Reid and Robert Davidson: Innovations in Contemporary Haida Art," *American Indian Art Magazine* 18(4):48–55.

 1995 "Charles Edenshaw: His Art and Audience," *American Indian Art Magazine* 20(3):44–53.

Janzé, Phil
 1995 Personal communication. Phil Janzé is a Gitk'san artist well recognized for his artistry and craftsmanship in wood and precious metals.

Jensen, Vicki
 1992 *Where the People Gather: Carving a Totem Pole.* Vancouver, B.C.: Douglas & McIntyre; Seattle: University of Washington Press.

Johnson, Elizabeth L., and Kathryn Bernick
 1986 *Hands of Our Ancestors: The Revival of Salish Weaving at Musqueam.* Museum note 16, University of British Columbia/Museum of Anthropology, Vancouver.

Jonaitis, Aldona
 1986 *Art of the Northern Tlingit.* Seattle: University of Washington Press.
 1988 *From the Land of the Totem Poles: The Northwest Coast Indian Art Collection at the American Museum of Natural History.* Seattle: University of Washington Press.
 1995 *A Wealth of Thought: Franz Boas on Native American Art.* Seattle: University of Washington Press.

Jonaitis, Aldona, editor
 1991 *Chiefly Feasts: The Enduring Kwakiutl Potlatch.* Seattle: University of Washington Press.

Kaeppler, Adrienne
 1978a *"Artificial Curiosities," An Exposition of Native Manufactures, Collected on the Three Pacific Voyages of Captain James Cook, RN.* Honolulu: Bernice Pauahi Bishop Museum.
 1978b *Cook Voyage Artifacts in Leningrad, Berne, and Florence Museums.* Honolulu: Bishop Museum Press.

Kaplan, Susan A., and Kristin J. Barsness
 1986 *Raven's Journey.* Philadelphia: University of Pennsylvania Museum Publications.

Keithahn, Edward L., editor
 1963 *Monuments in Cedar.* Seattle: Superior Publishing.

Kennedy, Dorothy I. D., and Randall T. Bouchard
 1990 "Bella Coola," in *Handbook of North American Indians,* vol. 7, W. Sturtevant, editor. Washington, D.C.: Smithsonian Institution Press.

Kew, Michael
 1980 "Sculpture and Engraving of the Central Coast Salish Indians." Museum note 9, University of British Columbia Museum of Anthropology.

King, Jonathan C. H.
 1979 *Portrait Masks from the Northwest Coast of America.* London: Thames and Hudson.
 1981 *Artificial Curiosities from the Northwest Coast of America.* London: British Museum.

Kirk, Ruth, and Richard D. Daugherty
 1978 *Exploring Washington Archaeology.* Seattle: University of Washington Press.

Lobb, Allan, and Art Wolfe
 1990 *Indian Baskets of the Pacific Northwest and Alaska.* Portland, Oregon: Graphic Arts Center Publishing.
 1996 Personal communication with author.

MacDonald, George
 1981 "Cosmic Equations in Northwest Coast Indian Art," pp. 225–38 in *The World Is as Sharp as a Knife,* D. Abbott, editor. Victoria: British Columbia Provincial Museum.

1983a "Prehistoric Art of the Northern Northwest Coast," pp. 99–120 in *Indian Art Traditions of the Northwest Coast,* R. Carlson, editor. Burnaby, B. C.: Archaeology Press, Simon Fraser University.

1983b *Haida Monumental Art: Villages of the Queen Charlotte Islands.* Vancouver: UBC Press.

1996 *Haida Art.* Seattle: University of Washington Press.

MacLaren, Ian, editor

(in *Nothing but a Passenger: Field Writings and Watercolors of Paul Kane.*

press) Orange, Texas: Stark Museum of Art.

Macnair, Peter L., Alan L. Hoover, and Kevin Neary

1980 *The Legacy: Continuing Traditions of Canadian Northwest Coast Indian Art.* Victoria: British Columbia Provincial Museum.

Macnair, Peter L., and Alan L. Hoover

1984 *The Magic Leaves: A History of Argillite Carving.* Victoria: Royal British Columbia Museum.

Marr, Carolyn J.

1991 "Basketry Regions of Washington State," *American Indian Art Magazine* 16(2):40–49.

Maurer, Evan M.

1977 *The Native American Heritage: A Survey of North American Indian Art.* Chicago: Art Institute of Chicago.

Milburn, Maureen

1986 "Louis Shotridge and the Objects of Everlasting Esteem," in *Raven's Journey,* by S. Kaplan and K. Barsness. Philadelphia: University of Pennsylvania Museum Publications

Muir, John

1915 *Travels in Alaska.* Boston: Houghton Mifflin.

Nicholls, David, editor

1997 *Instrument of Change: James Schoppert Retrospective.* Anchorage Museum of History and Art, Alaska.

NTC

1996 "Indian Boarding Schools: The Nuu-chah-nulth Experience." Pt. Alberni, B. C.: Publication of the Nuu-chah-nulth Tribal Council.

Nuytten, Phil

1982 *The Totem Carvers: Charlie James, Ellen Neel, Mungo Martin.* Vancouver, B.C.: Panorama Publications.

Pasco, Katie

1997 "The Tsimshian Connection in Weaving the Painted Formline," *American Indian Art Magazine* 22(2):44–51.

Plummer, Katherine

1991 *The Shogun's Reluctant Ambassadors: Japanese Sea Drifters in the North Pacific.* Portland: Oregon Historical Society.

Polese, Richard, et al.

1977 *The Malaspina Expedition: "In the Pursuit of Knowledge."* Santa Fe: Museum of New Mexico Press.

Poole, Michael

1980 *Shadow and Spirit.* Film production. Vancouver, B.C.: Canadian Broadcasting Co.

Quimby, George I.

1985 "Japanese Wrecks, Iron Tools, and Prehistoric Indians of the Northwest Coast," *Arctic Anthropology* 22(2):7–15.

Reid, Bill

1967 "The Art: An Appreciation," in *Arts of the Raven,* W. Duff, editor. Vancouver, B.C.: Vancouver Art Gallery

1987 "Overture" to "Silent Speakers: Arts of the Northwest Coast," by Martine J. Reid, in *The Spirit Sings: The Arts of Canada's First Peoples,* S.D. Harrison et al., editors. Toronto: McClelland and Stewart.

Reid, Bill et al.

1993 *Gallant Beasts and Monsters.* Vancouver, B.C.: Buschlen-Mowatt Gallery.

Reid, William, and Adelaide DeMenil

1971 *Out of the Silence.* Ft. Worth: Amon Carter Museum.

Sawyer, Alan R.

1983 "Toward More Precise Northwest Coast Attributions: Two Substyles of Haisla Masks," in *The Box of Daylight: Northwest Coast Indian Art,* by Bill Holm. Seattle: University of Washington Press.

Schlick, Mary Dodds

1994 *Columbia River Basketry.* Seattle: University of Washington Press.

Schlick, Mary D., and Kate C. Duncan

1991 "Wasco-style Woven Beadwork: Merging Artistic Traditions," *American Indian Art Magazine* 16(3):36–45.

Schuster, Carl

1951 "Joint Marks: A Possible Index of Cultural Contact Between America, Oceania, and the Far East," *Royal Tropical Institute* 39:4–51.

Schuster, Carl, and Edmund Carpenter

1996 *Patterns That Connect: Social Symbolism in Ancient and Tribal Art.* New York: Harry N. Abrams.

Shadbolt, Doris

1986 *Bill Reid.* Vancouver, B.C.: Douglas & McIntyre; Seattle: University of Washington Press.

Sheehan, Carol

1981 *Pipes That Won't Smoke, Coal That Won't Burn: Haida Sculpture in Argillite.* Calgary, Alberta: Glenbow Museum Publications.

Siebert, Erna, and Werner Forman

1967 *North American Indian Art: Masks, Amulets, Woodcarvings, and Ceremonial Dress from the Northwest Coast.* New York: Paul Hamlyn.

Silverstein, Michael

1990 "Chinookans of the Lower Columbia," in *Handbook of the North American Indian,* vol. 7, W. Sturtevant, editor. Washington, D.C.: Smithsonian Institution Press.

Stewart, Hillary

1979 *Robert Davidson: Haida Printmaker.* Vancouver, B.C.: Douglas & McIntyre.

Sturtevant, William C., editor

1990 *Handbook of North American Indians,* vol. 7. Washington, D.C.: Smithsonian Institution Press.

Suttles, Wayne

1987 "Productivity and its Constraints, A Coast Salish Case," pp. 100–37, in *Coast Salish Essays.* Vancouver: Talonbooks; Seattle: University of Washington Press. Also published in Carlson, ed., 1983.

Swanton, John R.

1905 *Contributions to the Ethnography of the Haida,* vol. 8, part 1. Leiden: E. J. Brill; New York: G. E. Stechert.

1909 *Tlingit Myths and Texts.* Bureau of American Ethnology Bulletin 39. Washington, D.C.: Smithsonian Institution Press.

Thom, Ian, editor

1993 *Robert Davidson: Eagle of the Dawn.* Vancouver, B.C.: Douglas & McIntyre; Seattle: University of Washington Press.

Thompson, Judy

 1991 "Some Curious Dresses of the Natives: A Re-examination of Some Early Garments from the Alaska Coast," *American Indian Art Magazine* 16(3):66–76.

Wallace, William

 1980 Personal communication. The son of John Wallace, William Wallace helped his father on some of the canoes he made, but did not take up carving as a profession. He pursued instead a very successful career as a seine boat skipper.

Wardwell, Allen

 1996 *Tangible Visions: Shamanic Art of the Northwest Coast.* New York: Monacelli Press.

Watkins, Helen Abbott

 1992 Personal communication. A Shungookeidi Tlingit, Helen Watkins is dedicated to traditional food gathering and preparation and is a spruce root weaver.

Wright, Robin K.

 1977 "Haida Argillite Pipes." Master's thesis. University of Washington, Seattle.

 1983 "Anonymous Attributions: A Tribute to a Mid-19th-Century Argillite Pipe Carver, The Master of the Long Fingers," in *The Box of Daylight: Northwest Coast Indian Art,* by Bill Holm. Seattle: University of Washington Press.

 1995 "Hlgas7agaa: Haida Argillite," pp. 130–41, in *The Spirit Within: Northwest Coast Native Art from the John H. Hauberg Collection,* S. Brown, editor. Seattle Art Museum.

Wright, Robin K., editor

 1991 *A Time of Gathering: Native Heritage in Washington State.* Burke Museum monograph 7. Seattle: University of Washington Press.

Wyatt, Victoria

 1989 *Images of the Inside Passage: An Alaskan Portrait by Winter and Pond.* Seattle: University of Washington Press.

Young, Reverend S. Hall

 1927 *Hall Young of Alaska, "The Mushing Parson": The Autobiography of S. Hall Young.* New York and Chicago: Fleming H. Revell.

INDEX

Boldface numbers refer to photographs.

Abalone shell (material), 31, **32, 33, 34,
**35, 37, 39, **75, 79, 83, 84, 90, 91, 92, 93,
98, 118, 119, 121, **132, 166; native, 35;
attached by tying, 133
Abayah (Mrs. Mungo Martin), 158
Acapulco (Mexico): as site of early
Japanese shipwreck, 11
Adams, Primrose, 145, 172
Alaska Native Brotherhood/Sisterhood
(ANB/ANS), 141–42
Alaska Native Claims Settlement Act
(ANCSA), 122, 142
Alaska State Museum, 144, 163
Alcoholism, 141
Alder (material), **14,** 27, 29, **32,** 33, **43,
44,** 57, **59, 61,** 63, **64, 65,** 70, **71,** 73, **80,
87, 92, 93,** 124, 133, **137, 166,** 169, **170,**
175, **177**
Alert Bay (British Columbia), 149, 180
Aleut sea otter hunters, 34
Alfred, Wayne, 181, 182, 183
American Museum of Natural History,
149, 179
Amos, Patrick, 184
Analysis of form (Holm 1965), 4, 48,
100, 109, 116, 162, 163; as indicator of
time-depth for formline develop-
ment, 4
Angoon (village): US Naval bombard-
ment of, 124
Angularity: characteristic of early-style
U-shapes, 15; of elements on early
horn ladle, 29
Antler (material): southern artifacts
in, 11
Argillite (material), 68, **94, 95, 96, 97,**
111, **114, 115,** 119, **120, 121,** 143, 190;
beginning of trade in, 51; Victorian
design elements in, 84; overview of
carving tradition, 94–97; and wood
carving, 112
Arts of the Raven gallery (Vancouver,
B.C.), 159; catalog (1967 exhibit), 162
Asian/Pacific traditions, 11, 194n. 10
Assymetry in design, 99, 103, 137, 147
Athabaskan/Eyak language, 124
Athabaskan quillwork, 129

Bakwas (Man of the Ground), 155
Baleen (material), 33, 92
Baranof Island, 34, 123, 193n. 2
Baranov, Alexander, 34
Barbeau, Marius, 100
Basketry, **46,** 52, **53,** 63, 101, **117,** 129–31,
142, 145, **146, 158,** 159, 172
Bear femur (material), 80
Bear Mother myth, 120–21
Bear motif (brown or grizzly): on
AMNH/Emmons chest, 21; on raven
rattle, 84, 85; on frontlet, **91;** on hat,
92; on argillite chest, **98, 119;** in
argillite figures, **121;** shirt, **126;** model
totem pole, **150, 156;** mask, **171;** dis-
cussed, 120, 125
Beaver motif: on AMNH/Emmons
chest, 21; bent-corner dish, **30;**
sculptured bowl, **59, 170**
Bella Bella (village): canoe paddle, 103;
design style, 106, 148
Bella Coola: provenance, **132**
Benson, George, 144
Bent-corner bowl/dish, 30, **31, 36, 70,**
79, **81, 82, 94, 102,** 109, 175
Bent-corner box/chest: and formline
style, 21–24, 104–10; illustrated, **23,
24, 26, 104–10**
Beynon, William, 100
Bighorn sheep horn (material), **55;**
preparation for carving, 55
Birch (material), **19,** 76, 77, 87, **92**
Birchbark bowls: relation to wood
bowls, 74
Bird skin (material), 90, **91**
Bitterroot: collection of, for food, 52,
197n. 4
Blue paint pigment, 133, 196n. 5
Blunden Harbor village (Ba'aas), 149
Boarding schools, 141
Boas, Franz, 100, 127, 177, 193n. 1
Bob, Dempsey, 169, 171
Bone: comb, design style, 7, 21; Kwatna
artifacts, 9; southern artifacts, 11; as
material, **19;** battle club, **41;** soul
catcher, 72, **77, 79**
Box of Daylight raven hat/frontlet, **90,**
92

Boxley, David, 169
Brass (material), **34, 64, 132,** 133
British Columbia, central: style charac-
teristics, 87, 103
British Columbia, northern: significant
artifacts in, 7; examples of design
ratio reversal, 19
British Columbia, southern: archaeo-
logical sites, 11
British Museum: grease bowl (Dixon,
NWC 25), **14**
Bronze sculpture, 188, 189, 191
Brown, Capt. Andrew, 143
Brown, Steve, 163
Bureau of Indian Affairs, 101, 141
Burke Museum: old rattles, 88; canoe
model, 112; J. Wallace canoe, 144;
ATOG exhibit, 189; chest, 196n. 1
Button robe, **176**

Camas: collection of, for food, 52,
197n. 4
Canadian Museum of Civilization, 84
Canoe models, 59, 61, **64, 65, 84,** 94,
101, 111, **112,** 123, **137,** 142, 144; north-
ern style, 84
Canoe paddles, 103–4
Cape Fox Corporation, 144
Carpenter, Captain (Heiltsuk artist), 105
Catlinite, 94
Caus: collection of, for food, 52, 197n. 4
Celadonite, 196n. 5
Celtic design, 190
Central Coast Salish design style: eye
treatment in, 7, 133; compared to
northern artifacts and styles, 9, 10;
secondary concept as departure
from, 15; no tertiary line on ovoids,
25; Suttles's essay on, 44; discussed,
57–59; provenance, **58, 59;** full-relief
figures, 135; revival of older style, 186
Chapman, Isaac, 142
Cheek designs: on pre-1774 ivory bird,
13; lack of in early-style inner ovoids,
15; indicating presence of secondary
concept, 15; simple form in early
styles, 16; uncommon structure on
very early box, 26; mentioned, 39, 49

Chest, bent-corner, **20, 26, 105, 110**; collected by Emmons, Juneau, 21; contents protected by Konankada, 22

Chest design, 21, 22, 48, 49, 103, 104, 106, 111, 175; conventionalized form established, 21; structural tradition, 39

Chief Shakes: houseposts, 31, 33; Killer Whale canoe, 123

Child, Mervyn, 177

Chilkat design style: double tertiary U-shapes in, 16; and pattern boards for weaving, 35, 125, 129; in weaving tradition, 124–29, 195n. 2; illustrated, **126, 127, 128**

Chilkat robes: with Gonakadeit designs, 22

Chilkat shirt: with bear design, **126**

Chinookan: provenance, 43, **44**, 54, 55, **56**; nation, 51–56; language, 197n. 3

Chugach (Pacific Eskimo), 124

Churchill, Delores, 145

Circles: in Pacific Island traditions, 11; on early southern artifacts, 11; as eye forms on early box, 24; in Willie Seaweed's style, 152

Civilian Conservation Corps, 144

Clan crests: designs not common on chests, 22

Clappers, **87, 88**

Coastal environment, 56–57; northern and central areas contrasted, 198n. 6

Coast Salish: provenance, **43, 44, 57**, 63, **187**; design style, 58, 92, 186, 187; artists, 58, 59, 63

Coast Tsimshian: provenance, **81, 110, 111**; mentioned, 91

Colfax, Greg, 184, 185, 186

Collinson, Lewis, 143

Color shift, 39, 40, 50, 80

Columbia River, 51, 53, 54, 55, 56, 61

Comb: bone, and beginnings of northern Northwest Coast art style, 7; incised elements of, 8; wood, Tsimshian, 72, **79**

Condor motif, **52, 53**

Cook, Capt. James, 40, 65; objects collected by, 41; expedition, 63, 195n. 3

Copper (material), **17, 91, 92, 171, 183, 188**; rivets, 35, 37; mentioned, 133, 196n. 5; pendant, as wealth symbol, 181

Cormorant, **180**; crest, 181

Corn husk (material), **52, 53**

Cow horn (material), 75

Crabapple wood (material), **118,** 119

Cranmer, Agnes, 181

Cranmer, Doug, 155, 161

Creature images, 59–61

Crescents: on prehistoric southern artifacts, 11; influence of negative elements on positive design, 14; mentioned, 69, 92, 174

Crosby, Rev. Thomas, 137

Cross, John, 100, 143

Cross-hatching: in tertiary areas, 77; in positive forms, 87, 107, 112

Curio shops, 101

Dall sheep horn: ladle, 74, **75**, 78; dagger, **83**

Dance staff: early design style, 31, 33, **34**

David, George, 183, 185

David, Joe, 166–67, 171, 191

Davidson, Alfred, 112

Davidson, Florence, 145, 172

Davidson, Reg, 171

Davidson, Robert, 164, 170, 171–72, 174, 176, 190, 197n. 1

Davidson, Robert, Sr., 112

Deerskin (material), 172, **173**

Dick, Beau, 177

Dick, Blackie, 155

Dick, General (artist), 103

Dick, Simon, 178, 179

Ditidaht: provenance, **136, 183, 184**

Dixon, Capt. George, 14

Dogfish, 77

Douglas, Scott, 163

Drum, hand, 172, **173**

Duff, Wilson, 111, 161

Dzawada̱' enux̱w: provenance, 148, 149

Dzunukwa image: described, 149, 152; illustrated, **151, 154, 155**

Eagle: quills, as reinforcement, **20**, 21; battle helmet, 31, **34**; as design element, 104; house post, 124, **125**

Edenshaw, Albert Edward, 100

Edenshaw, Charles (Tahaygen), 99, 100, 111–21, 139, 142, 143, 164, 172, 198n. 8

Edenshaw, Isabella, 100, 116, 117, 145, 172

Elk motif, **52, 158,** 159

Emmons, George T.: notes, on Konandaka, 69; notes, on Tlingit daggers, 84; collected rattle fragments, 88; notes, on Chilkat blanket designs, 127

Epidemic diseases, 47, 100, 120, 141

Ermine (material/pelts), 33, 92

Eulachon oil, 30

Euro-American(s), 64; ship carving, 64

Eyak peoples, 124

Feder, Norman: quoted, 186

Fern stems (material), **130, 146**

Flicker feathers (material), **91**

Floral/foliate design, 84, 131, 190

Foolish Dancer, 64

Form. See Analysis of form (Holm 1965)

Formline: positive-negative ratio, on early ivory bird, 13; positive design in two-dimensional tradition, 14; structure, on early spruce root hat, 18; distorted, on very early box design, 24

Formline designs: characteristics listed (Holm), 15–16; primary, organization of on early box, 22; unusual structure on very early box design, 26

Formline elements: on grease bowl and ivory bird, 15; massive, characteristic of early styles, 16; wide positive, on early spruce root hat, 18; thinline principle, 50; "overlaps," 82

Formline system: as embryonic concept, 10; earliest known object exhibiting, 13

Fort Astoria, 51

Fort Rupert (British Columbia), 177, 180

Fort Vancouver, 52

Fort Victoria, 43, 44, 56, 61

"Fort Wrangell Master" (carver), 123

Fraser River, 56

Friendly Cove, 40

Frog: dish, 72, **73**; on raven rattle, 84, **85**; on shark rattle, 88, **89**, 198n. 11; House, 100, 123, 196n. 6; on woven hat, 111, **116**; on argillite chest, **119**, 120; on bird rattle, 134, **135**

Frontlet. See Headdress

George, Charlie, Jr., 149, 155

George, Charlie, Sr., 149

George, Chief, 149

Gibbs, George: drawing (1850), 197n. 5

Gitenmax School, 169

Gitk'san, 91

Gitlaxdamiks, 19

Gladstone, Charles, 142, 161

Glass: mirror (material), **90**, 91, 92, **93**, 133; beads, for rattle-top baskets, 130; bottles, basketry-covered, **146**; etched, **187**, 189; cast, **188**, 189

Globular rattle, **19**, 61, 88

Gold (material), 159, 175

Gonakadeit (Chief of Undersea World): as shagoon of Tlingit clans, 22; in designs, 22, 69, 74, 103, 106, 127–28. *See also* Konankada

Grant, Dorothy, 176

Grass (material), **130**, **146**

Grease dish: Dixon. (1787), **14**; as measure of stylistic age, 22, 27, 30; (c. 1850), 72, **73**

Green, Henry, 190

Greene, Stan, 186

Grooving: early design texture, 30

Guardian spirit quest, 58

Gulf of Georgia, 55

Guskimukw: provenance, **64**

Gwatsinukw: provenance, **64**

Gwaytihl, Charles, 100

Haida: provenance, **13**, **14**, 27, 35, 37, 67, 70, 72, 75, 76, 79, 80, 82, 95–97, 106–9, 112–21, 132, 143, 170, 172, **174**, 178; and chest design conventions, 22; argillite carving begins, 51; style attributes, 85; oral literature/mythology, 115, 121; Kaigani, 144; northern formline style compared with Nuu-chahnulth, 167; and contemporary tradition, 171

Haida Gwaii (Queen Charlotte Islands): early artifacts collected from, 13, 14; mythology, oral literature of, 115, 119, 121; and smallpox epidemic, 120

Haines (Alaska), 77, 123, 165

Hair (material): human, 19, 64, 88, 122, 154, 155; horse, **177**, **186**

Haisla, 50; provenance, **80**, **81**, **87**, **104**, 111

Haliotis fulgens (California abalone), 35, **38**, **39**

Halkomelem, 55, 186; ritualist's rattle, **58**, 59

Halliday, William, 147

Hamat'sa tradition, 178, 179

Hamilton, Ron, 183, 184, 189

Hart, Jim, 171

Hats: woven, **18**, **63**, **116**, 172; wooden, **33**, **90**, 91, 92, **174**, 175, **180**; Pacific

Eskimo, 195n. 5; old, newly painted, 198n. 8; selling prices, 200n. 3

Hauberg, John H.: as house post collector, 149

Head canoe: seal dish, **27**; painted model, **82**, 84

Headdress, 32, **93**; frontlet, **91**, **93**, **132**, 133, **166**

Heiltsuk: artists, use of northern style, 10; Kwatna artifacts, in territory of, 10; and thin formlines, 50; provenance, **87**, **103**, 104, **105**; influence of style, 156, 177

Heit, Chuck, 169, 170, 171

Helmets, Tlingit, **17**, **34**

Heron, 134

High-end dish, **71**; design, 71, 72; potlatch use of, 74

Hoko River: wet-site, 10; Archeological Project, 194n. 5

Holm, Bill, 4; quoted, 14, 30, 31, 162; on northern style, 14–16, 26; on formline face in box design, 107; on Nuuchah-nulth sculptural style in humanoid faces, 136; contribution of analysis, 162–63; as artist, 163

Hoonah (village), 33

Horn (general material): and design development, 29, 37, 68; preparation of, by artists, 55; compared with glass, 189

Horn: spoons/ladles, **28**, 31, 35, **37**, **38**, 39, **55**, 74–78; dagger, 83; bracelet, 194n. 7

Horsehair (material), **177**, **186**

House screen, 70, 196n. 5

Houseposts, model, **42**, **43**, **124**, 147, 148, 149, 196n. 5

Hudson's Bay Company, 56

Hudson, Jack, 169

Hunt, Calvin, 181

Hunt, George, 149, 177

Hunt, Helen, 158

Hunt, Henry, 155, 157, 180, 181

Hunt, Henry, Jr., 157

Hunt, Richard, 157, 159, 180, 181

Hunt, Stanley, 157

Hunt, Thomas, 177

Hunt, Tom, 179, 180

Hunt, Tony, 157, 158, 159, 181

Hunt, Tony, Jr., 157

Imbrication, 159

Indian agents, 100

Indian hemp, 52, 53

Inner ovoids: concentric placement on early box, 25; style of hollowing around creates fineline, 25; absence of fineline around is conspicuous, 25; style of, elaborated, 106, 107, 109

Inupiaq bentwood containers, 30

Isleta: provenance, **188**

Ivory: early (1774) seabird charm, 13, 22; (material), **12**, 78, 94, 111, **118**, 119, 120, **121**; amulet, 72, 77, **78**

Jackson, Nathan P., 144, 164, 165

Jackson, Stephen, 165

James, Charlie (Yakudlas), 147, 148, 149

James, Jack, 155

Janzé, Phil, 174

Japan: as source of tools and materials, 11, 194n. 10

Jefferson County Historical Society, 118

John Muir Elementary School, 112

John, Jimmy, 184

Johnson, Sam, 155

Joseph, Mary, and Jesus, 137

Juneau (Alaska), 101, 129, 144; as source of AMNH/Emmons chest, 21

'Kaakanéi, 30, 31, 36

Kadashan, Ida, 145

Kadjisdu.áxch' II (carver), 31, 33, 100, *See also* Chief Shakes, houseposts; Killer Whale House

Kane, Paul 44, 61, 197n. 5, 200n. 3

Katalla (village), 124, **125**

Katzeek, Dan, 145

Ketchikan (Alaska), 144, 145

Kihle: Haida name for grease dish, 27

Kiks.ádi clan, 34, 123

Kiksht, 53, 54, 55, 197n. 3

Killer Whale House, 131

Klookwana ceremonial, 183

Klukwan (Alaska), 145, 165

Kogwontaan clan, 33

Konankada (Chief of Undersea World): Haida name, 22; on chests, 69, 106, 107; on high-ended bowl, 74, on bent-corner bowl, 82. *See also* Gonakadeit

Kumugwe' (Chief of Undersea Beings), 181, **182**

Kwaguhl: provenance, 157, **179**, **180**, **181**

Kwakwaka'wakw: housepost, 43; language, 59, 198n. 7; provenance, 43, **64**, 135, **148–58**, **176–83**; traditionalists/

artists, 101, 132–33, 176; nation, 133, 134, 147, 148, 155, 159, 180, 181
Kwatna site: bone artifacts excavated from, 9

Lachane wet site: artifacts excavated
Lachane wet site (*continued*)
 from, 8; lack of two-dimensional decoration in objects, 9; and northern design style, 10
Ladles/spoons: horn, **28**, 31, 35, **37**, **38**, 39, **55**, 74–78; wood, 74, **76**, 77
Land mammal: characteristics in Gonakadeit designs, 22
Language groups, 184, 198n. 7
Large, Rev. R. W., 103
Leather (material), 83
Leverian Museum (London), 40
Lewis and Clark expedition, 51, 53, 61
Livingston, John, 159, 163, 176
Long Fingers, Master of, 96, 97
Lyle, Lieut. David, 84

MacDonald, George, 7, 22, 40, 69; quoted, 162, 163
MacKay, Jim, 143
Makah: provenance, 43, 44, 59, **63**, 65, **137**, **185**, 186; bowl, 59; canoe style, 60
Makah Cultural and Research Center, 197n. 9
Malaria, 52
Malaspina, Capt. Alejandro, 16, 19, 26, 195n. 3, 198n. 12
Mallard skin (material), **33**
Mandelbrot Set, 68, 191
Manitoba Museum of Man and Nature, 200n. 3
Maori tattoo designs, 191
Maple (material), **29**, **35**, **56**, **76**, **79**, **86**, **91**, **133**, **135**
Marks, Gerry, 142
Marks, John, 142, 143
Marks, Willie, 144
Martin, Mungo, 101, 147, 157, 158, 159, 161, 183
Masks, **62**, 63, **64**, **136**, **152–55**, 157, **169–71**, 177, 178, **181–86**. *See also individual artists*
Masset (British Columbia), 145, 164
Massim: culture district, as possible source of design elements, 11
Master of the Long Fingers, 96, 97
Mather, Flora, 145

Matilpi, Maxine, 176
McGookin, Len, 190
McGuire, Pat, 143
McLennon, Bill: infra-red photography, UBC/MOA, 111, 200n. 1
Metlakatla (Alaska), 122, 169, 200n. 2
Mintz, Bud, 174
Missionaries, 120
Missionization, 48
Model totem poles, 94, 101, 111, 112, **113**, **114**, 121, 123, **137**, **138**, 142, **143**, 147, **148–51**
Modeste, Ron, 186
Moiety system, 39
Moosehide shirts, 126
Mountain goat: wool (material), **126–28**; compared with sheep's wool, 129; horn (material), **37**, **38**, 39, **75**; image of, 143; horn bracelet, 194n. 7
Mountain sheep horn: early ladles, design of, 27–29; (material), **28**, **75**; translucence of, 189
Mowachaht: provenance, **40**
Museo de América (Madrid): Malaspina collection, 16
Musqueam: provenance, **187**

Naakush'ta (Dak'laweidi carver), 100, 196n. 6
'Nak'waxda'xw: provenance, 149, **150–54**
Nass River: photo from, 19; as raven-rattle tradition source, 88; as frontlet tradition source, 91, 92, 133; mentioned, 100, 170
Neah Bay, 41, 185, 186,
Neel, Ellen, 155
Negative design areas: minimal, on 1791 hat, 18; mentioned, 68, 173
Negative design elements: interplay of, 8
Negative formlines, 172–73, 190
New Guinea: culture area, as possible source of design elements, 11
Newcombe, Charles, 100, 193
Nishga: and raven-rattle tradition, 88; and headdress-frontlet tradition, 91; and sculptural style, **170**
Nitinat: provenance, **136**. *See also* Ditidaht
Noisecat, Ed Archie, 191
Non-concentricity: as early characteristic, 15; mentioned, 69, 194n. 1

Non-Native artists, 163–64, 176
Non-parallelism, 67, 69, 104
Nootka, Nootkan, 198n. 7
Nootka Sound, 43, 64
Northern British Columbia: style, 87; mentioned, 101, 133, 169
Northwest Coast: northern and central environments compared, 198n. 6
Nuu-chah-nulth: provenance, 40, 41, **60–65**, 135–37, **166**, 167, **183**, **184**; early art traditions, 41; mentioned, 59, 60, 63, 134, 166, 183; language, 184
Nuxalk (Bella Coola), 10, 177; provenance, **92**, **132**, 133

Octopus: bags, 131; image, **134**, 135
Oliver, Emmett, 189
Oliver, Marvin, 188–89
Opercula shell (material), **17**, **64**, **81**, **102**, **107**, **108**, **169**, **171**, **174**
Otter image, **134**, 135
Ovoid-shaped relief: on very early box design, 25
Owl: image, **95**; as Haida crest emblem, 95
Oystercatcher rattle, 135
Ozette: village, 41, 44, 45, 60, 184, 185; bone clubs, 43; design images, 59; archive, 197n. 9

Pacific Islands: artifacts and art traditions, 11
Paint: (material), 17, 18, 19, 22, 26, 33–36, 63–65, 67, 72, 76, 80, 82, 86, 87, 88, 91, 92, 102, 103, 104–9, 111–13, 116–17, 122, 133, 135–37, 145, 148, 165–69, 172, 175, 177–86
Painting: brush strokes, 61; formline, 68; red-on-black, 110; blue and vermilion, 133, 196n. 5
Pasco, Duane, 163, 166
Pasco, Katy, 125
Pattern boards, 125–29
Paul, Tim, 183, 184
Peratrovich, Selina, 145, 200n. 3
Perez, Comm. Juan, 13, 18, 195n. 3
Pine (material), 81; bowl bottom, 84
Pipes: wooden, 31, 35, **38**, 94, 96, 97; argillite, 94, **95**, **96**, **97**
Pipestone, red Minnesota, 94
Plague, 47, 100, 120, 141
Plaiting, 60
Plywood (material), **152**
Point, Krista, 187

Point, Susan, 87, 189

Pointe, Shane, 188

Pook-ubs, 184, **185**

Porcupine quill (material/technique), 126, 129, 131

Port Mulgrave (Yakutat Bay): site of Malaspina landing, 16

Positive design elements: interplay of, 8

Potlatch: ceremonies, 74, 132, 133, 147, 158; governmental repression of, 101, 147, 158

Price, Tom, 100, 119, 120, 143

Primary formlines: defined in terms of traditional color usage, 15; on soul catcher, 79

Prince Rupert: artifacts excavated, 8

Prince William Sound (Alaska), 124

Proto–Northwest Coast style: as evolutionary concept, 7; use of design concepts in early northern art, 9; definition, 10; elements, origin of unclear, 11; influence of painting on evolution of, 14; secondary concept a departure from, 15; characteristics on early box designs, 24; difference with northern tradition, 25; added to by individuals, 25; does not include tertiary line, 25; elements on Nuu-chah-nulth club, 41; comparative concepts, 61, 63; influence on Nuxalk sculpture, 92; mentioned, 50, 57, 59, 68, 133, 134, 135, 190

Provincial Museum, 158. *See also* Royal British Columbia Museum

Puget Sound Salish, 55

Quatsino, 43

Queen Charlotte Islands. *See* Haida Gwaii

Queen Charlotte Strait, 149

Quinault: bowl, 55; provenance, **57, 188**; First Nation, 189

Rattles: globular, **19**, 61, 88; bird, 61; salmon, **124**; mussel shell, **167**. *See also* Raven rattle

Raven: headband, 36, 39; mentioned, 79, 95, 133, 143; in Haida myth, 116

Raven-at-the Head-of-the-Nass, 15, 33, 95

Raven cycle stories, 87

Raven rattle, 31, **35**, 48, 49, 84, **85, 86**, 94, 95, 120, 134, 135, 198n. 12, 199nn. 13, 14; use of three-dimensional

overlay on, 31; Sheishoox (Tlingit), 35; rattle-type dish, 87

Raven's backbone, 33

Reciprocity: in culture and design, 39

Redcedar (material), **9, 10, 20, 21, 22, 23, 24, 26, 30, 31**, 102, **104–10**, 111, **134–37**, 148, **149**, 152, **154–57**, 165, **169, 171, 177–86**; bark, 59, **60, 63**, 92, **93**, 120, **121, 136, 152, 154, 155, 178, 179, 181, 183–86**; woven cover, 70, 71; bowl bottom piece, 84; root, **158, 159**; old hats, newly painted, 198n. 8

Red formlines, 77, 103, 174

Red inner ovoids, 39, 26, 80

Red primary formlines, 84, 112, 116

Red-on-black painting, 110

Reid, Bill: quoted, 3, 11, 47, 48, 68, 99, 139–40, 161; artistic career, 142, 161, 164, 174–75

Robes: woven, 127, **129**; button, 176

Robson, John, 100, 120, 143

Rorick, Isabel, 116, 145, **172**

Rosso, Larry, 171

Royal British Columbia Museum, 149, 157, 158, 159, 161, 162, 163

Russian: occupation, 15; America Company, 34

Salazar, Manuel, 187

Salish, Thompson River: provenance, **158**, 159. *See also* Central Coast Salish

Salishan, 43, 44, 45

Sally bags, 52, 53, 197n. 4

Salmon: image, 23–25; packing industry, 132

Salmon Boy (story), 123

Samuel, Cheryl, 163

Santiago (Perez's vessel), 13

Schoppert, James, 165

Scow, William, 149

Screen puppet, **179**

Sea bear, 143

Sea lion: portrayed on early ladle, 28; image, 29; whiskers, 33; hide, 91

Sea monster, 80, 81, 82

Sea Monster House, 149

Seal: early dish, **27**; oil, 30; image, **137**

Sealaska Heritage Foundation, 142

Seal/head canoe dish, 27

Sea otter hunters, Aleut, 34

Seattle Art Museum, 149

Seattle, 57, 101, 143, 144, 169; canoe celebration (Paddle to Seattle), 189

Seaweed, Joe, 149, 152

Seaweed, Willie (Kwagitola, Hihlamas, Smoky-Top), 147, 149, 150–54, 156, 178, 179, 183

Sea wolf, 116

Secondary areas: design development in painting style, 14, 15, 18, 26; mentioned, 72, 82, 103; in bone soul catcher, 79

Shamans: Haida figures of, 120

"Shaman's hat" design, **146**

Shark: rattle, 88; image, 91

Shark's Backbone House, 33

Shaughnessy, Arthur (Hemasilakw), 148, 149, 183

Sheep horn: vessels, 53, 54, **55**; rattle, **58, 59**, *See also* Horn (general material)

Sheldon Jackson School, 141

Sheldrake, Rupert: on morphic resonance and diffusion, 11

Shell buttons, 59

Shkihlakaa (Tlingit artist), 100

Shortridge, Louis, 100, 193n. 2, 196n. 6

Silkscreen/serigraph, 159, 174, 187, 188

Silver (general material), 68, 94, 111, 119, 159, 187; paint, 136

Silverwork, 77, 84, 142

Simeon, Dwayne, 178, 179

Sisiutl, **138, 149, 151**, 180, **181**

Sitka National Historical Park, 144

Sitka, 43, 101, 129, 141; battle of Old, 34

Skeena River, 100

Skeuomorphic feature, 80

Skidegate (village), 119, 142

Skip-stitch design: on spruce root hat, 18

Smallpox. *See* Epidemic diseases

Smith, George, 143

Smithsonian Museum of Natural History, 57

Soapberry (*Shepherdia canadiensis*), 29, 196n. 3

Soapstone (material), **94**

Southeast Alaska: early objects from, 7, 15, 21, 30; ceremonial artifacts, 22; cave, 60; frog dish, 72; head canoes, 84; shaman's graves, 88; twentieth-century Native artists, 143, 144, 164, 165

Sparrow, Debra, 187

Sparrow, Robyn, 187

Speck, Henry, 155

Spiral forms: use of in early styles, 16

Spruce (material), **17, 30, 31, 122**, 123, 124, **125**

Spruce root (material), **18, 33, 63,** 87, 116–17, 130, 146; early hats, **18,** 195n. 5; to sew box bottom, 22; conical rain hat, **63;** early baskets, 193n. 2

Square U-shapes: common in early styles, 16

Staff, speaker's or dancer's, 33, **34,** 196n. 7

Stanley, Daniel, 142

Steel (material), **83, 152**

Steel tools: shipwrecks as source of, 11; in refining carved faces on chest, 22; presence on Northwest Coast, 91

Stevens, Gov. Isaac, 57

Stilthda, Simeon, 100

Stogan, Leila, 187

Stogan, Wanda, 187

Straits Salish, 55, 186; house, 61

Sturgeon image, **52, 53**

Subsecondary elements, 68, 69, 107

Sun image, **87, 132,** 133

Suttles, Wayne, 44

Swan, James G., 118, 119

Swan skin (material), 92

Swanton, John R., 100, 193

Tahaygen. *See* Edenshaw, Charles

Tait, Norman, 169, 170, 171

Tate, Rev. Charles M., 137

Terasaki, George, 19

Tertiary areas, 49, 71, 72, 82, 96, 106, 107, 112, 116, 120; in proto–Northwest Coast style, 7; in eighteenth-century work, 15

Tertiary elements: archaic appearance on AMNH/Emmons chest, 21

Tertiary fineline: U-surrounds, 15; ovoids, 15; development of concept, 25

Tertiary line: defined, 25

Tertiary "splits": uncommon in early work, 26

Thlunaut, Jenny, 125

Thompson, Arthur, 183, 184

Thunderbird: and whale image, 39, **61,** 92, 133; as Kolus, 148, 149, **150, 156**

Thunderbird Park (Victoria, B.C.), 157, 158, 159

Tlasula performance, 181

Tlingit and Haida Central Council, 142

Tlingit: early objects recovered, 7, 16, 19; and Yakutat helmet, 16; provenance, **17, 18,** 21, 22, **26, 27, 28, 29, 30, 31, 33, 34, 35, 36,** 38, **39,** 70, 71, 72, 75,

77, 78, **79,** 83, 85, 86, **91,** 124, **126–31,** 145, **146;** frontlet, 31; and formline, 50; shamans' equipment, 78, 123; design style, 84, 87, 175, 177; and two-dimensional facial style, 86; historians, 88; battle helmets, 88, 91, 189; Tongass or southern, 105–6

Tobacco pipes. *See* Pipes

Tool handle, **10**

Totem Bight Park (Ketchikan, Alaska), 144

Totem poles, 120, 188, 190. *See also* Model totem poles

Toya.aat of Wrangell: owner of Pacific Island staff, 11; attribution to, 123

Tozier, Capt. D.F., 43

Trigons, 8, 9, 11, 41, 61, 69, 92, 174; defined, 8; in early Northern style, 9; in southern artifacts, 11; influence of negative elements on positive design, 13; distort eyebrow formline, 25; on early raven headpiece, 31; sculptural form, 136

Trigon "splits," 82, 84, 107

Ts'eka performance, 177, 181

Tsimshian: provenance, 19, 76, 79, 87, 91, 92, 168, 169, 170; rattle with heavy-style formlines, 19; frontlet, 133; sculpture style, 189

Two-strand twining, 18

U-shapes: distorted by trigon placement on box, 25; in very early box, secondary, 26

Ultra-primary design, 68, 103, 104; defined, 109, 110

Undecorated space, 39, 28

University Museum, University of Pennsylvania. *See* Shotridge, Louis

University of British Columbia, Museum of Anthropology (UBC/ MOA), 111, 161, 163, 189, 200n. 11

Vancouver Art Gallery, 162

Vancouver (British Columbia), 162, 186; airport, 189

Vancouver Island, 63, 64, 84, 92, 132, 133, 134, 166, 167, 183

Vermilion paint pigment, 133

Vertebrae, carved, **80**

Victoria (British Columbia) 47, 157, 159, 177, 181, 186. *See also* Fort Victoria

Wakashan: language family, 59; style in

sculpture, 133, 134, 135, 157

Walkus, Charlie G., 155

Walkus, George, 155, 156

Wallace, Dwight, 144

Wallace, John, 143, 144

Wallace, Lee, 144

Walrus, 91

Wardwell, Allen, 3

Waterlogged deposits: artifacts excavated from, 8

Watson, Jim, 145

Whale: image, 22, **29, 36,** 39, 59–61, **80,** 92, 93, 97, **116,** 117, 127, 128, 131, 133, 148, **150,** 152; bowl, 31, 35; House, 31, 33, 100; blowhole, on bent-corner dish, 35, 82; jawbone, **41;** tail, 60; -like sea creature, 77; raven-finned, 96. *See also* Thunderbird and whale image

White, Loren, 163

Williams, David, 144

Wilson, Billy, 144

Wilson, Joseph, 166, 187

Withe: to sew box bottom, 22

Wolf image, **40,** 41, 134, **183, 184, 186**

Wood (material), 68, **82, 83,** 88, **89, 94,** 111–13, 115, 126, **134,** 187

Wood spoons/ladles, **74, 75,** 77

Woodworm, 146

Wrangell (Alaska), 123

Wright, Dr. Robin, 45

Yakutat Bay (Port Mulgrave), 16, 124

Yankee whalers, 80

Yellowcedar (material), **67, 70, 81, 82, 102, 103, 105,** 112, **145, 148, 150, 154, 167**

Yellowcedar bark, 126–29

Yeomans, Don, 171–75, 190

Yew (Pacific yew, *Taxus brevifolia*), 57, 59, 111–13

Young, Henry, 121, 143

Yup'ik bentwood containers, 30